RENAISSANCE
BODIES

Critical Views

RENAISSANCE BODIES

The Human Figure in English Culture
c. 1540–1660

Edited by Lucy Gent *and*
Nigel Llewellyn

REAKTION BOOKS

Published by Reaktion Books Ltd
11 Rathbone Place, London W1P 1DE, UK

First published 1990; reprinted 1995

Designed by Humphrey Stone

Photoset by Wilmaset, Birkenhead, Wirral

Printed and Bound in Great Britain by
Redwood Books, Trowbridge, Wiltshire

British Library Cataloguing in Publication Data
Renaissance bodies: the human figure in English culture
c1540–1660.

1. English arts. Special subjects. Man. Body, history
I. Gent, Lucy II. Llewellyn, Nigel, 1951 –
700

ISBN 0–948462–09–4
ISBN 0–948462–08–6 pbk

Contents

Photographic Acknowledgements

The editors and publishers wish to express their thanks to the following for permission to reproduce illustrations: Bodleian Library, Oxford, pp. 87, 102; The British Library, pp. 22, 24, 26, 28, 29, 30, 104, 177 top; the Trustees of the British Museum, pp. 174 bottom right, 175 bottom left; Conway Library, Courtauld Institute of Art, p. 203 top; Courtauld Institute of Art, pp. 91, 92, 95, 98, 168 left, 169 left and right, 174 bottom left, 175 top right, 175 bottom right, 177 bottom; Devonshire Collections, Chatsworth (Courtauld Institute of Art), p. 57; the Marquess of Salisbury, p. 17; the Marquess of Tavistock and the Trustees of the Bedford Estates, p. 41; the Royal Commission on the Historical Monuments of England, pp. 222, 226, 227, 234; the Warburg Institute, pp. 161, 168 right, 171, 174 top left, 174 top right, 175 top left, 176 top and bottom.

Notes on the Editors and Contributors

LUCY GENT was Senior Lecturer in English at the Polytechnic of North London from 1976 to 1988. Her *Picture and Poetry, 1560–1620* was published in 1981, and her articles have appeared in *Modern Language Review*, *Renaissance Quarterly*, *English*, *Essays and Studies*, *Renaissance Studies* and elsewhere. Since 1988 she has been studying landscape design.

NIGEL LLEWELLYN is a lecturer in the History of Art at the University of Sussex. He has published numerous essays and reviews on English Renaissance art, as well as on Virgil and Ovid. He is currently organising an exhibition, to be entitled *The Art of Death*, for the Victoria and Albert Museum, London.

ANDREW BELSEY is a lecturer in Philosophy in the School of English Studies, Journalism and Philosophy at the University of Wales, College of Cardiff. He is the author of articles in several areas of philosophy and, with Catherine Belsey, of 'Christina Rossetti: Sister to the Brotherhood', *Textual Practice*, 2 (1988).

CATHERINE BELSEY is Professor of English at the University of Wales, College of Cardiff, where she chairs the Centre for Cultural and Critical Theory. Her books include *Critical Practice* (1980), *The Subject of Tragedy: Identity and Difference in Renaissance Drama* (1985) and *John Milton: Language, Gender, Power* (1988).

ELLEN CHIRELSTEIN is a member of the Centre for Independent Study in New Haven, Connecticut, and has taught at the School of Visual Arts in New York. She has lectured at the Yale Center for British Art, New Haven, and is currently working on aspects of Elizabeth and Jacobean painting in the History of Art Department at Yale University.

ELIZABETH ALICE HONIG studied History of Art at Bryn Mawr College and afterwards at Yale University, where she is currently completing her doctoral dissertation on Dutch and Flemish market scenes. She has written on aspects of seventeenth-century Dutch genre painting for various Dutch and American publications.

TAMSYN WILLIAMS studied at Oxford Polytechnic and the Courtauld Institute, London, where she was engaged in research on political prints of the English

Revolution. She now devotes much of her time to painting, and teaches art history in a local school in Cornwall.

JONATHAN SAWDAY is a lecturer in Renaissance literature and critical theory at the University of Southampton. He is the author of *Bodies by Art Fashioned: The Renaissance Culture of Dissection* (1990) and co-editor, with T. F. Healey, of *Literature and the English Civil War: A Collection of Essays* (Forthcoming).

ANNA BRYSON is a lecturer in intellectual history at the University of Sussex. Her current interests include aristocratic social values and behaviour in sixteenth- and seventeenth-century England. Her book *From Courtesy to Civility: Changing Codes of Conduct in Early Modern England* is soon to be published.

JOHN PEACOCK is a lecturer in English Literature at Southampton University, where he specialises in Renaissance literature. His research has concentrated on Elizabethan, Jacobean and Caroline court culture, and his publications include essays on Ben Jonson, Inigo Jones and Anthony van Dyck. He is currently writing a book on Inigo Jones's masque designs.

SUSAN WISEMAN is a lecturer in English Literature at the University of Kent. Her articles and reviews have appeared in the *Edinburgh Review*, *Woman's Review*, *British Book News* and elsewhere.

MAURICE HOWARD has taught at the universities of Pennsylvania and St Andrews; he is currently a lecturer in the History of Art at the University of Sussex. He is the author of *The Early Tudor Country House: Architecture and Politics, 1490–1550* (1987).

Introduction

LUCY GENT AND NIGEL LLEWELLYN

English Renaissance culture perceived the human form in a rich variety of ways. *Hamlet*, for example, is haunted by words, actions and presences to do with the sheer physicality of human existence. 'We fat ourselves for maggots,' says Hamlet as the hunt goes on for Polonius' corpse. The body's tendency to disappear under the elaborations of costume is acted out in the vain courtier Osric. By the end of Act Five the stage is a landscape replete with bodies. Yet the play echoes the raptures of many a Renaissance treatise exalting humanity – 'What a piece of work is man' – before collapsing them into a 'quintessence of dust'. By means of the play within a play we are reminded that the figure is always represented.

In some of the period's images of the body there is also a distinctive strangeness, deriving perhaps from the survival of older conventions of representation alongside newer fashions. The long-legged carapaced monsters of De Critz and Larkin,[1] the bizarre images of Elizabeth, withhold their meaning from us, as though the human figure were decked out for strange tribal rituals in remote and alien societies. A painter presents seventeenth-century sisters in bed with their chrysalis-like swaddled children in an image so stylised it is as reminiscent of a Romanesque sculpture as of Renaissance bed-scenes by Italian painters,[2] Quite different conventions display the human frame in relation to arcane cosmological scenes, as in the diagrams of Robert Fludd.[3]

Our theme requires the connotations of both 'body' and 'figure'. At one end of the spectrum of meanings between the two words, 'figure' suggests outline and representation, connotations that are carried by many miniatures, such as Hilliard's *Young man amongst roses* (London, Victoria and Albert Museum). It can mean number and symbol, which seems irrelevant to a book on the human form until one remembers the many images of the human figure inscribed within a geometrical shape. As meanings of 'figure' move in the other direction towards 'bodily

shape' and 'embodied human form', the word still carries a note of abstraction and distance, as if the human form were viewed by someone. At the same time 'figure' is a symbol of the life that representation itself stands for.

'Body', by contrast, suggests the solidly central unrepresented fact of existence, a materiality that of itself is inarticulate. It is the mute substance of which 'figure' is a more nervous and expressive shadow. Where 'figure' moves out towards the abstract and mathematical, 'body' gravitates towards death, as with the corpse hinted at in Shakespeare's *Sonnet 12* where summer's green is 'Borne on the bier with white and bristly beard'.

This moment is a particularly good one to launch a collection of essays around the theme of the represented human figure, the Renaissance body. Whereas twenty years ago there were few critical options other than the exercise of denotation, iconography or the decoding of metaphor,[4] today there is a widespread interest in theories of representation, of the self and of the body, and many methodologies available to criticism. Hence there is new scope to unfold the richness of material from the English Renaissance and suggest new perspectives. The essays collected here represent current research in a variety of fields and exploit a variety of methodologies.

One context, however, needs to be borne in mind, that of the depicted figure's role in the history of art and, indirectly, in literary criticism. During the Renaissance there was a strong belief that the success and progress of works of art were measured by their treatment of the human figure. This story is as old as writing on art; antiquity encouraged its adoption by Renaissance humanists and, subsequently, by even more powerful forms of humanism.[5] Art historians often present the Renaissance as the moment in human history when a tradition that was abstract and mathematical came together with the exemplary religious tradition to create a new version of bodily perfection. The key concept is that the human figure can express perfection. This view underpins art history and obliquely affects English literary criticism.

In a chapter of Vitruvius' *De Architectura* dealing with the design of temples, the Renaissance humanists found a passage which provided a rational formula for the definition of bodily perfection.[6] Vitruvius was writing an architectural handbook and found himself having to justify the choice of certain shapes and proportions which could be used to define ground-plans, elevations and other dimensions in building. Taking as an unproblematic commonplace the assumption that the

human body could be the measure of perfection, Vitruvius described the body of a man with limbs outstretched disposed within the basic, perfect geometrical shapes of the square and the circle.

This perfectly circumscribed figure established a set of proportions and provided, for example, a guide for the design of columns: there are nine head-heights in the total height of the well-proportioned figure; therefore, let the height of a column be the equivalent of its capital times nine.[7] Some of the contributors to this collection discuss illustrations appended to the Vitruvian text by Renaissance artists fascinated by the neat symmetry of the idea.

The learned writers and, increasingly, artists who developed this idea were particularly attracted by its potential to provide a useful, legitimising synthesis between two conflicting traditions of thought. A pagan tradition surfaced in ideas about the way architectural dimensions could approximate to what the Platonists called perfect essences and encapsulate mathematical versions of those perfections, and the Judeo-Christian tradition cast the human body as a distant reflection of the perfection of the Creator. As the first human was made in God's image, this first body must, of necessity, have been perfect. Therefore an enquiry into the definition of bodily perfection was, by implication, an enquiry into the nature of the Godhead itself.

These ideas led to the full-blown humanist notion of the human figure as a vehicle for moral education and the maintenance of abstract ethical concepts. In his early treatise on painting (1435), L. B. Alberti argued that the greatest work of visual art was the *istoria*, whose power lay in its use of human figures to transmit important moral truths.[8] The *istoria* (badly served in translation as 'History Painting') told a story by means of human figures in certain poses, displaying certain gestures and expressions.

In the following century the historian and theorist of art, Giorgio Vasari, established an historiographic commonplace when he argued that progress in the figurative arts could be measured by an artist's capacity to render the human form with attention both to ideals of beauty (usually based on classical models) and to the accurate depiction of natural forms. According to Vasari's *Lives* Masaccio was a key master of the early Renaissance because his figures seemed to stand upon the ground; at about the same time Donatello created figures of great beauty based on antique prototypes; in whatever medium, Michelangelo's works were explorations of the human form; Leonardo's

eccentric scientific enquiries were intended to reveal the workings of the human body as a natural machine.

Ever since, the traditional critical yardsticks applied in the visual arts, not without some bearing on literary criticism, have been largely determined by this model. The task of traditional history is to trace progress and perfection in the treatment of the human figure. Having invented the concepts of Mannerism and Baroque, academic critics proceeded to condemn those styles for being based not on a steady application of the truths learned from drawing the human figure but on artificial and unnatural novelties.

Subsequent art-historians have treated whole epochs in Western history on the basis of the rank and moral virtue of the figures made by the artists of the period. To take two examples, Bernard Berenson identified the figure style of the carved stone reliefs on the Arch of Constantine as a clear sign of the decline of ancient Roman civilisation, and Nazi propagandists condemned Expressionist figure styles as corrupt.[9] Such alignments between politics and taste show that the form of the human figure is not simply an aesthetic concept isolated from everyday life but rather a force at work in society. Burckhardt's analysis of the Renaissance state considered as a work of art includes a description of the physical characteristics of the heroes of his story that emphasises their nobility and graceful bearing. For his pupil Heinrich Wölfflin, the most influential art historian of the first half of the twentieth century, the High Renaissance was a classical moment when aristocratic ideals triumphed over bourgeois realism.[10] Raphael's paintings for the Vatican *Stanze* were characteristic of the demand, so often to be voiced over the next generations, that important pictures be populated by figures which were ideal from the social as well as from the aesthetic standpoint.[11]

In such company, historiography has presented the visual arts of the English Renaissance as hopelessly second-rate. The English displayed little knowledge of Italianate or classical motifs mediated by continental sources; therefore, the figure style of English Renaissance artists and the sense of proportion of its architects have often been found wanting. The portraits and effigies are wooden, so the story goes, and they lack that sophistication of presentation ordained by contemporary European styles such as Mannerism: 'The history of English sculpture in the sixteenth century is a sorry tale,' yet, the same author adds, 'there is little reason to suppose that patrons were not satisfied with what they got'.[12]

The situation regarding English Renaissance literature and its critic-

ism is rather different. Shakespeare's has always been seen as the 'golden age', praised as much for its independent character as for its reliance on European ideas. Thus, the Vitruvian ideal circulated in England, albeit at varying removes from its European sources, but it was only one component in the version of Renaissance humanism developed by English writers, and it provided only one version of the human figure among many current in England. For example, of the writers of Italian high culture, Pico della Mirandola was far more widely known than Vasari (whose *Lives* were, by 1600, known only to a small number of English readers),[13] and the second proposition of his well-known epitome of man, that he can rise to the angels or fall to the beasts, was closer to northern Protestant belief than to ideas common amongst his own humanist, orthodox Italian peer group. The English selected their Italian sources with great care.

English literature has never been dominated by a narrow canon of High Art such as ruled the visual arts; Jonson's attempt to judge his contemporaries' writing by the procrustean standards of neo-classicism was not influential.[14] But English literary criticism, when it developed as an academic subject in the later nineteenth century, adopted humanism as a fundamental principle; and at the heart of humanism lay the all-important concept of man.

Humanist orthodoxy has directed interpretations of the English Renaissance figure in many ways. As an example, one might cite the assumption that the individual was the source of value and existed above social forces, or the assumption that the Burckhardtian and implicitly male 'individual' was the norm against which to measure all variants. The concept of a universal 'Renaissance man' – who was not, of course, universal but was decidedly masculine – encouraged the formation of a canon of 'great' texts and the marginalisation or exclusion of others, such as those of popular culture or those by women.[15] In other words, humanism set bounds on the kinds of human images taken seriously as the objects of study and the ways in which they were to be considered.

In a more devious and subtle way humanism may also have affected readings of the body, because it regarded the self as overwhelmingly important, and the true self as that which resides within.[16] Within precisely what is a moot point, but one obvious answer is 'the body', which makes the body, being simply a receptacle for the personality, less important. This view derives largely from the Christian hierarchy in which the body is a rather lowly, albeit necessary, container for the soul

or spirit. It becomes acceptable when spiritualised by love; against such a denaturing of the body Donne perhaps protests in 'But yet the body is his book', which with something of a shock reorders the body in the hierarchy by associating it with high culture and intellectual objects such as books.[17]

But the physical body's theological status in the sixteenth and seventeenth centuries was modified and tempered by two factors at least. Living conditions necessitated a greater tolerance of others' bodies;[18] while, in the field of representation, there was a far more lively oral and popular culture whose texts, outside of preachings in church, were not concerned with making hierarchies of matter and spirit. Bodily functions tended to be sources of embarrassment to many a Mr Podsnap in the nineteenth century; so was Keats's vulgar foregrounding of it to his readers.[19] Nineteenth-century critics tended to write the body out of their readings of texts in favour of something more admirable and more sanitised, namely, character, the individual and the true self. These critical topics have, for example, loomed large in criticism of *Hamlet*. That the true part of us is the self which lies within has been a powerful piece of our culture's propaganda. Renaissance texts have repeatedly been used to mount the dubious argument that the later sixteenth century saw the emergence of the modern sense of self, even, recently, by critics who stand well aside from many of the assumptions of Renaissance humanism.[20]

However, older ways of treating the human figure in English Renaissance texts have been radically questioned by theories of representation[21] developed through the interaction of linguistics with psychoanalysis, anthropology and sociology.[22] The human figure ceases to be considered as a transcendent given and instead becomes a signifier, and therefore, in so far as our minds are involved, it is constructed by language, by cultural practices encoded in language, and by visual images which mesh with systems of language. It ceases to be, in the depictions of art, an imitation but rather a construction or a creation. 'Vitruvian Man', and the Burckhardtian individual, are no longer norms against which to measure other versions of the human figure but instead are read as interpretations arising from particularities of society and circumstance.

Nowadays, the traditional readings of the human figure in the Renaissance invite comparison with those beautiful Viennese facades which, Freud instructed his daughter Anna, hid very different realities. Critical practices based on psychoanalysis, on Bakhtin and popular

culture, on Foucault, and on Feminism give rise to another set of pictures. For example, the idea of the perfectly proportioned human figure, so attractive in its claim to universality, harmony and unity, has been shown by Svetlana Alpers to depend on its opposite, the idea of a body less than masculine, less than ideally proportioned, that is, the female body.[23]

While some regret these newer critical enterprises because they ruin (to borrow Marvell's phrase) 'the great work of time',[24] that is the twentieth-century heritage of Western European culture culminating in humanism, the present essays show, we hope, how fruitfully modern critical approaches may be used.

One feature of these essays is their interdisciplinary framework.[25] The aim here is to enrich current discussions in the fields of art history and literary criticism and to question the boundaries between the different disciplines as they tend currently to be drawn; for one thing is certain, current divisions of subject-matter and method in academic departments correspond scarcely at all to the way the boundaries would have been drawn in the English Renaissance, as a consideration of categories of knowledge then prevailing will readily show.[26] An example of the arbitrariness of boundaries is that the very term 'Renaissance' was not known to people living through that period.

Our aim is also to avoid the violent polarisation of critical disputes that has infected both literary and art historical scholarship over the last twenty years, the polarisation between, broadly speaking, structuralism or post-structuralism, and humanism. Ironically, an awareness of the imprisoning force of thinking in terms of binary oppositions has not deterred either 'side' from attacking the other. Hence, these essays display a wide range of critical approaches rather than strict methodological unity. This is deliberate. For even if the two sides cannot ever become one, there should at least be room for difference, a climate in which various essays using a range of approaches can thrive.

The distance between critical positions in the volume can be illustrated by the difference between the Belseys' essay and that of Tamsyn Williams. The first makes a frankly post-structuralist reading of its texts, such as would not have been available to a reader in the Renaissance; the second is concerned with the recovery of contexts that will allow us to begin to read images hitherto neglected. A title-page formerly deemed to be poverty-stricken in its meaning and to employ crude images begins to acquire the density we associate with a literary or artistic text. By contrast, the post-structuralist reading may demolish

cherished assumptions and leave the precious and familiar text stripped of its reassuring interpretations. Such readings are often described as reductive. But established critical modes have a knack of becoming self-nourishing, as in the very process of continuing they nurture the critics' own myths; and in the face of this tendency, a so-called 'reductive' reading can provide a salutory change of diet.

But while the precise critical approaches may vary, all the essays in this collection are involved with the themes and problems outlined above. Many of them concern depictions of the human figure that would have been ignored 20 or 50 years ago, on the grounds that they were not art. The power of the human image is plentifully acknowledged here, but not because it displays idealism or the artist's grasp of a 'great tradition' which, as the embodiment of inherent quality, should be studied, admired and taken as an example. Instead its power is seen to come from the discourses of which it formed a part.

Tamsyn Williams, for example, investigates the human figure in the visual language of polemical seventeenth-century prints. Here the images were effective because of a wide consensus about what was and what was not considered normal; these popular wood-cuts were deployed for their directness, accessibility and called for no esoteric readings. They were meaningful to a wide audience who were not accustomed to ignoring images because they lacked inherent quality in our modern sense of 'art'.

The anatomised human body – which is the physical body of the criminal subjected to legal authority – is the subject of Jonathan Sawday's essay. He considers the image not as an icon of disinterested scientific observation but rather as the product of contradictions as strong as the contrast between the dissected bodies and the tranquil pastorals in which they are sometimes set. Thus he recovers some sense of the complex cultural practices surrounding anatomy and makes us aware of the allusions to dissection by English writers in the early seventeenth century. The outlawed body is also the subject of Sue Wiseman, who discusses the dramatic presentation of the female body, controlled and violated by men, and turned into a site of symbolic meaning.

Three essays deal with portraits of women. The social construction of gender in the portrait of the widow is the subject of Elizabeth Honig, who shows how the image is given traits of the dead husband. She also explores the complex relationship between a living sitter and their representation in words or paint. Ellen Chirelstein shows how in Robert

Peake's portrait of *Lady Elizabeth Pope*, a classical and illusionist prototype is modified to make an image formed by conventions of heraldry, miniature and masque, as well as of panel painting.

An aspect of royal portraiture is reassessed by the Belseys; they consider the significance of the way clothing covers and obscures the body in some portraits of Elizabeth I, leading to a view of the portrait as propaganda for Elizabethan imperialism and distinguishing between, on the one hand, individuality in the sense of character and, on the other, individuality considered as power, authority and wealth.

Modern academic discourse creates frameworks of expectation for the analysis of the styles in which the human figure is represented. Nigel Llewellyn, in interpreting Tudor royal tombs, does not follow the criteria of sculpture considered as art-objects but instead discusses the cultural meaning of funeral effigies in terms of such factors as location and materials. Architecture's relation to the human figure is taken up in two essays. John Peacock shows how, while not figurative in the obvious sense, architecture can be designed on the basis of principles gleaned from the study of the human form and therefore transmits the kinds of moral messages traditionally read into such representations. Maurice Howard takes on quite a different problem: the creation of a social and political identity via patronage. Using the concept of self-fashioning, he suggests that a group of mid-sixteenth-century patrons commissioned buildings embodying notions of Protestantism, nationhood and commonwealth. If Howard posits the human figure constituted, as it were, through a building programme, Anna Bryson focusses on the image of gentlemanly stance and gesture as constructed by courtesy books, and their coding of moral qualities, so that the body's movements manifest superior civility and inner virtue.

These essays deal with the familiar and the remote, the human figure and the Renaissance text. The body is the most quotidian part of our landscape and the most potent signifier known to us. Yet there is no easy way of reading its meaning. Vasari (as Peacock reminds us) believed that figure painting should strive for the life-like, but in whose terms and according to whose ideals can such veracity be defined? We seem not to be able to trust Nature to be truthful for (as Anna Bryson shows us) many social theorists in Renaissance England felt that the natural body should be restrained.

The remote enters with the ancient objects of English Renaissance culture that are the material of these essays. Any attempt to construct meanings for them is fraught with difficulty, for all the 'naturalness' of

interpreting a well-known text or image. Some would say they can only be made to speak with our voices, so that any enterprise to interpret them other than from a twentieth-century viewpoint is doomed to failure. Whether we are 'recovering' meaning or inventing meanings through a complex process of 'reading' is perhaps a question for each reader to answer.

Icons of Divinity: Portraits of Elizabeth I

ANDREW BELSEY AND CATHERINE BELSEY

I

The face is pale and perhaps slightly unearthly, with a high forehead sharply defined against red-gold hair. Brilliant lighting falls directly on the Queen, eliminating almost all shadow. The white lace ruff and the enormous pearls in her hair complete a circle, radiating outwards against a dark background from a face which seems in consequence to be the source of light rather than its object. Elizabeth gazes out to the left, beyond the frame of the painting, contemplating a destiny invisible to the spectator. She appears remote and a little austere. George Gower's 'Armada' portrait (1588?) presents the Queen as an emblem of majesty (p. 12).

Her richly jewelled dress, meanwhile, and the ropes of pearls round her neck, are palpable signifiers of magnificence. The skirt and the bodice, with its long sleeves hanging behind, are of black velvet, all bordered with a single row of pearls held between gold edging. Silk bows, matching the rose-coloured lining of the outer sleeves, are held in place by rubies and emeralds. The satin underskirt and sleeves are embroidered with pearls and with devices in gold thread which resemble the sun.

Only the face and hands are visible. The exaggerated sleeves and the gigantic skirt efface between them all other indications of a human body. The effect of the richly lined oversleeves is of a sumptuous casing which, without attributing to the Queen anything so specific as broad shoulders (she has, indeed, no *bones* at all), extends the dimensions of the figure to make of the arms an anatomically improbable, embracing, encompassing semi-circle. This image of Elizabeth invites comparison and contrast with the body of Henry VIII, famously portrayed by Holbein as an icon of masculinity and power (p. 13). Henry's equally improbable shoulders are made to seem flesh and blood by the King's stance: in the firmly modelled cartoon, which is all that survives of Holbein's original painting of the

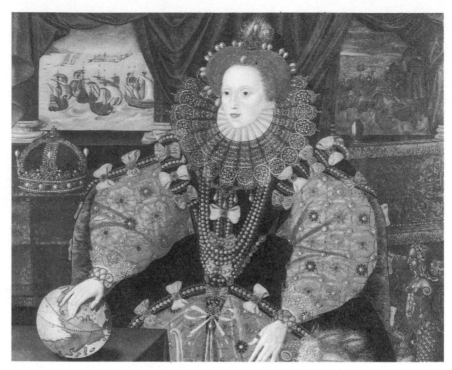

George Gower, *Elizabeth I – The 'Armada' Portrait*, 1588. Woburn Abbey.

King and his family in 1537, Henry stands, legs astride, arms akimbo, the feet aligned with the shoulders in a posture that combines aggression with strength. The King meets the spectator's gaze, requiring submission.

Elizabeth must have been aware of the implications of the Holbein portrait, then hanging in the Privy Chamber at Whitehall. And she was, after all, happy for dynastic reasons to recognise her resemblance to her father.[1] But the same artistic-political strategies were not available to a woman. Henry's magnificence resides in his muscularity, in the picture's exaggeration of his physical attributes. However, in the sixteenth century as in the twentieth, because of the cultural construction of gender, an emphasis on the physical character of the female body connotes something quite different: not authority but availability, not sovereignty but subjection. Where Henry's right to dominate is confirmed by his virility, represented in the extraordinarily prominent codpiece, Elizabeth's depends by contrast on sexuality subdued, on the self-containment and self-control of the Virgin-Queen. Louis Adrian Montrose, making an illuminating comparison between the two pictures, points out that in the

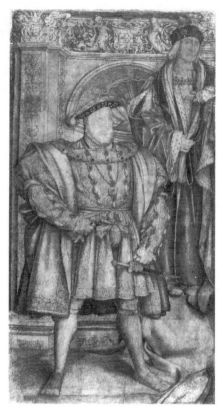

Haus Holbein, *Henry VIII with Henry VII*, 1536–7.
National Portrait Gallery, London.

place corresponding to Henry's codpiece, the 'Armada' portrait of Elizabeth displays a giant pearl. At the base of the triangle made by her stomacher, and foregrounded by a white ribbon tied in a bow, hangs an emblem of the Queen's chastity.[2] Indeed, the composition of the portrait insists on the pearl's emblematic significance. The near-vertical line which forms the fastening of the bodice links a succession of pearls, culminating in the vast pearl of the headdress, emphasising a symmetry between majesty and virginity. The juxtaposition of the two huge gems displays the Queen impregnable in both senses, powerful precisely to the degree that she is inviolable.

The point is allegorically reinforced. As so often in her portraits, the Queen stands before a chair of state, and in this instance the arm of the chair is supported by the carved figure of a mermaid. During the Middle

Ages and the Renaissance mermaids represented the dangerous and destructive possibilities of uncontrolled female sexuality. According to legend, they offered sailors tempting glimpses of their beauty as they combed their long golden hair among the waves. Interchangeable with the sirens who threatened to destroy Odysseus and his crew, mermaids also sang with extraordinary sweetness and seductiveness. Sailors who failed to exercise the highest self-discipline were known to leap into the sea in pursuit of their charms, but cheated of satisfaction by the mermaids' scaly tails, they were drowned, and their ungoverned ships were lost among the rocks. In the painting the angle of the mermaid's eminently visible body, the direction of her gaze and even her surprisingly aquiline features suggest a parody of the image of the Queen, implying that she represents an alternative sexual identity to Elizabeth's. The Queen firmly turns her back on the form of femininity that the mermaid stands for.

Directly above the figure of the mermaid, however, the picture records a disaster at sea. A row of columns opens on to the loss of the Armada as Spanish galleons are lashed against huge rocks in the darkness. The shipwreck of the Spanish fleet was real enough, but its role in the portrait is as allegorical as the mermaid's. Elizabeth stands with her back to darkness and turmoil, confident in the power of the Protestant wind which God has shown himself willing to use to destroy the enemies of his Church and people. On the left of the picture, meanwhile, English fire-ships set out towards the approaching Armada. The episode is bathed in golden light, and the sea is calm. The weather, we are to understand, acknowledges the direction of Elizabeth's gaze and responds to the sun-like radiance of her face.

The imperialist allegory of the painting is explained in detail by Roy Strong in his invaluable *Gloriana: The Portraits of Queen Elizabeth I*. The Queen's hand caresses the globe, and her elegant fingers cover that portion of it which represents America. By 1588 the colonial project in Virginia had been established as the foundation of the British Empire in the New World. Above the globe, and echoing its shape, the crown links the Armada victory with colonial possession. The 'closed' Tudor crown resembled the crown of the Holy Roman Empire and reinforced the claim of the Tudor monarchs to equal status with the Emperor. In the 'Armada' portrait Elizabeth appears not only as the ruler of a victorious realm but also as aspiring Empress of the world.[3]

It is widely agreed that pictures of Elizabeth are supremely icons of magnificence. The 'Armada' portrait proclaims the sovereignty and the

right to rule: the splendour of her appearance, her vision and her *self-control* are evidence of the majesty and the authority which inhere in the person of the Queen. But the painting also declares the magnificence of her realm: England's wealth and maritime prowess are evidence of its authority in the world, of national sovereignty divinely endorsed. In this sense the 'Armada' portrait is profoundly political, and it shares this character with many other representations of Elizabeth. Most of the specific claims it makes on her behalf recur elsewhere. The virgin-pearl, for example, reappears in exactly the same place in the 'Hardwick' portrait of 1599(?). Chastity is also the theme of the series of 'Sieve' portraits, painted between 1579 and about 1583. The reference is to Tuccia, a Vestal Virgin accused of breaking her vow of chastity, who refuted the slander by filling a sieve with water from the River Tiber and bearing it back to the Temple of Vesta without spilling a drop. When the Queen is portrayed holding what might otherwise be mistaken for a colander, she invokes the magic power of chastity, demonstrated by Tuccia, to seal the leaky orifices of the female body, to make it hard, impenetrable, invulnerable.[4] Elizabeth-Tuccia thus miraculously transcends the body of a weak and feeble woman, and makes of this transcendence a mystical sovereignty which has the effect of inverting the conventional hierarchy of gender. Her virginity shows her more than a woman, more, indeed, than human.

Similarly, the command of the weather she displays in the 'Armada' painting is also a theme of the 'Ditchley' portrait of c.1592, where Elizabeth stands with her back to a dark sky rent by lightning. In front of her, by contrast, is calm and sunshine as the clouds disperse (p. 16). And in the 'Rainbow' portrait, probably painted in about 1600 by Marcus Gheerærts the Younger, the Queen wears a brilliant flame-coloured taffeta cloak and holds a tiny rainbow. The painting is inscribed 'Non sine sole iris' (No rainbow without the sun) (p. 17). The red-gold wig of Elizabeth's later years, assumed as her own hair lost its colour, was evidently more than a requirement of feminine vanity: it was an important element in the political meaning of her image.

The imperial theme, too, was a recurrent feature of royal portraiture in the 1580s and 1590s. The globe first appeared with the Queen in 1579 in the earliest of the 'Sieve' portraits by George Gower. This was two years after the publication of John Dee's *General and Rare Memorials Pertayning to the Perfect Arte of Navigation*, a plea for the establishment of a British Empire. The first 'Sieve' portrait shows part of a luminous globe behind the Queen's right shoulder. A much more detailed rework-

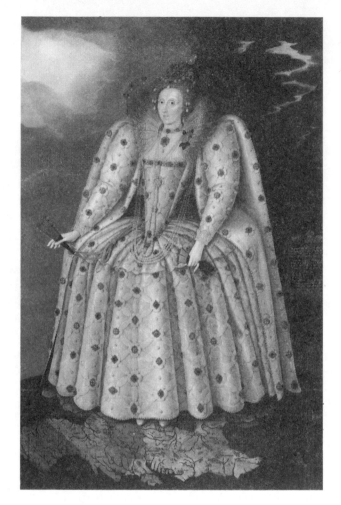

M. Gheerærts the Younger, *Elizabeth I – the 'Ditchley' Portrait, c.* 1592.
National Portrait Gallery, London.

ing of the 'Sieve' motif in 1580 includes a number of other icons of
empire. Here the globe appears again, in this instance with a glowing
Britain set like a precious stone in a sea of ships. The 'Armada' portrait
reproduces the globe, and finally in 1592 Elizabeth appears in the
'Ditchley' portrait standing on an enlarged map of her realm, with the
edges of the globe stretching out beyond it against the sky. Here the
Queen is shown literally on top of the world.

Much of the story of the iconography of royal portraiture in this period
is familiar from the work of Roy Strong and Frances Yates.[5] What has

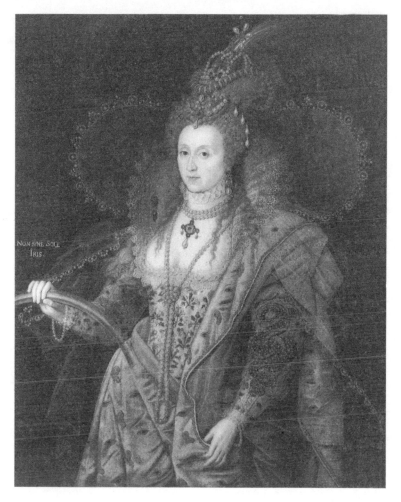

M. Gheerærts the Younger, *Elizabeth I – The 'Rainbow' Portrait*. Hatfield House.

received rather less attention, however, is the remarkable geometry of the 'Armada' portrait. Of course, the style of painting is non-illusionist: it does not use either perspective or shadow to construct for the spectator the illusion of what the eye might actually see. The furnishings of the room are in different visual planes, and the chair is visible from two distinct angles at once. Moreover, the picture has no 'moment': two separate episodes in the history of the Armada appear to be taking place in the open air immediately behind an oblivious Queen. But in place of illusion the picture offers a complex composition of circles and semi-circles, and this contributes to the impression that we are presented with

a figure abstracted from any kind of immediacy or materiality. The globe echoes the shape made by the Queen's head with its surrounding ruff, like a planet in relation to the sun. Meanwhile, the beaded border of her skirt draws attention to the corresponding pearl edges of the crown, and the semi-circle is reproduced again in the Queen's forehead and in the black outline of the skirt. The figure of the Queen is thus composed of a series of arcs, bisected, like the crown, by the line of jewels on the front of the bodice, and contained by the encompassing semi-circle of the sleeves. The portrait is a design more than it is a representation of the human figure: pattern takes the place of substance to construct the image of a dis-embodied, extra-human Queen.

This is partly, of course, a matter of fashion. English painters had relatively little contact with Italy, and were decidedly not working in the Italian Renaissance tradition of perspective and *chiaroscuro*. As the 'Armada' portrait indicates, English painting of this period still had much in common with heraldry.[6] On the other hand, Spanish activity in the Netherlands produced an influx of immigrant Flemish painters through-out the period, and particularly in the 1570s, so that an alternative and much more illusionist tradition was available. Portraits of Elizabeth's subjects in the final decades of the sixteenth century were certainly stiff and formal by the standards of the next generation, but it would be hard to find among those which survive anything to equal the abstract geometry of the later portraits of the Queen. And as Lucy Gent points out, Elizabeth herself was certainly in a position to exercise a choice in the matter, since she had constant access to the work of Holbein.[7] In the early 1590s Elizabeth sat to Isaac Oliver, who was thoroughly familiar with the Renaissance strategies for producing the effect of depth and shadow. She did not, however, like the results at all. Her own expressed views, as far as we know them, seem on the whole to have been contradictory: she told Nicholas Hilliard that the Italians were the best painters; she also told him that she disapproved of shadows.[8]

Strong believes that Elizabeth's view of Italian painting was formed on the basis of her encounter with Federigo Zuccaro and that it was Zuccaro who painted the 'Darnley' portrait in 1575 (p. 19).[9] It is instructive to compare this with the 'Armada' portrait, painted some 13 years later. The strategies of the 'Darnley' painting, while duly respecting the Tudor preference for line and colour over perspective and modelling, are nevertheless relatively illusionist. Elizabeth's dress, of white and gold brocade, is much less elaborate than the 'Armada' costume, and the headdress is comparatively unassuming. The pearls are there, but in

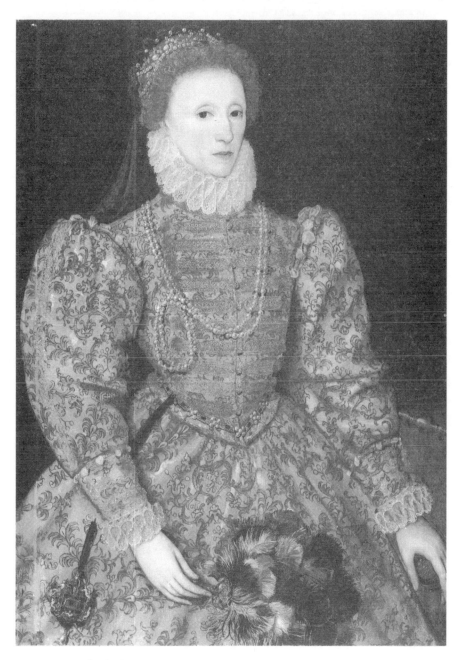

Elizabeth I – the 'Darnley' Portrait, unknown artist, *c.* 1575.
National Portrait Gallery, London.

nothing like the abundance of the later portrait. The 'Darnley' portrait seems to present a human figure rather than an icon.

At the same time, with hindsight it is possible to read in this picture indications of the signifying practices that were to come in royal portraiture. The crown and sceptre are visible on a table to the right. Both the austerity of the Queen's expression and her fashionably inflated shoulders perhaps in their different ways draw attention to her descent from Henry VIII. And the red and gold frogging on the bodice, in conjunction with the shape of the waist, hints at a softened, duly feminised, ornamental breastplate, and thus aligns Elizabeth with the warrior maidens of the psychomachia, Virtues defeating Vices in armed struggle against evil.[10]

Marina Warner traces a line of descent, which passes through Queen Elizabeth I, from Athena to Britannia and Margaret Thatcher. She might have added Spenser's Britomart, whose name indicates both her patriotism and her warlike character. These iron ladies are guardians of virtue, controlling and subduing masculine sexuality. Their function is to civilise and check impulses which are understood to be natural: they contain and discipline unruly male desire. But they do so without abandoning the virtues which are seen as specifically feminine. It is precisely as chaste maidens or model wives and mothers that they exercise the only form of power that patriarchy leaves to women: the right of prohibition. They are thus able to remain objects of desire without themselves being subject to it.[11]

This was precisely the role of Elizabeth in the many volumes of love poetry addressed to her. She became the virtuous focus of masculine desire, the unmoved mover who stirred her subjects to acts of gallantry and heroism.[12] It is as courtly lady, beautiful but aloof, and as armed maiden, austere and commanding, that the Queen appears in the 'Darnley' portrait. The allegory of Elizabeth is thus already beginning to be visible in this relatively illusionist portrait. Even in a painting which Strong attributes to an Italian painter, on the basis of its innovatory strategies and its formal debt to Titian, the Queen's iconic character is in the process of construction.[13]

A decade later, in a series of portraits attributed to John Bettes, she has become pure geometry (p. 21). Golden rays extend downwards from her sun-like face, the more startling for their contrast with her black dress. Her body is more or less indecipherable, and her arms are quite lost in the voluminous gauze oversleeves. Here only the jewels are illusionist, depicted with *trompe-l'œil* fidelity. The extraordinary shape shown here

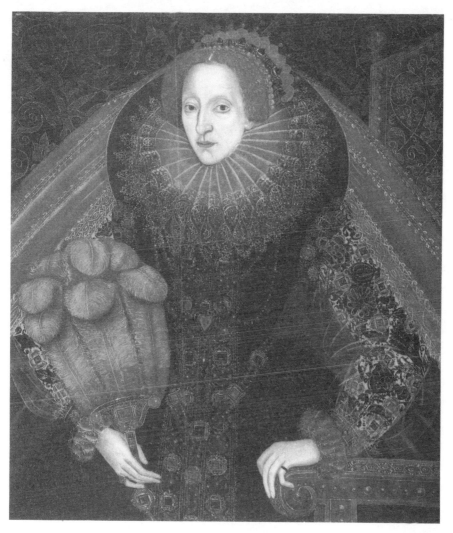

Queen Elizabeth I (attributed to J. Bettes the Younger, *c.* 1585–90).
National Portrait Gallery, London.

and in the 'Armada' portrait is, none the less, the image of Elizabeth
which is so familiar in the twentieth century that it is readily adaptable to
commercial purposes. In 1988 an advertisement proclaiming that 'Eliza-
beth I enjoyed her Burton ale' showed the Queen in an approximation to
the 'Armada' costume, slightly humanised, but still displaying the
remarkable semi-circle formed by the immense sleeves. In the twentieth
century the geometry remains memorable, even if it is not quite possible

to reproduce the repudiation of human attributes which characterises the sixteenth-century portraits.

II

Now the Queen has left the earth and appears in a position of dominance over the whole universe (below). The image appears as the frontispiece to

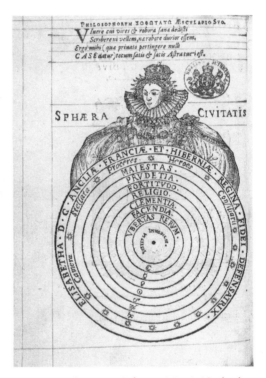

Frontispiece to John Case, *Sphæra civitatis* (Oxford, 1588).

John Case's *Sphæra civitatis*, published in 1588, the year of the Armada.[14] Less an icon of colourful magnificence because of the different technical possibilities of the woodcut, the diagram nevertheless offers an image replete with mysterious, challenging significances. While it is true that the diagram is 'closely related in imagery to the "Armada" portrait',[15] what is immediately striking is that the latter places the Queen in relation to the earthly globe, whereas Case represents her with the *universe*. What is going on?

On first inspection the diagram appears to show what became known as the Ptolemaic system of the universe, a set of concentric spheres

(shown in cross-section as circles).[16] At the centre is the globe of the Earth, labelled *Justitia Immobilis*. Then come the spheres of the seven celestial wanderers, the Moon, Mercury, Venus, the Sun, Mars, Jupiter and Saturn, each planet indicated by its astronomical symbol and identified with a corresponding regal virtue in a characteristic piece of Renaissance typology. The sphere beyond the wanderers is occupied by the fixed stars, accompanied by a rather obscure description. The outermost sphere is filled by an inscription of the official style and title of the Queen. Finally, above and beyond the spheres is the figure of the Queen herself, apparently in the act of embracing the universe. She is again an encompassing semi-circle, with a splendid cloak, an impossible ruff, and an imperial crown.

But this description of Case's diagram raises many questions of interpretation. How should it be understood? What are the meanings of the various labels and inscriptions? According to Charles B. Schmitt, the diagram offers a 'rather striking portrait of Queen Elizabeth in a sort of *regina universi* pose'.[17] The vague nature of this characterisation points to the fact that existing commentaries have not appreciated the full significance of Case's diagram. Frances Yates, for example, comments that the diagram shows the 'tendency of Virgo-Astraea-Elizabeth to expand until she fills the universe'.[18] But Elizabeth does not fill the universe. She is outside it, beyond it. And that is a very remarkable place to find an earthly monarch.

The striking implications of the image arise from the fact that Case's diagram has a vital double aspect. Or perhaps it would be more accurate to say that it has more than one duality. On the one hand it is the universe. And on the other hand it is what it proclaims itself to be, *sphæra civitatis*, the state. On the one hand it is the world in the sixteenth-century sense, the cosmos. And on the other hand it is the world in the modern sense, the planet Earth. So on the one hand it shows the Queen ruling over the cosmic world. And on the other hand it shows her ruling over the mundane world. The claims of the 'Ditchley' portrait are here multiplied: Elizabeth is doubly on top of the world.

Frances Yates has interpreted the political aspect of these ambiguities by reference to yet another related duality, the analogy between unified rule in heaven and on Earth. 'As the heaven is regulated in all its parts . . . by the one first mover who is God, so the world of men is at its best when it is ruled by one prince.'[19] Understood in this way, Case's diagram clearly indicates the imperialist aspirations of the last two decades of the sixteenth century. Not only does Elizabeth claim the right to undisputed

monarchy in her existing realms (no Pope, for instance), she also claims justification for extending and expanding those realms. It is as if 'the imperialist theme is given a universal application'.[20]

It is certainly true that the political aspect of Case's diagram can be illuminated by placing it within the appropriate tradition of medieval and Renaissance political theory. But the cosmological aspect equally needs the appropriate theoretical illumination, which is the iconographical

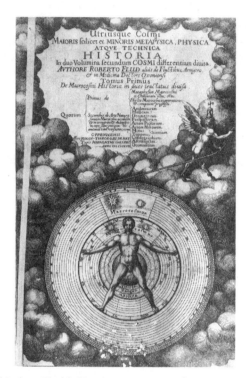

Title Page of Robert Fludd, *Utruisque cosmi . . . historia* (Oppenheim, 1617).

tradition of medieval and Renaissance cosmology.[21] This, however, produces an even more political interpretation, for Case's diagram does not simply reproduce or conform to the conventional images of Renaissance cosmology. It transforms them and transcends them, sometimes in quite startling ways.

This iconographical tradition included representations of the human figure in relation to the universe: the macrocosm-microcosm relation. The idea goes back to antiquity (it was Aristotle who first defined the human being as a microcosm), but like other classical theories it was

adapted to Christian use in the Middle Ages. Pictorial realisations of the idea range from that of Hildegard of Bingen in the twelfth century to Robert Fludd's in the seventeenth (p. 24).[22]

Such diagrams make a number of claims about the nature of things. First, that since both macrocosm and microcosm were made by God therefore there are important analogies between them. Next, that the human figure, being made in God's image, can to some extent understand the nature and laws of the universe, and even put them to the use and benefit of human life (the implication sometimes being the restoration, as far as is possible on Earth, of the prelapsarian state of perfect knowledge and control). So the human figure enjoys some superiority over the non-human universe. And yet the human figure is always within the universe; it is enclosed by it, encompassed by it. If it rules, it rules from within.

Not so the Queen. The positions are audaciously reversed. She encloses the universe, encompasses it in her embrace. From without, she rules the cosmic world.

Elizabeth's cosmic world, Case's universe, was Ptolemaic. Copernicus had published his alternative heliocentric system in 1543, and it was a perfectly respectable and much-debated hypothesis among professional astronomers (some of whom, such as the Englishman Thomas Digges, were extremely strong adherents). But the earth-centred astronomy of Ptolemy was still the established system during the reign of Elizabeth. The medieval cosmological tradition which combined a Christianised Aristotelian physics with Ptolemaic mathematical astronomy was still strong. The *Tractatus de sphæra* (*On the Sphere*) by Johannes de Sacrobosco (John of Holywood),[23] delineated the rudiments of geocentric spherical astronomy and cosmology, and though written in the early thirteenth century, it was still a standard textbook in the sixteenth century, continuing in use even into the seventeenth.[24]

Sacrobosco described 'the heavens' in the language of medieval (i.e., Christianised) Aristotelian physics:

Around the elementary region revolves with continuous circular motion the etherial, which is lucid and immune from all variation in its immutable essence. And it is called 'Fifth Essence' by the philosophers. Of which there are nine spheres . . . namely, of the moon, Mercury, Venus, the sun, Mars, Jupiter, Saturn, the fixed stars, and the last heaven. Each of these spheres incloses its inferior spherically.[25]

Sacrobosco's 'last heaven' was the sphere of the *primum mobile*, which meant literally that it was the 'first moved', the origin of movement that mechanically transmitted regular motion to all the other spheres. But it

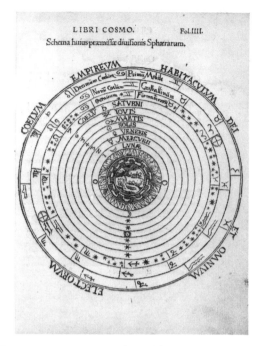

Peter Apian, *Cosmographicus liber* (Antwerp, 1533).

was first only in the created universe. Something transcendent was required as the ultimate source of motion. So the *primum mobile* was thought of as the place where God, the First Mover, either directly through his intelligence or spirit or indirectly through his angels, applied the motive power that kept the cosmos turning.

This became the standard conception of the universe, but the details of the system were not beyond dispute: the medieval-Renaissance tradition of cosmology was not as ossified nor as unified as is sometimes thought.[26] There were disagreements about terminology and, more important, the number of spheres. Although Sacrobosco described all the spheres beyond the elementary region collectively as 'the heavens' (a usage which persisted, of course, and still persists in everyday speech today), other astronomers began to locate Heaven in the specifically Christian sense beyond the spheres as Sacrobosco describes them, placing it either in a tenth sphere or in the unbounded region beyond all spheres.[27] This clearly had an appeal for Christian cosmologists, as it demonstrated the role of God in ruling the universe and governing its motions.

The system of Sacrobosco, then, had nine spheres, the outermost being occupied by the activity of the First Mover who was, for a medieval

Aristotelian like Sacrobosco, the Christian God. By the sixteenth century, however, variations had sprung up. Apian (1533), for example, favoured ten spheres, each labelled a 'heaven', and an unbounded Heaven beyond, described as 'Cœlum Empireum Habitaculum Dei et Omnium Electorum' (p. 26).[28]

Even a switch to the Copernican system did not fundamentally change this aspect of the rival tradition. Thomas Digges's delightful and fabulous heliocentric diagram, 'A Perfit description of the Cælestiall Orbes', published in 1576, conflated Heaven with the infinite region of the fixed stars, and labelled it thus: 'This orbe of starres fixed infinitely up extendeth hit self in altitude sphericallye, and therefore immovable the pallace of foelicitye garnished with perpetuall glorious lightes innumerable farr excellinge our sonne both in quantitye and qualitye the very court of coelestiall angelles devoid of greefe and replenished with perfite endlesse joye the habitacle for the elect'.[29] This is a decidedly Anglicised version of Copernicanism, however, for Copernicus himself stuck strictly to astronomical tasks and did not concern himself with the physical location of Heaven.

Though Copernicanism was known in England during the reign of Elizabeth, it was not standard, and the Ptolemaic system was iconographically more significant for Case's project, since it identified the fixed earth with *Justitia Immobilis* at the centre, suitable as an image of global imperialism. The outer extremities of Case's universe, however, are even more interesting. The fixed stars of the eighth sphere are labelled *Camera Stellata Proceres Heroes Consiliarii*, which punningly identifies the Councillors of the Court of Star Chamber with the fixed stars.[30] This is a bold claim (with evident authoritarian political implications), but far more startling are the facts that the ninth sphere – that of the *primum mobile*, the place where God acts – is occupied by the description 'Elisabetha D. G. Angliæ Franciæ et Hiberniæ Regina Fidei Defensatrix', and that Elizabeth herself occupies the region beyond the spheres, the unbounded Heaven.

Whatever the differences of detail, the Ptolemaic astronomers all agreed that God and Heaven were located beyond the visible universe, and even the Copernican Digges put them in the outermost region. Yet in Case's diagram Elizabeth *twice* usurps the position and role of God, by appearing as both *primum mobile* and Sovereign of Heaven. In the latter role, the depiction of her embracing the universe from a superior position mimics the image of God as the creator of the universe (p. 28): both God

and Queen are crowned and wear loose, ample cloaks fastened in front by jewelled clasps.

Other examples of Elizabeth claiming the place of God can be found in the iconography of the period. The depiction of the Sabbath in the *Nuremberg Chronicle* (1493) shows Heaven as an eccentric eleventh sphere, with God sitting enthroned above the created universe and surrounded by ranks of angels, his right hand raised in blessing and his left holding an orb (p. 29). The title-page of the *Bishops' Bible* (1569) shows Elizabeth enthroned in a similar position, but instead of God's creation it is the preaching of God's word that she surmounts – and authorises. The Queen's image guarantees God's truth. She too has her left hand round an orb. As in the Case woodcut, she is supported by regal virtues, two of whom, Justice and Mercy, crown her (p. 30).

From his position in Heaven above and beyond the universe, God sits not only as creator but also as judge. Plate 41 of Holbein's *Dance of Death* (1538) shows God surmounting the universe at the Last Judgment, and graphic representations of this event would have been familiar, as they were often found over entrances or chancel arches of churches. It is

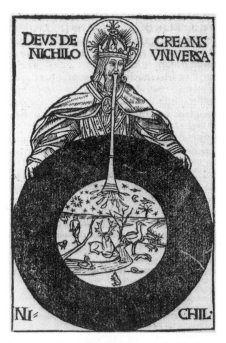

Charles de Bouelles, *Libellus de nichilo* (Paris, 1510).

De sanctificatione septime diei

Onsummato igitur mundo:per fabricam diuine solercie sex dierum.Creati em dispositi z ornati tandē pfecti sunt celi z terra.Compleuit dꝰ glosus opus suū:z requieuit die septimo ab operibꝰ manuum suarū:postꝗ cūctum mundū:z omnia que in eo sunt creasset:no quasi operando lassus: sed nouam creaturam facere cessauit: cuius materia vel similitudo non preccsserit. Opus enim propaga/ tionis operari non desinit.Et dominus eidem diei benedixit:z sanctificauit illū:vocauitꝗ ipsum Sabatū quod nomen bebraica lingua requiem significat.Eo ꝗ in ipso cessauerat ab omi opere ꝗ patrarat.Vn z Judei eo die a laboribus propriis vacare dignoscitur.Quem z ante leges certe gentes celebrem obser uarunt. Jamꝗ ad calcem ventum est operum diuinozum. Illum ergo timeamus:amemus:z veneremur. In quo sunt omnia siue visibilia siue inuisibilia.Et a domino celi:domino bonoz omniū. Cui data omis potestas in celo z in terra.Et presentia bona:quatenus bona sint.Et veram eterne vite felicitatem quera mus.

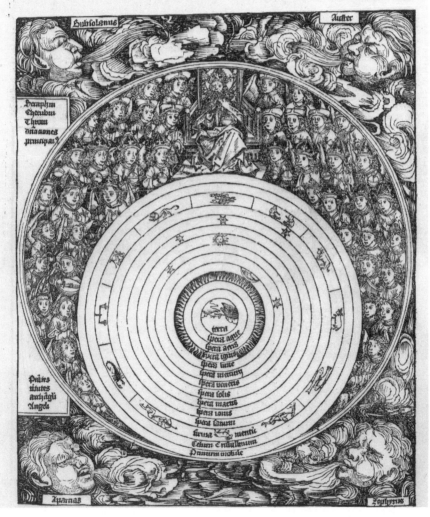

The Sabbath, from Hartmann Schedel, *Liber chronicarum* (Nuremberg, 1493).

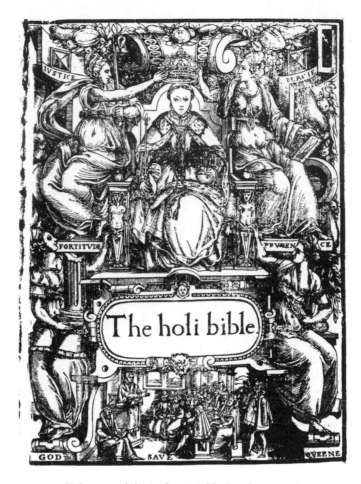

Title page of the *Bishops' Bible* (London, 1569).

worth noting, therefore, that the Doom painting over the chancel arch of St Margaret's Church, Tivetshall, Norfolk, was overpainted with the royal arms of Elizabeth.[31] According to Strong, such 'manifestations of the royal governorship of the *Ecclesia Anglicana* became "portraits" of the Queen'.[32] What is more significant, however, is that this 'portrait' of Elizabeth would be replacing the image always found top-centre in a Doom painting: God-as-Christ-in-Majesty.

Not content with a mundane role, Elizabeth achieved lift-off to Heaven. To be portrayed as having imperialist ambitions, however grandiose, is nothing by comparison. To be turned into a Vestal Virgin, as in the 'Sieve' portraits, or to be 'soberly hailed as a second Virgin' – an

extraordinary extension of the image of Mary as the second Eve – even these claims pale against the image of Elizabeth as transcendent supramundane ruler.[33] There are hints of divine attributes in the 'Armada' and 'Ditchley' portraits, where she commands not just the earthly globe but also the elements in the meteorological sense, but it is Case's woodcut of the *Sphæra civitatis* that finally transforms Elizabeth into God, the extra-human Queen, the unmoved mover commanding the affairs not just of the realm, not just of the Earth, but of the cosmos.

III

It was in the Renaissance that personal portraiture first became an art form in its own right. In fifteenth-century Italian and Flemish painting, and during the course of the sixteenth century in England, individual subjects were increasingly identified, characterised and commemorated, their individuality fixed and recorded for the contemplation of themselves and others. Renaissance humanism put forward with mounting conviction the view that human beings, rather than supernatural forces, were the agents of human history. And in the cause of legitimating the existing inequalities of wealth and power, humanism was also in due course to promise each human being a unique subjectivity, which was in turn understood to be the origin of his or her personal history: what you were justified – or limited – what you could become. Eventually, character was destiny. The Renaissance portrait initiated the process of recording that character in its uniqueness – as an example to others, as an affirmation of dynasty, or simply as a way of arresting the depredations of time.

The humanist subject of the Renaissance received an access of confidence from the development in Venice in the early sixteenth century of flat glass mirrors, which were soon exported to the rest of Europe. Metal mirrors in the Middle Ages must have been both relatively rare and comparatively unsatisfactory.[34] In the medieval art of northern Europe they usually appear as emblems of (female) vanity: mermaids carry them; Idleness commonly looks in one in illustrations of *The Romance of the Rose*; the Whore of Babylon holds a looking-glass in the Apocalypse tapestries at Angers. Later Spenser's Lucifera looks admiringly at her face in a mirror.[35] But if mirrors retained something of this moralised meaning, the wider availability of accurate reflection in the sixteenth century must at the same time have contributed to the individual's sense of his or her own uniqueness.[36]

According to Jacques Lacan's rereading of Freud, mirrors are critical,

mythologically at least, in the acquisition of subjectivity. Seeing in the mirror its own image, apparently unified and autonomous, the infant experiences a moment of jubilation as it assumes its own specular identity. This sense of triumph, in Lacan's account, is 'imaginary', that is, both imaged and illusory. The recognition of the self as a unity is at the same time a misrecognition, since the moment of singular identity is simultaneously one of division – between the I/eye that appears in the mirror image and the I/eye that perceives it. Renaissance mirrors must have reaffirmed the emergent humanist subject's misrecognition of its own unity and autonomy. Moreover, in the mirror the subject also becomes the object of its own knowledge. The knowing subject of humanism perceives, studies, reflects on, *knows* its identity in its image.[37]

Mirror images, however, are necessarily discontinuous: they move with the subject, turn away, change and grow old. The mirror reflects the loss of power and prowess, as well as its possession. Portraiture, by contrast, can be seen as offering to immortalise an ideal image of the subject; the portrait promises to fix and perpetuate the subject's auto-nomy and its knowingness, whether the I/eye meets the gaze of the spectator across time and space, or contemplates a distant vision which exceeds our knowledge. This fixing of the subject is also necessarily imaginary: the ideal image is always other than the subject itself. In any case, there is a sense in which the real mastery, the real knowingness, are understood ultimately to be a property of the artist, the person who knows, interprets and captures the true identity of the sitter. The Renaissance inaugurated the process, so familiar in the twentieth century that it seems inevitable, of naming and ranking artists in order of merit and corresponding (financial) value.[38] Like the Lacanian mirror, the portrait, too, betrays its promise in the moment of fulfilment.

Since Elizabethan portraiture increasingly recorded the identity of specific individuals, portraits and illusionist techniques developed along-side each other as humanism increased its hold. But while the bodies of her subjects were depicted with increasing verisimilitude, the image of the Queen became, we have suggested, progressively more geometrical, more heraldic, more remote from illusionism. Elizabeth I, after all, was not a subject but a sovereign, and as Charles I would later insist, from an absolutist point of view 'a subject and a sovereign are clean different things'.[39] Elizabeth had no need, therefore, of illusionist techniques, of resemblance, or even of identity in the obvious sense of the term. Portraits of the Queen are a record not of her subjectivity but of her authority, wealth and greatness, the qualities that require absolute obedience. These

pictures do not present an image, not even an ideal image, of her body, since the available repertoire of likenesses of the human body offers no obvious image for a woman who is also a ruler in a patriarchal society. The portraits of the Queen subdue her sexuality in order to proclaim her power, and in the process they place her outside the realm of nature. In these images Elizabeth escapes the constraints of time and space; she represents a superhuman transcendence; and finally she takes the place of God.

But like the unity, autonomy and knowingness of the subject, the sovereign's divinity is also necessarily imaginary. Elizabeth's control, especially in the later years of her reign, was in practice increasingly precarious. The economy was in serious trouble. In the 1590s the cumulative effects of inflation combined with a succession of poor harvests from 1594 onwards, and as a result, by 1597 the purchasing power of wages had fallen to its lowest level since the thirteenth century. At the same time, the enclosures led to an increase in vagrancy which was almost beyond manageable proportions. There were serious food riots in 1595 and again in 1596 and 1597. The government, meanwhile, resorted increasingly to the sale of monopolies to raise funds. In 1601 Parliament delivered a direct challenge to the royal prerogative by initiating a bill against monopolies, and the Queen was obliged to yield on the substantive issue in order to save the prerogative. As a result, the parliamentary impediment to absolutist aspirations was momentarily visible for all to see.

The hounding out of heresy, whether religious or political, is always a symptom of instability in the state. Trials for witchcraft reached a peak in the 1590s. The execution of Mary Queen of Scots in 1587 failed to put a stop to the activity of the Catholics, and the decade between 1585 and 1594 witnessed a series of major treason trials. The Essex rebellion of 1601 was a devastating blow to Elizabeth's confidence. And though it was increasingly apparent that James VI of Scotland was the only possible heir to the English throne, Elizabeth resolutely refused to quell anxiety on this score by naming her successor.[40] The sphere of the state was by no means as unshakeable as Court propaganda implied.

The Case diagram awards Elizabeth the familiar title of Queen of England, France and Ireland. The Queen had no authority in France: the last English territory, Calais, fell to the French in 1558, before she came to the throne. The Irish problem, chronic from 1560 onwards, subsided in the 1580s, when 1000 English settlers moved in to effect the plantation of Munster. But it became acute again when trouble broke out in 1594,

and the Nine Years' War followed. By the time the news of the Irish surrender reached London in 1603, the Queen was dead.[41]

The presence of the globe as an icon of empire in the royal portraiture of the 1580s and 1590s was even more optimistic. In the last decade of the reign, despite the iconography of the royal portraits, the British empire was still no more than a devout wish, a story of courageous effort defeated by lack of state commitment, and especially by insufficient government funding. By this time the Virginia project had foundered, and it was not until the seventeenth century that British imperialism got seriously under way. At the end of Elizabeth's reign her subjects had attempted and failed to intervene in the Guinea trade; they had failed to break into the Caribbean slave trade; and they had failed to establish a lasting colony in North America.[42]

According to Case's diagram, the Elizabethan state in 1588 was blessed with Plenty. Within a few years this would come to seem a more doubtful claim. The Queen's Clemency was not much in evidence in the 1590s either, and if her Majesty remained in place, her Prudence was certainly severely tested. By the end of the century it was no longer obvious that Elizabeth-as-First-Mover was the only moving force in the realm, or that all the initiative any longer lay with the Queen.

In the deposition scene of Shakespeare's *Richard II* the King, who once resembled the sun (III. ii. 36–52; III. iii. 62–7), sends for a mirror, 'that it may show me what a face I have / Since it is bankrupt of his majesty' (*King Richard II*, IV. i. 266–7). Richard expects to find a difference between the image of a sovereign and the image of the subject he is about to become. In the event he is disappointed:

> No deeper wrinkles yet? Hath sorrow struck
> So many blows upon this face of mine
> And made no deeper wounds? O flatt'ring glass,
> Like to my followers in prosperity,
> Thou dost beguile me! Was this face the face
> That every day under his household roof
> Did keep ten thousand men? Was this the face
> That like the sun did make beholders wink?
> Is this the face which fac'd so many follies
> That was at last out-fac'd by Bolingbroke?

And in a theatrical gesture, Richard dashes the mirror to the ground:

> A brittle glory shineth in this face;
> As brittle as the glory is the face;
> For there it is, crack'd in a hundred shivers.
> (IV. i. 277–89)

In 1595, when the play was probably written, the glory of the monarchy was, in the Lacanian sense, imaginary. The awareness that the Queen's authority was precisely 'brittle' is registered in the refusal to allow the deposition scene to be printed during Elizabeth's lifetime. None the less, after the Essex rebellion, Elizabeth told the antiquary William Lambarde, with whatever ironic reference, 'I am Richard II, knowe ye not that?'[43] The comment sounds like an acknowledgement that the Queen's image has only narrowly avoided the fate of Richard's, 'crack'd in a hundred shivers'.[44]

Are the majestic affirmations of the royal portraits no more, then, than beautiful lies? How, in other words, should we read these images of a face 'That like the sun did make beholders wink'? The answer, we propose, is that the pictures are elements in a struggle at the level of representation for control of the state. The Tudors ruled as much by 'right' as by force. In the absence of a standing army, or anything like an effective system of policing, sixteenth-century monarchs owed their power in some degree to the cultural practices by which they enlisted the loyalty and the submission of their subjects. Castles gave way in this period to palaces, as property became evidence of the propriety of Tudor rule. Control of the Church permitted the preaching of obedience to the sovereign as God's will, reinforced by the appearance of the Royal Arms in churches. Progresses and pageants displayed the magnificence which legitimated monarchical power.

Images of the Queen affirm that power in every detail. They display the authority which demonstrates her right to rule in spite of her sex. And the more precarious the power, the more extravagant the claims of the royal portraits. They are in this sense weapons in an ideological and cultural struggle.

Viewed in this way, these dazzling paintings also betray to us now something of the nature of the absolutism they proclaim. From the perspective of the twentieth century, the image of the iron maiden, the proprietary hand on the globe, the 'immobile', inflexible justice of the Case diagram, and the repudiation of the human in its entirety, all tell, perhaps in spite of themselves, part of the ruthless but still familiar story of monarchy and of empire.

2

Lady Elizabeth Pope: The Heraldic Body

ELLEN CHIRELSTEIN

Elizabeth Watson married Sir William Pope in 1615 and her portrait, probably commissioned by her husband, was painted by Robert Peake (?1551–1619), Serjeant Painter to James I and 'picture maker' to Prince Henry, to celebrate the occasion. (p. 37).[1]

Peake's portrait shows a young woman seated under a laurel tree in a pastoral landscape. Partially covering her upper body is a classical mantle of heavy black cloth, knotted at her shoulder.[2] The fabric is embroidered with pearls in an elaborate ostrich feather design. Her hat, a form of pleated turban, repeats the same distinct ostrich feather pattern. Loose hair falls across her shoulders and upper arms, obscuring but also faintly suggesting the line of her exposed left breast. A heavily faceted necklace rests on her shoulders, its pendant between her breasts; her neck is encircled by a choker whose large, hanging pearl points to the pendant. The work is informed throughout by tensions between the voluptuousness of her presentation – conveyed by the loosened hair, the relaxed curves of the ostrich feather pattern and the graceful position of her hands – and the more rigid codes of Elizabethan portrait convention. Lady Elizabeth's head is held in a precise vertical position, and the slight angle of the line between the pearl and the pendant implies that her body is not equally upright. Yet even this intimation of a relaxed pose is effectively denied by the rigid axial coordination of the necklaces and the awkward position of her arms. Both are bent, the right arm resting lightly on a green stump, the left held stiffly away from her body.

The background, with its indistinctly rendered trees or bushes and rounded, heart-shaped clouds held within a small patch of blue sky, implies a distant view, but Peake compresses the suggested space so that wisps of Lady Elizabeth's hair seem to touch and respond to the pattern of the clouds. The landscape is, in effect, a stage flat that emblematically represents a pastoral context. It holds the figure and the laurel tree on the surface, securely foregrounded in the frontal plane.

Robert Peake, *Lady Elizabeth Pope*. The Tate Gallery, London.

Within this frontal plane, symbolic framing devices define a perimeter or boundary for Lady Elizabeth's image. Laurel branches fill the top of the panel, focussing the viewer's gaze, while sheltering Lady Elizabeth within a private bower. This reframing of her image is repeated in a self-generating frame. Lady Elizabeth's arms are positioned so that a powerful circular movement through hands, arms, hair and head creates

a little world of her body within that protective bower. With this enframing device Peake seems to recreate for the viewer the Renaissance conception of the human body as a miniature or microcosm of the world: 'Your world's a lady, then; each creature Human is a world in feature, is it not?'[3]

Elizabeth Pope's overtly self-enclosing gesture as a sign of modesty and passivity was typical of many Elizabethan and Jacobean portraits of women: hands are either clasped together or rest at their side or on a chair or table.[4] Despite its participation in this convention, the structure of Peake's image actually emphasises a specific moment of sensual touch. In her left hand, Lady Elizabeth measures a thick fold of cloth between thumb and ring finger. The cloth, its material presence, is described in a stunning display of craft; the precise details of each fold and drape are revealed by the distortions imposed on the pearls of the ostrich feather pattern. This fabric is the only real volumetrically conceived space in the painting.[5] Its descriptive power, as Lady Elizabeth touches it, quite literally fashions her identity, and at the same moment she seems to invite the beholder to share the intimacy of that touch and to feel the palpable fabric that creates her presence.

A variety of pictorial conventions were in circulation during this period. Those that may be regarded as relevant and important to the making of the Peake portrait are examined in the discussion that follows. All of Robert Peake's paintings display the Elizabethan and Jacobean artists' commitment to a silhouetted abstraction of the figure through the use of line and bright local colour.[6] This pronounced geometric ordering confined Peake's sitters to a shallow and constricted space. But in this portrait of *Lady Elizabeth Pope*, Peake seems to be responding to the important changes Inigo Jones introduced in his designs for the masque at court. The masque was, in some respects, the most important form of courtly entertainment and social ritual, creating heroic roles for members of the court within an idealised fiction of harmony and order. Peake was dependent on the patronage of the court and inevitably aware, as a court artist must be, of the significance of these costly pageants. And their influence is reflected in this portrait. Peake has depicted Lady Elizabeth wearing a costume that suggests she is a performer in a 'private' masque. Her costume, as I will discuss in greater detail below, presents her as a personification of America. America was the object of intense speculation and interest for the English in this period, and Peake makes use of this general context to create a particular focus for her image.

I have referred to Inigo Jones and his innovative designs for the masque. As often remarked, Jones made significant changes by creating perspective views in some of his scenes. In addition, the costume drawings reflect a conception of the figure in which the bodies of the performers move, have weight and volume, and display the contours of a classical figure. The portrait of Lady Elizabeth is unusual in that her body is only partially covered by a classical mantle. While a mantle is often shown worn over a dress, this seems to be the only English painting of the period where the woman's figure is revealed in the manner of a classical heroine.[7] Although Peake adds these Italianate elements to his portrait – the allusion to or quotation of space and the classically inspired body – they appear as a kind of reference to Jones's innovations and do not fundamentally reorder his conception of the painting.

A very different and, to our eyes, wholly separate system seems to have structured Peake's primary and unconscious conception of this work, not as a view into another world, the convention that typically governs Italian painting, but as a flat heraldic field influenced by the non-illusionistic ordering of heraldic shields. This heraldic system, with its surface geometries of quarterings and vivid colour, appears to control the display of Elizabeth Pope's body, despite the painting's allusions to depth and movement. Its references to volume, space and motion lie on the surface rather like the hand-painted colours on an old photograph that do not alter or disturb an underlying structure. Lady Elizabeth's body remains essentially heraldic: flat, schematised and immobile.

With its formal and symbolic complexities, Peake conveys meaning to us, in part, through a play of oppositions and contrasting elements: the public display of full-scale portraiture and the private experience of the miniature; the heraldic flatness of Elizabeth Pope's body and the sensuous physicality of her costume. And while her image remains within an heraldic tradition, the depictions or references to movement, to the display of the body and to space and depth within the painting suggest an attempt to alter or break with the conventions of the English icon.

I

Elizabeth Pope's classical drape of fabric probably has its source in the illustrations of personified figures in contemporary prints and emblem books. William Hole's engraving for the title-page of Drayton's *Poly-Olbion* of 1612, for example, shows the figure of Great Britain with a heavily embroidered classical drape that exposes one breast.[8] Peake also makes use, however, of the 'antique' or classicising dress in Inigo Jones's

drawings for the masque. Ben Jonson describes Jones's costumes for the male dancers in *Hymenaei*: 'That the Lords had part of it (for the fashion) taken from the antique Greek statue, mixed with some modern additions, which made it both graceful and strange . . . '[9] The portrait of Elizabeth Pope suggests that Peake shared this taste for the combination of antique and modern, 'graceful and strange'. Her pleated hat or exotic turban – a modern addition – recalls the hat of the Polish knight in Cesare Vecellio's costume book, published in 1598, or the Turk's turban in Boissard's costume illustrations.[10]

I have suggested that Lady Elizabeth appears as if she were a performer in a 'private' pictorial masque because clearly her mantle could not be worn while she was dancing.[11] It is, in fact, an artfully draped cloth that could be seen with propriety and decorum only while she remained immobile. Her costume is very different from those in the paintings of John De Critz (p. 41) that record the actual dress worn by Lucy Harrington, Countess of Bedford, as a Power of Juno in Jonson's *Hymenaei*. The costume shown there, however allegorical, would have allowed Lucy Harrington to dance in the masque.[12]

Lady Elizabeth is shown in this fictive masque with her loosened hair modestly covering her breast and upper arms. The free fall of hair functions in various interrelated ways. The sitter was a recent bride and the painting observes an important convention that called for the flowing and loose arrangement of a bride's hair. 'She was Married in her hair', as Chamberlain reported to Alice Carlton, Dudley's sister, in 1613.[13] In his notes for the wedding masque, *Hymenaei*, Jonson cites an array of classical sources on marriage rites, including the bride's hair 'that flows so liberal and so fair'.[14] An additional association with loosened hair which appears in many other masques is the undressed hair of the goddesses and female personifications. Jonson describes the costumes worn by the figures of Splendour and Geminatio in the *Masque of Beauty*: Splendour is dressed 'in a robe of flame colour, naked breasted, her bright hair loose flowing'; Geminatio with 'Her hair likewise flowing'.[15] Elizabeth Pope's artfully arranged fall of hair signals to the viewer that she is to be perceived simultaneously both as bride and personified figure. We are meant to recognise the newly-wed Elizabeth Pope as a bride within her allegorical role. As in the masque, the symbolic role is not allowed to efface the identity of the aristocratic figure. And as Stephen Orgel explains, 'It is the relationship between the reality and the symbol, the impersonator and the impersonation, that is of crucial importance for the seventeenth-century spectator.'[16]

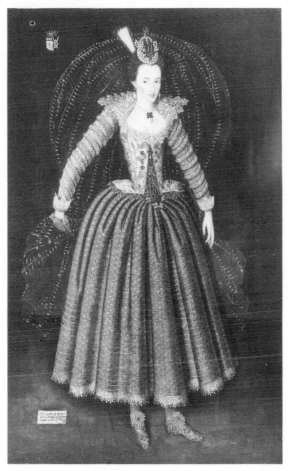

John De Critz, *Lucy Harrington, 3rd Countess of Bedford*. Woburn Abbey.

The meaning of Lady Elizabeth's costume, that creates her image as America, is determined by the pattern of ostrich feathers that cover the fabric of her hat and mantle. Feathers had long been identified with the New World in visual representations.[17] For example, feathers appear in the headdress of the figure *America* in the print from the series, *The Four Continents*, by Cornelis Visscher (p. 42). In the anonymous seventeenth-century print titled *America* (p. 42) the figure wears an elaborate headdress of ostrich feathers. And in George Chapman's *Memorable Masque* of 1613, designed by Inigo Jones, the participants' costumes refer very directly to America and to the Virginia colony. The aristocratic masquers, representing Virginian princes, wore white ostrich feathers,

Cornelis Visscher, *America*. The New York Historical Society.

Triumphal Car: America (detail), unknown artist. Yale University Art Gallery.

while the Indian costumes of the other performers incorporated an assortment of feathers:

The Torchbearers likewise of Indian garb . . . all showfully garnist with several-hewed feathers; the humble variety whereof strucke off the more amplie the Maskers high beauties; shining in the habits of themselves.[18]

The distinction Chapman makes between the maskers' 'high beauties' and those feathers of the 'humbler variety' (for example, the kind of straight feathers illustrated by John White in his drawings of Virginia) is important because the distinctions of rank were always carefully observed in the masque. Ostrich feathers were, in fact, called the 'courtier's plume', and on Lady Elizabeth's hat their purple colour adds regal and noble meaning to their display.[19]

The Memorable Masque was staged to celebrate the wedding of James's daughter Elizabeth to Frederic V, Elector Palatine, and the references in it to Virginia — named after the Virgin Queen Elizabeth — were probably designed to offer a compliment to the Princess Elizabeth. In a similar way, Elizabeth Pope's image as America seems to link her name with these two famous Elizabeths. But there is also in her portrait a more personal connection to Virginia and the Virginia Company.

Elizabeth was the only child and sole heiress of Sir Thomas Watson.[20] Both the Watson and Pope families had close connections with the court of James I, and the King visited them on several occasions.[21] Sir Thomas was a Teller of the Exchequer, that is to say one of the receivers of crown revenue, and a Member of Parliament and, most significantly for our understanding of his daughter's portrait, one of the largest investors in the Virginia Company.[22] Master of its controlling council in 1614, his name appears on several of the pamphlets issued by the company to advertise the colony's wealth and the advantages of trade and settlement there.[23]

On a biographical level, then, the depiction of Elizabeth Pope as America seems appropriate. But other cultural contexts are also likely to have had meaning for this painting of a virgin bride, commissioned by her husband. English society generally thought of the wife as a possession of her husband, and Lady Elizabeth's image as America opens the possibility of considering a husband's possession of his wife within the broader context of England's possession of the New World.[24] Elizabeth Pope appears as an object of desire that can be read as a personal image and as an expression of national aspiration. English claims to title and capture of America fill the literature of the period. From the rhetoric of

the Virginia Company pamphlets that describe the New England coast as a species of virginal garden, 'her treasures having never yet been opened, nor her originalls wasted, consumed, or abused' to Donne's apostrophe to his mistress in Elegy 19 ('Oh, my America, my New Found Land'), the sexualising of America – the trope of sexual possession – frequently informs the way America is described during this period.[25]

When Elizabeth Pope is perceived as America, other elements in the painting assume particular meanings that attach to her personification. The lavish display of pearls shows her obvious wealth and position but also reminds us that pearls are often signs of virginity. Together the pearls and the coral bracelet also serve as an allusion to the sea and the riches of that sea separating England and America.[26] Such attributes seem to share the view of the New World voiced by Drayton's 'Virginian Voyage' of 1609, as 'VIRGINIA, Earth's onely paradise' in which English success will be crowned with pearls and gold.[27] Written in support of the Virginia Company voyages, this poem celebrates America as a new Eden where artful nature sustains its inhabitants 'without your Toyle'. While the landscape in Lady Elizabeth's portrait has, I think, several meanings associated with the masque, one of the meanings must surely be that of an edenic scene, the kind of pastoral image that echoes Drayton's poem.

II

Elizabethan and Jacobean paintings have been described as miniatures blown up under glass. The viewer is confronted by an image that appears as if it were held in the hand, and the full-scale figure seems to couple both real and aesthetic space in much the same way as does the miniature. Peake's portrait of Elizabeth Pope is full-sized, but he has, I think, deliberately evoked many of the formal and associative qualities of the miniature: not only the very different physical relation between viewer and image but also the miniature's courtly origins, its representational function and its expression of 'private' emotion.

The miniature originated with the court of Henry VII and remained a distinctly aristocratic fashion.[28] Assuming a familiarity with courtly symbols and references, it involved a distinctly privileged viewing not unlike that demanded of audiences for impresa and emblems. 'For the device does not exist by itself; it has to be read; moreover it has to be difficult to read. To read it is a kind of play, and its function is to define the group that can play – to establish the group's sense of coherence, identity, and security.'[29] While the appeal to an aristocratic audience characterised both the miniature and much full-scale portraiture of the

period, Peake seems deliberately to invoke the art form that is most closely identified with the court, the centre of social and political power.

An image and at the same time a valuable object, the miniature – the 'painting in little' – was a complex *objet d'art*. The portrait was enclosed within a locket that was often enamelled and jewelled, and frame and image were viewed as one entity. As John Pope-Hennessy has noted, 'Though today we regard the Elizabethan miniature as a portrait and its metal and enamel casing as a frame, there is little doubt that the Elizabethan would have regarded both portrait and frame as a single unit, an enamelled jewel containing a limned likeness.'[30] In Nicholas Hilliard's words, the miniature was meant 'to be viewed of necessity in hand near unto the eye'.[31] Thus, the intimacy and closeness of the gaze were an essential aspect of the viewer's experience. By focussing Elizabeth Pope's figure within the larger frame of the portrait through a double internal framing – the branches of the laurel tree and the self-generated circle of her body – Peake tries to reproduce this physical intimacy between viewer and object.

Peake's reference to the miniature in this wedding portrait also carries with it the miniature's primary function as a love token, an expression of 'private' emotion in the courtly rituals of love.[32] As such, it served in various relationships, from the overtly political exchange of images between monarchs to the more intimate gifts between lovers. Whether held in the hand or worn on the body as a jewel, the miniature implied in an abstract sense the absent sitter's presence and even suggested the owner's possession of that sitter: 'They are indeed the most personally intimate form of portraiture: their littleness, worn or held in the hand, providing an ambiguous sense of ownership of the subject.'[33] The miniature could be worn in ways that were truly intimate and carried overtones of sexual possession that were still within an acceptable courtly decorum. Such attendant overtones are suggested in Lord Herbert of Cherbury's description of a knight's wife gazing with 'earnestness and passion' upon his portrait, which 'she caused to be set in gold and enameled, and so wore it about her neck so low that she hid it under her breasts.'[34]

In an obvious sense, the possession of the loved one is the object and outcome of any wedding ceremony. It is not surprising, then, that in Peake's portrait possession again plays a significant role in the construction of meaning. Elizabeth Pope's 'antique' costume and pose, at once revealing and modest, convey an ambiguous sexuality that relates to the private play of the miniature image. And Peake's focussing of the gaze

through the symbolic double framing of the sitter – like the small compass of the miniature – evokes the experience of that intimate exchange in this private art form. William Pope possesses her image as indeed he possesses her.

The precise description of the fabric and jewels in Lady Elizabeth's costume reflects the emphasis on detail and descriptive surface traditional in the art of northern Europe. In the opening passage of *The Arte of Limning*, Nicholas Hilliard gives us an insight into the desire for exact imitation which characterised both miniature and full-scale painting:

And yet it [limning] excelleth all other painting whatsoever in sundry points, in giving the true lustre to pearl and precious stone, and worketh the metals gold or silver with themselves, which so enricheth and enobleth the work that *it seemeth to be the thing itself*, even the work of God and not of man: being fittest for the decking of princes' books, or to put in jewels of gold, and for the imitation of the purest flowers and most beautiful creatures in the finest and purest colours which are chargeable.[35] (Italics mine)

While assuming the more familiar Renaissance interest in the relation between Nature and Art, Hilliard also articulates in this packed sentence the power of the artist's craft to rival the works of God. Indeed, on occasion Hilliard included both real and painted – artificial – jewels on a miniature image. This seems to be a strategy on his part to illustrate and heighten the comparison between the jewel and its representation and, by implication, the power of the artist's craft to deceive the beholder. For example, his miniature of *Queen Elizabeth* in her coronation robes (*c.* 1590) includes a diamond that is indistinguishable from the artificial diamonds on either side.[36] The use of real jewels on the image both literally and figuratively enhances the value of the image itself.[37] And Hilliard offers the 'princely' viewer a chance to play between the real and the feigned and to delight in this paradox between the two.[38] In some instances what 'seemeth to be the thing itself' is indeed the thing itself. Hilliard expresses for us that impulse to reproduce – as if in a mirror – the costly jewels and fabric in this and other Elizabethan and Jacobean portraits.

The play between the real and the artificially crafted that Hilliard created in his miniatures reflects that quality of Netherlandish painting that is concerned with the precise description of the material world – its 'attentiveness to descriptive presence', in Svetlana Alpers' phrase.[39] In his life of Van Eyck, Van Mander quotes a poem on the *Ghent Altarpiece*, by the poet and painter, Lucas De Heere, praising the painting for this very quality:

But it is almost in vain to praise one thing more than another. The most beautiful sparkling jewelry can be seen; it looks as if it were all real and comes forward from the picture. This is not a painting but a mirror in which you are looking.[40]

The descriptive surfaces of the fabric and jewels that Elizabeth Pope wears have a representational presence that invites the viewer to compare the real and the represented, to acknowledge the 'value' of the image. In addition, of course, this precise depiction of fabric and jewels reflects the wealth and status of the subject. In this and other portraits of the period, dress *defined* the social standing of the sitter, as evidenced by the English sumptuary laws, laws that were 'designed to maintain the received hierarchy by restrictive definitions of rank.'[41]

But the jewels in the portrait also play with the various tropes in sixteenth- and seventeenth-century poetry that compare the woman herself to a jewel. The beholder is invited to explore the white skin of Elizabeth Pope's face and bosom, her delicately veined and graceful hands and the luminous whiteness of the pearls that decorate her body and costume. The dialogue between draped pearls and pearl-like skin, these subtle affinities and variations of white pigment, recall those Petrarchan catalogues of the beautiful mistress with pearl-like teeth and ruby lips or Sidney's description of 'Beauties, of many carats fine.'[42]

III

Robert Peake trained as an apprentice in the Goldsmiths' Company and began his career working for the Office of the Revels in the 1570s. By the 1590s, many of his patrons were drawn from the highest ranks of the Elizabethan nobility.[43] Peake, then, came to prominence at the very height of the late Elizabethan style, a style that emphasised line and decorative surface pattern. Hilliard repeatedly asserts this English preference for line in his now familiar discussion with Queen Elizabeth on the use of shadows in painting:

Forget not therefore that the principle part of painting or drawing after the life consisteth in the truth of the line . . . Great shadowing in a painting appears, . . . like a truth ill told.[44]

Several interrelated elements contributed to the perpetuation of this distinctive portrait tradition. Michael Leslie makes the point that for the Elizabethans and Jacobeans the fixed iconic pose of the sitters was used to suggest their noble status. Portraiture was associated with the assertion of social standing and antiquity of lineage, and therefore artists consciously cultivated the styles that evoked the connotations of medieval

portraiture.[45] For example, In the *Tudor Succession* at Sudeley Castle, attributed to Lucas De Heere (and in the later version by an unknown artist at the British Art Centre), the iconic, fixed pose of the royal family is very different from the mobility allowed the mythic figures in these historiated group portraits.[46]

The familiarity with imprese and emblems also worked against a more 'realistic' illusion. Both sorts of devices were frequently included or inserted into the portrait without regard for the demands of spatial recession. As Lucy Gent has observed, the presence of these devices 'invited them [Elizabethan viewers] to regard a picture as an emblem shadowing out something to be learnt.'[47] Indeed, Leslie has suggested that Elizabethan and Jacobean portraits appear 'iconic and flat' because they are designed to be personal devices or imprese that depend on the viewers' ability to read the difficult and convoluted relationship between the various symbolic images and mottoes that were included in the painting.[48]

And of course heraldry, which was closely linked to emblems and imprese, had a formative influence on English painting. Heraldry enters the practice of painting overtly through the use of family crests and coats-of-arms on the images themselves, but more fundamental are the overlapping practices and techniques of the two.[49] Indeed, it is probably safe to assume that for the Elizabethans and Jacobeans the concept of painting included emblem, impresa and heraldic device.

It [heraldry] tended to be regarded by many men as an art of picture, also an art of painting . . . Socially it was desirable, whereas painting was not: gentlemen and would-be gentlemen in England prided themselves on their skill in heraldry, which, it was argued, was virtually one of the liberal arts, and hence entitled to considerable respect. In England it had a well developed technical vocabulary, in sharp contrast to art-painting.[50]

Heraldry figured in virtually all aspects of social and intellectual life in this period. In Peter Heylins's often reprinted *Cosmographie* of 1621, a discussion of heraldry accompanied discussions of history, geography and theology. Heraldic terms and imagery were used in contemporary literature; large numbers of books on heraldry appeared regularly in library inventories. It is not surprising, then, that many portraits include the prominent display of heraldic crests and coats of arms. Indeed, family colours and symbolic charges were sometimes worked into the design of the dress or armour of the sitter (their patterns emphasising the surface qualities of the painting).[51] This phenomenon has been seen as a consequence of the almost obsessive interest in heraldry as a means of

defining status and family position in a society that both perceived itself to be and was, in fact, increasingly mobile.[52]

In the composition of heraldic devices the shield, representing the achievement of arms, that is the right to show arms, was the most important feature. Small devices or simple geometric shapes known as 'charges' decorate the shield, dictating the basic structure and ordering of the field or background. As the shield was originally designed to be clearly visible and distinctive from a distance, only a limited range of contrasting colours were used. The colour symbolism in heraldic devices was a part of the more general Elizabethan interest in the status and hierarchical properties of colours as they appeared in nature and society. Henry Peacham, for example, in *The Compleat Gentleman*, examines the various ways of blazoning: 'three only are ancient, and of most use with us, viz. By Colours, By Planets, and By precious stones.' He goes on to explain that blazoning by precious colours is most 'correspondent for the Nobility'.[53]

Heraldry informs and influences even those paintings by Robert Peake that do not include an overt display of coats of arms and crests. In fact, I would argue that Peake's initial or primary conception of painting is heraldic. In his early portrait of an *Unknown Military Commander*, signed and dated 1598 (p. 50), Peake divides the panel in ways that suggest the geometric quarterings and divisions of the heraldic shield. His figure appears in precise outline against a timeless 'murrey-coloured' background. As the brightest areas in the painting, the white baton in his right hand and the clear red chivalric bow on his left arm hold the viewer's attention, undermining and scattering a unified perception of the whole. Signs of office and rank, these attributes of military service function as important signs that declare the aged sitter's continuing ability to command. Peake's use of signal colours here is heraldic not only because of their prominent display and flattening effect but also because of the direct access they provide to symbolic meaning.

Elizabeth Pope's figure, unlike that of the *Unknown Military Commander*, is placed in a landscape setting, but in spite of this allusion to spatial recession, Peake continues to structure the panel not as a view into another world but as an heraldic field. The pink and white of her skin, the bright red lips, the purple feathers and the coral bracelet all order the viewer's reading of the panel and fix attention to its surface. These flag-like colours, displayed in separate areas of the painting, are especially striking in a portrait that has few subtle or softened transitions in colour and tone. Sharp contrasts of light and dark enliven the surface, under-

Robert Peake, *Unknown Military Commander Aged 60*, 1598.
Yale Center for British Art, Paul Mellon Collection.

mining Peake's representation of depth. The view into space implied by
his inclusion of a 'distant' landscape is disrupted by the prominence given
to unmodulated colours and sharp tonal contrasts. The tension between
surface and depth, absent in such early works as the *Unknown Military
Commander*, informs this portrait as it does all of Peake's later work.

From the time of his appointment as Serjeant Painter to the Court of James I, Peake seems to have introduced a new kind of space and 'realistic' context into his portraits. Although this implied spatial recession would appear to conflict with his flat and linear depiction of figures and with his continued use of bright, unmodulated colours, his work from this period does characteristically include all of these elements. In three ambitious court portraits of Henry, Prince of Wales, for example, Peake constructs the compositions as if they were made up of a series of stage flats. We read the figures of Prince Henry and the Earl of Essex in Peake's double portrait of *c.* 1605 (p. 52), as well as the fallen deer, the horse and the waiting groom, as if they were painted on stage flats inserted behind them at regular intervals. They remain two-dimensional and static despite the complexity of the landscape Peake has designed for them. And although Henry and his horse are more fully modelled in the equestrian portrait of *c.* 1608/12 (p. 53), the backdrop of the brick wall and Peake's insertion of the figure of Time/Opportunity behind the horse produce the effect of a compressed, sequentially ordered space. Finally, in his portrait of *Henry as a Warrior Prince*, *c.* 1611/12 (p. 54), modelled after the Goltzius engraving of a Roman hero, the figure is only superficially integrated into the landscape.[54] Peake has transformed the massive, heavily muscled, exaggerated contrapposto of Goltzius' figure into a silhouetted diagonal display that moves dramatically across the surface, while also creating the static divisions of heraldic shields.

In these ambitiously conceived portraits, Peake appears to have been responding to the artistic innovations in Inigo Jones's designs for the masques at court. In 1605, Jones introduced single-point-perspective stage scenery in his designs for Ben Jonson's *Masque of Blacknesse*. Jonson described the effect:

These [the light-bearers] thus presented, the scene behind seemed a vast sea, and united with this that flowed forth, from the termination or horizon of which (being the level of state, which was placed in the upper end of the hall) was drawn, by the lines of perspective, the whole work shooting downwards from the eye; which decorum made it more conspicuous, and caught the eye far off with a wandering beauty. To which was added an obscure and cloudy night piece that made the whole set off.[55]

Orgel and Strong point out that the audience for this revolutionary production was not equipped to read the scene correctly and that, in fact, it was to be many years before English audiences became versed in the reading of such illusions.[56] And while it is clear that Jones's fellow court artist, Robert Peake, did respond to this startling innovation, the painter

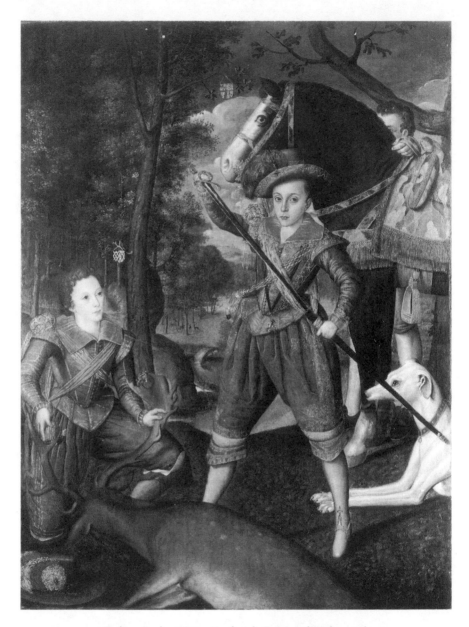

Robert Peake, *Henry Frederick, Prince of Wales, and*
Robert Devereux, 3rd Earl of Essex.
The Metropolitan Museum of Art, New York.

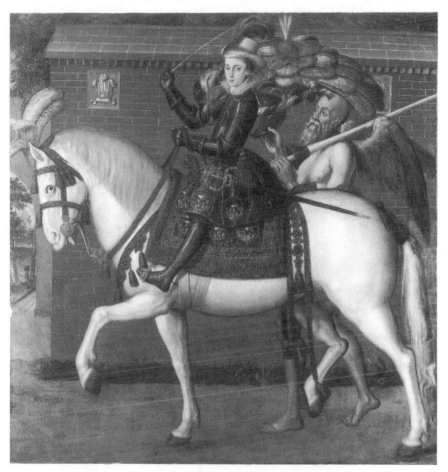

Robert Peake, *Henry Frederick, Prince of Wales*. Parham Park, Sussex.

translated or perhaps adapted the stage designer's perspective view of deep space into a series of stage flats. Sequential recession appears in his portraits of Prince Henry, but the image is not structured to 'shoot down from the eye'. Peake continued to conceive the panel in heraldic terms; for him, the structure of the surface – its conceptual force – remained essentially intact.

Peake's interest in perspective is evidenced in his publication in 1611 of the first English translation of Sebastiano Serlio's *Five Books of Architecture*. This work, which has been somewhat overlooked by scholars, reveals certain aspects of his approach at this period to the concept of perspective and hence deserves quoting at some length. In his advice to

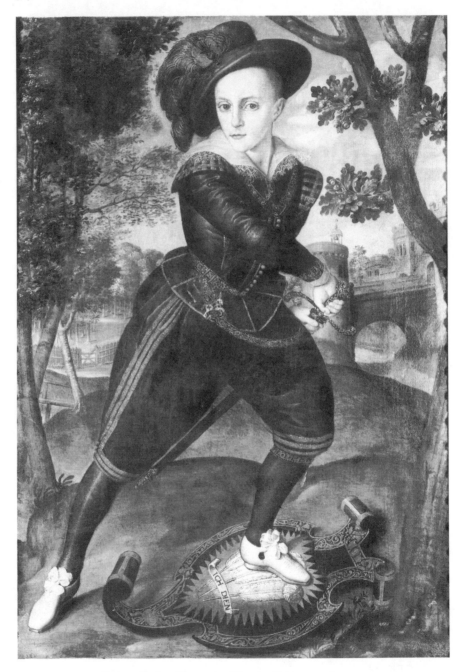

Robert Peake, *Henry as a Warrior Prince*, c. 1611–12.
Palazzo Chiablese, Turin.

the Lovers of Architecture, Peake makes a special point of emphasising his reversal of Serlio's original order of publication:

Our learned author Sebastain Serly, having great foresight to shew and explain the common rules of Architecture, did first publish his Fourth Booke, entreating of Architecture, and after his Third Booke, declaring excellent Antiquities. Fearing that if hee had begune with Geometrie and Perspective common workmen would have thought (that the two former although small) had not been so needefull to studie or practise as the other: Which friendly Reader, considered, hindered mee long either from Translating or Publishing the two former, being perswaded by sundry friends and workmen, to have desisted my purpose, both from Translating or Publishing. The which I had surely effected if I had been over-ruled by their requests and perswasions; alleadging strong reasons, that the common Workemen of our time little regarded or esteemed *Right Simmetrie*: the which is confused and erroneous, in the judgement of the Learned Architect, if they will follow the Order of Antiquities hereafter ensuing. Wherefore least my good meaning, together with my labour in Translating and Publishing, should not be regarded and esteemed (as worthie) considering it not onely tendeth to the great profit of the Architect or Workemen, but also generally to all other Artificers of our Nation: I advise all generally, not to deceive themselves, nor to be self-conceited in their owne workes, but well understand this my labour (tending to the common good) and be perswaded that who shall so follow these rules hereafter set downe, shall not onely have his worke well esteemed of the common people, but also generally commended and applauded of all workmen and men of judgement.[57] (Italics mine)

The book is dedicated to Prince Henry and clearly reveals Peake's awareness of the value placed on the rules of perspective and perspective devices by the Prince and members of the court. In his dedication Peake attributes the unfortunate results in the work of 'English Architects and Artificers of all sorts' to the 'ignorance of geometrie' that had given England 'many lame workes, with shame of many Workemen'. Peake frames this address to his readers in terms of the national interest, an evidence that then, as now, artistic styles were viewed as an important element in national pride.[58]

Peake wants all architects and artificers, a term which then generally included painters, to study and practice geometry and perspective. In Book Two of the translation, Serlio himself provides the rules for perspective and connects them to painters who became architects after achieving 'great skill in perspective arts'. Peake, then, is very certain about the necessity for 'right Simmetrie' and connects it to the study of geometry and perspective. But what does 'right Simmetrie' mean for him? Architectural concepts of classical or Italian harmony and proportion were increasingly important in some court circles and Peake must have

been aware of this taste, but his view of the 'unfortunate results' in English work does not prompt him to introduce geometry and perspective in his own painting. Thus, he seems to us to deny an essential aspect of the audience's experience of the masque: that one views the performers moving in relation to and within an ordered space. Stephen Orgel has explained that the perspective was designed so that the 'one perfect place in the hall from which the illusion achieves its fullest effect is where the king sat'.[59] Perspective, in the sense that only the king had the perfect view, was conceived symbolically. Roy Strong has suggested that, in the masques in which Prince Henry was a performer, perspective was used to focus the eye on the central masquer, thus, perspective was used as a symbol rather than as 'a fundamental premise for the total reordering of pictorial space'.[60] This symbolic use of perspective – its restricted use in the masques of this period – might suggest why Peake, although interested in the innovations and classicising aspects of the masque and fully aware, it would seem, of the uses of geometry and perspective, did not, in fact, reorder the pictorial space in his paintings. His figures do not move in space. Instead, they remain displayed across the surface, and background and landscape appear as if drawn on a curtain pulled down behind them.[61] For reasons we cannot now fully understand, Peake's experience of viewing the masque as a display of 'light and motion' did not alter the structure of his portraits.

 Although changing taste led Prince Henry and Queen Anne to recruit artists from abroad, their continued patronage of Peake reflects perhaps not a sense of loyalty, as one scholar has suggested, but rather the fact that the new visual aesthetic – the preference for more naturalistic illusion and classical models – had not yet decisively displaced the traditions of Elizabethan and Jacobean portraiture.[62]

IV

Another aspect of Inigo Jones's production which Peake, as a court artist, seems to have studied with interest was his designs for the costumes worn by the performers in his masques. These Italianate drawings indicate that a classical body inhabits the costume. Chest, arms and legs are muscled, weight-bearing and mobile. In his designs for women's costumes, the full contours of breasts and nipples are frequently revealed beneath a veil of transparent fabric, and the costume itself is drawn to suggest movement, seen, for example, in the drawing *Tethys* (p. 57). Jonson's description of the costumes of the female dancers in *Hymenaei* note these very qualities:

Inigo Jones, *Tethys*.

The ladies attire was wholly new, for the invention, and full of glory, having in it the most true impression of a celestial figure: the upper part of white cloth of silver wrought with Juno's birds and fruits; a loose undergarment, full gathered, of carnation, striped with silver and parted with a golden zone; beneath that another flowing garment of watchet cloth of silver, laced with gold; through all which, though they were round and swelling, there yet appeared some touch of their delicate lineaments, preserving the sweetness of proportion and expressing itself beyond expression.[63]

Although in Peake's *Lady Elizabeth* her mantle seems to reveal her breasts, in fact her 'round and swelling' contours are flattened. The kind of dialogue between body and draped cloth that appears in classical dress has only a faint echo in this portrait – the very soft curve of cloth that responds to the pressure of her right breast. Lady Elizabeth's undraped arms and breast are concealed by the delicate fiction of her hair, revealing only a deep *décolletage* common to many court portraits. Yet, I think the

qualified display of her body to the viewer raises some questions about the differences between the appearance of the woman's body in the masque, that 'sweetness of proportion that expressed itself beyond expression', and Elizabeth Pope's flat and and unmodelled bosom. Jonson is, in his description, openly responding to the sensuous appeal of the breasts and bodies of the aristocratic dancers. The appearance of the 'corporeal body' in the fictional, Neoplatonic world of the masque

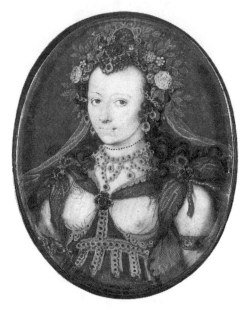

Isaac Oliver, *Portrait of an Unknown Woman as Flora.*
Rijksmuseum, Amsterdam.

provides entry to the beauty of the soul within, but the body was, as Gloria Kury has suggested, 'a volatile and problematic threshold'.[64] There are no known full-scale portraits from this period that depict truly rounded breasts and nipples; the kind of alluring display permitted in the idealised and privileged context of the masque does not seem to have been acceptable in portraits. Peake's image of Elizabeth Pope appears to test, then, the limits of allowable nudity. Significantly, in that most private of art forms, the miniature, breasts and nipples are fully pictured. For example, in Isaac Oliver's *Unknown Woman as Flora*, c. 1610 (above), the sitter wears a masque costume that leaves her arms uncovered and her breasts fully exposed under its transparent fabric.[65] But what was permissible in the miniature and the masque does not seem

to have been available for painters of full-sized portraits. Although Peake alludes to an Italianate figure, he ultimately modifies it according to long-established portrait conventions; Elizabeth Pope's figure is not an object of desire or a vehicle for the expression of emotion. In this respect, her heraldic body restricts the play of erotic meaning to the voluptuous display of wealth and status.

The portrait of Elizabeth Pope seems to juxtapose related dualities: exposure and concealment, public display and private possession, voluptuousness and chastity. The life-sized image invites 'public' admiration of her beauty, while the miniature-like framing structures suggest a private exchange between lovers. And while the layering and fall of the laurel branches create a protected bower, they also gently constrain her image, as indeed the wife was bound by the virtues of chastity, silence and obedience.[66] Yet Lady Elizabeth's direct gaze and self-enclosing gesture reflects a sense of chastity – the single most important virtue for a woman – *in possession of itself.*[67]

The artful nature that Peake has, Prospero-like, contrived for her with laurel leaves, binds her lover, her husband, with Petrarchan overtones of eternal fidelity to the beautiful woman, the source of poetic inspiration. The primary beholder – the patron – is transformed by Peake into a lover inspired by her perfect beauty.[68]

All of these related dualities could be seen, I think, not as 'warring forces' that undermine or undo the painting's meaning but as complex elements that allow for what might be termed a kind of rhetorical mobility that is able to 'speak persuasively for opposed positions.'[69]

3

In Memory: Lady Dacre
and Pairing by Hans Eworth

ELIZABETH HONIG

On 29 June 1541 twenty-five-year-old Thomas Fiennes, Baron Dacre, was executed at Tyburn for the murder of a gamekeeper in a brawl. His innocence was maintained by popular opinion, and this was echoed by later chroniclers who blamed his conviction on greedy courtiers and on Henry VIII's vindictive cruelty.[1] Upon the accession of Elizabeth I in 1558 the family honours were finally restored to Fiennes's surviving son and daughter. At around the same time his widow had her portrait painted by the Flemish artist Hans Eworth.[2]

The painting (p. 61) shows Mary Neville, Baroness Dacre, seated solidly in a red armchair, the very image of weighty, almost masculine, stability. She gazes off to the side, evidently absorbed in her private thoughts, yet Eworth has carefully provided clues to the beholder to suggest what those thoughts might be. Following first the axis from Mary Neville's unseeing eyes to the left, we come upon another pair of eyes, those of Thomas Fiennes. Though long dead, he has rejoined his wife on the plane of representation in the form of a small portrait set within her large one.[3] It hangs against a lush tapestry which Eworth has remade with as much care as he has remade the sober work of his great predecessor Holbein.[4] On its frame are inscribed a date and the sitter's age, fixing the image as the relic of a certain moment (1540) and defining Fiennes temporally in relation to that moment (*aetatis* 24). The historical specificity of this portrait seconds the play of scale in differentiating its status from that of the primary portrait: in the latter, 'time' is obliquely referred to by the clock face that decorates the sand-box on the table, but it is an unspecified time, as distinguished from the specificity of Lord Dacre's past instant.

Traces of Mary Neville's thoughts also follow a vertical axis downward from her eyes. Upon her breast is pinned a nosegay – 'There's rosemary, that's for remembrance . . . There's pansies, that's for thoughts,' as the Renaissance 'language of flowers' had it.[5] Next on this

Hans Eworth, *Mary Neville, Lady Dacre*. National Gallery of Canada, Ottawa.

axis is a book which she holds slightly open in her left hand. An illuminated letter glimpsed on the page indicates that this is one of the devotional works that were considered fitting reading material for a woman.[6] Thus at Mary Neville's left hand we find that she has stopped reading, while at her right hand we find that she has stopped writing, for

her quill pen hangs suspended over another open volume. Writing and reading, particularly in a pictorial context, are usually associated with a man; here, they are performed by a manly woman.[7] What relation do the Baroness's arrested literary activities have to the suggestions of thought and memory we have remarked? A visual clue lies in the tie from which Baron Dacre's portrait hangs. One strand hangs over the edge of the frame, and the other two disappear behind it, but they seem to be completed by two other points in the image: the tie that leads from his wife's flowers to drop over the edge of one book, and the tip of the quill pen which is poised above the other. Pictorial axes and pictorial metaphors bind a painted image of the past, present writing and devotional reading together, focussed by Lady Dacre's thoughtful, unseeing eyes.

Mary Neville's portrait poses many questions to the interpreter: the relationship between the pictured image, writing and reading and how they are channelled through the sitter's thoughts; the relative status of words and images within the discourse of the portrait; the relation of a portrait to the time of and after its making; and why these things should have been important to Baroness Dacre – or to Hans Eworth. As a portrait, Eworth's work carries within it an insistence on a 'backward' direction of interpretative practice toward the moment of its making – a strong element of what the philosopher Hans-Georg Gadamer calls 'occasionality' in a painting. 'Occasionality', as Gadamer means it, 'lies in a work's claim to significance, in contradistinction from whatever is observed in it or can be deduced from it that goes against this claim. A portrait desires to be understood as a portrait, even when the relation to the original is practically crushed by the actual pictorial content of the picture.'[8] Thus one task of the interpreter must be to reveal traces of the particular circumstances behind the portrait, but this occasionality is ultimately only an element or a motive of meaning in the image. As a pictorial fixing of the moment of its making, the portrait inevitably also exists in a 'forward' temporal direction along which subjectivity of interpretation is unavoidable. In my reading of Eworth's portrait I will follow the construction of meaning in both of these directions and will also try to recognise how they are acknowledged within the work itself. Thus my preliminary inquiry into certain socio-historical phenomena which seem to inform the portrait will then provide the basis for a closer examination of how meaning is made in this painting and what the manner of making itself can mean. This process of interpretation should enable me to provide an account of the painting which is not incompatible either with the intentions of the artist or those of the sitter, or with

the assumptions which are more unconsciously figured in it. I begin with the meaning that lies simply in the circumstances of Lady Dacre's presenting herself to the artist for representation. It seems likely that this circumstance was the restoration to honour of the Dacre family, for the character which Mary Neville has clearly chosen to assume at this moment is that of the widow, harking back over the many intervening years to her marriage with Baron Dacre.

THE GOOD WIDOW: HIGH TUDOR MARRIAGE AND WIDOWHOOD

A large proportion of sixteenth-century British portraits are 'marriage portraits,' showing couples from the highest nobility or merely from the gentry, couples who have been married for years or who have just been married, couples portrayed together on the same canvas or separately in pendant works.[9] This reflects a society in which self-definition in terms of marriage was essential on political and economic levels, as well as on personal or moral ones. The problem of defining the institution of sixteenth-century marriage has been the subject of considerable historical debate over the past decade, and it now seems clear that its nature varied according to circumstance and class.[10] During the period when new ideals of marriage were being formed, leading toward the modern idea of companionate marriage, the changes were apparently occurring most rapidly among the bourgeoisie and gentry and only gradually and partially penetrating the upper reaches of the old aristocracy; there, dynastic considerations as well as a different code of public behaviour determined such usually private matters.[11]

A key issue in the understanding of the new 'companionate' marriage is the nature of the affective bond between husband and wife. Lawrence Stone concludes that the practice of arranged marriage, combined with the high adult mortality rate, necessitated pragmatically low expectations of marital happiness;[12] Alan Macfarlane believes that affection was central in marriage but claims to speak for 'the minor gentry downwards.'[13] The art historian Berthold Hinz has traced the figuration of the 'non-affective marriage' as the double portrait in which the two partners are merely represented within the same frame, not acknowledging each other's presence or showing any sort of physical or emotional connection; this type was particularly popular with the aristocracy in the sixteenth century.[14] We must keep in mind, though, that portraits of marriages – Lady Dacre's included – do not express the lived essence of the marriage but reflect the aspects of marriage that sitter and society considered appropriate for representation.

Such ideals found their literary expression in books offering advice
about marriage. These became increasingly popular during the sixteenth
century, evidence of a deep concern with the practical and psychological
problems of domesticity.[15] The author of one, Edmund Tilney, was a
warm advocate of the affective marriage.[16] In his *Briefe & pleasant
discourse of duties in Mariage*, subtitled 'The Flower of Friendshippe', he
declares that 'no friendship, or amitie, is, or ought to be more deere, and
surer, than the love of man and wyfe . . . '[17] He carefully explains how a
true and perfect love should grow between the couple – and this before
the marriage, for he argues against the arranged marriage of strangers.
Tilney also lays some of the responsibility for the happiness of the
marriage on the husband. While on the one hand this seems to carry a
step further opinions articulated by his progressive contemporaries,
Tilney speaks a rhetoric of love which, in the voices of other writers,
indicates chastity, understanding and tolerance more than deep
emotion.[18] He furthermore places his work squarely in a tradition of
courtly manners by choosing Castiglione as his model and populating the
dialogue with well-known humanists. Thus, even the discourse of
affection cannot be taken at its face value but must be considered in the
context of the ideologies which underlie it.

The companionate marriage has been hailed as one of the most
progressive contributions of the English Renaissance to the status of
women, for it assumed that the wife was capable of the sympathy,
understanding and intelligence necessary to maintain her side of the
partnership.[19] Yet such 'progress' was inevitably made through describ-
ing the role of the woman in relation to her husband, for the Renaissance
woman was defined entirely in terms of marriage. The conjugal paradigm
was essential to social philosophers, jurists and theologians alike as a way
of thinking about women. So deeply rooted was this notion of woman as
one-half of a married couple that in Tudor portraiture women portrayed
singly are posed according to the conventions of pair portraiture.[20] There
is also no doubt that in the ideal companionate marriage the woman's
role was a subordinate one, much as it was in its medieval form.
Obedience was truly the cardinal feminine virtue; writers on women
expound and cajole, berate and persuade; they endlessly cite scientific
fact and biblical authority.[21] It is difficult to gauge the relation of their
verbiage to social reality, but the ideal is unmistakable.[22] Take for
instance a commonplace that will be useful for our examination of the
representation of marriage: the idea that in wedlock two individuals
become one.[23] This implies a levelling of male and female partners,

indicating that they cannot be hierarchised after their union. But listen to the progressive Tilney: the husband 'by little and little must gently procure that he maye also steale away hir private will, and appetite, so that of two bodies there may be made one onelye hart'.[24] The composite married being is made at the expense – no expense at all from the male point of view – of the female partner's individuality, will, desire.

What then when the equation is reversed – when, from the two that have been added to become one, one is taken away? What happens, particularly, if this is the one who had originally absorbed the other? – for this is the situation of the widowed Lady Dacre. Her portrait presents a curious resolution of the question: the partner whose individual being was supposedly subordinated to the point of negation has expanded to a total occupation of the space of representation. The husband, definitively negated by death, is subordinated and absorbed by her primary image while still playing a structuring and, as it were, occasional role in it. The painting calls upon specific social notions of widowhood, complicated in their depiction by particular circumstance and individual maker.

Renaissance commentators frequently voice concern about the situation of the widow. The woman who had once been married was not so aberrant as the woman never married, yet as a woman who was in fact *un*married she caused a certain amount of uneasiness. Writers attempted to define her status and to determine whether or not it was best for her to re-enter the married state. Again, the resolutions to these problems differed according to class. The social fact of the wealthy widow was that of a woman independent of a man, with considerable freedom to manage her own property. Women with such economic power did exist – Bess of Hardwick is a famous example – but they were both truly exceptional and unacceptable. They would no doubt have come under considerable pressure to remarry, particularly if the control of land was at stake.[25] Yet there were also both idealistic and practical matters that argued against remarriage. Essentially, the proponents of this view resolved the problem of the widow as unmarried woman by claiming that she was *not* unmarried but still tied to her dead husband. By marrying her, he had made her part of himself in a fundamental way: death did not change this. Hence, remarriage was often portrayed as a sort of shameful posthumous cuckoldry of the first husband, and the blame for it fell squarely on the natural sexuality of woman which became unfettered when she ceased to be tied to a 'rational' man.[26]

The argument against remarriage seems to have been in part a response to economic concerns which, paradoxically, were often strongest in the

very classes in which widows were urged to remarry. When the wealthy widow was a mother, it was feared that her taking a second husband would endanger the interests of the children of the first marriage. In his *Instruction of a christen woman*, intended largely for noblewomen, Vives makes a strong case against remarriage and explicitly admits dynastic concerns as crucial in this matter.[27] Vives's good widow continues in what had been one of her primary functions as a wife, that of custodian of her husband's goods. She must handle his household as he would wish, 'and thynke that he is happie to leave such a wyfe behynde hym'.[28] The good widow does *not* function as an independent woman but as the remaining element of a combinative marriage which had been defined in terms of the male partner. We may consider that Lady Dacre is portrayed as conforming to such an ideal, as the attributes of male and female, husband and wife, are united in her attitude and appearance. Yet even if we read the image of Lady Dacre as the portrayal of a Good Widow, we are still not wrong to see it as somehow disturbing, a problematic assimilation of masculine traits into a woman. The whole socially constructed idea of the Good Widow is an artificial one, born of male anxieties about the place and potential of the female when released from the bonds of wedlock.

Just how artificial this ideal is becomes clear when the facts of Mary Neville's biography are taken into account. The baroness was not in fact faithful to the memory of Thomas Fiennes: it is recorded that in 1559 she had already remarried not once but twice and had had at least six children by her third husband.[29] Yet in her portrait, seventeen years of personal history, marriages, births and deaths are erased to allow her to play her part on a very particular occasion.

A year after the restoration of the Dacre family honours, Hans Eworth painted another portrait of Mary Neville (p. 67). In this extraordinary painting, Lady Dacre is shown with her only surviving son from her first marriage, Gregory, tenth Baron Dacre.[30] The mother stands to her son's right, looking outward with the rather undirected gaze familiar from her first portrait. In one claw-like hand she clutches a jewelled glove; in the other she holds a heavy signet ring, a symbol of dynastic authority, through which she passes the tip of her forefinger. She stands impregnable behind a great red cushion upon which she rests her right arm with confident ease. Standing before her, 'backed up' by the broad expanse of his mother's figure, is Gregory Fiennes. He is the treasure which she displays, and his gaze openly meets that of the beholder. Equally 'open' are his garments, slashed and refastened, trimmed and layered, insub-

Hans Eworth, *Mary Neville and her Son Gregory, 10th Baron Dacre.*
On loan to the National Portrait Gallery, London:
reproduced by permission of the owner.

stantial compared to the solid apparel which encases the baroness. And while her fingers grasp at tokens of wealth and power, his are invisible, inexpressive, passive. The emphasis on her son's superficiality and almost feminine youthfulness stresses the contrasting masculine consolidation of self which power, cemented by experience, has given Mary Neville.

The locus of power in this portrait is clear to the modern beholder; to Eworth's contemporaries, what would have been striking was its *re-location*. A sixteenth-century viewer would have immediately recognised the paradigm of the double marriage portrait as the model for this image,[31] yet it breaks one of the fundamental conventions of its model: that the man should be on the dominant left-hand side of the image and the woman on the right.[32] Indeed, even when a woman was painted outside a marriage context she was nearly always shown turning towards the viewer's left, as if toward the centre from the right-hand side of a pair.[33] The Dacre portrait also transgresses the norm of posing women to face more frontally than men, both within and outside marriage portraiture. This convention, I believe, is linked to the matter of the sitter's relation to the viewer. Women face us and meet our eyes while

men turn away and look to the side, absorbed in their own thoughts: the artist grants the man interiority, while women are receptive of and dependent upon the gaze of the viewing other. In both of her portraits Mary Neville claims the masculine privilege. Virilified by age and power, by marriage and especially by widowhood, she finally occupies her first husband's place as the keeper of the Dacre dynasty.

ARS MEMORIA/MEMORIA ARTES

Thus far I have considered various social constructs of woman as wife and widow which the Ottawa portrait's occasionality draws upon and figures forth. I have been concentrating on the person of Mary Neville rather than on the full dialogue of representation within the frame of the painting, which would include the secondary portrait of Thomas Fiennes. To explain its presence on a primary level, in terms of the apparent demands of the portrait's commissioner, I shall begin by examining another aspect of the Good Widow ideal, that of the wife's role as the preserver of her husband's memory. In a later section, I shall show that the issues raised here are related to more general questions of the ontological status of representation in time.

Marriage, as we have seen, was not only until death: the wife's duties to her husband continued through her widowhood. Besides acting as custodian of his material goods, a woman who remained faithful to the memory of her husband kept that memory alive. The increasing emphasis on this role of the widow was in accord with a broader trend at this time, as 'commemoration' shifted from the public to the private sphere. According to the doctrines of the Reformation – and specifically the abolition of Purgatory – lavish funerals and masses for the soul of the deceased were not sufficient or even appropriate: a new way of coping with the fact of death had to be invented. [34] Philippe Ariès has noted that, beginning in the sixteenth century, tombstones appear on which simple epitaphs make an appeal to 'memory'.[35] Instead of demanding prayers for the soul of the dead, these epitaphs ask the living to think back into the past to capture and preserve the appearance and character of the dead and the events of their life.

Vives reminds the widow that her husband is not really dead: 'a good wydowe ought to suppose, that hyr husbande is not utterly deade, but liveth bothe wyth lyfe of hys soule . . . and besyde wyth hyr remembraunce'. He adds, 'Leat the wydowe remembre, and have styll before hir eyes in hyr mynde, that our soules dooe not perishe together wyth the body'.[36] In the memory, conceived of as a visual faculty, both substantial

Richard Brathwaite, *English Gentlewoman*,
title-page (detail).

body and immortal soul are preserved as viewed, for the dead truly live 'if the lyvely image of them be imprinted in our hartes wyth often thynking upon theym', and they die only if we forget them.[37] Through remembering, a mental picture is first formed and then fixed in the heart and the emotions; therefore, faithfulness to a memory both produces and can be represented by an image of the dead husband. An illustration on the title-page of Richard Brathwaite's *English Gentlewoman* (1631) makes explicit this concept as it had continued in marriage iconography (above). Among eight vignettes illustrating womanly virtues, one shows a seated woman; beside her, a curtain is pulled aside to reveal a full-length portrait of her husband. On a banner appears a motto which she seems to be speaking: 'Fancy/ admits no change/ of choice'.

Closer to Eworth's time there is a tradition of portraits of women with portraits of their husbands, both on the continent and in England, where the second portrait is often a miniature.[38] But seldom is there any clear temporal break between the two levels of image – the wives are not noticeably older than their re-pictured husbands – and since the women follow convention in looking at the viewer, the aspect of memory is not made an issue. On the other hand, in the portrait of Lady Dacre the placement of Thomas Fiennes's image on the axis of her unfocussed eyes suggests that it is the figuration of those thoughts which initially seem so private. Thus we find, not surprisingly, that the woman's interiority is not

one of wholeness and containment of self but one of devotion to the male, his memory internalised as 'image'.

Seen as possessors of intellects which were essentially passive, of minds which tended toward the emotional rather than the reasonable, women were particularly associated with devotion to memory. Retaining traces of the past, rather than actively producing new thoughts, was considered the essence of their mental process.[39] In Mary Neville's portrait, we have seen that the image of her remembered devotion to her husband is visually tied to religious devotion, indicated by the prayer book in her hand; it is an image which then interposes itself between the moment of reading and the moment of writing. Or rather, it is the image of the memory provoked by her devotions and is perhaps about to be written into the book before the baroness, transformed into a verbal testimony of the vision which she, as a woman, is so able to retain. In the following century there arose in England a tradition of widows as their husbands' biographers, and the portrait of Lady Dacre seems to embody some of the expectations and assumptions that underlay that development.[40] But no more than any of her contemporaries did Lady Dacre actually write any sort of memorial to her husband: she only commissioned this painting. In being pictured, her text becomes always about to be written, and it is the image of Thomas Fiennes, remembered and recorded as an image, that proclaims the preservation of memory.

The metaphor used in this analysis thus far has been that of a presumably intended relation between Eworth's visible refiguration of Thomas Fiennes and the invisible figuration of him in the mind's eye of Mary Neville. We have seen that in the writings of Vives, reflecting common contemporary ideas, memory is made the equivalent of a picture, as both function to preserve the past.[41] But when this concept is put into play in a painting, the change from language to pictorial metalanguage necessarily causes a shift in the issues that are at stake. By doubling representation, Eworth demonstrates the power of the image to join past to present; this should occur both through the memory-images of Lady Dacre and through his own two painted portraits. But his strategy also compels us to consider the status of the image as enduring memorial and the status of the primary portrait as a work of art which calls attention to itself through incorporating the second painting. To clarify how these issues were important to the artist and his patrons, I will now turn to the portraits of a couple painted by Eworth nearly a decade after that of Lady Dacre.

VANITAS AND VALUE

Richard Wakeman and his wife, Joan, née Thornbury, are shown at three-quarter length in pendant images – the most common way of presenting a couple in Tudor portraiture (pp. 72, 73). Both present themselves self-consciously, acknowledging that they are posing in order to be portrayed and to be viewed. The artist, in turn, has made no attempt to suggest inner, psychological presence but allows his sitters' resolute exteriority to carry the full burden of signification. Although the two images are of equal size,[42] Richard Wakeman is made to appear the larger and more imposing figure: he stands closer to the picture plane and occupies a greater portion of its surface. His heavy coat and broad collar emphasise the width of his shoulders, and between them his head is supported by a smooth high collar with a heavy gold chain, more armour than ornament, at its base. His stance conveys a confidence that borders on the aggressive, a challenge which is repeated in his expression, as he confronts the viewer's gaze with a firm mouth and a raised eyebrow.

Turned slightly more to the front and standing properly to her husband's left, Joan Wakeman's pose is clearly a passive one. Her simple stance, uncomplicated gaze and placement farther from the picture plane serve to diminish her as a psychological presence; similarly, her feminine costume diminishes her as a physical presence. Her hands engage in no 'gestures' at all but are clasped at her waist in a position typical of female portraiture, connoting submissiveness. At her neck, a chain is loosely wound and tied in an ornamental knot: she is 'tied' by the chain of wedlock and is ornamented by it, but she is not supported as her husband is by his share of it.

Unlike most of Eworth's other sitters, the Wakemans were not members of the nobility but mere gentry from a well-to-do Gloucester-shire family.[43] Their portraits, therefore, lack the trappings of politics and dynasty and instead partake unusually clearly of conventions of marriage portraiture that were developing at this time in Eworth's native Netherlands – conventions which evolved for the portrayal of people of the Wakemans' class in the context of the modern marriage and its ideals. The 'chaste, silent and obedient' wife was the paragon of virtue for the bourgeoisie and the gentry, and the formula used to portray Joan Wakeman is one which connotes those qualities whilst that depicted in the portrait of her husband connotes her male opposite, active, independent and eloquent.

The Wakemans' portraits seem to conform easily to accepted ideas

WHY VANTIST THOWE THY CHANGYNG FACE OR
HAST OF HYT SVCHE STORE
TO FORM A NEWE OR NONE THOWE HAST OR NOT LY
AS BEFORE

AETATIS XLIIII
M·D·LXVI·

Hans Eworth, *Portrait of Richard Wakeman*. Private Collection.

Hans Eworth, *Portrait of Joan Thornbury, Mrs Wakeman*. Private Collection.

about marriage and its depiction, but their second level of discourse – their verbal inscriptions – problematises their apparently unproblematic representation. The inscriptions themselves, as assertively graphic presences upon the panels, immediately undercut the images' potentially illusionistic qualities.[44] Yet the sixteenth-century portrait frequently bears such markings and preserves its function as a document, a fixing of the appearance of a certain individual (name) who has passed through a relative amount of time (age) at a certain absolute time (date). In acknowledging the temporality of the subject, such inscriptions conversely assert the ability of the painted 'copy' to perform its proper function of making immortal and of transcending time. The Wakemans' inscriptions, however, do not participate in this dialogue of assertion between word and image; instead, they create another dialogue which draws attention to these very assertions and, in doing so, renders them suspect.

Above the recording of Richard Wakeman's age (43) and the date, the following couplet appears:

> Why vantist thowe thy changying face or hast of hyt such store
> To form anewe or none thowe hast or not lyke as before.

The words sound like a challenge, which I think is to be read as 'spoken' by Richard Wakeman, as the inscription on his wife's portrait is to be read as 'spoken' by her; for the inscriptions match two traditions of writing on tombs which call upon the passer-by to behold and to consider the situation of the dead, either by directly addressing him (with remarks comparable to the words of Richard Wakeman) or by merely reflecting upon that situation (as do the words of Joan Wakeman).[45] The relevance of appropriating funerary modes of verse will become clear in the following discussion.

Combined with his confrontational stance, Richard Wakeman's words might be addressed to any spectator, yet they remain cryptic unless also understood as part of a dialogue with his wife which will be completed by her words. He demands 'why vauntest thou thy face' – why do you put it forward so proudly? Addressed to his wife, the implied question is, 'Why do you put it forward to be painted?' For, as he says, it is a *changing* face, and this makes questionable the act of displaying it to be recorded. 'Hast of it such store?' he continues, on one level a standard accusation of vanity. But the following line shifts the connotation of the word 'store' by demanding whether 'you' will be able to form a new face or not – and suggests that, even if you can, it will necessarily not be like that which you

had before. The instant of display passes, the face changes; but in that display for the artist the face's momentary quality has been appropriated *by the image*, and a new face must be made, if possible, from the 'store' within. The painted image is thus invested at a quasi-physical level with the visible essence of its subject, as defined at the moment of its making.

Joan Thornbury Wakeman does not reply directly to her husband but speaks in the first person as if to mediate between him and the viewer. Three couplets appear above her age (36) and the date:

> My chyldhodde past that bewtifiid my flesshe
> And gonne my youthe that gave me color fresshe
> Y am now cum to thos rype yeris at last
> That telles me howe my wonton days be past
> And therefore frinde so turnes the tyme me
> Y ons was young and now am as you see.

This statement is at once a forthright response and a paradoxical contradiction to the ideas conveyed by her husband's challenge. With typical *vanitas* rhetoric she recognises the passage of time and the ravages it has worked upon her, first simply reflecting on this fact and then, in the final couplet, speaking in her turn to the viewer. 'So turns the time me' — even now, at the moment of viewing, time is changing her as it is changing the 'frinde' with whom she communicates. What then of the final line, 'I once was young and now am as you see'? 'Now,' at *any* time, Joan Wakeman is *not* as she looks in the portrait. Her husband's speech made it clear that the face was appropriated through being pictured, and no viewer but the artist can ever see her possessing that particular appearance.

Why, within the implied dialogue of the Wakemans' portraits, is the temporal paradox here directed at the passive female image from that of the aggressive male, and why is the issue so crucial that it must be aired in the ostensibly benign context of marriage portraiture? Let us consider first an assumption about the purpose of portraiture that is made here: the portrait is a record. This function is particularly central to marriage portraits, which served as dynastic chronicles for the couple's descendants, hanging in the family galleries; towards the end of the century, we begin to find ancestral portraits within family portraits, a visual documentation of genealogy.[46] In its role as a family record, the goal of the portrait is to be an accurate transcription of the sitter's appearance and a document of his or her social situation.

Such demands on the part of the patrons complemented the status of painting as craft that was so deep-rooted in Renaissance England, even

concerning pre-eminent artists such as Holbein and Hilliard.[47] The description of status through a social mask, through controlled and deliberate gestures and signs, does not demand or even allow the artist the interpretative response to character which was increasingly favoured in Italy. Expectations of the miniature were different, since it was considered to communicate at a more private level; in a famous passage, Hilliard describes how the limner must catch 'thosse stolne glances wch sudainely like lighting passe and another Countenance taketh place . . .'[48] He refers to the transience of 'appearances' as does Richard Wakeman's inscription, but Hilliard is concerned with the potential of the fleeting expression to convey mood and character while Eworth is troubled by it, seeing it as something that undermines the validity of the portrait as record.

Existing alongside or perhaps acting as the basis of the concept of the portrait as record is the idea of the portrait as a bid for immortality; this underlies much continental rhetoric about the genre and is implicit in the development of portraiture as a component of tomb sculpture.[49] As a memorial, the status of the portrait was different from that of other images, and in England this raised the portrait to a level of respect that rendered it virtually inviolate. During the long years of iconoclasm in the mid-sixteenth century, portrait images were often the only ones spared destruction. Elizabeth I, at the beginning of her reign, issued specific proclamations protecting tombs and monuments, basing her defence on the idea of the 'commemorative image' which held that memorials were 'only to show a memory to posterity of the persons there buried . . . and not to nourish any kind of superstition'.[50]

Elizabeth's argument loosely follows those made throughout the century by defenders of religious images. Pictures, they contended, served merely as 'reminders' or, in Catholic terms, as references to a 'prototype' – they were a substitution for and shared the status of the images of the memory.[51] The value of images lay in qualities that existed between them and the minds of their beholders. Protestant detractors of images often dwelt on their materiality or objecthood and the possible demotion of the figure represented to mere physicality.[52] These notions are in part reflections of the sense that the representational object physically partook of the nature of its referent. It was the defenders of images who wished to deny them this power, but it is abundantly clear that, particularly in the popular and Protestant mind, there was a strong sense of the investment of subject in portrayal. Rioters spared portraits even before Elizabeth's ruling, surely because to damage them was to damage murderously the

person they portrayed; and throughout Elizabeth's reign, abuse of her picture was considered abuse of her, and there were actually assassination attempts made by doing violence to her portrait.[53]

The memorial or documentary portrait neutralises the demand for the 'penetration' and representation of the soul of the sitter, but it may instead partake of his or her nature in a substantive way. In the process of being portrayed one shares oneself not with the artist-viewer, as did Hilliard's flirtatious sitters, but with the object. Returning to the inscription on Richard Wakeman's portrait, firstly, we find that it articulates a certain anxiety about the dangers of such self-investment. Secondly, when his words are combined with those of his wife and set onto the surface of an image, an interplay is set up between the traditional vanity of proud appearance and the *vanitas* of the object on which that appearance is remade. The painted panel is, essentially, a man-made object of beauty, and as such is destined to decay and perish.[54] There seems to be far less certainty in northern Europe than in Italy that art can triumph in its *paragone* with time; this could in part be due to the reminders of iconoclasm that art is always subject to destruction, but I think also to a more persistent consideration of the status of the work of art as object, perishable rather than transcendent. As such, the work of art is in itself a reminder of transience, a *vanitas*.

The following poem appears inscribed on a portrait by Peake, dating from thirty years after Eworth's *Wakemans*:

> The life that natures lendes death soone destroi(es)
> and momentarie is that lifes remembrans
> This seeminge life which pourful art supplieth
> is but a shaddowe, though lifes parfect semblans
> But that trewe life which vertue doth restore
> is life in deede, and lasteth evermore.[55]

Here, the viewer is explicitly reminded of the limitations of the portrait: first, that there are two sides to life, that which is visible and passing and that which is invisible and enduring. The image, whether of 'remembrans' or of paint, is only concerned with the first of these and so is by definition flawed, impermanent. Art is termed 'pourful', but this seems to be ironic, for it is twice removed from the 'trewe life' of the last couplet and only gives a shadow of the life that is mortal. The term shadow is multivalent; art is the shadow of a life which is itself shadowed by death.

In the Wakemans' portraits, the figured shadows curiously play the roles of both signifiers and metaphors. In the normal fiction of pictorial representation the shadow is a strategy of illusionism used to denote the

corporeality of the body. But I think we have reason to read these shadows as a deliberate addition by Eworth to the *vanitas* iconography of the works, for shadows are not part of his usual scheme of portrayal.[56] In the Wakeman portraits the resolute placement of the words on the *surface* of the panel, directly above the shadows, undercuts their efficacy in defining the space of and surrounding the bodies; instead, the shadows take on a metaphoric role, pictorialising the fact of mortality. Paradoxically cast in a dual role of asserting life and symbolising its loss, the shadow replicates at one more remove the status of the portrait itself, which represents its subject as alive, testifies to present vitality but, in the very act of picturing, inevitably reminds the viewer of death.

VANITY: THE PAINTED LADY

In his *Treatise of the Images of Christ* (1567), the Catholic theologian Nicolas Sanders explains that like all beings man has both an immutable nature and a physical substance and that only the second may be pictured: 'The cause why the shape of our Persons may be represented by arte, and not our natures, is, for that, the Artificer who worketh by his own knoledge, is able to conceive in his understanding, and afterward to foorme outwardly that proper shape of every thing which he perceiveth by his senses that it hath'.[57] Sanders here articulates a dichotomy which was common at the time but, none the less, troubling. The Peake portrait is one of many in which words call attention to a missing element in an image, the soul that portraiture is not able to give. It is significant that Peake's inscription, like most inscriptions of this type, is on the portrait of a man. This brings us back to the question of why the dialogue of *vanitas* on the Wakeman portraits is directed at Joan Wakeman, why it is *she* who is charged with vaunting her beauty to the gaze and brush of the painter, while Richard Wakeman's presentation of himself goes unchallenged.

Portraiture's abilities are relegated to the level of surface appearances, and this takes on a particular pressure in the portrayal of a woman, for woman is defined as *being* appearance. We have seen this assumption at work in the 'exteriority' of traditional female portraiture; the concept is excused or explained by Christian–Aristotelian dichotomising (soul: man/body:woman) underscored by biblical principles. Its real psychosocial underpinnings co-operated in fundamental ways with the power structures of Tudor England, but for the purposes of this essay it will be sufficient to consider what is revealed by the rhetoric of the subject. While man was created whole and perfect, it was said, woman was created as

the mere image of him, defective, incomplete; the traits she lacked were the 'immutable' aspects of the soul.[58] To picture a woman, then, was truly to capture and partake of her essence. Woman and picture become parallel, as both exist as images of man, dependent upon him, lacking those things which are immortal.[59]

A further common ground between woman and painting is that both are defined in terms of the senses, with all the attractions and dangers this denotes. The remarrying widow, discussed above, was behaving in a typically female manner since her lack of reason caused her to be excessively passionate and desirous of gratification. Woman is morally repulsive yet endlessly fascinating and attractive as the embodiment of what is sensual in mankind. Sensuality and pure appearance come together in man's greatest charge against woman – echoing, in our context, his greatest charge against painting – that she is *vain*. The vanity of woman and the *vanitas* of the image may seem to embody different qualities, but they are conflated both metaphorically and actually in significant ways.

'Painting' was an ambivalent term in sixteenth-century England; terms such as 'curious' or 'artificial' were used to distinguish perspectival images, while the simple word 'painting' referred to cosmetics[60] – and to non-illusionistic art such as conventional portraiture. England's greatest painters were women, which is to say that the vice of using cosmetics was a particularly feminine one.[61] Cosmetics were comparable to painted pictures not merely because of their physical properties but also in the status of the 'image' they each created and in the response they were intended to elicit from their viewer. The artifice of images, said the iconoclasts, was inferior to and hindered the handiwork of God; the artifice of cosmetics, the moralists cried, offended God by adulterating his workmanship.[62] In painting herself, the woman audaciously creates a work of art that purports to correct and outdo that of the Creator, and Stubbes even uses Pliny's tale of the artist and the cobbler to illustrate this point.[63] The transience of women's efforts was stressed: they concentrated on 'the beautie of their bodyes, which lasteth but for a time . . . but for the beautie of the soule they care nothing at all'.[64] Finally, women were accused of using cosmetics in order to fashion themselves falsely into objects of appeal, to entice men to lust through beautiful deceits.

Woman is the artificer, the trickster, the allurer, the dealer in that which is superficial yet attractive. Musing on the problems faced by the artist when confronted with his model, Hilliard remarks, 'howbeit *gent* or *vulgar* wee are all generally commanded to turne awaye ouer eyes

frome beauty of humayne shape, least it inflame the mind, howe then the curious drawer wach and as it catch those lovely graces . . . '[65] Again, the problem he sets is redoubled when the sitter is a woman, for then the 'curious drawer' is himself the first viewer to be snared by external beauty in a series of painted faces; he must confront in the original the very qualities that he hopes to create artfully in its copy. The painter is asked to make artifice from artifice, the sensual from the sensual, the transitory from the transitory – indeed, the vain image from a living *memento mori*. The painted woman elides neatly with many characteristics of the portrait, but they are those characteristics that mark it as problematic and that lead to the questioning of its ability to preserve those strong, active and enduring traits with which the man liked to consider himself endowed.

Woman exists as the image of man, created as such by God after He had created man in his own image.[66] Accordingly, the good wife does not paint herself but instead remakes herself in the image of her husband; he becomes her 'dayly looking glasse . . . whereto she must always frame hir owne countenance'.[67] In the course of married life, the husband's duty is to consider the vanity of the superficial being that is his image, his wife; he must be aware of her artifice and maintain and instruct her in the judgement she lacks. No wonder a husband like Richard Wakeman takes the opportunity of their joint representation to instruct his wife, and through her the viewer, about the vanity of portraiture.

A telling comparison to Eworth's formula is the portrait painted in 1541, possibly by Dirck Jacobsz, in which a husband teaches his wife about the vanity of life (p. 81).[68] Two inscriptions, both directed from him to her, meditate on the passing of worldly riches. These texts are visually repeated by the couple's emphatic gestures toward the multitude of traditional *vanitas* attributes which litter the table before them. In the Dutch portrait, however, the wife does not participate in the dialogue but simply mediates, by her glance, between her husband's discourse and the viewer. There is none of Eworth's subtle conflation of the couple portrayed, the fact of their portrayal or the message of the image. Vanity is emblematised in the depicted items and explicated by the inscribed words, but the image *qua* image is not permeated by *vanitas*, is not undermined by it. In the Wakemans' case, each sitter gives a part or moment of the self in the cause of permanence while at the same time acknowledging the futility of the gesture. As the status of what each gives must differ, they are represented in separate frames; the wife responds to her husband, completing and embodying the charge of vanity conveyed

(?) Dirck Jacobsz, *Marriage Portrait*, 1541. Amsterdams Historisch Museum.

by his image. Eworth's portraits encode assumptions and definitions which had developed in order to cope with the duality of the sexes, with the inevitability of decay and with the implications of having a marriage portrait painted within this system of beliefs.

BROKEN TIME: PORTRAITURE PAIRED AND IM-PAIRED

The inscriptions on the Wakemans' portraits fix the temporality of the representations, their absolute belonging to a time that is past. At the same time they admit to the existence of the portrait as an object in changing time, into which ever-different viewers enter to gaze, remember and be reminded of the time that has passed and is passing. In the portrait of Lady Dacre no such words appear within the image proper; their very absence is important, for there is thus no element that works to deny illusionism as an attainable goal of the picture. This then enables the metalanguage of incasement – the image within the image – to work a purely pictorial ruse that asks similar questions, questions which are, however, put on a different basis by being asked visually rather than verbally. The fact of Eworth's pairing here seems to show on one level

that artifice can indeed transcend time: his painting should heal the break that occurred in the Dacres' marriage by reuniting the dead and the living in a single frame. But Eworth's double act of portrayal and re-portrayal is not so simple. Instead, the relative time of the two images and the value of their endurance are problematised, as Eworth reframes the question of portraiture.

The situation of the Fiennes and Neville portraits may be put thus: art and death have fixed the husband in youth; his wife has changed and is now, on another occasion, fixed in her turn. The rupture of time between the two serves not as a *memento mori* but, as it were, a *memento senescere*. A stage of life is reached; art intervenes; the resultant image is saved for time to come. This construction assumes that the primary and secondary portraits here function in essentially the same way. But do they? Holbein's portrait is obviously very different in its structure and style from that which encompasses it. To define this difference, we may consider a question which Berthold Hinz has posed about late Renaissance portraiture: does a portrait's 'anti-aesthetic', documentary function conflict irresolvably with the wish to consider it as a work of art?[69] Hinz implies that what defines a portrait as 'art' rather than 'document' is an acquisitive desire for it on the part of collectors to whom the sitter is unimportant. The problem is one of ambivalence between the 'use' and 'value' orientation of the painted object – a problem because, as the portrait becomes 'art', the name of the sitter it was intended to immortalise may be lost without any harm to the picture in its new status. This kind of transformation did indeed occur in England during the late sixteenth century: Van Mander reports that Holbein's portraits were sought out and purchased by collectors because they were by him, their subjects thus becoming unimportant.[70] From the point of view of these later beholders, what we termed the 'occasionalistic', patron-centred character of the portrait is dismissed or rejected in favour of the aesthetic character of authorship.

Having returned to Gadamer's terminology, I would like to introduce a dichotomy he sets up, on which Hinz's materialist-historical division is in fact based. Gadamer proposes a distinction between what he calls the 'copy' and the 'picture'. The goal of the copy is to resemble its original, and we measure its success by the degree to which we recognise the original in it: 'it is its nature to lose its own independent existence and to serve entirely the communication of what is copied' – it cancels itself out by definition of its purpose.[71] Gadamer's 'picture', though, is not merely

a means to an end: it is itself what is meant, and it 'affirms its own being in order to let what is depicted exist'.[72] His definition of the 'copy' seems to fit the commemorative-dynastic type of portraiture which Holbein's painting exemplifies. The face of Lord Dacre is described against an absolutely neutral ground, and no second term is given for interpretative play within the image. The documentary information inscribed upon the portrait's frame cements its status as a copy rather than providing any release from it.

Through the devices by which he incorporates Holbein's work into his own, however, Eworth signals a self-consciousness of artificing that makes a bid for Lady Dacre's portrait as something different, what Gadamer terms a 'picture'. The care with which Eworth's sitter has been described is certainly important, but the rich symbolism of form and content, the quasi-narrative activity so ambiguously connoted, folds layers of meaning into the image as representation that are absent from a documentary portrait, taking it beyond a function of mere replication. The portrait of Thomas Fiennes serves both as a component of the structure of meaning here and as an element that draws attention to that mode of making meaning by the absence within its own frame.

This is not to suggest that Eworth simply sets up his great predecessor as a sort of straw man off whom to play a type of portraiture which is 'better' in so far as it is non-inscriptive, iconographically rich and psychologically suggestive, but there are, nevertheless, *paragones* here at a number of levels. Holbein's portrait is a competition with time for both of the sitters and for the artists as well. Van Mander actually concludes his life of Holbein by acknowledging this as a goal of his art but also doubting its efficacy: 'Holbein made the world more beautiful with his noble art. Human life and all worldly things are perishable; they will melt, will be destroyed, will come to an inexorable and unpreventable end. So Holbein died in London, choked by pest, in the year 1554 . . . His body was left rotting, a corpse, soon to disappear, but he left his name and fame to posterity and to an imperishable memory'.[73] Only a few years after the death of his rival on the artistic scene in England, Eworth both pays him homage and attempts to outdo him, helps to preserve his fame (memory) and undercuts it by positioning his work as a portrait *qua* copy. He absorbs the Fiennes portrait's temporality into his own rhetoric of temporality, validating it by the very fact that it can play such a central role. Indeed, Eworth's strategy of incasement here ultimately suggests that the whole idea that an image can exist purely as a copy is flawed;

even the documentary portrait already carries within itself the potential to become a term in a discourse, be it verbal and historical or, as here, visual and critical.

Holbein's representation itself plays with image-making, and Eworth repeats and acknowledges the cleverness of its artifice. On the right of Thomas Fiennes's jacket, the bottom-most fastener slightly overlaps what is thus a partly fictive frame.[74] Paint crosses over the border of illusion and into the world of reality – or, now, into another world of illusion. In thus calling attention to its artifice, Holbein's portrait itself gestures towards the boundaries of the copy and begins to enter the status of picture, refusing to be 'cancelled out'. Eworth echoes Holbein's strategy by encroaching upon the frame of the Fiennes portrait from the space of the primary representation, with the tie creeping over it from above and the tassel overlapping at the side. These sleights, by just breaking the perfect self-enclosure of the framed portrait, anchor it into the space – and the time – of his own image.

Eworth plays out the question of the boundaries of representation and representability on the frame of the painting – that is, on the represented frame of his rival time-slayer Holbein, the frame of a portrait which 'transcends' time only to be recaptured in a further attempt to fix an image. The breaking of the Fiennes portrait's frame signifies its ambivalent function and status here: it is a memory-image that is 'living' in the fiction of the thoughts of the surviving widow and also a painted image that claims the ability to fix and preserve the appearance of the dead beyond the time of living memory; it is a copy that serves to resemble and record its sitter in 1540, aged 24, and also a picture that is both a rival and a co-conspirator in Eworth's complex discourse of time, memory and the image. In the representation in paint of the husband and wife who are divided and yet are one, we find, paradoxically, that the 'vanity' of the memorial image which captures only the transient is redeemed when, by the manoeuvres of the artificer, it is transformed into a picture. The feigning artist re-presents a woman who is an image herself as well as a maker of images; he remakes the image made through her memory, an image that is living because of her living absorption into herself of its original. Eworth's ultimate *paragone* in his portrayal of Mary Neville is one with the powers of the woman who is his subject. It is in fact precisely by co-operating with those feminine powers and replicating them through his art that he can both fulfil the demands of an occasion which requires the representation of a bridge between present and past time,

and offer a new solution to the question of how any portrait conquers future time – not through its physical endurance, but through that supposedly passive, 'feminine' memory that is endlessly replicating as every viewer, every artist, sees, recalls, remakes.

4
'Magnetic Figures': Polemical Prints of the English Revolution

TAMSYN WILLIAMS

According to a critic, clumsy woodcut portraits were 'magnetic figures' whose barely recognisable faces

> ... did enchant
> The fancies of the weak, and ignorant,
> And caus'd them to bestow more time, and coin,
> On such fond pamphlets, than on books divine.[1]

Made in 1645, this claim that such figures enchanted the public readership of news-sheets raises interesting questions about the depiction of the human body. Did they exercise such fascination, and if so, how? And further, how were printed figures meaningful to seventeenth-century audiences? The answers to these questions are elusive simply because the broad publication of these tracts is not matched by surviving contemporary responses. I shall examine these written sources later, but at the heart of my analysis is the structural evidence of the prints themselves; in particular satirical depictions of the cavaliers, roundheads and religious sects which demonstrate so well the various reworkings of the human figure. In accounting for the ways in which prints of human bodies acquired meaning, context is of the utmost importance, not just in terms of accompanying text and titles but also in the sense that these were *popular* images. The relationship between image and context was controlled by decorum. As a contemporary poet explained, different kinds of poems and pictures demanded different styles:

That I use some broad words sometimes 'tis but conform to the pattern I imitate: Brueghel representing, without any dishonesty, here a Boor shitting, there a Boor in pissing, to render the vulgar more ridiculous (are properly the subject of ridiculousness) and whose follies, abuses, and vices, are properly the subject of satire.[2]

It is exactly this sort of 'broad' treatment that characterises the cheap woodcuts in which, for instance, one could dare to depict an erection

A New Sect of Religion Descryed,
called Adamites (1641)

(above). Such a licence is far removed from more polite cultural forms, and it gives to the prints an unexpectedly spectacular quality. Francis Barker has referred to the 'spectacular presences' of human figures on the Renaissance stage, before self-consciousness gripped the psyche.[3] Although Barker's arguments are not wholly convincing, there is certainly a similar tendency in the prints. Ridicule was the intention. Just as the Baptists were drawn semi-naked 'to make them odious to the world', so witty woodcuts of prelates were published 'for everyone to spend a cudgel at'.[4] The idea was, as John Vicars claimed of his unkind engraving of John Goodwin, to embarrass the victims and to teach others to shun the offenders.[5] In 1642 a pamphleteer denied that his woodcut of the Devil contained 'more spite or vanity, than wit or Christianity'; his aim, he claimed, was to expose vices in order to shame the vicious.[6]

The sort of images that I shall be considering were, therefore, designed to appeal to the widest possible popular audience. Allegorical personages and complex, ambiguous messages were left to the costlier engraved

frontispieces of bulky, thoughtful tomes. My subject is the direct, punchy woodcuts which accompanied brief, readable pamphlets and broadsheets. Such publications were emotive and not intellectual; the image-makers personalised difficult issues and featured everyday, familiar stereotypes; they drew on such easily accessible verbal and visual sources as popular literature, proverbs and the Bible.

This accessibility is shared with features of the common stage, both in the way in which the figures are depicted and in the function of the pictures. Eye-catching, entertaining prints show characters in dramatic postures, set against bare back-drops. Not only are speech tags nearly always present, but the direction and the style of type identify the speaker clearly. Certainly the existence of parallels between prints and plays did not go unnoticed by contemporaries. One writer in 1644 called a frontispiece a 'stage'.[7] In reference to pamphlets, a news-sheet editor observed that 'Titles . . . are the colours that set off the picture, or the bills that direct us to the theatre'.[8] That a number of pamphleteers were ex-playwrights may explain the recurring use of dramatic dialogue and the interest in eventful illustration. Accustomed to street pageantry and regular visits to playhouses – at least until 1642 – the public may have brought expectations about theatrical performance to their reading of tracts, especially when literature was read aloud. Shared stylistic conventions would have made the material more accessible to a wide section of society.

Something which emerges time and again is the issue of titles. Practically all of these prints are traditional images, whether second-hand or freshly cut. Hardly anyone invented new iconography. What one finds is an energetic and apposite redefinition of the picture by means of crude titles and text. In other words, when these 'bills . . . direct us to the theatre', we are treated to an old (and popular) play with a new script. One group of images which demonstrates this excellently concerns cavaliers and roundheads.

CAVALIERS AND ROUNDHEADS

The label 'cavalier' derived from two rowdy clashes at Westminster in December 1641 between London citizens and apprentices and 'gentle-men-like' officers brandishing swords. Yelled abuse of 'roundheads' from the military were met with cries from the Londoners of 'cavaliers'.[9] At the root of the derisive terms were the class and appearance of the protagonists. 'Cavalier' meant gentleman because it implied that he was

mounted. His shoulder-length locks contrasted with the shorter hairstyle of the citizen.

To illustrate accounts of the riots London publishers seized on the descriptive distinction of types. On the back page of one news pamphlet of 1642 was an oft-repeated woodcut of a finely-dressed officer with long curls.[10] Another useful old print, which dated also from Elizabethan and Jacobean ballads, featured a gentleman with plumes and spurred boots alongside a commoner in a plain jerkin and a soft felt hat (p. 90). Of no interest to pamphleteers was the fact that the protesting citizens included a range of social types. What they emphasised in woodcut and in word was the overriding difference between the two groups. Visual images served to polarise opposites in the hope of mobilising public opinion.

Dress was a highly charged sign-system. Because it signified sex, wealth and power, it was meant to be worn accordingly; hence the sumptuary laws of the seventeenth century. For the staunchest moralists, a certain type of dress was a visible sign of the evils of the day, whether the subjects were women, foppish youths or clergy. This attitude lay partly in the orthodox belief that clothing was a token of shame for the sin of Adam, that to exaggerate one's garb was a public confession of weakness and vanity.[11] In Tudor interludes some of the vices were known as 'gallants' and were dressed in feathered hats, slashed doublets and sleeves and (later) bombasted breeches.[12] Interestingly, those old woodcuts of courtiers and countrymen which now stood for cavaliers and roundheads had illustrated ballads on these very themes, because some of the new topics of Elizabethan broadsheets had included upstart courtiers and swaggering soldiers (p. 91).[13] In one of these, a rural lass was happy to wear a 'homely hat' and 'country guise' rather than the new shapes at court.[14] What good was finery in amongst the brambles? asked a husbandman: far better a strong russet coat.[15] With the lessons of the Prodigal Son clearly in mind, the extravagance of frills and satin was a recurrent theme. A ballad of the early seventeenth century, illustrated with the same cuts of figures, compared the old-style courtier with the new.[16] Whereas in the past, went the verse, money was spent on looking after one's servants, now the gentry indulged in the latest fashions. Another Elizabethan publication on the same theme was Stephen Bateman's pamphlet on vices of 1569.[17] Relevant figures included well-dressed women who stood for Lechery and Pride. An emblem signifying Gluttony included a fashionable courtier, with hand on sword, representing Riot.

All of this means that the image of the cavalier was based on emotive

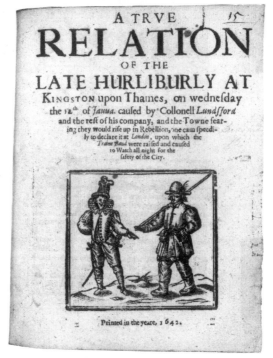

A True Relation of The Late Hurliburly At
Kingston upon Thames (1642).

prejudices related to status and appearance. He was, furthermore,
inseparable from the familiar, derisive figure of the 'roaring boy'. 'Should
I wear long locks,' a Londoner noted in 1642, 'I should be esteemed a
roaring boy or swaggerer.'[18] That these braggarts conformed to many
citizens' opinions of courtiers is reflected in one up-market broadsheet of
1641 (p. 91). An attractive etching (perhaps of Dutch origin) shows two
long-haired and finely dressed youths gambling, drinking and smoking in
a cellar. What gives the tract a political dimension is the title which refers
blatantly to a renowned courtier: The Sucklington Faction: Or (Suck-
lings) Roaring Boyes.

Something else which may have acted against the cavaliers was the
theatricality of their style of dress. Possibly their showy ensembles
irritated the anti-theatre lobby. Apart from that, there is plenty of
evidence that the officers' taste for wigs and buskin boots was held to be
distinctly and damagingly popish. A woodcut of 1643 revealed 'the
kingdom's monster' to be a many-headed conspirator.[19] Disclosed from
under a cloak (part of the cavalier's outfit) the fiend was seen by 'His

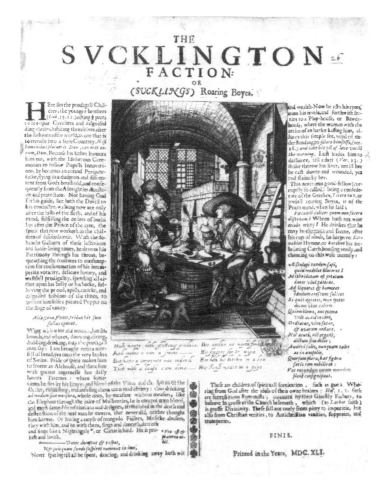

The Sucklington Faction (1641).

Spanish ruff and jacket . . . to be half Papist, and half Cavalier'. The parallel was drawn between dress and behaviour by citing the standard anti-Catholic topos of the ruthless Papist officer. From 1643 the news-sheet *Mercurius Civicus* sometimes featured woodcuts of royalist soldiers holding enormous swords, no doubt with phallic associations.[20] Among many other examples is a frontispiece of 1644 which is very similar in detail to an illustration from an earlier book on the Thirty Years' War (p. 92).[21] The English version lacks the careful detail of its European counterpart, and yet it retains the horrific essentials of children being piked, helpless mothers praying for help and buildings engulfed in flames.

A
COPIE OF THE

10

KINGS Meſſage ſent by the Duke of *Lenox*.

Alſo the Copie of a Petition to the KING from the Inhabi-
tants of *Somerſetſhire*, to come with him to the Parliament.

A Declaration by the Committee of Dorſetſhire, againſt the Cava-
liers in thoſe parts ; declaring how ſixe French Papiſts raviſhed a wo-
man one after another: She having been but three dayes before
delivered out of Child-bed.

Alſo, how a Gentleman at Oxford was cruelly tortured in Irons, and
for what they were ſo cruell towards him.

And how they would have burnt down an Ale-ho ſe at the Brill, be-
cauſe the woman refuſed Farthing tokens ; And other cruelties of the
Cavaliers, manifeſted to the Kingd me.

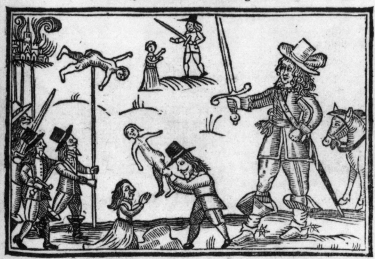

Publiſſied according to Order of Parliament.
LONDON, Printed by *Iane Coe.* 1644.

A Copie of the Kings Message sent by the Duke of Lenox (1644).

As well as anti-catholicism the picture connotes the biblical horrors of the Massacre of the Innocents. The image of the lawless hooligan was especially pertinent in 1646 when the authorities were failing to cope with disbanded royalists. An etched broadsheet of that year depicted 'an English Antic'.[22] The exaggerated frills and ribbons made a mockery of the gentleman's heroic pose; base similes in the text such as the close-stool pan, the coxcomb and the monkey's tail undermined his pretensions of dignity. A reworking of the image published four days later specified the target.[23] In gruesome detail the text dwelt on aggressive royalist tactics – and the English Antic was recast as a wolf with eagle's claws. Contemporary belief maintained that animals did not have souls, so animal insults reduced the cavalier to an inferior level: as well as being an affected fop, he was denounced as beyond moral consideration.[24]

What made accusations of beastliness and femininity so apt were those long locks. Writing in 1642 one parliamentarian admitted that many long-haired youths supported Parliament and that not all royalists had bouncing curls. None the less, the writer – in common with others since at least the sixteenth century – recalled the Apostle's rule that long hair was shameful to men but was a glory to women in providing a covering (1 Corinthians 11:14); long hair advertised women's inferiority. Not only this, 'yet is long hair the visible sign or mark to distinguish a Locust, Rev. 9. 8. and they had hair like women'.[25] 'In regard of their long hair,' added another writer in 1642, 'they may be said to wear a horse's tail.'[26] Woodcuts of cavaliers with ridiculously long locks were one mocking device. Prints of pets were another. Puddle, the poodle, with his lion-like mane, and the black mongrel Boy accompanied Prince Rupert, the arch-cavalier, in several parliamentarian woodcuts.[27] Given that beastliness was synonymous with lust, Rupert's brutish relationships were ripe for scandal. A favourite with polemicists was his malignant she-monkey. Woodcuts set the body of the animal in a skirt and a headscarf, with a sword at her waist and a pipe in her mouth.[28] Apart from the chin muffler which indicated that she was a bawd, the little animal drew on the different associations of the term 'cavalier'. To depict her smoking was to link her with images of 'roaring girls' from the Elizabethan period onwards, those other females who stepped outside the bounds of conventional femininity.[29] As well as evoking swaggerers, the pet was bestial, female and armed.

Not until 1646 with the formation of the New Model Army did eye-catching images of crop-haired and bristly-chinned soldiers appear. Until then one approach to the label 'roundhead' was a light-hearted rework-

ing of traditional mocking themes such as the cuckold or the Devil without his horns.[30] More seriously, royalist commentators linked the new political tag with the familiar religious target, the Puritan. The black-brimmed hat became all-powerful. One of the earliest representations occurred in Henry Peacham's emblem book of 1612.[31] Although the device stood for 'Sanctitas Simulata', the charge against the reformers was as much political as religious: the print showed a presumptuous sugar-loaf hat placed over a crown. The eloquence of the hat developed with time. In a book of 1651 by Thomas Hobbes on political power, one of the figures in the engraved frontispiece is Liberty.[32] Balanced on the tip of her staff is a broad-brimmed hat.

As a means of identifying Parliamentarians, the black brim provided a starting point for further attack. In a pamphlet of 1642 the woodcut title-page is punctuated with rows of black hats atop the heads of Mr Warden and his committee and Mrs Warden and her friends. In the text Mr Warden tells his fellows that the only beads of which his wife approves are pearls in a hatband: 'my wife (that piece of devout obstinacy) esteems that decent wearing, thereby expressing the haughty pride of a citizen's wife.'[33] The sugar-loaf hats worn by Cromwell's council in a woodcut of 1649 complemented the horns of their colleague, the Devil.[34] A print of 1661 which shows a member of the Rump Parliament with a stick in his buttock was all the more credible for the costume detail.[35]

Explicitly and implicitly, aesthetic was tied to polemic. The terms were based on description, but the origin of the tags and their subsequent developments in print were tied to prejudices about bodily appearance. As we have seen, the image of the cavalier was influenced by ideas about swaggerers and European papists and played on animal and female associations. Even the fresh notion of the roundhead – created for the first time in the 1640s – was interpreted in traditional forms. Instead of conceiving new iconography, producers cast the figure in a comic light – or emphasised the social origin of the roundhead's appearance. The headwear of the Puritan politician was subjected to the same moral criticism as the extravagant dress of the cavalier: that Mrs Warden should wish to have a pearl hatband was deemed typical of the citizen's aspirations of grandeur.

RELIGIOUS DISSIDENTS

If one major group of prints concerns politics, then another predictably large group turns on religion. One book more than any other shaped

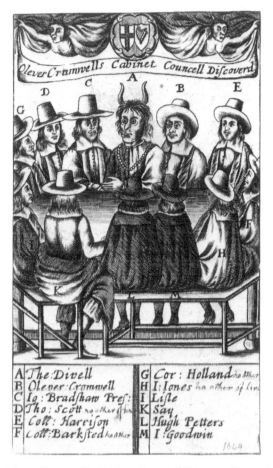

Olever Crumwells Cabinet Councell Discoverd (1649).

public conceptions of papists: Foxe's *Actes and Monuments* of the mid-sixteenth century.[36] This volume not only established the idea of a Catholic conspiracy against England, but in addition the woodcut illustrations of Protestant martyrs undergoing the most awful tortures stuck in the public imagination. Again and again, commentators of the 1640s and 1650s drew modern analogies with Foxe's woodcuts, albeit in very different ways. The news-sheet *Perfect Occurrences* of 1645 reckoned that the cavaliers' cruelties were fitting subjects for 'a second book of Martyrs'.[37] In a comedy of six years later the character of Religion was 'to become a Martyr, and be pictur'd with a long label out of . . . [his] . . . mouth, like those in Foxe's Book'.[38] Another writer

recalls how, as a child, he had been fascinated by the pictures of martyrs at the stake:

Ever since I had known them there, not one hair more of their head was burnt, nor any smell of the fire singeing of their clothes. This made me think martyrdom was nothing. But O, though the Lion be painted fiercer than he is, the fire is far fiercer than it is painted.[39]

During the mid-seventeenth century, although there was nothing in England to equal the finely detailed illustrations of Foxe, pamphleteers relied on a vivid memory of them to stir the emotions of their readers. Seventeenth-century styles of print-making favoured the far simpler iconography of familiar Lutheran publications: conventional anticlerical figures of devils, square-capped bishops and the Pope were scattered liberally in tracts against contemporary social enemies like non-resident clergy and Laudian prelates. These traditional characters were backed up with more recent stereotypes; woodcuts of fashionable courtiers – the same figures that stood elsewhere for malicious cavaliers – reinforced links between social status, Catholicism and the court.[40]

Just as images of papists were informed by memories of Foxe, woodcuts of religious separatists drew heavily on characters from Elizabethan and especially Jacobean plays, characters like Mrs Mulligrub, Tribulation Wholesome and Zeal-of-the-Land Busy.[41] And by borrowing figures from such popular sources, pamphleteers of the 1640s and 1650s hoped to characterise their victims in ways that even barely literate people could understand. The aim of the satire was to annihilate the dissidents by exposing the fickleness and errors of their creed. As well as using stage stereotypes, satirical prose of the mid-seventeenth century consisted of so-called 'eyewitness reports' by converts (a common rhetorical device) or of the sectaries' examinations and trials. Not only pictures but language was structured so that the audience was crudely interpellated as decent and self-righteous. In 1650, for example, by giving details of Ranter rituals one writer hoped 'to satisfy all good people concerning the wicked prejudices and blasphemous viewpoints of this generation'.[42]

Prominent images of human bodies were invaluable weapons in the smear campaigns – and the labels attached to the figures were also calculatedly emotive. For a start, one technique was to catalogue the tenets of the various religious groups. The dissidents had no common body of belief other than rejection of a parochial state Church financed by tithes. While some broadsheets and pamphlets covered the different practices in detail, blunter tracts adopted the wholesale approach which

had characterised the attitude of the Laudian authorities. Like all crude polemic, title-pages in particular simplified the coverage: prints and headlines confined attention to a few recurrent dissidents; woodcut figures were accompanied by a limited range of clear identity tags. During the 1640s those Protestants who preferred a church based on the Calvinist model to the Episcopalian were all given the prominent label 'Puritan' when represented in woodcuts. The debt to earlier satire was noted in 1641 by the Member of Parliament Henry Parker, who claimed to be neither Puritan nor anti-Puritan:

Scholars, and the greatest of the clergy, are now become the most injurious detesters and depravers of Puritans, having taken up in pulpits and presses, almost as vile and scurrilous a licence of fiction and detraction, as is usual in play-houses, taverns, and bordelloes.[43]

As John Bastwick observed in the same year

Yet are they made the scourge of the world . . . it is enough to ruin a man's cause, if his adversary can but taint him with the name of Puritan.[44]

At least the Puritans were a significant body of reformers. Familists, on the other hand, were always few in number. Their popularity in woodcuts of the early 1640s depended more on earlier plays such as Marston's *The Dutch Courtesan* of 1605 than on the contemporary strength of their following. Likewise, until the later 1640s English Baptists were nearly all abroad, but with accounts of the Munster riots of the sixteenth century still in circulation, another popular and evocative label was 'Anabaptist'. 'Brownist' appealed to imaginations in that it was an indigenous sect, for Robert Browne (1550?–1633) was a lay preacher from Southwark. Another common tag was 'Adamite'; here the attraction lay above all in their seemingly shocking tenets. In other cases the strange names of obscure dissidents were exploited. The prominent labels of 'Disciplinarian' and 'Publican', for instance, added to the alienation of the sects.

In representations of religious dissidents, as in prints of other groups, dress was an eloquent rhetoric. A woodcut of 1636 shows two 'upstart prophets' in ruffs, tall black hats and baggy breeches (p. 98). Fashionable in England at the turn of the century, this style of clothing was used to link modern dissidents with their predecessors and, in turn, with their brothers and sisters in Amsterdam and New England. A picture of *Religions Enemies* of 1641 stressed the origins of the various groups by showing a Baptist and a Familist in ruffs, a papist in friar's habit and a

Thomas Heywood, *A True Discourse of the Two infamous upstart Prophets* (1636).

Brownist in civilian suit and shoes (p. 99). Another woodcut of 1642 depicted the Brownist and the Baptists in ruffs, the Publican and the Donatists as civilians, and the Disciplinarian as semi-naked.[45] The text stressed the sixteenth-century origins of those in ruffs. By 1647 when sectaries were more widespread, the ruffs had disappeared. Broadsheets of that year presented the characters in tall hats and flat white collars, or else naked. Whereas in 1641 a Brownist was recognisable by his ruff, by

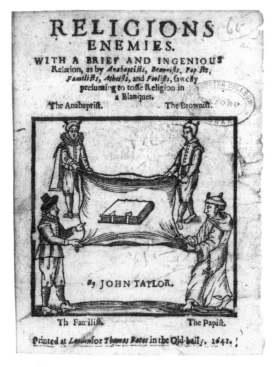

Religions Enemies (1641).

1660 actors dressed as Puritans wore narrow bands, short hair and broad-brimmed hats.[46]

Not all of the sectaries believed in lay preaching, but both broadsheets and pamphlets mocked 'mechanic' preachers without troubling to make any distinction. An excellent example of mechanic bodies is a sheet of 1647: *These Tradesmen are Preachers in and about the City of London*.[47] The 'most Dangerous and Damnable Tenets' were listed below the picture. Among them were the perfectly rational beliefs that the soul died with the body, that God called for religious toleration, that there was no resurrection and that Grace depended on free will. At the centre of the paper was a print of different tradespeople at mundane work, such as a smith bent over his anvil, a meal-man weighing flour and a button-maker counting buttons. 'Mechanic' was a class label, as testified for instance by the 'rude mechanicals' of *A Midsummer Night's Dream*.[48] That these 'mechanic spirits' were responsible for the intellectual concepts enumerated below was considered the best case for their implausibility.

Shocked pamphleteers also seized on the idea that religious services were not to be confined within the walls of parish churches. In a variety of woodcuts, pictorial details of lattice windows and floorboards located human figures meeting inside ordinary rooms. Yet again the rule of decorum organised the presentation of the human body. Throughout both decades, for example, the proverb 'A mere tale in a tub' combined with actual events to inspire countless prints. One woodcut of 1641 depicted the lay preacher Samuel How delivering his famous sermon of 1639 in the Nag's Head tavern.[49] In subsequent editions the inn sign was cut away and other separatists' names replaced that of How. A woodcut of 1648 contrasted 'The Orthodox True Minister' with 'the Seducer and false Prophet'.[50] One section showed a preacher in a pulpit. In the other half the prophet preached from a tavern window to a congregation, some of whom were up a tree. A park was the scene for a sermon by an Adamite weaver in 1641 (p. 102).[51]

That women were prominent members of separatist congregations was emphasised in woodcuts of the 1640s and 1650s in order to undermine the sects' credibility. In the woodcut of 'the Seducer and false Prophet' one of those perched among the branches was a woman. The 1641 print of a tub-preacher drew on well-known contemporary convention in placing a Holy Mother – so-called in the contemporary press – to the left of the tub from which the preacher held forth. Conventional news of strange births, illustrated with traditional woodcuts of beds and monsters, was reinterpreted to fit the satirising of sects. One pamphlet of 1646 concerned a Catholic, Mrs Haughton, who was reported to have sworn that she would rather her child had no head at all than a round head.[52] In the woodcut title-page women are surrounded by domestic pets, evocative of witches' familiars as well as connoting the beastliness already referred to. Prayer books and rosaries are present in abundance, and even a friar brandishing a crucifix finds a place at the foot of the bed. As well as alluding to the important role of women in the preservation of Catholicism in England, the image also plays on common prejudices about female susceptibility to religious novelties. The prejudices were, however, extremely flexible: a few years later the woodcut represented a Ranter's monstrous offspring.[53]

The idea that all dissidents indulged in immoral sexual behaviour was a commonplace of literary polemic. When Thomas Nashe's Jack Wilton visited Munster, he commented not only on the dress and lower class of the Anabaptists but on their liberal attitude to sex.[54] In Jacobean plays members of the Family of Love lived up to the name of the sect.[55] Reports

and prints of holy brothers and sisters in embrace, therefore, were not new. A frequent woodcut of 1641 shows Brownists meeting in a room.[56] Outside the door two members are locked in each other's arms. 'A little in zeal, good sister Ruth,' urges her fellow. That some women needed minimal persuasion was the message of another woodcut of 1641.[57] Titled 'A Company of Women preachers' the print represents four women dancing around a topless sister. Significantly it also illustrates a pamphlet about prostitutes.[58] The notion that women preachers did frolic in the nude was held in relation to the Adamites especially. Adamites called their meeting place 'Paradise' and celebrated communion naked in the manner of Adam before the Fall.[59] How ridiculous, wrote one pamphleteer in 1641; in contrast to these sectaries, Adam hid his nakedness in shame.[60] Without doubt, wrote another, their nudity was linked to sexual appetite:

> . . . they're so hot within
> With lust, that they all clothing do disdain.[61]

From 1641 onwards pamphleteers revelled in the Adamites' nudity. One pamphlet of that year uses the rhetorical device of the eye-witness account given by a scholar who had become entangled with the 'troublesome' tendency. Displaying wonderful imaginative talent, he relates how a man takes him to a fair gallery hung with clothes, where they both undressed. Then an old man, holding a long stick, shows him in to a chamber packed with nude people. The function of the stick was so

that if the planet of Venus reigned in their lower parts, making them swell for pride, or rather for lust, then should the clerk with his long stick strike down the presumptuous flesh.

The stick was needed that day. A woman suddenly stood up, causing a brother who was in the middle of prophesying to have an erection. The clerk struck him so viciously that he cried out in anger and in pain. A woodcut on the front cover matches the colourful incident (p. 87). An item of clothing lies on the floor. To the right stands a naked woman, with hair flowing to her waist. With a hand pointing heavenwards the naked preacher poses on a stool. His erect penis is beaten by the rod of the nude clerk who commands 'Down Proud Flesh Down'. This marvellous woodcut is the best of a batch of similar images.[62] Whether pictured in a room or in a park, the emphasis is always on bare buttocks and bosoms. The aim was to show the Adamites, in the most entertaining way, to be sensual, animal and subhuman. And just as nudity was the sign of the

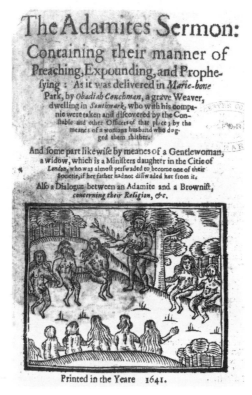

The Adamites Sermon (1641).

Adamite, so the ritual of believers' baptism meant that – for exactly the same normative reasons – bare chests came to signify the Baptists.[63]

In the 1650s, satire of Brownists, Adamites and Baptists was replaced by satire of Ranters and then of Quakers. This material was inspired by and added weight to Parliament's Blasphemy Act of 9 August 1650, which was in response to Abiezer Coppe's *A Fiery Flying Roll*.[64] Among the heresies punishable by imprisonment were allegations that women and men equalled God and could judge sin for themselves; that there was no need for civil or moral righteousness; and 'acts of uncleanness, Prophane, Swearing, Drunkenness, and the like Filthiness, and Brutishness'.[65] Among these 'monstrous' challenges to authority, it was hardly surprising that the latter acts – to which Laurence Clarkson, for instance, admitted freely – appealed most to polemicists.[66] To illustrate the tracts, prints of the 1640s were reprinted, and earlier themes re-emerged in mixed forms. One woodcut of late 1650 illustrated a Ranter form of

church service (p. 104). A woman welcomes a 'fellow creature' at the door. Behind her a sister kneels to kiss a brother's buttocks while he obligingly lifts up his shirt tails, a gesture of goodwill matched by naked men and women dancing around a fiddler. 'Let us eat while they dance,' proposes one of three men who tucks into food and wine. Women and men wear hats, and both sexes take an active and equal part in proceedings. In a similar woodcut of the same year a couple kissing are watched by a hatted woman and man who urge, 'Increase multiply'.[67] Next to this a tub-preacher lectures a motley congregation which includes a man with a wooden leg and a headless figure. 'We have overcome the Devil' promises the preacher. Three brothers sit smoking, eating and drinking, and a fiddler accompanies a Christmas carol sung by naked dancers.

Such 'broad' treatment of sectarian bodies was meant to reflect the separatists' tenets and to shock (and amuse) godly readers. The Ranters believed that because the saved could commit no sin, they could afford to flout God's ordinances – a perversion of the Scriptures to any polemicist speaking from a position that drew on the attitudes of the authorities. The sectaries drank to the health of Christ and then said derisively, 'Increase and multiply'. 'Let all with breath praise the Lord' was the Benedictus of a Ranter breaking wind. Just as feasts of beef and wine were the Ranters' sacrament, so their hymns took the form of drinking songs or Christmas carols. To dance was to rejoice at their victory over the Devil, and Christmas was a time for celebration. Dancing had long been attacked, above all if it interfered with religion.[68] To Protestant reformers yuletide was popish and pagan and an excuse for debauchery and extravagance, and as a result in December 1652 seasonal festivities were banned officially. Depicting characters in festive mood was deliberately provocative.

From the mid-1650s onwards polemic against the Quakers was cloaked in similar terms. As well as prints of amorous couples and naked dancers, the case of Quaker James Naylor received extensive coverage. A woodcut of 1657 depicted him standing in a pillory and whipped behind a cart through the streets of London.[69] In agonising detail an etched version recorded how Naylor had 'his tongue bored through with a hot iron'.[70] Illustrating the interrogations of 1657 was an old woodcut, reminiscent and evocative of Foxe's book, of a pilloried man surrounded by the pikes of officialdom.[71]

Human figures were an invaluable way in which to expose the shocking sectarian tenets, and pictorial satire an effective way to re-create the appearance and dramatic behaviour of the targets. The end result was

The Ranters Ranting:

WITH

The apprehending, examinations, and confession of *Iohn Collins,*
I. Shakespear, Tho. Wiberton, and five more which are to answer
the next Sessions. And severall songs or catches, which were sung
at their meetings. Also their severall kinds of mirth, and dancing.
Their blasphemous opinions. Their belief concerning heaven and
hell. And the reason why one of the same opinion cut off the
heads of his own mother and brother. Set forth for the further
discovery of this ungodly crew.

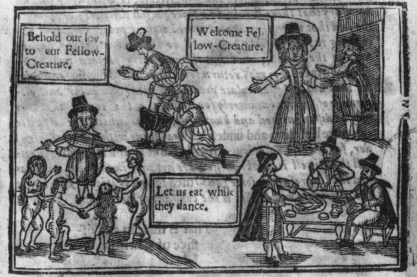

LONDON
Printed by B. Alsop, 1650.

The Ranters Ranting (1650).

a crude form of social control. News of these so-called strange sects rested on a consensus about what was and was not normal: thus, in print, if not in the mind of the reader, ideas about socially acceptable behaviour were reinforced. The situation was paradoxical: owing to their representation in print, radical sects became a means of affirming traditional values and hence a force for the order of authority.[72]

RESPONSES

There remains the question of how all these prints were received. To some extent, the likely response of contemporaries to woodcut figures can be gauged from the images themselves. The calculated power of the human figure is evident, for a start, in the careful representation of clothing, even in the crudest prints. One has only to think back, for a few examples among many, to buskin boots or to pearl hat bands. Let us take the broad-brimmed hat. When Thomas Hobbes's title-page was reprinted to accompany a book about Jesuitism, the figure of Liberty lost not only her title but the hat on the point of her staff.[73] To reuse a woodcut of cavalier atrocities in the context of Scottish wars, the publisher was careful to trim the brims of the soldiers' hats.[74]

If there was one prerequisite for this genre centred on the human form, it was accessibility. That the situation was hardly a straightforward one of cause and effect, however, is clear from what people wrote about the prints. Among the literate at least, written evidence demonstrates that, far from simply 'spending a cudgel' at the victims of satire, many reacted to printed figures in sophisticated and imaginative ways. Those who wrote about prints discussed them on a conventional basis in terms of accepted traditions about visual imagery. More than that, they used these traditional ideas about pictures as vehicles for their own polemic. Illustrations of human figures became springboards for making yet further political claims.

The belief that an image represented its subject in a real sense, for example, was picked up by the editor of *Mercurius Britanicus* early in 1645.[75] He was replying to a complaint from another news-sheet that a scandalous print of Sir John Hotham, the governor of Hull, was still on sale in London.[76] It depicted him 'riding on horseback in his warlike habit, and the King standing bare-headed at his horse feet'. *Mercurius Britanicus* replied

Why, you know Aulicus – Pictoribus atque Poetis; painters and poets dare anything: and therefore also they painted in a frame, the Pope sitting . . . and his Majesty upon his knees, presenting him with his crown: such a picture as this was

also taken . . . by some of our ships . . . and . . . brought hither to the Parliament; so that it is likely if Sir John would have been persuaded to yield up Hull, his Majesty had been a very fair way of giving away his crown, and subjecting himself, and his Kingdoms to the vassalage of Rome.

The tone here is complex, even ironic, but the passage depends on an assumption that what is depicted is likely to happen; whatever the writer's precise intentions, he is using the royal portraits as a kind of persuasive rhetoric. On a similar level, Henry Burton, a well-known Presbyterian, tried in 1641 to convince readers that his daughter's response to a print was prophetic of a reformation.[77] The illustration showed Charles I toppling the Pope's triple crown with his sword:

. . . having a young daughter then . . . to whom I showed this picture, interpreting the same unto her: the child presently thereupon replied. O father, our King shall cut off the Pope's head: it must be so, it must be so. And this so redled [sic], she spake with such an extraordinary rigour and vivacity or quickness of spirit and utterance as both myself and wife were struck with great admiration.

To counter the effect of visual images, other critics denounced illustrations as 'deluding frontispieces'.[78] Only the foolish and the uneducated were held to be deceived. To Edward Finch, a High Church vicar (who was himself the target of a satirical woodcut), 'Envious pamphlets and scurrilous frontispieces' were but '*ad populam phalerae*'.[79] It was well known that the 'multitude with greed, would love to look upon the piece, not read'; that 'vulgar men only peruse the title-page, then throw't by'.[80] Of *Eikon Basilike* John Milton wrote that the figure of Charles I was 'set there to catch foolish and silly gazers'.[81] 'Why so bewitched?' asked another critic of the printed royal portrait.[82] The tradition that pictures were for the illiterate served to argue the worthlessness of disagreeable images.

The power of the human figure is shown also by responses to published portraits of writers. That John Goodwin's features appeared so often displayed, in the view of John Vicars, 'the excessive pride of the man'.[83] To discredit the pamphlets of parliamentarian and emblem-writer George Wither, John Taylor seized on the poet's image:

> It look'd so smug, religious, irreligious,
> So amiable lovely, sweet and fine . . .
> Till (like Narcissus) gazing in that brook,
> Pride drown'd thee, in thy self admiring book.[84]

A favourite angle of attack was the charge of idolatry. In refuting John Rogers's treatise against visual images in churches, *The Tabernacle for the Sun*, the Presbyterian Zachary Crofton added that

Surely Mr Rogers has caused his effigy or brave picture to be fixed before his book, therefore he begins to be deflowered and to decline true Gospel-discipline: yet such is his argument.[85]

As for the public response to the celebrated engraving of the King in *Eikon Basilike*, that was said to be nothing but 'idol-worship'.[86] In reply to scathing criticism from a royalist Oxford journal of a woodcut of Parliament a London writer asked sarcastically:

How comes it to pass that those at Oxford are offended with pictures? Are the painted papist windows of Christ-Church and Magdalen College broken in pieces? Are the crucifixes and images defaced? What is the matter? It may be . . . that the cavaliers . . . hate the image of God in any man.[87]

Richard Overton's satirical woodcut of Sir Symon Synod was described as 'blasphemous' and 'sacrilegious'.[88] To protest against unfair satire the Quakers extended their case against visual images to include satirical figures. Not only were 'jesting books' and ballads like 'Gods' to the heathens, they claimed, but the woodcuts of the Quakers themselves made by their enemies contravened God's commandment of 'Thou shalt not make any image of male or female'.[89]

Discussion about prints of human figures was just as effective as the prints themselves. As *The Man in the Moon* noted of *Eikon Basilike* in 1649: 'The more such dogs bark against this picture of King Charles, the more veneration will be given it'.[90] This stresses the importance attached to interpretation. Writers who claimed that the infamous royal portrait, for instance, was set there 'to befool people' were making a polemical point.[91] None the less, the crux of the matter was how people were seen to read images. To put this into one contemporary's words, 'The palate of the guest is more to be regarded in censuring of sauces than the palate of the cook'.[92]

Given that the eloquence of the human figure lay in the reader's response and subsequent interpretation, an obvious method of countering that power was to reinterpret it. This had the double advantage of cutting through the intended sense of a picture while twisting its meaning to one's own ends. Pictorial replies were few because written versions were easier: apart from the fact that producing a fresh image took time, words were less liable to misinterpretation. To Henry Walker, John Taylor's woodcut of a tub-preacher was in fact a self-portrait: it showed

the drunken poet asleep in a barrel.[93] A crudely cut image of Laud set into an oval was mocked by Richard Overton:

Ha what's here? a flat cap, narrow ruff, and lawn sleeves, sure it stands for the Bishop of Canterbury; but I hope his sorrows have not so strangely metamorphos'd him; does he learn to tumble in a hoop too? Perhaps he intends to show tricks in Bartholomew Fair.[94]

The humble olive branch of the emblem of *The Scotish Dove* was mistaken deliberately for a bough of sour crab-apple.[95]

Private satisfaction was gained from defacing images. Instances that I have come across include scribbles all over a portrait and horns added to a woodcut of sectaries (p. 99).[96] When it comes to public, official responses to prints, the evidence is rather conflicting. Few prints were brought to the notice of Parliament. In the Printing Act of April 1643 'portraits' and 'pictures' were classified with 'small pamphlets' and were relegated to the licence of the Clerk of the Stationers' Company 'for the time being'. Only the lengthy Printing Act of September 1649 referred to prints and rolling presses.[97] In the remaining Printing Acts, Stationers' registers and Journals of the Houses of Commons and Lords, attention was devoted largely to the texts and the publishers of tracts. Illustrations and printmakers were generally ignored.

One reason for this apparent anomaly is that most illustrations formed an integral part of a pamphlet or book, so that censorship of the tract included the picture. Apart from this, evidence suggests that the authorities faced problems in tracking down prints. Thus, loose pictures could be handed in to the Houses of Parliament and ordered to be burnt – but unless the block or plate was discovered and destroyed, many more impressions could still be produced. Despite burning hundreds of copies of the offensive print of Sir John Hotham in 1642, the portraits were still on sale in 1644.[98] In April 1646 the Committee for Examinations (which specialised in attempting to censor scandalous pamphlets) resolved 'to find out the author and printer of a scandalous paper, with the pictures of a Prelate, a Presbyterian, and Pope, or to that effect, upon it'.[99] Not only did the Clerk find the engraving difficult to describe, but the producers could not be traced: the *Commons' Journal* does not mention the subject again.

Censorship was difficult in any case, precisely because of the ambiguity of meaning and effect. Of a 'scandalous frontispiece in derogation of the Parliament' one news-sheet asked:

If it were done by the Author's consent why have we not the mind of his frontispiece? Or is it no crime to calumniate or cast dirt . . . in a figurative or emblematical manner?[100]

The publisher of the print was accused of avoiding censorship in two ways. On the one hand there was the privilege of artistic licence by which one could say things in pictures but not in words. Secondly, by omitting an explanation of the image, the publisher left the meaning – or the 'mind' – of the frontispiece open to interpretation. Edward Dering made just such a point in 1644:

. . . call the representation, as you do the thing resembled; call the picture by the name of the person, whose it is, who will quarrel? Unless for the consequence being dangerous, or for fear of scandal.[101]

The intentions of producers of prints were not clarified. In 1651 a bill of indictment was drawn up against the printmaker Robert Vaughan for engraving a portrait of Prince Charles with the aim of promoting the royal heir. What the prosecution focussed on was once again not the image but the 'traiterous' inscription which proclaimed Charles to be King.[102]

Just as individuals valued the fact that pictures were open to manipulative interpretation, so did the authorities. Only one surviving print bears any relation to the censored engraving of Sir John Hotham.[103] This represents the governor on horse-back, with the King entering Hull in the lower distance. According to the censor the print was seditious because it showed Hotham towering above the bare-headed King.[104] Yet the image simply depicts Hotham on his horse with Charles I in the lower distance. The point was not so much the force of a particular portrait; rather Parliament was making a political statement about its support for the monarch. An odder interpretation of the royal image appeared in the Presbyterian John Bastwick's book of 1641:

It is worth the looking on, to see the pride of the Prelates, in setting the King's picture over their dresser, in the High Commission Court; for they have placed his Highness standing, with his hat off before their Worships, like a delinquent, his crown and sceptre laid low, as the poor Emperors and Kings were wont to stand before his impiety, the Pope, when they were cited to his Courts.[105]

This was a standard royal portrait hung in a conventional official place. Bastwick's claim that the bishops were showing disrespect by standing in front of the hatless monarch was stretching a point to the extreme.

Ultimately, the use and context of pictures were what mattered. The published context – where titles and text affected the way one looked at

the human figure – was shaped by the pamphleteers. How people then went on to use portraits added extra significance. A diary entry of 18 April 1660 recounts:

At this day the picture of King Charles the Second was often printed and set up in houses without the least molestation, for whereas it was almost a hanging matter so to do, the Rump Parliament was so hated and jeered that butchers' boys would say, Will you buy any parliament rumps and kidneys?[106]

Another person who used visual imagery to protest his political sympathies was the former Chairman to a Committee for Scandals – a parliamentarian turned royalist:

Out comes the spruce tobacco-box, with the King's picture at it, which he wears, and kisses, not so much out of kindness and devotion, as for a hint, and introduction to his politics, now at hand.[107]

I began by asking how printed images of human figures were meaningful in the seventeenth century. The picture which emerges is one of extreme and fascinating complexity. On the one hand, printed figures were valued for their expressive and arresting qualities in that they put the human body on show and were capable of reaching a wide audience. As we have seen, publishers of images took great efforts to produce portraits and satire with which people could identify. In this way even the simplest woodcut characters were capable of eloquent significance. At the same time the meaning of visual figures could be valuably obscure. Not only did witty writers twist the meaning of pictures to their own ends, but owing to the ambiguity of the pictorial figure, whether an image was seditious or not was always open to question. How a reader used and perceived an illustration of the human body, in other words, added to that figure's significance. The complexity extends further. Despite this wonderful flexibility of meaning, printed images of human figures were deeply conservative. Fresh titles and text were used to trigger new connotations from old, traditional iconography – but even these connotations were based on strongly-held attitudes to gender, clothing and other social elements. During an era of great social change, with opportunities to turn the world upside-down, images of human figures in the popular press only acted to confirm deep, narrow-minded prejudice.

5

The Fate of Marsyas: Dissecting the Renaissance Body

JONATHAN SAWDAY

Quid me mihi detrahis?
(Who is it that tears me from myself?).

Ovid, *Metamorphoses* VI, 385

The subject of this essay is the representation of the anatomised human body in the Renaissance. The evidence that I shall be exploring is culled from the text-books of the anatomists themselves. It was from texts containing images such as those reproduced in this essay, as well as from the evidence of practical dissection, that the Renaissance physician learned his trade and endeavoured to understand the internal structure and organisation of the human body. These works, containing images and descriptions of the human body by Renaissance anatomists such as Berengarius, Valverde de Hamusco, Estienne, Spigelius and, above all, Vesalius, are associated with the birth of anatomy as a 'science' of the human body in a period which has been described as an 'anatomical Renaissance'.[1] In England, this Renaissance was not to take root until the mid-seventeenth century, when Harvey's work began to be appreciated by a wider audience and his example followed by his countrymen. The images we shall be looking at, however, were widely available in England in the form of translations, re-issues and compendiums. Moreover, as Harvey himself exemplifies, the English physician or surgeon, anxious to obtain the most recent knowledge of human anatomy, saw a period of study on the continent in the medical schools of Padua, Bologna or (slightly later) Leiden as an accepted part of his training. So, although it is the work of continental figures which will be of greatest importance in this account, we can nevertheless view these images as forming, at a fairly early date, a significant part of that area of English culture which is our concern.

Looking at these tortured, vivisected figures which open themselves to display, depicted within the peaceful frame of a pastoral landscape, one

soon begins to sense that, whether or not these are 'accurate' depictions of the body's internal structure, they are also something more than an attempt to render the human body a fit subject of investigation. My purpose, then, is to trace something of the network of cultural practices surrounding the attempt made in the early modern period at portraying the body's internal structures. In pursuing these images – images of the body which have become almost iconic of Renaissance natural science – we shall encounter complex and contradictory codes. Only relatively recently have these codes begun to be examined with an eye to uncovering the material culture out of which they sprang.[2] We might understand these images as the external evidence for a set of beliefs and practices which the advent of modern 'disinterested' scientific investigation has rendered all but invisible. As we shall see, the desire to surround the body with appropriately detached scientific terms was, however, a strategy embarked upon by the Renaissance anatomist for reasons which were in reality far from disinterested.

We begin this exploration not, however, with an image, but with a myth – albeit one that produced one of the greatest paintings of the age. The story of the satyr Marsyas, flayed alive for daring to challenge and, worse, lose to Apollo in a musical competition is told in Book VI of Ovid's *Metamorphoses*. As retold in Arthur Golding's 1567 translation of Ovid, the story is one which is suffused with horror. To the satyr's agonised cry, which serves as the epitaph to this essay – 'Who is it that tears me from myself?' – there is only dumbfounded silence at the terrible revenge of the god:

For all his crying ore his eares quight pulled was his skin.
Nought else he was than one whole wounde. The griesly bloud did spin
From every part, the sinewes lay discovered to the eye,
The quivering veynes without a skin lay beating nakedly.
The panting bowels in his bulke ye might have numbred well,
And in his brest the shere small strings a man might easly tell.
(Golding, 128)[3]

For his presumption, Marsyas becomes Apollo's victim. His vain attempt at competing with the god results in a brutal disruption of his own body – an act of public cruelty which serves to underline the power of his opponent. The spectacle of the ordeal of Marsyas is one which reduces to tears those who witness the performance of the satyr's 'living death'. The tears themselves are transformed into a commemorative flood, issuing from the suddenly corporeal earth which, in Golding's version of the

story, is endowed with a fertile power of rejuvenation and commemoration.[4]

To artists in the sixteenth century, the satyr's agony was to become an object of recurring fascination. Titian's *Flaying of Marsyas* (c. 1570–5), now in the Archiepiscopal palace at Kremsier, is perhaps the most famous rendition. Titian's painting, which has been described as exceeding any other conception of the artist in 'cruelty and goriness', is comparable to explicitly Christian scenes of torment and suffering – the flaying of St Bartholomew or the crucifixion of St Peter.[5] Titian was not the only artist, however, to attempt this subject. Giulio Romano's drawing in the Louvre (c. 1526), as well as Raphael's fresco in the Stanza della Segnatura in the Vatican (c. 1510), suggest something of the appeal of the myth to Renaissance artists. It is also worth noting, in the present context, that the ordeal of Marsyas is explicitly depicted in the most important anatomical text of the period – Vesalius' *De humani corporis fabrica* (1543) – in the form of a series of historiated initials.[6]

It is, however, the structural elements in the Marsyas story which are our concern. These elements alert us to a means of reading the bodily disruption of the satyr which has an important bearing on the discovery of the anatomised human body. The story of Marsyas begins with a contest in which one of the contestants is transformed into the subject of a living dissection as a punishment for transgression. The god Apollo, associated with the curative powers of healing and medicine, here wields his knife to torment rather than investigate and assist. The spectacle is witnessed by an audience alive to the victim's suffering, but able, in an Ovidian transformation, only to commemorate rather than intervene. Finally, and perhaps most disturbingly, whether in the story as it is told by Ovid or in Golding's version, at the very moment when the physical suffering is most acute, a complex and confusing amalgam of emotional responses to the spectacle is recorded. The body of Marsyas becomes an object of erotic longing, voyeuristically glimpsed – witness the naked beating of 'quivering' veins, or the 'panting' bowels in Golding's version. But it is also the object of quasi-scientific detachment and intellectual curiosity where sinews wait to be 'discovered', the panting bowels are there to be 'numbred', and the opened chest awaits the scrutiny of any casual observer. The evocation of the eroticised body in torment, itself perhaps reminiscent of Christian agonies of passion, might lead us to understand the story as expressing 'agonized ecstasy' out of which emerges 'Apollonian clarity'.[7] But the idea, suggested in Golding's version, of 'numbering' and 'discovering' the opened body prompts the

reflection that now the flayed, vulnerable, transgressive, eroticised body of Marsyas is open to the eye of scientific discovery.

The eye of scientific discovery, though, was not in possession of neutral gaze in the early-modern period. To understand the structures of subordination and domination at work in the actual process of scientific discovery, we may turn to an eyewitness account of a course of dissections which took place in the Church of San Francesco in Bologna in January 1540. It was in this church that a medical student in the University of Bologna – Baldasar Heseler – saw and later recorded his impressions of a course of anatomy lessons conducted by the great Flemish anatomist Andreas Vesalius. The first demonstration (there were to be twenty-six such sessions, which were eventually to consume three human corpses and the bodies of six dogs) began in the morning:

The anatomy of our subject was arranged in the place where they used to elect the Rector Medicorum; a table on which the Subject was laid, was conveniently and well installed with the four steps of benches in a circle, so that nearly 200 persons could see the Anatomy. However, nobody was allowed to enter before the anatomists, and after them, those who had paid 20 sol. More than 150 students were present and D. Curtius, Erigius, and many other doctors, followers of Curtius. At last, D. Andreas Vesalius arrived, and many candles were lighted . . .[8]

The demonstration begins, then, with a procession – a ritual designed to underline the rank and dignity of those present. The cadaver itself occupies a position which, on other occasions, would be taken by the authoritative figure of the Rector of the Medical Faculty. The audience, some of whom have paid to witness the proceedings, are partisan – many of them 'followers of Curtius'. Finally, with the theatrical flourish of a stage-entry and the lighting of many candles, the chief protagonist – Vesalius himself – is ushered in to the room.

To term Vesalius a 'protagonist' may seem curiously at variance with the serious task in hand which was to be undertaken that January in Bologna. Yet, what Heseler and his fellow students were witnessing was in the nature of a gladiatorial combat. The opponents, Vesalius and the Galenic anatomist Curtius, were to produce a series of demonstrations on the human body which were not simply to record the facts of anatomical demonstration, but to test the competing claims of two methodologies. To one of those methodologies, the history of science has assigned the name 'Galenic' or, in a more loaded term, 'pre-Vesalian'. As we now know, it was the 'Vesalian' method which, eventually, was to triumph. That victory was itself to lead to the optimistic record of achievement and

discovery which was to characterise the investigation of the human body by William Harvey and his successors in the seventeenth century.

As the course of dissections progressed, Vesalius, as was the practice, moved from one cadaver to another. In an age lacking in preservative agents, the anatomy could not be a leisurely affair.[9] A particular anatomical structure, moreover, might have to be explored with the help of more than one cadaver. The legal source of such material was the scaffold, though Vesalius, in common with anatomists all over Europe, frequently had to find his bodies from other, illicit, sources.[10] The provenance of the bodies which were dissected is made explicit in the Tenth Demonstration with a grisly observation which, momentarily, alerts us to the peculiar nature of what is being investigated. For not only are these objects of dissection; they are also the bodies of once living people. Indeed, even as the course of demonstrations progressed, living people were being prepared for their own role in this theatre of investigation:

After dinner, he [Vesalius] said, I shall demonstrate the remaining inner muscles of the thigh, and perhaps also those of the leg with the foot to complete and finish the whole anatomy of the muscles of the body. For tomorrow we shall have another body – I believe they will hang another man upon which I shall demonstrate to you all the veins, arteries, and nerves. For this subject is now too dryed and wrinkled.[11]

There is something disturbing in the syntax here. The man who is still alive as Vesalius speaks has already been conceptually anatomised. Objectified, he is to be the passive recipient – a blank drawing page – of anatomical knowledge *upon which* (not within whom) structures will be proven. These organisations of veins, arteries and nerves are a complex interlacing which exists in the mind of the anatomist and must be mapped onto the subject stretched out on the dissection table. The dissection continues the following day (Fourteenth Demonstration):

Because our next subject was hanged this morning (there were two of them) during Curtius' lecture, and they were still hanging, as I myself saw, the students in the meantime had killed a pregnant bitch . . .[12]

We know the names of those who were hanged – Lorenzo da Bonconvento and Francesco da Buderio – criminals executed for street murder on 22 January 1540.

The connection between anatomical investigation and the final tearing apart of the criminal body after death within the confines of the anatomy theatre is of the greatest importance to any study of the history of

anatomical discovery in the early-modern period. In the spectacle of execution is enacted what Michel Foucault has analysed as the demands of the law, which result in an attempt at inscribing on the body of the felon the full weight of the wronged sovereign's displeasure. The malefactor's body thus becomes 'the anchoring point for a manifestation of power'.[13] In the anatomy theatre this process was taken to its extreme. Before a crowd of invited and paying onlookers, a new inscription is placed on top of that left on the criminal body by the executioner. The anatomist claims the body for 'science', and in so doing, the punishment is reinforced. The criminal body can have no individual identity save that guaranteed by the anatomist. Paradoxically, it was perhaps the full spectacle of such punishment which, whatever was intended, ensured that, even if criminal identity was destroyed, a new identity was created. The new identity is that of the scientific subject.[14] It was, however, the connection between the anatomist and the executioner, as Ruth Richardson has shown in her analysis of the circumstances surrounding the passage of the Anatomy Act of 1832, which was to endow the anatomist with such sinister notoriety.[15]

The competition which took place between Vesalius and Curtius at Bologna that winter, a competition which consumed the bodies of hanged criminals, is an enterprise which seems to echo in a different sphere the mythical competition in which Marsyas was both a competitor and the prize. The ultimate punishment for the transgressor against either divine or human law is to be made a spectacle under the flaying knife of authority. The anatomist is not simply a disinterested investigator of the natural world; he is fully implicated, as the extension of the law's revenge, in the re-assertion of the rights of sovereign power over the body of the condemned criminal. And here a new difficulty is manifested. If the transgressor is to be punished through the rites of dissection, what of the victor? To what extent is his investigation also open to the charge of transgression? In Ovid's story of Marsyas, the tears of the audience are prompted not only by the spectacle they witness, but also by the realisation of the full cruelty of the god who punishes. As Wethey observes of Titian's painting, 'it is . . . difficult to see beyond the horror of pictorial representation and to be sympathetic with gods who are so implacably cruel toward mankind'.[16] In the different but nevertheless related sphere of public execution, the tearing apart of the criminal body is an ambivalent spectacle. It *should* be a site of horror-struck contemplation of the deserved end of criminal activity. But it could provoke the opposite reaction – sympathy with the transgressor and disgust at the

prospect of the unequal triumph which has been observed.[17] The anatomist, moreover, is not working in the realm of representation – his subject is not paint and canvas but the human body itself. The difficulty is compounded by the realisation that the artist who studies anatomy in order to depict the body must either engage, at some level, with this theatre of investigation and punishment or else conduct his researches in the clandestine (and frequently illegal) privacy of his own studio.[18] That is the choice suggested by Leonardo da Vinci when he describes, in an oft-quoted passage from the notebooks, breathlessly and with an evident *frisson* of delight, what it is that makes the perfect anatomist.[19]

The question remains, then: how could either the artist or the anatomist seek to neutralise the full import of the spectacle in which they, too, are players? How was anatomy to escape from the punitive spectacle in which it was implicated, in order to emerge as a 'disinterested' and autonomous discipline in its own right? Essentially, one suspects that the desire forms part of a larger problem which faced the practice of medicine as a whole in the early-modern period. Simply stated, in an age when the social status of the physician (certainly in England) was by no means assured, and when the surgeon and the anatomist, because of the manual nature of their trade, attained a significantly lower position in the social hierarchy than that accorded to the physician, the means of carrying on their profession was indissolubly linked to the base 'trade' of the public executioner.[20] Yet from what other legal source were bodies to be attained? It is out of this dilemma that the extraordinary representation of the anatomised body in the early-modern period begins to take shape.

When we turn to the plates which form the illustrations to anatomical textbooks of the period, the full complexity of the problematic status of anatomical investigation begins to unravel. These images are frequently associated (sometimes less than convincingly) with some of the foremost artists of the period.[21] To a modern eye these images appear extra-ordinary. It is possible that they appeared equally disturbing to the onlooker in the early-modern period. But a tendency to dismiss them as either grotesque or primitive must be avoided. Instead, it ought to be acknowledged that their extraordinary quality may be a function of a network of codes whose meaning can only with some difficulty be traced. For example, the illustrations which appear in the *De dissectione partium corporis* of Charles Estienne and Estiènne de la Rivière, published at Paris in 1545 (p. 128) have been described as amongst the 'ugliest anatomical work known'.[22]

It is the power to shock and disturb which alerts us to the demands

placed on the Renaissance anatomist and to the terrible story, once more, of Marsyas. For, just as in Ovid's account, on the surface these images seem to underline the arbitrary and disturbing power of the law, which was to be impressed upon the victim and the spectator alike through the unequal struggle in which the individual is stripped of his very identity. Yet, as we have observed, when brought into conflict with the demands of investigation and demonstration which were the preserve of the anatomy theatre as a scientific (as opposed to judicial) space, this process could result in an equal guarantee of the victim's preservation. The scientific subject – the dissected corpse – becomes objectified. It becomes the focal point of interest and, indeed, the centre of a ritualistic undertaking.

We can witness the unproblematic visual counterpart of the direct inscription of authority on the body of the criminal on page 119. This illustration, a woodcut which first appeared in the *Fasciculus Medicinae* of Johannes de Ketham (Venice, 1493), shows an anatomical demonstration taking place in the older, pre-Vesalian, style.[23] The elevated figure of the professor of anatomy pronounces upon the body from a written text (a detail not shown in the version of the illustration reproduced here). The actual business of dissection is accomplished by an assistant – the *demonstrator* who wields the knife – while the *ostensor* indicates, with his wand, the salient points. We can term the scene unproblematic since, as Luke Wilson has observed of this image:

the hierarchy of functions is very clear, with the professor elevated and elaborately framed . . . The cadaver, represented horizontally relative to the frame of the picture, does not really participate in the vertically differentiated hierarchy at all . . . [it] remains inert in this scheme; unremarkable and as yet unopened . . .[24]

The body, then, is the passive recipient of textual authority which emanates from the elevated anatomist. The key term, in Wilson's account, is the word 'unremarkable'. For the stable hierarchy of functions to be left intact, it is vital that the body should be, literally, unremarkable. Authority resides elsewhere, with the function of the passive corpse being only that of reception rather than transmission. This older, pre-Vesalian, illustration is, it should be added, a uniquely dramatic example of the hierarchical ordering of relations within the anatomy theatre. A slightly later, and frequently reprinted illustration first appeared in 1522 in the *Isagoge Breves* of Berengarius of Carpi, professor of surgery in Paris and later Bologna between 1507 and 1522.[25] The rotation of the scene to give an elongated view of the proceedings has

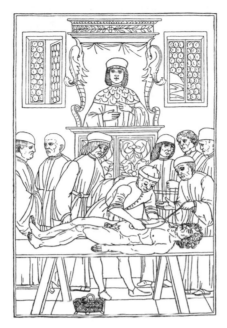

An Anatomy Lesson, from Johannes de Ketham, *Fasciculus Medicinæ*
(Venice, 3rd edn, 1495).

lessened the forceful presentation of hierarchy demonstrated in the de
Ketham illustration. That said, however, the two illustrations are clearly
linked in some way. The positions of the *demonstrator* and the *ostensor*
relative to the corpse, the basket which has metamorphosed into an
enormous bowl, the gathering of the spectators behind the corpse – these
common elements indicate some kind of relation between the two
illustrations. What has altered is the position of the anatomist. It is as
though he has been (partially) removed from the scene, with his
domination of the corpse, so evident in the previous illustration,
appreciably lessened.

These earlier illustrations are products of a regime of learning which,
with the publication of Vesalius' great work, was very soon to appear
hopelessly outdated. But even in the early, pre-Vesalian, demonstrations
a transition is apparent. The movement of the anatomist down and away
from the corpse in the Berengarius illustration has the effect of offering
the cadaver and the anatomist as rivals to one another, competing for the
spectator's attention.

An attempt at resolving this tension was to be made, in an extra-
ordinary fashion, in the great title-page of Vesalius' work of 1543
(p. 121).[26] The symbolism, iconography and authorship of this famous
woodcut have been much discussed, and a variety of interpretations
offered.[27] There is general agreement that, whatever the precise details of
meaning enshrined in the illustration, it is nevertheless seeking to offer a
programmatic statement relating to the methods of the 'New Anatomy'
of Vesalius. These methods, from a strictly medical point of view, offered
a radically new means of understanding the anatomical structure of the
human body and the methodology by which that structure was to be
examined. The tradition of textual authority whereby the body is, as it
were, the subject of textual inscription – the passive object of contem-
plation offered while the lecturer reads from the classical corpus of
medical texts – is now, in part at least, abandoned. Instead the body has
become a site of discovery rather than a means of confirming past
authority.

This transformation in the status of the scientific body goes hand in
hand (one might even say produces) a transformation in the role of the
anatomist. He has stepped down from the professorial chair, thus
ensuring that the vertical hierarchy so evident in the Ketham illustration
is destroyed. At the same time, the horizontal distance between corpse
and anatomist, which the Berengarius scene set out to establish, has now
vanished. Anatomist and corpse confront one another at an almost equal
level. Out of this confrontation, a new figure has emerged – one who
exists in dynamic tension with the corpse which is the object of his
labours. This new figure is that of the empirical scientist shown at the site
of his labours rather than at a removed distance. The heroic figure of the
modern scientist can be seen, emerging for the first time out of this
crowded scene of dissection.[28] But the paradox of the anatomist's
ambivalent status still appears to remain. In dispensing with his assistants
and engaging in the messy business of dissection himself, the anatomist is
now, more than ever, associated with the brutal source of his material.
He has exchanged the role of judicial pronouncement from on high for
the more artisanal undertaking which, formally, would have been
reserved for menials.

Looking at the crowded scene which acts as the frontispiece to
Vesalius' text, a very real contradiction has become evident. How was
the anatomist to distance himself from the spectacle of punishment when,
at the same time, his relationship with the cadaver has become so
intimate? Four important features in the illustration are offered as a

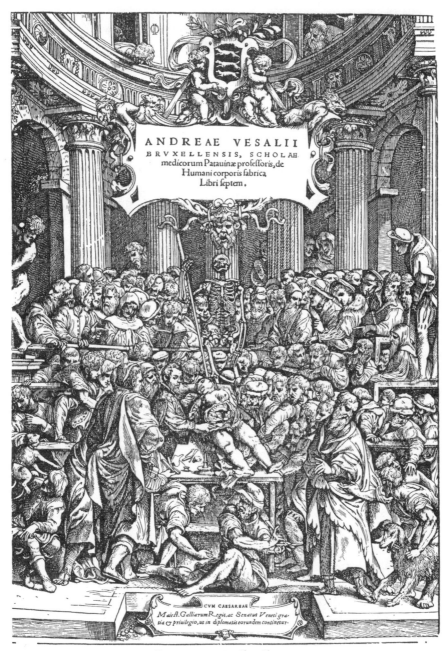

ANDREAE VESALII
BRVXELLENSIS, SCHOLAE
medicorum Patauinæ profeſſoris, de
Humani corporis fabrica
Libri ſeptem.

CVM CAESAREAE
Maieſt. Galliarum Regis, ac Senatus Veneti gra-
tia & priuilegio, ut in diplomatis eorundem continetur.

B A S I L E AE·

Title-page of Andreas Vesalius, *De humani corporis fabrica* (Basel, 1543).

means of establishing a new, autonomous role for the anatomist who wishes to be understood as a heroic figure rather than as an extension of the apparatus of the law. Two of the features are immediately obvious. In placing Vesalius on a level with the audience, indeed by having him surrounded by figures from amongst whom he is only with some degree of difficulty isolated, his task is shown to be one which receives popular endorsement. Vesalius does not exist in splendid and removed isolation – a remote figure of authority. Rather his task is shown to be one which is almost collective. This placing of Vesalius within the audience through the device of deliberately blurring the boundaries of the dissection pit is in sharp contrast to the actual practice of anatomy in the theatres in which he would have actually worked.[29] The second feature consists of the squabbling figures beneath the table. As has frequently been observed, these figures can be understood as the pre-Vesalian assistants. Now no longer needed, they are banished beneath the dissection table while the new-found dignity of anatomy is asserted above them.

The third means by which the autonomous figure of the anatomist is created in the illustration can be understood through the deliberate placing of the skeleton at the centre of the image. Frequently taken as no more than a *memento mori*, the skeleton is placed in the position which would formerly have been occupied by the Galenic anatomist. But the skeleton, it is important to stress, is not only being ignored, it is actually being treated by the audience with a contemptuous disregard for its significance as a reminder of human destiny. One spectator peers, comically, from between the bony legs of the skeleton, while another actually pushes the skeleton's left hand aside with his head in order to gain an unobstructed view of what is taking place. If the skeleton is to be understood as a *memento mori*, then we must conclude that it is an ironic presence of which the audience is utterly unaware. Rather than under-standing it as such, however, the casual disregard with which it is treated suggests that a commentary on a previous methodology is being offered. The supporting wand of the skeleton directs attention down to the corpse, away from the position which would have hitherto been accorded the central figure of the anatomist. The Galenic anatomist is now no more than a bony presence in the anatomy theatre, and one that can safely be ignored in favour of a new object of attention – the confrontation which is taking place between cadaver and anatomist.[30]

The final means of attempting to resolve the social and professional contradictions of the anatomist's position returns us to the body itself – the subject of the dissection. Juxtaposing the three images of dissection

we have been examining, we can see that the Vesalian treatment of the corpse sets the 1543 illustration apart from its predecessors. The body, in both Ketham's and Berengarius' illustrations, is absolutely prone. It is passively awaiting the act of dissection. In the later woodcut, on the other hand, not only has the body been rotated through 90 degrees, it (or rather she, since this is almost certainly a female corpse which is being dissected) has been elevated slightly, so that the face is almost at a level with that of Vesalius. At the same time, the face is turned towards Vesalius, who looks away from his subject, refusing to return the glance. The face of the corpse, in fact, is one of the very few which gazes directly at the anatomist.

A link is thus established between the corpse and the anatomist – one which is entirely absent from the earlier illustrations – reinforcing the intimacy of the connection between the dissector and the dead human body.[31] But it is important to understand that this link is one that is established by the corpse in the first instance, not the anatomist. What can be concluded from this gaze which appears to emanate from the dissection and is directed towards the dissector? In some measure, what is suggested here is a degree of compliance on the part of the corpse. It is as though she has, herself, sanctioned the performance in which she plays such a central part. The final attempt at resolving the contradictions of the anatomist's position thus results in the most daring assertion of all – namely, that not only is the anatomist not involved in an act of punitive violation, but that the corpse is working, in conjunction with the anatomist, towards a shared end. It is with a shock that we register the uncomfortable message of the title-page of this important work – the corpse *desires* dissection. She is as intent as any anatomist in having her inner recesses opened to the public gaze.

When we turn to the most important feature of the anatomy textbooks of the Renaissance, the actual images of the dissected body, this willing compliance of the corpse in the process of demonstration is immediately apparent. An example of the famous Vesalian muscle figures from the *Fabrica* (p. 124) shows the corpse at a fairly deep level of dissection.[32] But just as Marsyas was condemned by Apollo to a 'living death', so, too, these corpses are still alive. Various attempts have been made at explaining why these images appear in the form that they do. Are they evidence for the fact that, in modern medical terms, the sixteenth-century anatomist made 'no separation between morphology and function'?[33] Or perhaps, conversely, they are acting as a triumphant sign that:

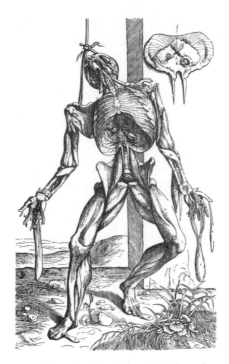

Tauola delle Fig.del Lib.IIII. 108

Muscular Figure, from Vesalius.

The Anatomised Anatomist,
from Valverde.

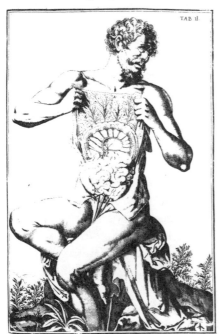

TAB II

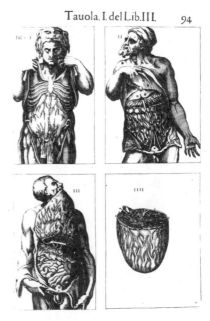

Tauola. I. del Lib.III. 94

Self-demonstrating Figure, from
Andreas Spigelius, *De humani corporis fabrica*.

Self-demonstrating Figure,
from Valverde.

the heroic human subject of the anatomy has not been completely conquered. By the end of the 'musclemen' series a skeleton is all that remains – yet the bones are poised to retain signs of human suffering. They function as *memento mori* rather than medical illustrations.[34]

Neither of the above views of Vesalian images seems conspicuously at odds with the figures themselves, but then neither the explanation culled from the history of medicine nor the handy *memento mori* argument quite accounts for the complex articulation of these figures. Just as in the compliant corpse on the dissection table on the title-page to the *Fabrica*, however, what is most striking is the co-operation of the figures with the spectator. It is true that, in producing such images, we would expect the artist to have depicted the body in poses which most clearly demonstrated the anatomical relation of the various features *inter se*. But was the device of 'living dissection' the best or only method of achieving a pedagogic end? The illustration on p. 124, for example, reveals the dissection to have reached a point at which the body can no longer, even in terms of the grim metaphor which is here being deployed, sustain its own pose unaided. As Harcourt observes, 'the process of dissection . . . undercuts the teleological notion that literally animates the figures' so that the body is 'no longer able to sustain itself in the face of its own violation'.[35] But even at this level, the body still has enough life remaining to assent, with a degree of autonomy, to the demands of the spectator. So, the right forearm is still able to lift and display its underside, while the pose as a whole, even though it is assisted by a rope, is one that is suggestive of a living rather than a dead body. If we accept this as a violation of the body, then we must also accept it as a violation which is so complete that all resistance is useless, and in which the body's subjection is so ruthlessly enforced that all that remains for it is co-operation with its tormentor.

One further additional element remains to be explained. A uniform device throughout the 'musclemen' series is that the figures are shown not within the artist's studio nor within the confines of the anatomy theatre. Instead they are posed in a pleasant rural landscape with the prospect of a town in the background. It has been shown that, if the sheets upon which these images are depicted are placed in a contiguous series, the background forms a panorama. The landscape has been variously identified as either Rome or the region to the south-west of Padua.[36] This outdoor setting, as can be seen in examples from other anatomical images of the period (p. 124 and p. 128), is a common, although by no means universal,

device. One is tempted to ask why the figures should have been posed in such a way.

Some kind of answer to these problems can be provided if we observe and examine the convention of 'self-demonstration' which is shown on page 124.[37] Now the figures are not only self-supporting, but they are also shown to be actively involved in the process of demonstrating their own anatomies. Though Vesalius did not himself employ the convention of self-demonstration, the hint of complicity between anatomist and corpse suggested on the title-page to the *Fabrica* is here completely apparent. So fully implicated are the figures in their own internal scrutiny that now there is no longer any need for an anatomist. The anatomist and the corpse have become as one, merging into one another. The absent anatomist, or the corpse which is its own anatomist, is most graphically illustrated in the post-Vesalian figure of the anatomised anatomist (p. 124).[38] Valverde's text, first published in Rome in 1556, was a considerable success, with editions appearing throughout the seventeenth century in Italy, Flanders and Holland.[39] Here the act of self-dissection has been taken a stage further. One dissected figure is shown in the act of dissecting another. It is as though the anatomist has returned the glance directed upwards from the dissection slab and consented to become a willing subject of dissection.

In each and every case, these figures answer to the desire on the part of the Renaissance anatomist to resolve the contradictions which have been touched on earlier. These illustrations act as a signal to both the medical and lay readership that the practice of anatomy is neither a bodily violation nor an unnatural disruption of a set of taboos which stretch back to Augustine and perhaps even earlier. The anatomist himself is to be considered as removed, intellectually if not in practice, from the theatre of punishment. Instead of being an extension of the apparatus of the law, he is to be understood as proclaiming the autonomy of a new science of the body, far removed from the brutal spectacle which, in the majority of cases, was in reality the means by which bodies came into his hands. Whether or not the convention became established in pursuit of purely compositional ends, the compliant figure and the self-dissective figure were both perfectly suited to asserting this neutralising view of the anatomist's task. The body which dissects itself is a graphic example of the willing acceptance of anatomical dissection. It as though the anatomical demonstration is a project of such compelling intellectual excitement that even the dissected subject wishes to play an active part in the spectacle.

The actual setting of these dissections – the careful delineation of rural landscapes in which so many of these images were placed – answers to a similar desire, though in a slightly different fashion. The body which has walked out of the anatomy theatre and entered the world fulfils a dual function. First there is a punning conceit at work which is connected to the original models of so many of these figures. As has been frequently observed, inspiration for many Vesalian and post-Vesalian images was derived not only from dissected corpses themselves but from scattered fragments of antique statuary which, in the sixteenth century, had only recently become known.[40] The Belvedere torso, for example, forms the basis of a number of the visceral studies in the *Fabrica*. Thus the body which is re-placed within the natural world is being returned, as it were, to the place from which it had originally come. As such it has become a fragment once more, although this time one which is endowed with a classical pedigree. It now exists as an object of contemplation – a ruin of the human figure to set alongside other ruins which, even as these images were being produced, were being discovered. The ruined and dissected body is given, through this device, a place in the history of fragments which have awaited discovery. A secondary, but perhaps equally import-ant function of the pastoral setting is to proclaim the body as a free agent in the world at large. Emerging from the anatomy theatre itself to stalk the countryside, the Vesalian figures, even at the most extreme levels of dissection, have finally been released from the confining space of the anatomy theatre.

The Estienne figure (p. 128) is perhaps the most remarkable in this respect.[41] From a purely functional point of view, much of the figure is entirely redundant. Why, unless there is desire to demonstrate aspects of surface anatomy, is the whole figure shown when the only anatomical structure which is to be displayed is the interior of the cranium with most of the contents removed? In Estienne's figure, in fact, considerable labour has been expended in producing an illustration the majority of which is quite useless for the purposes of communicating anatomical knowledge. The presence of the landscape as well is at least as important as the dissected cranium. The body is slowly merging into that landscape. By leaning the body against a curiously anthropomorphic tree (which, on close inspection, is revealed as having been pruned in its upper branches as though it were echoing the pollarding which the body has undergone), the artist seems deliberately to have set out to blur the distinction between the body and the earth, rocks, pebbles and clouds which form the setting. At the far left of the frame is a shattered tree stump, suggestive

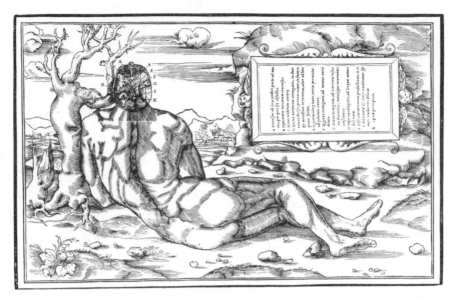

Dissected Figure in a Landscape, from Charles Estienne and Estiènne de la Rivière,
De dissectione partium corporis (Paris, 1545).

of fragmentation once more, while the right arm of the figure seems
already to have undergone a transformation and become a piece of solid
rock rather than flesh. We might recall the Ovidian transformation which
closes the Marsyas story, where the tears of the onlookers drain into the
earth which is then transformed:

> The fruitfull earth waxt moyst therewith, and moysted did receyve
> Their teares, and in hir bowels deep did of the same conceyve.[42]

The metamorphosis, prompted by the spectacle of the satyr's ordeal,
transforms the earth into a body, in much the same way that, in
Estienne's image of the dissected corpse, body and earth merge into one
another. Even the seemingly superfluous pebbles which lie scattered on
the ground around the body serve a purpose within the overall conceit of
the image. They exist as fragments – chips and scatterings – whose origin
might equally be the body/rock which is Estienne's semi-dissected figure,
or the earth itself into which the figure merges. The return of the body to
the earth from which, in theological terms, it sprang could not be more
graphically represented.

What is being asserted in these images, then, over and over again, is the
naturalness of dissection. It is as though we were being repeatedly told

that the anatomist, far from attempting to disrupt the body's organic integrity, is only assisting that natural process of decay and dissolution which the body is, in any case, inevitably fated to undergo. There remains, however, one further artistic device presented in these images of dissection on which, in the space of this essay, we can only briefly touch. This final device leads us to the core of the anatomists' bid for an authority which need no longer be limited by the strict injunction of the law's demands. In effect, it amounts to nothing less than the claim that the study of anatomy is divinely sanctioned, and it was to lead to the construction, in the late sixteenth century, of the most famous anatomy theatre in Europe – the theatre of anatomy at Leiden University.

Anatomists since Galen had long claimed that their art was one which had divine sanction. The grounds for this claim, which seems at first to run counter to every tenet of received Christian doctrine concerning the integrity of the body and the soul, were firmly rooted in theological argument. One (English) example out of the many available must suffice. In 1615, the English anatomist Helkiah Crooke, surgeon to James I, published an anatomical textbook entitled *Microcosmographia*. The work, though it was not particularly original, contained the all-important Vesalian images, and it was to become something of a best-seller.[43] Crooke's work sets out clearly the divine scope of anatomical study:

Whosoever doth well know himself, knoweth all things, seeing in himself he hath the resemblances and representation of all things. First he shall know God, because he is fashioned and framed according to his image, by reason whereof, hee is called among the Divines, the Royall and Imperiall Temple of God; he shall know the brute beasts, because he hath the faculties of sence and appetite common with them . . .[44]

Crooke's claim is based, here, on the mythical injunction of the Delphic oracle to Apollo – *Nosce te ipsum* or 'Know yourself'. For the anatomists this famous Renaissance adage was immediately and readily adaptable as a means of offering divine, or at least classical, sanction to their undertaking. If man was indeed a 'temple' of the Holy Ghost and if the injunction to 'know yourself' could be taken literally, then did this not establish a clear case for the anatomist as working under the force of a divine commandment? Far from disturbing or destroying the physical integrity of the human organism, the anatomist, instead, offered his researches as an exploration of the divinely created human frame which served only to re-assert the claims of man's divinity. And in taking apart the body, the anatomist could in no sense be thought of as violating a divine commandment, since to argue that God's actions of recompaction

at the resurrection would thus be thwarted would be to place a limit on divine power.[45] Finally, did not the scriptures offer a dual example of anatomy? Firstly, in St Paul's comparison of the church to the individual members of one body, and secondly, (and more daringly) in the act of self-demonstration performed by Christ at the Last Supper when his own body was distributed amongst those present?

These and similar arguments were amongst those presented by the practitioners of this new Renaissance science. Visually, we can see the image of partition of the 'temple' of the body informing another self-demonstrative figure, to be found in Berengarius' work. Here (p. 131) a dramatic realisation of the self-demonstration of the temple of the body is presented.[46] The figure stands, left arm stretched across the body in order to display the veins which have been roughly indicated. With the right hand the skin covering the chest is hooked back, whilst the upper thighs are cloaked in skin which, like a discarded garment – a fitting image for the body, often considered as the 'robe' of the soul – has fallen away from the abdomen. The inner man is revealed. That this is to be understood as a sacramental, even sacrificial, act is indicated by the dramatic rays which surround the figure with an aura of light. These and similar écorché figures might remind us, yet again, of the Marsyas myth, particularly the reading of it suggested by Edgar Wind. The agony of the flaying of the satyr becomes an explicit 'ordeal of purification'. In Wind's words:

To reveal the hidden clarity in others, whose souls were covered and confused by their bodies, required a cathartic method, a Dionysian ordeal by which the 'terrestrial Marsyas' was tortured so that the 'heavenly Apollo' might be crowned.[47]

Once the divine scope of anatomy is realised, then it becomes possible to turn, with a more complete understanding, to the most complete realisation of the anatomist's aspirations – the great theatre of anatomy which was constructed at Leiden University at the end of the sixteenth century. The Leiden anatomy theatre (see p. 132 and p. 133) was largely the creation of one man.[48] Peter Pauw, a commentator on Galen and Hippocrates, but also a practical anatomist of some distinction, was the author of a work on the human skeleton – De humani corporis Ossibus (Leiden, 1615). Pauw was appointed professor of anatomy at Leiden in 1589, and his first and greatest achievement was to oversee the construction of a new, and permanent, theatre. The model for the theatre was the Padua theatre where Pauw (together with William Harvey and many English medical students) had studied. But the Leiden construction was slightly larger than its precursor, and hence, as the prints show, did

Self-dissecting Figure, from Berengarius,
Isagoge Breves (Bologna, 1523).

not create the effect of peering into the bottom of a well as did the
experience of witnessing an anatomical demonstration at Padua. The
theatre was built within the existing structure of a church, parts of which
were still consecrated. Surrounding the dissection area were six con-
centric rows of benches. The benches nearest the dissection area were
reserved for professors and important guests, while the three outer rows
were reserved for members of the public. Only the second and third rows
were expressly reserved for medical students and those with a pro-
fessional interest in the proceedings. In thus making provision for the
attendance of a largely lay audience, the administrators of the Leiden
theatre were following received practice throughout Europe. In many
respects, a dissection was, quite literally, a theatrical performance, with
music playing during the dissection and refreshment provided. Members
of the public were willing to pay to see this performance.

The theatre at Leiden was also much more than simply a convenient
structure for bringing together corpse, anatomist and audience. It was an
ornately decorated building, as the illustrations demonstrate. Around the
dissection area, and on the interior walls of the building, were ranged a
collection of human and animal skeletons, some of them bearing
appropriately moralising instructions. These mottos (e.g. *Pulvis et
Vmbris Sumus* – we are dust and shadows) develop the theme of death

Interior of the Leiden Anatomy Theatre 1644. First published by Andries Clouk. University Library Leiden. Collection Bodel Nijenhuis.

and dissolution. In effect they act as a textual commentary on the events which the audience inside the theatre had gathered to watch.

The central image of the theatre was a montage of two skeletons between whom was placed a tree around which was curled a serpent. One skeleton was placed in the attitude of offering an apple to the other. The skeletal presence of Adam and Eve has thus entered the theatre, represented at the moment of the Fall when death entered the world. The Leiden anatomy theatre, it seems, was much more than a structure in which physiological facts could be taught and learned. Instead, it offered a complete, architectural lesson in human history and human destiny.

Having realised this, however, we have still not grasped the full significance of the anatomy theatre. So far, all that we can say is that it was an undoubtedly extravagant realisation of a series of Renaissance commonplaces. But the view of the theatre which shows a dissection in progress, a far more orderly scene than that depicted on the title-page of the Vesalian *Fabrica*, contains a number of important indications as to

VERA ANATOMIÆ LUGDUNO-BATAVÆ CUM SCELETIS ET RELIQVIS QVÆ IBI EXTANT DELINEATIO.

Interior of Leiden Anatomy Theatre c. 1640. First published by Jacob Marcus. University Library Leiden, Collection Bodel Nijenhuis.

the nature of what is being depicted. It soon becomes apparent that, not only is this an anatomical demonstration in progress, but it also has something of the nature of a religious service. On the dissection table lies the subject of the enquiry. Behind the table, in the very centre of the image, stands the anatomist, shown gesturing towards the opened book at his right hand. The skeletons of Adam and Eve have been moved aside, a movement which performs a dual function. On a purely formal level, it allows the spectator an unobstructed view of the proceedings. But at a symbolic level, this movement of Adam and Eve to either side is of the utmost importance. The anatomist now stands in close contact with the cadaver but in a position which serves to re-assert his authority over the prone body. The four figures – Adam, Eve, the corpse and the anatomist – are held in precise equilibrium with one another. A final detail completes the scene. In the cabinet of instruments above the head of the anatomist is a great pair of dividers. In the view of the empty theatre, these dividers are placed within the cabinet, labelled 'archium instrvme[n]torum anatomi-

corum'. In the depiction of the anatomy lesson in progress, the dividers have advanced out of the cabinet and have expanded in size, hovering precisely over the head of the gesturing anatomist – a symbol of God, the divine architect, whose greatest construction the anatomist, Peter Pauw, has opened and is now displaying.

At one level what is taking place within the Leiden anatomy theatre is no more (and no less) than a lesson in human anatomy which has been frozen in a moment of civic pride. The anatomy theatre itself, the crowd of spectators (both living and dead), the instruments of the profession, the seal of the university and the view of Leiden all testify to the commemoration of a structure and a discipline which was thought worthy of memorialisation. But at another level, the image is perhaps the most extravagant example that we have of artistic propaganda invested on behalf of science. The opened dividers form the apex of an equilateral triangle – an illustration of the Trinity – at either foot of which is Adam and Eve, while the base is composed of the outstretched human body. At the centre of the composition is the face of Pauw, who makes a gesture not unlike that of a priest at mass or, given the Protestant context of Leiden, a communion. The opened body itself is here not violated but sanctified – as though Christ's injunction at the Last Supper had been given its most complete and literal interpretation.

In the course of this essay I have tried to uncover the possible codes by which Renaissance scientists endeavoured to overcome both popular prejudices and religious taboos concerning the dead human body. I am not here trying to argue that each and every anatomy lesson, or that each and every anatomy text, carried this dense weight of protective inscription. More often than not one suspects that the artists responsible for these images were working within a set of conventions whose underlying meaning they themselves either did not fully understand or perhaps did not even recognise. Nor am I trying to argue that the anatomists responsible for the production of these costly and now rare texts were, all of them, decent liberal men who deplored the brutal spectacle of legal revenge in which their discipline was rooted. If we can, though, ascribe motives, we are left with perhaps a more self-interested set of determinants. The age of Vesalius and his contemporaries was, it is still true to say, an age of exciting discovery. No project seemed more promising than the microcosmic discovery of the human body. But just as in the macrocosm, the price of discovery was high. That price was paid in the subjection of individuals, whether it was the natives of the newly discovered Americas who were to be exploited or the marginal members

of European society. In the anatomy theatres of Europe the bodies of the poor, the condemned and the outcast, were reduced in a public spectacle of partition. To this spectacle paying audiences thronged not merely for enlightenment, but for entertainment. One final glance at the empty Leiden anatomy theatre serves to reinforce this brutal fact. In the theatre, while two men pull back the cover which has been draped over the corpse, voyeuristically intent on seeing the half-dissected body which lies on the slab, a small drama is being enacted in the bottom, right-hand corner of the image. A fashionably dressed woman is being shown what, at first glance, appears to be a piece of fabric. Looking more closely at the image, we see that what she is smilingly contemplating is not fabric at all. It is, rather, the flayed skin of a corpse. To Marsyas' cry, 'Who is it that tears me from myself?', we cannot answer either Science, Law or human cruelty, since all three are compounded.

6

The Rhetoric of Status:
Gesture, Demeanour and the Image of
the Gentleman in Sixteenth- and
Seventeenth-Century England

ANNA BRYSON

In a well-known passage in his *De Republica Anglorum*, that ambitious social and political survey of Elizabethan England, Sir Thomas Smith grappled with the problem of defining the gentry. He observed, with a certain cynicism, that 'gentlemen . . . be made good cheape in England', and wrote that:

Whosoever studieth the lawes of the realme, who studieth in the universities, who professeth liberal sciences, and to be shorte, who can live idly and without manuall labour, and will beare the port, charge and countenance of a gentleman, he shall be called master . . . and shall be taken for a gentleman.[1]

Smith, an academic lawyer and civil servant, probably over-estimated the importance of academic and legal qualifications in the making of a gentleman. Such meritocratic criteria were controversial. For every member of the élite who prided himself on his learning there were certainly many more who regarded academic skills with suspicion or downright contempt and who stuck by the traditional values of inherited wealth and real (or assumed) lineage.

Yet many of Smith's contemporaries, and most modern historians, have generally agreed that gentlemanly identity in early modern England was not a simple matter of wealth or blood but involved complex considerations of style of life and social image. If the English gentry can be regarded, in the last resort, as an economic class dependent on a continuing grip on landed wealth, they were also what modern sociologists would term a 'status group', committed to cultural practices which defined and attracted social esteem. Some affluent yeomen had the means to 'live idly' and chose not to do so; many gentlemen all but destroyed their fortunes in their efforts to maintain an appropriate way of life. In

Smith's comment that the gentleman is he who 'will beare' the appropriate 'port, charge and countenance' we can see the recognition that wealth may be the necessary condition of élite status, but that it is only the means to the presentation of the right social image.

Cultural historians have analysed various aspects of this social requirement, for example, in the assertion of status through architecture and patronage of the arts, in household entertainment and in the changing educational practices suggested by Smith's admiration for the 'liberal sciences'.[2] They have not, however, responded to the more precise and literal implications of Smith's use of the words 'port' and 'countenance'. These direct attention to the way a gentleman was supposed to look, to his personal, physical behaviour and deportment. In this essay I shall explore some of the ways in which care and control of the body was held to reflect and enhance the status of the gentleman in Tudor and Stuart England.

That bodily deportment and demeanour were regarded as significant aspects of status is clear from contemporary texts such as Peacham's *Compleat Gentleman*, which is the most famous of a whole genre of books devoted to describing the proper characteristics, duties and education of the nobleman or gentleman.[3] Of all the Italian Renaissance texts translated into English, Baldassare Castiglione's *The Booke of the Courtyer*, appearing in Hoby's version in 1561, was undoubtedly among the most influential. It was constantly reprinted, earned glowing recommendations in English educational works and was reputedly a favourite with such fashionable Elizabethans as Sir Philip Sidney.[4] The ideal constructed by Castiglione was one of verbal and physical grace, with rather more emphasis on the social attractiveness of the courtier than on his ethical and political substance.

English handbooks for the gentry tended on the other hand to concentrate more severely on academic and moral qualities, but they rarely omitted comment on gentlemanly care and control of the body. The pedagogue James Cleland, in his earnest and lengthy *Hero-Paideia: or the Institution of a Young Nobleman* (1607), included more than one chapter on manners and some detailed guidance on how a gentleman should walk. Some years later, the pious Robert Brathwayt, in his *The English Gentleman* (1630), devoted space to 'the carriage or deportment of the body' as well as to the weighty issues of prudence, temperance and Godliness.[5] A range of specialised books on good manners, including physical demeanour, were published throughout the sixteenth and

seventeenth centuries alongside advice in such ambitiously 'compleat' manuals for the conduct and education of the élite.

Today we might regard the 'etiquette book' as a frivolous genre, but its seriousness in Renaissance England is sufficiently clear from the authorship of the two most influential examples which, although translations, were both adapted so many times into English as to become almost naturalised. The great humanist Desiderius Erasmus's *De Civilitate Morum Puerilium*, first translated as *A Lytell Booke of Good Maners for Chyldren* (1532), was still the basis for new texts under the later Stuarts.[6] The Italian bishop Giovanni Della Casa's *Galateo . . . A Treatise of the Maners and behaviours, it behoveth a man to use and eschewe*, a more sophisticated and discursive codification of gentlemanly good manners, was first translated in 1576 and appeared throughout the following century in various adapted forms.[7] It is, of course, dangerous to see such texts as providing direct evidence of the values and practices of the English nobility and gentry as a whole. Nevertheless, they provide invaluable material for an exploration of the developing ideals, if not necessarily the reality, of gentlemanly conduct.

But before we examine the principles of bodily conduct which emerge from this literature, it is important to consider briefly the theoretical basis for any approach to the history of the body and the social rules which surround it. Until recently, the study of basic manners in any period has not been taken very seriously by social or cultural historians. It has usually been an occasional bypath of antiquarian or light, popular history.[8] This situation has been changed, at least in part, by the impact of Norbert Elias's ambitious work of historical sociology, *The Civilising Process*, the first volume of which is entitled *The History of Manners*. Elias uses prescriptive writings on manners from the medieval to the modern period to develop an overall theory of the psychological and social development of Western civilisation. What fascinates him is the way in which manners in each period form the bridge between the public and objective structures of social and political order, on the one hand, and the personal and subjective patterns of feeling in the individual, on the other. In Elias's view, successive stages of Western socio-political development are each characterised by a particular sensibility or set of affective reactions in the dominant group, and this sensibility is revealed in codifications of manners.

Elias traces shifts in this sensibility from medieval feudal to modern bourgeois society, with a particular analytical emphasis on the Renaissance and early modern period. In his work, the form of the body politic

and the experience of the body personal are always interlinked. He further claims that the direction of Western manners has always been toward more control and sophistication, and toward a rising standard of shame, in attitudes to basic physical needs and drives. However, one does not have to accept this last contention in order to use his many insights and suggestions when studying manners over a more limited historical period. My approach will follow his in two respects. Firstly, I shall look at rules for bodily conduct as more than a random assemblage of custom and fashion, and I shall look for the relationship between rules and values. Secondly, and more specifically, I shall build on Elias's insight that sixteenth- and seventeenth-century didactic texts on social behaviour show a significant shift in the character of codes of manners for the social élite, that they in fact evince a 'new way of seeing'.[9]

My approach will also differ from that marked out in *The Civilising Process* in important ways, however. Elias tends to see rules of bodily propriety and demeanour as expressions of levels of psychic constraint, and he is to some extent writing a history of inhibition. This aim rather obscures analysis of the expressive content of rules of behaviour in a society, diverting attention from their significance as a language or discourse which creates, rather than simply regulates, the categories of bodily perception and experience. In his well-known and provocative book *The History of Sexuality*, Michel Foucault argued that 'sexuality' developed with the discourses which prescribed and described sexual behaviour, rather than being simply a 'natural' condition subject to more or less social control at different periods of Western history.[10] I shall employ a similar approach and try to show how, in one sense, rules of bodily demeanour construct the body of the gentleman as a particular kind of subject and object. I shall then pursue the notion of manners as a language and, indeed, as a highly practical 'rhetoric' which asserted, defended and legitimised social status. Elias certainly makes the connection between manners and the values and organisation of élites; this connection is at the heart of his theory. Yet his bird's-eye view of seven centuries as well as his concern with the mapping of inhibition prevents him from exploring in depth the ways in which everyday forms of conduct were related to power and status at any one period. I shall be more concerned with the precise 'image' of social authority which informs sixteenth- and seventeenth-century writings on gesture and demeanour. Finally, while Elias inevitably gives rather a simplistic view of the development of manners because of his vast chronological canvas, I shall try to indicate some of the complexity and conflict in the values

governing gentlemanly behaviour. In my view, the body personal, as well as the body politic, was the site of tension and contradiction in the values of authority and prestige.

Concern with the manners of the noble or gentleman was not a new phenomenon of the sixteenth century, and it can be traced in a number of late medieval sources. Chivalric romances, of course, give some idea of the code of behaviour expected of a gentleman in love and war, but much more technical information about manners is to be found in medieval 'books of courtesy'.[11] These survive in a number of English manuscripts, and while they are less numerous than conduct books in the age of printing and greater literacy, they are sufficiently consistent in form and content to provide a reasonable basis for comparison with the later texts already mentioned. It is on this kind of comparison that Elias bases his claim for a significant shift in standards of social behaviour in the early sixteenth century.[12] Usually quite brief, and often in verse form for easy memorisation, fifteenth-century courtesy books were directed at the child or gentleman-servitor in the noble or royal household. They contain a range of prescriptions about bodily demeanour and self-control, some-times of a kind to raise modern eyebrows. There are stern warnings against plunging one's hands into dishes of food, fighting at table or blowing one's nose on the table-linen. The reader is told to salute his superiors and strangers respectfully, to wash before and after meals and to avoid loud belching and farting.[13]

Yet for all that such literature allows us to reconstruct some of the basic norms of bodily behaviour, it shows no consistent focus on bodily courtesy as an ideal in itself. Instead, attention is overwhelmingly directed to one sort of social occasion and to the relationships which are to be expressed in the rituals of that occasion: this is the main meal or banquet, the ever-renewed expression of the solidarity and hierarchy of the noble household and its relation to the outside world in the obligation of hospitality. While 'table manners' have continued to this day to be an important theme in etiquette books, late medieval courtesy literature was largely and sometimes exclusively devoted to this area of sociability. The stages of the banquet – seating, proffering and accepting water for washing, eating and drinking through the various courses, rising and again washing – provide the narrative structure around which precepts are arranged in texts such as the aptly named *Stans Puer Ad Mensam*, the *Babees Boke*, and the *Urbanitatis*. John Russell's *Boke of Nurture* (c. 1450) places advice on courtesy in the context of a general treatise on household management and catering. *The Boke of Curtasye*, attributed

to the poet Lydgate, gives a few general guidelines for salutation and a scattering of moral and proverbial advice, but its central concern is still with table ritual.[14] In the description of this ritual the stress is always on the relations of lordship and service dramatised in the banquet procedures. If the precepts about physical behaviour often seem to us to indicate a remarkable crudity, they are embedded in complex ceremonial rules about when, how and to whom the courteous child or man must offer food, wine and water. Moreover, even the rules forbidding messy eating are related less to an overt bodily aesthetic than to the need to show due deference to the lord or host.

By contrast, sixteenth- and seventeenth-century writings on gentlemanly manners show the emergence of the body as a central subject and organising principle in the ideal of 'courtesy' or, a significantly new term, 'civility'. This is most obvious in Erasmus's *De Civilitate*, which offers a short introduction on the importance of manners and then a series of sections systematically relating civility to the parts of the body from the head downwards. The book deals with cleanliness and facial expression, carriage of the trunk and limbs, and modesty in concealing the 'privy membres' and their functions. Only after he has constructed an overall bodily image of the 'civil' man does Erasmus turn to correct conduct on particular occasions or in particular places, such as at table, in church or in the street. The English adaptors and imitators of Erasmus, such as Francis Seager, in *The Schoole of Vertue* (c. 1550), William Fiston, in *The Schoole of Good Manners* (1609), and Richard Weste, in *The Booke of Demeanor* (1619), all maintain this approach, listing faults of expression, gesture and gait in such a way that the reader can visualise the body as a whole.[15] Moreover, as Elias has noted,[16] whatever their precise social affiliations, the sixteenth-century manuals show a much more intensive scrutiny of what is distortive or disgusting in bodily behaviour than ever appears from the terse instructions in the medieval work.

An extreme example is to be found in the English translation and subsequent adaptation of the *Grobianus* of Frederik Dedekind. This German satirical work of 1555 sought to teach good manners purely by elaborate depiction of their opposite in a fantasy figure of ludicrous grossness. The 'Grobianus' figure keeps his hand in his codpiece, walks about soiled after relieving himself, belches and farts with gusto and assaults every woman within reach.[17] The construction of such a figure was as much for entertainment as for serious didactic purpose, and Grobianus was probably influenced by a popular carnival tradition which may also underlie the scatalogical themes in the work of Rabe-

lais.[18] Yet at this period even the more sober and serious works on manners offer numerous vignettes of vividly unpleasant habits. In one version of the *Galateo*, for example, there is a condemnation of men who 'thrust their fingers into their nostrils, and make pellets of that they picke out, even before everybody . . . [and] make cakes of the waxe, which they picke out of their ears'.[19] In nearly all accounts of courtesy and civility, the body has become a focus of careful description and prescription.

The arrangement of rules of good manners around an image of the body is most straightforward in those texts, like Erasmus's *De Civilitate*, which aimed to give simple instruction to schoolchildren. In the more sophisticated handbooks for young adults, advice on the care and carriage of the body is integrated with guidance on conversation and general sociability. Yet in these texts also the gentleman's body emerges as a totality to be continuously and minutely governed according to principles of grace and decorum. The influential *Galateo* gives a summary of various faults to be avoided, such as whistling, yawning and shuffling the feet,[20] and then returns to the subject of bodily grace at various points in the discussion of conversational skill. The reader is told not only how to behave at table, but also how to adjust gait and gesture in order to make a positive social impression in any company. While not specifically aimed at courtiers, Della Casa's work has clear affinities with the depiction of ideal courtly behaviour in Castiglione's *Booke of the Courtyer* and in similar derivative French courtly handbooks, such as Nicholas Faret's *The Honest Man: or, the Art to Please in Court*, translated in 1632. Such books sought to define a courtly, social aesthetic governing both body and speech.[21] They present an idealised social persona to be visualised and imitated rather than specific rules for particular occasions. In these texts bodily culture has become the most immediate aspect of personality, and Faret, for example, more laboriously systematic than Castiglione, offers sections on 'the Disposition of the Body' and 'the Naturall Grace', even before he addresses 'the Qualities of the Minde'.[22] Even if some aspects of the courtly image were subject to moral and political attack in early modern England, as in the rest of Europe, English authors nevertheless absorbed the basic concepts in imported courtly literature. Whether they claimed to be defining the ideal 'courtier', 'gentleman' or 'English gentleman' they showed a newly elaborate concern with the body as the site for the inscription and enactment of values of status. As is demonstrated elsewhere in this book, this changing preoccupation was characteristic of early modern English culture.

Elias interprets this increasingly detailed attention to bodily good manners as a sign of a new psychological sensitivity in sixteenth- and seventeenth-century European élites. He continues this story beyond the period by showing how, by the eighteenth century, certain bodily functions were considered so disgusting by etiquette writers that they could not even be named.[23] He also argues plausibly that the writings of Erasmus, Della Casa and their contemporaries imply a new requirement for self-consciousness and sympathy with the reactions of others in the 'courteous' or 'civil' gentleman. Hence Della Casa does not simply list unpleasant habits but also puts an open-ended prohibition on any words or actions, which 'present . . . to the imagination and conceite, matters unplesaunt'.[24]

Yet simply to concentrate on what appears to be a rising level of sensitivity in these sources is to beg the question of the changing framework or 'discourse' of social meanings in terms of which certain actions call forth embarrassment or shame and certain subjects become saturated with the possibility of offence. Rather than asking whether seventeenth-century norms of gentlemanly self-control in deportment and demeanour were more or less stringent than those of the fifteenth century, it seems better for our purposes to ask first about the changing conceptions of social virtue and hierarchy which entail a closer concern with the regulation of the body. In any case, didactic codifications inevitably tell us more about such conceptions than they can ever reveal about the actual feelings of the practitioners of 'courtesy' and 'civility'.

What underlies the developing interest of Renaissance conduct-writers in the continuous scrutiny and regulation of the gentleman's body is, above all, a changing conception of what manners are for or, more precisely, what they 'represent'. As I have already suggested, the rules of behaviour given in late medieval books of courtesy seem most obviously to express and ritualise relations of lordship, service and hospitality in the noble household. What are emphasised in these sources are symbolic acts of deference. Even today, 'good manners' involve symbolic acts of deference, as in forms of polite salutation and residual 'gallantries' to women, and in the very consciously hierarchical sixteenth and seventeenth centuries this aspect of courtesy was still very much present. Indeed, many of the early-modern manuals of conduct already mentioned give complex rules for the verbal, gestural and spatial acknowledgement of differences of status, age and gender. These are especially elaborate in the French etiquette books translated into English during the seventeenth century. Antoine de Courtin's *The Rules of*

Civility, first appearing in English in 1671, advised the reader exactly where to sit and stand in the presence of a superior person, and even how to behave deferentially when in bed with such a person.[25] Yet alongside this concern with ceremonial deference, writings on conduct from the Renaissance onward emphasise another function for the rules of manners: that of presenting or 'representing' personality, rather than simply acknowledging relationship. Of course, all codes of manners involve the representation of idealised character traits in a general way. As the sociologist Erving Goffman puts it, they are 'conventionalised means of communication by which the individual expresses his character or conveys his appreciation of the other participants in the situation'.[26] In fulfilling the rituals of service at table, the medieval gentleman, like Chaucer's young squire in *The Canterbury Tales*, both honoured his lord and conveyed that he himself was 'curteis' and 'serviceable'.[27] Sixteenth- and seventeenth-century codifications of manners, however, show a peculiarly intense interest in correct forms of behaviour as modes of self-presentation. Indeed, one of their most striking and pervasive features is a vocabulary which continually refers to manners as 'representations' and makes of demeanour and deportment an almost theatrical art.

Late-medieval authors usually introduce the subject of courtesy by stressing its necessity as a household skill and social virtue. Erasmus opened his *De Civilitate* with the more complex assertion that good manners are the exterior signs of inner character. He defines 'civility' as the 'outwarde honestie' which should mirror the virtuous condition of the soul. He calls the body and its adornment the 'habyte and apparayle of the inward mynde' and, in the process of defining correct demeanour, he lists facial and gestural faults as a catalogue of representations of inner vice and folly.[28] For example, in the section on head and face he wrote:

Let the eyen be stable, honest, well set, not frownyng which is syne of crueltye, nor wanton: which is token of malapertnes, nor wanderynge and rollinge, which is signe of madness . . .[29]

Richard Weste, if anything more explicit in stressing the bodily symbolism of virtue and vice than was his model, Erasmus, includes in his *Booke of Demeanor* such advice as:

> Let not thy brows be backward drawn,
> It is a sign of pride,
> Exalt them not, it shows a hart
> Most arrogant beside.[30]

William Fiston sums it up in his *Schoole of Good Manners*, asserting that 'the maners . . . are lively representations of the dispositions of the

mind'.[31] In the more sophisticated tradition of courtesy books for adults the same principle emerges. Della Casa's *Galateo* begins with the author's stated aim to show the reader how 'to put himselfe forth comely and seemely' in company and 'to shewe himself pleasant, courteous and gentle'.[32] The author of *The Art of Complaisance* (1673) defines good manners as the means to 'expose . . . great vertues without ostentation'.[33]

This representational view of manners implies a sense of the continual interpretative gaze of a social audience, deducing character from external signs. Hence it is not surprising to find Cleland, in his *Hero-Paideia*, advising his young nobleman:

Many men seeing you passe by them, will conceive presently a good or bad opinion of you. Wherefore yee must take very good heed unto your feete, and consider with what grace and countenance yee walke . . .[34]

In a later seventeenth-century adaptation of the *Galateo*, the reader is told that 'thou mayst know much of a man's disposition by his Countenance or Meen, as also by his gate'.[35] For sixteenth- and seventeenth-century writers on gentlemanly manners, then, the body was a text from which good and bad character could be read. They were depicting an idealised personality as a model to be imitated, but they were also recommending good manners as the means of constantly producing the image of an idealised personality. This way of perceiving manners made of the body a continuous index of the social self, rather than simply a vehicle for honourable actions on appropriate occasions.

Such a representational conception of good manners is clearly to be related to overall change in the pattern of aristocratic ideals and, indeed, ideology. Writing on 'courtesy' and 'civility' was, as I have noted, part and parcel of a more extensive literature on the proper character, education and duties of the gentleman or nobleman. While varied in tone and approach, this literature, taken as a whole, suggests that a substantial shift was gradually taking place in the cultural values and practices whereby the landed élite expressed and justified their power and authority. Early-modern theorists of nobility and gentility, while in most cases continuing to assert the traditional values of lineage and valour, nevertheless increasingly stressed that honour also inhered in personal, moral and intellectual qualities developed in a liberal education. The cardinal virtues of prudence, temperance, fortitude and justice and the scriptural values of piety and religious leadership were constantly combined and recombined in expositions of the gentlemanly ideal from

Sir Thomas Elyot's *The Boke Named the Governour* (1531) to Henry Peacham's *The Compleat Gentleman* (1622) or *The English Gentleman* (1660, attributed to Bishop Allestree). The image of the gentleman was redrawn along lines suggested by classically-based humanist ideals of personal 'virtue' and 'learning' in the service of the commonwealth.[36] Theorists recommended an educational programme for the gentry in which the acquisition of personal culture through the liberal arts and sciences took first place over fighting skills and knowledge of chivalry, except in its more decorative trappings. Of course, the new ideals and programmes often remained mere blue-prints, and almost every writer complained of the tendency of young gentlemen to prefer hunting, gambling, drinking and fashion to the solid achievement of virtue and learning.[37] Nevertheless, the English élite did respond to the new image of authority by adopting, at least superficially, academic educational practices. By the end of the sixteenth century they were sending their sons to grammar school (or its private household equivalent), the universities and the Inns of Court, a development which both reflected and reinforced their exposure to the images and legitimisations of status presented in classical and humanist texts.[38] Although wealth and heredity continued to be the basis of aristocratic dominance in society, the cultural values of the élite and their self-image were modified.

It is this change which makes sense of many new features in prescriptions for gentlemanly demeanour and deportment. To the extent that the gentleman's authority and identity were increasingly located in his possession of inner virtues perfected by education, these required a visible embodiment and social 'representation'. It is no accident that those writers who demanded the most elevated humanist virtues from the leaders of society should have concerned themselves with what today seems the relatively trivial area of manners. Erasmus himself, whose view of princes and aristocrats was ambivalent but whose ideas were in a sense appropriated by authority, made this necessity plain. In the introductory passage of the *De Civilitate* he wrote rather apologetically of manners as 'the grossest part of philosophy', but he dedicated the work to a princeling and warned that without 'civility' many otherwise virtuous and noble men would fail to make their qualities visible and would waste their abilities.[39]

In practice, of course, poor manners would have scarcely threatened the perceived status of a man of wealth and family on his home territory. Yet the social life of the English nobility and gentry was changing. There were now many situations which demanded that ways of projecting

status focussed on the person and not on the household entourage. Throughout this period, the royal court expanded, and even more significantly, nobles and gentlemen increasingly flocked to London for at least part of the year for recreational, as well as educational, legal and political purposes. In these social milieux, more fluid and sometimes more anonymous than the world of the counties, personal dress, address and demeanour could become a more urgent concern as the real or aspirant gentleman sought to present his claim, as Smith put it, to 'be called master'.[40] Extravagant dress (notoriously more profuse in the court and city than in the country) was one element in this attempt at conspicuousness; the gestures and deportment which symbolised noble 'virtue' were another. Erasmus and Della Casa wrote from urban cultures, to which the rituals of the English medieval household were quite alien. It is, perhaps, important that the 'representational' principles of manners central to their codifications of personal conduct should have been diffused in England as a rural aristocracy was beginning to enjoy an existence divided between county and court or city.

In the new image and education of the gentleman which developed during the sixteenth century, one element had a peculiar relevance to the idea of deportment and demeanour as 'representations' of self, designed to make a favourable impression on a social audience. This was the image of the gentleman as orator and the concomitant place of rhetoric in the changing pattern of gentlemanly education. The Renaissance view of the gentleman emphasised the 'civil', magisterial role of the élite as much or more than the military function. Peacham, in *The Compleat Gentleman*, divided nobility into the 'militarie' and the 'Civill Discipline' and defined the latter in terms of 'justice, knowledge of the Lawes, which is *consilii fons*; magnificence and eloquence'.[41] Most other handbooks for the gentleman likewise urged their readers to gain the ability to vanquish by the word rather than simply by the sword and exhorted them to identify with the great classical orators, such as Cicero. As taught in the grammar school education increasingly favoured by the gentry, sixteenth-century rhetoric seems to have been a formidably esoteric and dry discipline, with its hundreds of classifications and forms of figures of speech.[42] But for those who failed to master the whole system in Latin, there were a number of more straightforward vernacular textbooks like Thomas Wilson's *The Arte of Rhetorique* (1553). These books make it clear that rhetoric is not just a matter of speech but also a discipline of gesture and demeanour, the 'action' which accompanies words and must be equally persuasive. Moreover, the rhetoricians routinely asserted that 'the

gesture of a manne is the speeche of his bodie' and that 'The lineament of
the Body does disclose the disposition and inclination of the minde'.[43]
The aim of the orator is to persuade his audience, through force of
argument mediated through word and gesture, to create a pleasing
impression of himself and his opinions and to adjust his performance to
audience expectations. Interestingly, this aim corresponds quite precisely
with the purposes of manners conceived as representations.

The close connection between traditions of rhetoric and Renaissance
conceptions of manners is, in fact, very striking. Castiglione's *Booke of
the Courtyer* contains many passages drawn from Cicero's *De Oratore*.[44]
The courtly ideals of 'natural grace', 'moderation' and decorum which
inform Castiglione's and Della Casa's discussions of deportment and
conversation are in many ways simply more social and informal versions
of classical oratorical ideals. Erasmus, more famous as a scholar than as a
courtesy writer, was steeped in the rhetorical disciplines which he did so
much to propagate. It is not surprising then to find that his elementary
precepts on body control in the *De Civilitate* are almost identical with
those in Wilson's rhetorical handbook:

Gesture is a certain comely moderacion of the countenance, and all other partes,
of mannes bodye . . . the hedde to bee holden upright, the forehedde without
frouning, the browes without bendynge, the nose without blowyng, the eyes
quick and pleasaunt, the lippes not laid out, the teeth without grenning, the
armes not much caste abroade, but comely sette out . . .[45]

Distinctions of status had long been implicit within the tradition of
formal rhetoric, for example in the condemnation of slow and ponderous
movements of the hands as the mark of rustic 'clownes',[46] and the
relation between ideals of oratory and of gracious manners cannot have
been simply a one-way affair. Nevertheless, the status of rhetoric in the
education of the Renaissance gentleman seems to have encouraged the
development of codes of manners as a rhetoric of status.

The new scrutiny and regulation of the body which becomes evident in
Renaissance writing on gentlemanly manners is not simply an effect of
the humanist revival of rhetoric. It needs also to be understood in the
context of a larger shift in economic power and in the social and political
values associated with the appearance and multifarious uses of the term
'civility'. Nothing better illustrates the close connection between ideals of
personal social conduct and the values of public order and hierarchy than
the emergence of the word 'civility' in the specialised sense of good
manners, at precisely the time when its use had become frequent in
political discourse. The sixteenth-century concept of 'civility', while

looking back towards classical definitions of civic virtue and order, for
example in notions of 'civil magistracy' and 'civil law', increasingly
acquired meanings which looked forward to the modern concept of
'civilisation'. The classical opposition between the 'civil' and the 'barbar-
ian' was elaborately glossed and indeed transformed in Renaissance
writings into a basis for asserting the wholesale superiority of European
élite cultures over the 'savage' societies discovered elsewhere and over the
barbarians thought to dwell at home or even nearby in Ireland. It was
used to create not only a comparative, but an historical perspective, as
writers identified the 'savagery' of communities in the Americas with the
hypothetical primitive state of their own societies. As one author wrote:

The people which inhabited in old time the countrie where we dwell now, were as
rude and uncivill three thousand years agoe, as are Savages that have lately been
discovered by the Spaniards and Portingales.[47]

By the end of the sixteenth century, the label 'civil', like its modern
derivative 'civilised', was being applied to anything from political
organisation to sexual practices, from religion to the arts, from the level
of commerce to child-rearing.[48]

The word, 'civility', so diverse in its applications and so triumphantly
normative, is hard to define with any precision. Wherever it was used,
however, it carried with it the connotation of order based on reason, to
which was opposed undisciplined animal instinct and a lawless primitive
nature. The notion of the creative development of reason in the arts and
sciences which is so important a part of the modern concept of
'civilisation' was in the Renaissance image of civility somewhat second-
ary to the notion of proper regulation and hierarchy both in the
individual and in society.[49] The true savage, like Shakespeare's Caliban,
was defined less by simple ignorance than by the 'brutish' predominance
of instinct; savage society was defined less by lack of development than
by the absence of a proper hierarchy and political structure. It is true that
a wistful strand of Renaissance thought involved the vision of the
innocent and beautiful barbarian, uncorrupted by European vice and
degeneracy, but in general the negative image predominated.[50] This was
important not only for the European response to other nations, but also
for European interpretations of their own social hierarchies, in which the
developing opposition of the 'civil' and 'savage' played a significant part,
especially in the definition of manners. Parents today still tell their
children not to behave like little brutes or savages, and these meanings

can already be traced in sixteenth- and seventeenth-century advice on bodily demeanour and deportment.

The propensity of Renaissance courtesy writers to give vignettes of unpleasant behaviour has already been mentioned. What is also striking is the way in which these repulsive descriptions were constructed in terms of animal metaphors. In contrast to the brisk instructions of medieval texts, later advice on manners is full of images of the bestial. Erasmus warned that to gnaw bones was 'the property of dogges' and to lick dishes 'the property of cattes', and he conjured up an excruciating picture of men who 'in eatynge slubber up theyr meet lyke swyne'.[51] Weste used an alarming array of familiar and exotic animal metaphors, as when he advised:

> Blow not alowd as thou dost stand,
> For that is most absurd,
> Just like a broken-winded horse,
> It is to be abhord.

> Nor practize snufflingly to speake,
> For that doth imitate,
> The brutish Storke and Elephant,
> Yea and the wralling cat.[52]

Della Casa's readers were regaled with the image of men who '(lyke swyne with their snouts in the washe, all begroyned) never lift up their heads nor looke up (and ... not eate but raven)'.[53] Such writers constantly employ words like 'brutish' and 'beastly' to describe offensive manners. During the seventeenth century zestfully repulsive animal references become rarer, but the notion that good manners involve the conquest of the bestial in man and an identification with a rational human nature separate from brutish nature remains implicit. Courtin wrote pompously that basic rules of bodily decency are the effect of a code written into human nature to ensure the difference between man and beast. He asserted that men will naturally try to control themselves in 'spitting, coffing, sneezing, [and] eating', because 'every man is naturally convinced the more remote and contrary his actions are to the example of Brutes, the nearer does he approach to that perfection to which man tends by natural propensity'.[54] Hence gentlemanly social behaviour has come to require adjustment not only according to the principle that gesture and demeanour 'represent' inner virtues and vices, but as a measure of humanity itself. An increasing concentration on rules of bodily control becomes intelligible in this context, because the body is the

'natural' object shared with the beasts and therefore the area of human experience most threatened by a descent into animality.

The maintenance of the distinction between the 'civil' man and the beast or distant 'savage' could scarcely have been a practical issue in the everyday working of the English social hierarchy. However, the distinction was projected into European and English society on the assumption that the élite was more obliged to exemplify civility, and more responsible for civil order, than the comparatively 'brutish' lower classes. As one Jacobean author put it, gentlemen should be 'professors of civility'. Conversely, in the words of an influential Italian manual of conduct known in translation, the 'base people' were 'by nature uncivil, rude, untoward, discurteous, rough, savage, as it were barbarous'.[55] A hint of this assumption is, in fact, given in the characterisation of Caliban, whose savagery is inscribed on his deformed body and his subjection to passion, as 'a savage and deformed slave',[56] the last word being a frequent derogatory term for a servant. It is not then surprising that alongside animal metaphors for bad behaviour, the advisers on gentlemanly manners used negative examples associating the plebeian with the brute. Erasmus regarded wiping the nose on the sleeve as a habit of fishmongers and condemned thrusting fingers into a dish of pottage as the 'manners of carters'. In the *Galateo*, lewd reference to bodily functions was defined as characteristic of 'ye dregges and ye fylth of ye common people'. Bodily functions were, in a sense, cast off and pushed onto the 'carnivalesque' body of 'the common people'. In a satirical view of bad manners, Thomas Dekker ironically instructed his boorish anti-hero to 'gape wider than any oyster-wife'.[57] In nearly all cases it was the supposed beastliness of the common people in relation to bodily needs rather than simply a dirtiness associated with manual occupations which made them uncivil in the eyes of the writers on manners. The modern reader's views of good social behaviour are still moulded by concepts of the 'civilised' as against the animal or 'savage', and he or she may well think that the sixteenth-century gentleman, who had to be told not to spit on the floor, was somewhat 'primitive' in his manners. But it was precisely during this period that there began to emerge clearly that language of social hierarchy which made 'civilised' care and control of the body a sign of superior humanity.

If changing images of social order and of aristocratic authority encouraged a more intensive scrutiny and extensive regulation of the 'port and countenance' of the early-modern English gentleman, it must be stressed that this development was in various ways contested and

ambivalent. According to the humanist values of 'civility' and 'civil nobility', a member of the élite was distinguished by superior control of both body and impulses, but an older and persistent language of prestige in important respects contradicted them. Moralising writers on the duties of the aristocracy never tired of criticising the actual behaviour of the English gentry, particularly the young, and they nearly always identified arrogance and licentiousness as major defects. In a conduct manual of 1600, William Vaughan made a typical comment deploring those 'cavaleers' whose 'properties . . . are to flaunt like Pea Cockes, to play the Braggadochians, and to trust most impudently in the hugeness of their lims and in their drunken gates'.[58] In Dekker's *The Gul's Horne-Booke*, a young London gallant is presented as comically lacking in self-control, pushing others aside to be near the fire, failing to salute his elders respectfully and eating 'as impudently as can be, for that is most gentlemanlike'.[59] A great deal of colourful evidence of the roistering and thoroughly uncivil behaviour of young gentlemen on the loose, particularly in London, suggests that the response of the élite to ideals of gracefully controlled carriage and modesty of demeanour was less than complete. Status could be associated with deliberate licence, as was most bizarrely illustrated by the fashion among Restoration courtiers for 'streaking' naked through the streets.[60] This kind of joke, and the more usual forms of 'gentlemanly' extravagance in conduct, effectively inverted the 'civil' values of hierarchy, locating social superiority in freedom from rules and restraints, and locating inferiority in an obligation to self-control.

While the authors of conduct manuals scarcely endorsed licentious behaviour, their own prescriptions in fact give evidence of this counter-pressure against modesty and discipline. Firstly, when dealing with those aspects of manners concerned with ritual deference, rather than self-presentation, they show that, as Courtin put it, the inferiors in any situation are 'more particularly obliged to the rules of modesty'.[61] In Courtin's rules, the man of inferior rank must be careful to salute, must be quiet and composed and must respect the personal space and sensibility of his superior, without there being any reciprocal obligation. This implies, of course, that the assertion of freedom in demeanour and gesture could be an assertion of status, despite the principle that the superior man was he who exercised an exemplary self-control. Secondly, some compromise between gentlemanly freedom, or independence, and the demands of rules of civility was, in fact, built into advice on self-presentation. Brathwayt, in *The English Gentleman*, insists that his

readers should avoid over-scrupulousness in posture, an 'apish and servile imitation' which 'detracts much from the worth of man, who should subsist on himselfe . . .'[62] Too much modesty and squeamishness was held to smack of the 'shamefastness' appropriate only to children and women, and no less an authority than James I, in his *Basilikon Doron*, advised his son to 'eate in a manly, round and honest fashion' avoiding both absurd daintiness and grossness.[63] It was evident that gentlemen should be the masters, and not the slaves, of rules of deportment and demeanour.

While some limitations were set on the development of refinement in the gesture and carriage of the gentleman by counter-ideals of manly independence, there was a further ambiguity, even paradox, at the heart of the newly 'representational' view of manners. Through his manners the gentleman was supposed to proclaim his 'natural' virtue and title to authority, but such manners were self-evidently the product of education, effort and artifice. Castiglione was engagingly frank in defining the courtier's task as that of projecting a 'natural' ease and grace through self-concealing artifice. As Hoby put it, 'yt may bec saide to be a very arte, that appeareth not to be art, neyther ought a man to put more diligence in any thing than in covering it'.[64] The great pitfall for the courtier was thus 'affectation', that is to say, contrived words or gestures which revealed themselves as artifice. From the later sixteenth century, and particularly in the politically troubled early Stuart period, the courtier was a figure which came in for a great deal of moral criticism on the grounds of vanity, hypocrisy and an effeminate obsession with display.[65] None the less, the paradox of nature and artifice in concepts of gentlemanly manners was not confined to the perception of the courtier. It pervaded writing on prestigious social conduct regardless of the author's attitude to courtiers. 'Take heed of affectation and singularity', wrote the Puritan fifth Earl of Bedford to his sons, 'if so you act the nobleman instead of being one'.[66] On a practical everyday level, Bedford no doubt knew exactly what he meant by a real as opposed to an affected gentlemanly manner. On a deeper level the distinction was more obscure. Renaissance writing on manners, in presenting deportment and demeanour as a rhetoric of status which 'represented' inner noble virtues and 'civil' distance from plebians and brutes, showed the acting of 'natural' superiority to be the essential principle of the 'port and countenance' of the ideal gentleman.

7

Inigo Jones as a Figurative Artist

JOHN PEACOCK

The history of figurative art in Renaissance England is usually studied in categories such as painting, sculpture, engraving, tapestry and medallic portraiture. But the most important English figurative artist of the first half of the seventeenth century was Inigo Jones, whom we now think of as an architect. This is not so odd if we recall that Jones worked in a tradition, new to England, where architecture and figuration were linked and that he began his career classified as a 'picture maker'.[1]

Picture-making led to stage design, and Jones first came to prominence in 1605 as designer of the court masques, usually collaborating with Ben Jonson, who wrote most of the texts. Other poets wrote masques, other designers were occasionally employed, and other artists, especially composers and choreographers, necessarily collaborated in the productions. But almost from the first Jones and Jonson seemed the dominant partners. Publication of the masques after their (usually single) production was undertaken by the poet, which gave him considerable power in shaping the record and, in retrospect, the event itself. Jonson used this power to insist on a particular conception of the masque as representation, sometimes against other poets contending for cultural prestige and royal favour, and also to present a particular view of his own function in the collaborative enterprise in which he was involved with Jones.[2] Anxious to define his own primacy, Jonson produced a subordinate but suggestive categorisation of Jones as an artist.

In his first published text of a masque, *Hymenaei* (1606), Jonson begins with a preface acknowledging the hybrid nature of the genre and distinguishing the separate strains in its make-up. He makes a firm distinction between the 'outward' and the 'inward parts', the body and the soul. The soul is the poetry and the 'invention', the intellectual conception which gives rise to it and to the whole work. This endures, while the body, that is, the visual presentation, perishes.[3] Jonson is

pressing into service a distinction familiar in Italian art theory of the sixteenth century, between poetry and painting:

> poets mainly imitate what is inward . . . and painters mainly imitate what is outward.

> it seems that there is as much difference between poetry and painting as between the soul and the body.

> painting is called silent poetry, and poetry a speaking picture, and the former must be acknowledged the body, the latter the soul . . .[4]

Into this ready-made *paragone*, he implicitly fits himself and Jones – although no names are named. But in his next published text, *The Masques of Blackness and Beauty* (1608), he designates the other's role quite explicitly. After describing the set and costumes in the first scene of *The Masque of Blackness*, and before coming to his own poetic text, he sums up by saying: 'So much for the bodily part. Which was of master YNIGO JONES his designe and act.'[5] The soul-poet puts the body-painter in his place.

Jonson's use of the term 'designe' at least suggests that he sees Jones as a painter in a somewhat intellectualised sense. Later in the same text, he describes the main scene of *The Masque of Beauty*, which he thought well-conceived but imperfectly executed:

The Painters, I must needs say, (not to belie them) lent small colour to any, to attribute much of the spirit of these things to their pen'cills. But that must not be imputed a crime either to the invention, or designe.[6]

Here he is castigating not Jones, but the assistants who actually painted the sets, following the master's drawings. The deficiency was in 'colour', that is, in the material realisation of ideas worked out by the poet and scene-designer. Jonson's terminology comes from Lodovico Dolce's *Dialogo della pittura* (1557), which divides painting into three parts: *invenzione, disegno, colorito*.[7] *Disegno* is the process of giving visible form to those things which the painter, following the exercise of invention, proposes to represent, and he does this through drawing. But instead of merely reproducing natural appearances, *disegno* consists in perfecting the imperfections of nature, so that it uses a manual aptitude and a sensuous medium to rise to the level of the ideal.[8] Jonson's implied sharing out of Dolce's three concepts – *invenzione* for himself, *disegno* for Jones, *colorito* for the unsuccessful assistants – suggests a division of

labour which assigns Jones an ambivalent middle position, dependent on the poet for the originating concept of the work, the *invenzione*, but himself giving form to ideas which may be more or less well realised by subordinate artists.

The concepts which Jonson appropriated from cinquecento art theory to put Jones in his place were not innately docile instruments. The soul/body analogy from the *paragone* literature was reversible, as Jones would have known. Its bias had been intelligently challenged by Leonardo, who is quoted in Lomazzo, a key author for Jones:

> poetry is like the shadow of painting, and the shadow cannot exist without the body that casts it, which is none other than painting herself, as Leonardo so graciously puts it . . .[9]

And the concept of *disegno*, used in a relatively empirical sense by Dolce, a Venetian, moved in a more metaphysical direction in the context of central Italian thought. Quite possibly Jonson was introduced to Dolce's theory of painting by Jones. If so, his use of it to reinforce his own theory of the masque, which made the designer secondary and the poet not just supreme but transcendent, was to be ironically confounded. Jonson probably did not know that the concept of 'design', which he used so magisterially in 1608, had much more power than it was accorded by Dolce in the old-fashioned usage of fifty years before.[10] As Jones's career progressed, he abrogated this conceptual power to his increasingly dominant role in their relationship, the balance of which was shifting. When Jonson was finally cast off in 1631, he fulminated satirically against 'Omnipotent Design', and with reason.[11] But even leaving aside Jonson's effrontery and the poetic justice which overtook it, we should still consider the more suggestive aspect of his characterisation of Jones as the artist of the 'body', articulating his ideas through 'design.'

There actually is a benign sense enfolded in this characterisation. The *paragone* literature, written mostly by humanist critics, which classified *pittura* as 'body-art' rather than 'soul-art', was complemented by the treatises written by artists, which claimed that painting was an art of the body in a more positive sense. The fundamental discipline for the painter was *disegno*, and the elements of *disegno* consisted in learning to represent the human body. Moreover, *disegno* was fundamental to all the arts – architecture, just as much as painting or sculpture – which were all based on figuration. Jones absorbed this doctrine, and his progress from

picture-making to architecture via stage design (in Italian theory a branch of both painting and architecture) is informed by a serious regard for it.

Apart from the theoretical centrality of figuration to his oeuvre, figure drawing was part of Jones's working routine from an early stage: in masques, it was required for sets and proscenia, and especially for costumes. Later it was needed for schemes of interior decoration, in the Queen's House, for example, and for statuary, as on the west front of the remodelled St Paul's Cathedral. Eventually, what may be called pure figure drawing makes a significant appearance in his work, in the later 1630s and 1640s. This is puzzling, because in theory it should have been in evidence from the first; long before it appears, there is a theoretical space reserved for it, waiting to be populated.

Jones's ideas about figuration were formed early in his career by his reading of Vasari. One volume of his copy of the *Lives* has survived. It is the first volume of the Third Part. This is the volume which most crucially conveys Vasari's view of modern art, and Jones has annotated it in various places.[12] One annotation succinctly sums up his ideas: 'on must beeginn beetimes to learne y^e good principles',[13] and the style of his handwriting in some notes shows that he did in fact study Vasari from early in his career. In the *Proemio* he has marked a passage in which Vasari expounds those qualities which, while present in the art of the 'eccellenti maestri' of the Quattrocento, were only brought to perfection by their successors, the artists of his third period, or as we would say, the High Renaissance. The qualities are 'regola, ordine, misura, disegno e maniera', and Jones has marked the description of the last two:

Disegno was the imitation of the most beautiful aspects of nature in all figures, whether sculpted or painted – a capacity which comes from having a hand and intellect able to reproduce everything that the eye sees on a level surface . . .

Maniera then reached its finest pitch from the practice of constantly copying the most beautiful things, and joining together these superlative hands, heads, torsos and legs, so as to make a complete figure of all those fine features . . .[14]

Opposite the two terms underlined, Jones has written brief notes in the margin:

what desine is/To Imitate y^e best of/nature

gudd manner coms by Copiinge y^e fayrest thinges

His terse paraphrases suggest a determination to learn 'good principles' of figuration from Vasari, although this response to the text produces a complication, as we shall see.

Vasari's first concept sums up the whole Florentine tradition of

disegno, with its two basic ideas. One of these is the equal emphasis on 'hand' and 'intellect': design is conceptualisation as well as manual delineation. The other is that the objects of design are 'figures', and their interrelationships. The second idea goes back, in the literature, to Alberti's *Della pittura* (a book which Jones also possessed), although it could be deduced by anyone familiar with Florentine and central Italian art, as Jones was. It was an idea which stayed with him through his career.

Earlier in the *Lives*, in the introductory essay on painting, Vasari has stressed the intellectual aspect of *disegno*. He declares the common affiliation of all the arts to 'design, father of our three arts, architecture, sculpture and painting . . .'[15] The power to conceptualise is the power of generation. Previously, he had called *disegno* 'mother of each one of these arts . . .'[16] This was in a book debating the primacy of painting or sculpture, edited by Benedetto Varchi, which included contributions by contemporary Florentine artists; several artists besides Vasari stressed that all the arts stemmed from *disegno*. Varchi himself pushed this doctrine to its logical conclusion:

I would say then, arguing along strictly philosophical lines, that I consider, indeed I take it as certain, that sculpture and painting are substantially a single art, and in consequence the one is as noble as the other . . . Now it is generally acknowledged that not only do they have a common end, that is, an artistic imitation of nature, but also a common beginning, that is, design . . .[17]

When Vasari later switches his metaphor, asserting *disegno* to be not just mother but father of the arts, he is affirming this insistence on its intellectual role by enlisting the conventional association of masculinity and mental power. As for design as a manual practice, he has two sorts of advice to give, about acquiring skill and, beyond that, style. Representational skill comes from copying relief sculpture, casts from life or the antique, or figures modelled in clay, and then moving on to life studies, the drawing of the nude. This must be supplemented by the study of anatomy. The knowledge thus gained of the body from the inside and the outside ensures that the artist can draw the contours of his figures perfectly. This is where representational competence shades into a beautiful style, a *bella maniera*. Figures which are rendered with the assurance springing from thorough knowledge will for that very reason, says Vasari, display 'buona grazia e bella maniera'. But in the next sentence he takes this back, or at least implies it is not enough:

For whoever studies good paintings and sculptures, and at the same time looks with understanding at the live model, must necessarily have acquired a good manner in art.[18]

Life study must be supplemented by the study of art.

According to Vasari then, the study of drawing has two complementary aspects, one practical and the other historical. Skill or competence comes from following an empirical pedagogic method which, by implication, applies in all cases and at all times, and has presumably been handed down unchanged. Style comes from a critical study of the history of art, recognising and adopting what is best in a changing process (or progress, as Vasari would have it). In reality, the distinction between skill and style cannot be strictly preserved, since the highest competence takes on the quality of good style. In practice, *disegno* cannot be conceived of without *maniera*, which brings us back to the passage Jones annotated in the properly historical section of the *Lives*. By contrast, the essay on painting occurs in an introductory section, where Vasari discusses materials, technique and method. There, the main emphasis – concerned with copying models, life drawing and anatomy – is on learning to acquire graphic competence. Here, the emphasis is on an achieved aesthetic progress, through advances in style. Vasari writes in the past tense, although he sometimes shifts into the present tense – not illogically, since his exposition of historical advances implicitly details the sound methods which led to them. The parts paraphrased by Jones are in the past tense, however, and he translates them into the present. He is evidently reading Vasari's history as an exposition of method.

The character or bias of the method Jones is reading out of Vasari is indicated by the parallel words 'best' and 'fayrest', which translate the identical concept in the original: 'il piu bello'/'le piu belle'. These highlight the studious representation not of natural appearances but only of what is fit in nature to be represented, what approaches perfection. This involves remaking the figures or bodies which nature has made. Vasari's assumption to this effect derives antique authority from its allusion to the famous story of Zeuxis, who composed a Helen from the most beautiful features of various women.[19] Jones himself wrote in the margin of another of his books, 'beautifull figures ar made by taking the best of several men . . . ', paraphrasing no less an authority than Socrates.[20] It is not surprising, then, to find him reading Vasari's concept of *disegno* with a notable bias towards the overlapping concept of *maniera*. And, as we shall see, Jones's figurative drawings show him approaching the practice of design through the idea of *maniera*.

This approach, given the order of Vasari's treatment, starts strictly from the wrong end. But apart from this deviation, caused by Jones's peculiar historical circumstances, he took in the central tenets of Vasari's concept of *disegno*: the tendency to assimilate the arts to each other, and to base them all on the discipline of figuration.

Within this theoretical context, Jones's gradual transformation into an architect could be quite naturally accommodated, without any need for rethinking or redefinition. In practical terms, this move had been sanctioned as logical by Serlio, who wrote in the second book of his treatise (1545) that painting, and the study of perspective which painting demanded (and which might be demonstrated in stage design), were a necessary preparation for architecture, citing in support the shifting careers of Bramante, Raphael, Peruzzi and others.[21] Jones, developing from painter to stage designer, was appointed Surveyor of the King's Works in 1615, so that architecture now became his official avocation, and it was as 'the Architect' that Jonson summoned all his poetic powers to denounce him in 1631.[22] But this was only the most salient role in the whole cluster of his artistic functions, and like others it could be subsumed into Vasari's category of 'the arts of design', all with their roots in figuration.

There was, in addition, a complementary context in which architecture was linked to figuration – in which it appeared, in fact, as a figurative art in its own right. This was the tradition of Renaissance Vitruvianism, which Jones was the first English architect to adopt systematically. Vitruvius, in his discussion of building types, gave priority to the temples of the gods, implying that the temple-plan was a kind of ideal model for all other buildings. This, he declared in a doctrine that became famous, 'must have an exact proportion worked out after the fashion of the members of the finely-shaped human body'.[23] The fundamental validity of this proportion was shown by the fact that around the well-shaped (male) body a perfect circle, or alternatively a square, could be inscribed. Vitruvius develops his doctrine of proportion in both more concrete and more abstract directions. He points out that the units of measurement which the architect uses are derived from parts of the body: palm, foot, cubit and so on. But he goes on to argue that these various measures go together to produce the perfect number, and so number itself derives from the articulation of the human body.[24] The topic is brought down to earth again in a later chapter, when he discusses the proportions of the

Pietro Cataneo, *Vitruvian Figure inscribed
in a Cruciform Church Plan.*

several classical orders. He claims that the columns of the orders
originate from different body types: the Doric from a strong male body,
the Ionic from a more slender, matronly female body, the Corinthian
from 'the slight figure of a maiden'. This account even includes sugges-
tions of naturalistic imitation; the volutes of the Ionic capital are 'like
graceful, curling hair', and the fluting of the column shaft 'like the folds of
matronly robes'.[25] Such explanations are reinforced by a celebrated
passage at the beginning of Book I, about the origin of caryatids and
persics (male caryatids):[26] if complete sculptured figures can be sub-
stituted for columns and perform their load-bearing function while
having a specific ornamental value, then they are equivalents – columns
are figures and vice versa.

Vitruvius suggests then that architecture is a figurative art in an
abstract sense but also, sometimes, in a more mimetic sense. Renaissance
illustrators of his ideas represent both tendencies. The well-known
drawings of Leonardo and others, which show (sometimes by forcing the
issue) the male body circumscribed by a circle and a square, represent the
more abstract side of the doctrine. But a more anthropomorphic side is
represented in the drawings of Francesco di Giorgio which match human
figures to building plans or parts of the orders.[27] Jones knew the treatise
of Pietro Cataneo, a Sienese architect brought up in the tradition of
Francesco di Giorgio, which has an illustration of a male figure inscribed
in a cruciform church plan (above).[28] This synthesis of Vitruvius'
doctrine with the symbolic and animistic context of 'old-fashioned'

Christian architecture stresses its less abstract potential. Other treatise writers, such as G.A. Rusconi (also found in Jones's library), illustrate the Vitruvian account of caryatids and show that even in a neo-antique context architecture can be at its most explicitly figurative.[29] The logical end of this tendency is the riot of animistic figuration in sixteenth-century mannerist architecture, which is none the less Vitruvian, albeit in a highly accentuated way. Jones of course had no truck with mannerist 'Vitruvian' figuration in his built architecture, but it is extensively represented in the settings of his masques and is described in their texts in the most serious terms.[30]

Renaissance architects and theorists were deeply impressed by the Vitruvian analogy between building and body and often developed it in their own ways. The architectural writers whom Jones studied repeat and elaborate Vitruvius' arguments in the context of Christian doctrine. Daniele Barbaro, in his commented edition, is a great repeater of Vitruvius. This does not make him self-effacing. His is a highly directed reading of the text. He is capable of forecasting a point before Vitruvius makes it, such as the reminder that the architect's terms of mensuration are taken from the human body – thus giving it greater prominence than it had in the original.[31] In that sense, repetition becomes tantamount to a new reading; but an even greater change comes in the shift of the religious context. Barbaro not only makes the conventional paraphrase of pagan temple into Christian church but assumes a Christian Aristotelian view of nature and its chief glory, man, made in the image and likeness of God:

Nature, our instructor, teaches us how we are to proceed in the planning of buildings: for she requires that we learn the ratios of the proportions that we have to use in the structure of temples from nowhere else than that sacred temple made in the image and likeness of God, which is man – in whose make-up all the other wonders of nature are comprised.[32]

Barbaro follows Vitruvius in using the concept of *compositione* (Lat. *compositio*) to refer to the well-proportioned structure of the body, as well as that of the temple; and I shall return to this concept later.

Lomazzo also transposes Vitruvius' arguments into a Christian culture. As with Barbaro, repetition in itself can amount to a rereading. Lomazzo, before blindness confined him to literary pursuits, had been primarily a painter, and it is as a painter that he reads Vitruvius. Although his treatise deals with 'Painting, Sculpture and Architecture', the parts on architecture are written from a painter's point of view. So in Book I, writing on proportion, he deals successively with the proportions of figures and the proportions of columns, following Vitruvius' association

of the two but reversing his emphasis. He transposes some of Vitruvius' material about the gender characteristics of the different orders into the section on figures, while giving it full value too in the section on columns, where, in fact, he expands it and sums it up in his own way:

Wherefore, we may be bolde, to represent any columne after the similitude of mans body, which is the perfectest of all Gods creatures; and so shall it neither exceede, nor be defective: and so consequently will all the partes which are reduced unto these proportions, proove exceeding beautifull . . .[33]

This corresponds to the Christian humanist tone of Barbaro, proper to the temperate religious climate of Venice, but elsewhere Lomazzo, in keeping with the hispanised, Counter-Reformation atmosphere of his own city, Milan, is more fervent. He actually extends the Vitruvian doctrine of proportion in a chapter on 'Howe The Measures Of Ships, Temples And Other Things Were First Drawne From the Imitation Of Man's Bodie', the crux being an argument that the proportions of the Ark were based on the human form, and this by a divine revelation to Noah.[34] His ultimate emphasis is that skill in proportion comes from knowledge conferred by divine grace, which makes men 'worthy to ascend into heavenly glory, living by means of good works, and in the fear of God, with whose name I conclude these remarks on proportion'.[35] At this point, Lomazzo's English translator, Richard Haydocke, recoiled (not for the first time) like the good Protestant he was, perhaps at the ambiguous mention of 'good works' and the general air of religiosity. He ends his version of the chapter with the previous sentence, commenting on 'the proportionable agreement and admirable harmony of the partes of man's body':

Whereas therefore every one of us carrieth about him a modell of these proportions, let us not thinke the time lost, which is spent in learning how to know our selves.[36]

The new stress (these are Haydocke's italics) on self-examination rather than self-forgetfulness as part of an apologia for the study of the arts, and sober philosophical humanism rather than baroque religiosity, suggests how Lomazzo's elaboration of the Vitruvian doctrine of architecture as a 'body-art' came to be read in a Protestant culture. Jones, whatever his personal religion, was culturally a Protestant, and his mature architectural style is not out of keeping with Haydocke's sobered-up version of Lomazzo on proportion. But underlying that sober architecture there is still the Vitruvian idea of bodily representation.

Further extensions of this idea are found in other writers. Alberti, as

befits a pioneer self-consciously making a fresh start on the business of writing an architectural treatise, takes the idea back to a more basic form than it had in Vitruvius:

The most expert Artists among the Ancients, as we have observed elsewhere, were of Opinion, that an Edifice was like an Animal, so that in the Formation of it we ought to imitate Nature.[37]

In fact, this point had not been 'observed elsewhere' by Alberti, who is making an Aristotelian deduction from Vitruvius. There is an analogy with the *Poetics*, where Aristotle says that a poem is like a natural organism.[38] Alberti's expansion of the concept of the bodily into that of the organic is accompanied by a tendency to deduce new metaphors from the body analogy itself. So on the topic of architectural ornament he writes:

We should erect our Building naked, and let it be quite compleated before we dress it with Ornaments, which should always be our last Work . . .[39]

Alberti's opening up, at the beginning of the Renaissance architectural tradition, of the Vitruvian analogy to the concept of the organic and to the transformations of metaphor, was to be extremely influential.

All the principal writers whom Jones read on architecture followed Alberti's lead. Daniele Barbaro compared the architect drawing a cross-section to a physician, because he can show the anatomy of a building.[40] Vasari, describing the qualities of a well-proportioned building, said that it should 'represent' the human body both as a whole and in all its parts. The facade should have the symmetry of the human face, the door placed like the mouth, the windows like the eyes, and so on.[41] Vasari develops the comparison in elaborate detail: staircases, for example, are the arms and legs of the building. In effect, this is an allegorisation of the original Vitruvian analogy (pointing towards a conception like Spenser's House of Alma), animating it far beyond an abstract doctrine of proportion.

Palladio, discussing the planning of palaces and villas, compared their lay-out to that of the human body, some parts of which are noble, some mean and ugly, but all of which need each other. Implicit here is Menenius' fable of the body politic from Plutarch.[42] God, Palladio continues, has created the body in such a way as to solve the architect's planning problem:

as the Blessed Creator has ordered our members, so that the most beautiful are in places most exposed to view, and the less decent hidden; so too in building . . .[43]

The ignoble parts are also 'less decent' and 'hidden'; Palladio not only politicises but sexualises the body-building. We are not accustomed to

seeing Palladio's architecture, nor that of his disciple Jones, with these kinds of associations, perhaps because they have been caught and extracted by the filter of neo-classicism. It may, therefore, be necessary to stress that in the late Renaissance the Vitruvian body analogy did not remain only an abstract doctrine but had a proliferating life as a powerful metaphor.

For Jones, the Vitruvian idea of architecture as bodily representation was closely linked to the Vasarian idea of *disegno* as a fundamentally figurative discipline. He writes a personal manifesto to this effect in the Roman Sketchbook, as he looks back over his Italian journey, the climax of a decade of work, and considers what he has learnt:

Thursday y^e 19 January 1614 [i.e. 1615]

As in dessigne first on Studies the partes of the boddy of man as Eyes noses mouthes Eares and so of the rest to bee practicke in the partes sepperat can on comm to put them toggethear to maak a hoole figgur [and cloth it] and consequently a hoole Storry wth all y^e ornamentes

So in Architecture on must Studdy the Partes as loges Entranses Haales Chambers Staires doures windoues, and [then] adorrne them wth colloms Cornishes sfondati. Stattues. paintings. Compartimentes . . .[44]

The terms of the comparison are derived from Alberti, who had written the first Renaissance texts on painting and architecture.[45] In both arts Alberti had stressed the relation between parts and whole, whether in a building (which as we saw he likened to an organism) or in an *historia*, the kind of dramatic, complex figurative narration which he held to be the painter's highest project (what Jones calls a 'Storry'). Jones's first paragraph is spelling out further Alberti's key concept of *compositio*:

Composition is that procedure in painting whereby the parts are composed together in a picture. The great work of the painter is the *historia*; parts of the *historia* are the bodies, part of the body is the member, and part of the member is a surface.[46]

Surfaces are composed into members, members into bodies, bodies into the total *historia*. In this analysis the central concept is obviously the body, and we get what looks like an implicit extension of Vitruvius: that is, just as a good body is the paradigm for a good building, so it is for a good *historia*.

Jones's account of the construction of *storie* (to use the more usual

Italian term) updates Alberti in two ways. Firstly, he substitutes Vasari's concept of *disegno* for Alberti's concept of *compositio*. This seems to present no problem, since Vasari's exposition of design, which begins his essay on painting, is obviously descended from Alberti's treatise. He, too, stresses the relation between parts and whole, both in the works of nature (especially the bodies of humans and animals) and in works of art, and the final goal of his discussion is the 'invenzione delle storie'.[47] Secondly, Jones follows Vasari's lead in detailing the parts of the body which go 'to maak a hoole figgur', which Alberti had always referred to simply as 'members'. But whereas Vasari had preserved a certain level of generality in his detailing of the body, referring to 'hands, heads, torsos, legs', Jones goes into more minute detail, with his 'Eyes noses mouthes Eares and so of the rest . . . ' These categories come from the academic drawing manuals which were beginning to be published in the early seventeenth century and which Jones used for drawing practice. A typical example is Odoardo Fialetti's *Tutte le parti Del Corpo Humano diviso in piu pezzi* (1608), which begins with pages of eyes, ears, noses and mouths, before going on to larger matters (and eventually to whole compositions).[48] Jones, who in the motto inscribed on the Roman Sketchbook – 'Altro diletto che Imparar non trovo' – had declared himself to be a dedicated learner, here suggests that for him the most elementary graphic tasks have priority in practice as well as theory.

The drawing manuals had their origin in the circle of the Carracci, as part of a movement to re-educate artists in the rational classicism of the High Renaissance after the wayward figural and compositional deformations of Mannerism.[49] To someone such as Jones, who was learning the whole Renaissance tradition backwards, as it were, from a position historically and geographically beyond it, they could be seen as a late realisation of Alberti's programme for learning to construct *storie*. So he therefore implicitly associates the two under the umbrella of Vasarian *disegno*, a concept which could be said to mediate historically, or at least chronologically, between them. But this sturdy and plausible historical condensation contains a problem, which is that in Vasari the idea of *disegno* is bound up with the idea of *maniera*, in a way that it could not have been for either Alberti or the Carracci. Certainly Alberti in his writing and the Carracci in their painting display the idealist strain which persists in central Italian art and is compatible with an equally persistent naturalism. But Vasari – certainly in Jones's reading of him – insists that the representation of nature is a means to the production of beauty.

It seems then there is a difficulty in Jones's account of 'dessigne' and its basic function in the composing of *storie*.

Does this matter? Did Jones anyway ever put his knowledge of figuration to use in the invention of 'historical' compositions, analogous to the architecture he designed and built? In fact he did. His *storie* were the elaborate scenes of the court masques, which included not just painted figures but real ones, and real figures of the highest importance – the royal family and the courtiers. We have already seen that in one of the earliest masque texts Ben Jonson's use of the terms 'invention', 'design' and 'colour' – possibly prompted by Jones, whom he tried at the same time to keep in his place – implicitly categorises the masques as *pittura*. The fact that Jones delegated the actual painting to assistants does not affect this point. Vasari had declared in his life of Giulio Romano that a painter might express his ideas better in his drawings than in paint. Jones paraphrased this in the margin: 'Julio expressed his conceyt better in desine then in collors',[50] and this surely applies to him, as well.

In 1632, describing the proscenium and the opening scene of *Tempe Restored*, Jones wrote:

lest I should be too long in the description of the frame, I will go to the picture itself; and indeed these shows are nothing else but pictures with light and motion.[51]

His terminology may well be drawn from Daniele Barbaro, who had described a stage scene as a 'show' which is realised as a 'picture'.[52] Certainly Barbaro furnishes the historical justification for Jones's assertion, since in his translation of Vitruvius Jones would have read that in antiquity decorative mural painting began as an imitation of scene painting in the theatre, which included not just 'scenes' (that is, buildings and landscapes), but figures as well. Barbaro assigns this kind of painting the name 'scenographia', promises to write more about it and gives it pride of place in his later study of perspective (1569).[53] There he treats it as the very type of perspectival representation and insists on its fundamental utility to 'Pittori, Scultori, & Architetti'.[54] This line of argument, developed from Vitruvius, gives more than sufficient authority to Jones's assertion; if 'scenographia' is the classic paradigm of monumental painting, then it is a form of monumental painting in its own right.

Inigo Jones, *Naiad*, for *Tethys' Festival.*
Devonshire Collection, Chatsworth.

Marcantonio Raimondi after Raphael,
Temperance.

The masques, in which Jones pictured the most powerful figures in the
state, could be assimilated to the most powerful genre in the Italian
tradition of *pittura*, the monumental *historia*. In this context, the
costume designs for the masques become not just clothes arranged on
dummies but figure drawings in their own right, and this is how Jones
treated them, as studies towards the figures in the perfected composition.
However, the perfected composition was a performance, and the final
figurations were the masquers themselves as they appeared *ad vivum*.
Even so, this situation relates logically to Vasari's definitive account of
the progress of painting. In describing the qualities of a successful *istoria*
(his variant of the word) he requires that the items in it shall not seem
merely painted but have the appearance of three-dimensionality and be
'living and truthful'. He insists that the goal towards which painting has
developed is *vivacità*.[55] He particularly mentions Leonardo, who

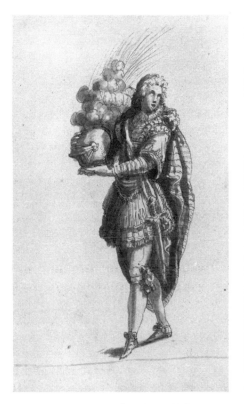
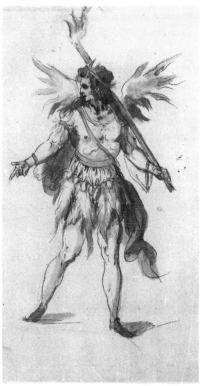

Inigo Jones, *Page bearing a Helmet.* Devonshire Collection, Chatsworth.

Inigo Jones, *Torchbearer: a Fiery Spirit,* for *The Lords' Masque.* Devonshire Collection, Chatsworth.

made his figures move and breathe; Correggio, whose works are more lively than the living; and Parmigianino (an artist very important to Jones), whose figures are so alive that one feels one can sense the beating of their pulses.[56] The only logical continuation of Vasari's history of painting would be that finally it should literally come to life, as it did in the *tableaux vivants* of the baroque theatre. Jones sets himself in this context when he speaks of his 'shows' as 'pictures with light and motion'.

Given the peculiarity of the mode in which he practised the art of 'storry', his study and practice of 'dessigne' also took on a peculiar character. Unlike the Italian artists whom he aimed to emulate, he was far from well grounded in the representational and especially figurative disciplines which Vasari took for granted. Evidently Jones had received some instruction, but beyond a certain point he had to teach himself.[57]

He used his regular tasks of designing court entertainments as a means of self-education, using costume design especially to practise figure drawing. This basic training was a way of disciplining not only himself but also the entire organisation of his 'pictures'. The figures in these pictures were real people, and very exalted people with wills of their own. His only way of retaining as much control as possible over the total conception was, in his costume studies, to ensure the acceptance of his ideas by representing the courtiers to themselves as appealingly as possible. Therefore, in order both to economise his own efforts at self-instruction and to maximise his influence over the patrons who were also the material of his grand compositions, he took a strategic short-cut: he approached the practice of *disegno* through the acquisition of *maniera*.

Jones had extracted two lessons from Vasari: 'what design is, to imitate the best of nature', and, next in order, that 'good manner comes by copying the fairest things'. In practice, he conflated this programme and set out 'to imitate the best of nature' precisely 'by copying the fairest things'. To him, 'the fairest things' were to be found in the figurative repertory of the Renaissance tradition, drawn both from antique sculpture and from the modern art which Vasari had praised. This was most accessible through the work of Cinquecento print-makers, expertly inaugurated (according to Vasari) in the ambience of Raphael, the supreme painter, by Marcantonio Raimondi. In his life of Marcantonio, whom he judged the first in both senses among Italian engravers, Vasari wrote that his legacy was 'the benefit that northerners have had from seeing, by way of prints, the styles of Italian art . . . ';[58] Jones's use of Marcantonio and the prints of his successors amply confirms this. Vasari also relates admiringly how Marcantonio began his career, by imitating the prints of Dürer so closely that they were taken for the originals.[59] This association of innovation with imitation is also entirely pertinent to Jones, whose imitations of Marcantonio, and of the *maniera* of Raphael as mediated by him, are the basis for his first essays in figurative design, which were to introduce the Stuart courtiers, through masques, to the 'maniere d' Italia'.

From the start, Jones's costume drawings, for all their romantically elaborate attire, are based on classicising figurative designs. A drawing for a Naiad in *Tethys' Festival* (1610), who has sea-shells in her hair and seaweed hanging from her shoulders (p. 168),[60] is derived from an image of Temperance, one of a series of Virtues engraved by Marcantonio after Raphael (p. 168).[61] Jones has thinned and elongated Raphael's sturdy, sculptural figure, transposing her into a mannerist key, but the original

Marcantonio Raimondi, *Two Fauns carrying a Child.*

figurative matrix is still there. A contemporary drawing for a squire in a tilt (p. 169),[62] one of the chivalric entertainments closely related to the masque, is taken from another print by Marcantonio, of David with the head of Goliath (p. 174).[63] This is after Francia, whom Vasari had praised as a precursor of the 'new, living beauty' in modern painting, to be perfected later by Raphael.[64] The image is clearly based on antique sculpture. Its late Quattrocento style furnishes the classical body with an aesthetic glamour which translates perfectly into the courtly social style of its new context. Apart from altering the pose of one arm for practical purposes, Jones reproduces the figure intact.

Vasari had said that *maniera* was perfected by using a principle of selection, composing the best features of various figures into a new figure which would be even more beautiful. Jones himself had written that in practice figuration was a matter of making parts into a whole. Many of his costume drawings combine features from different figures, and the most striking designs bear out Vasari's advice, since they are carefully

composed from models of considerable distinction. Jones's best-known image, often reproduced, is the design for a Fiery Spirit (p. 169) in *The Lords' Masque* (1613).[65] This is a composite of two figures from antique sculpture: one of two fauns from a bas-relief (p. 171), and the Apollo Belvedere (p. 174).[66] The basic idea, with suggestions for the costume, is provided by the faun, who is carrying a torch (Jones's Spirit is a torch-bearer). This figure is part of a composition which represents a complex of interrelated movements, and it therefore strains emphatically in one direction. Jones re-poses it with reference to the Apollo, with its more moderate representation of movement, its stability as a free-standing figure and its authority as a 'classic' masterpiece. The final form incorporates a conflict between stability and motion, the conceit of fire being introduced via certain subtle figural attenuations, such as the slimmer legs and feet and the sharpened profile. This beautiful design best demonstrates how Jones, along the lines suggested by Vasari, cultivated *maniera*.

A comparable design of the same period is for another torchbearer, this time an American Indian (p. 174), in *The Memorable Masque* (1613).[67] Here the basic figural idea comes from an engraving after Mantegna. The figure represents *La Servitù* (p. 174),[68] and Jones has not only freed it from its bonds – the ball and chain on its ankles and the yoke on the shoulder, which is changed into a torch and held aloft – but from the constraints of Mantegna's style, which Vasari had characterised as sometimes 'sharp' and 'dry'.[69] In keeping with the theme of the noble savage or natural man, he has amplified the form of the body, given it a more 'heroic', athletic bulk. His models are partly the faun from the bas-relief again and partly a figure of a nude warrior, engraved after Raphael (p. 175).[70] This reworking of Mantegna in a High Renaissance style to produce a neo-antique figure is another of Jones's most striking compositions and another good example of his *maniera*.

This is not the place for a full analysis of Jones's costume designs or of the masques as *storie*. In the 1630s, when the partnership with Jonson dissolved, he obtained full control over the masques and used the occasions they provided to make himself a very competent figurative designer. It was at this stage that he seems to have felt confident enough to extend his interest in figure drawing far beyond the bounds of expediency, into areas which in theory he ought to have explored during the preceding twenty-five years, but on which he had not spent much attention. In one direction, he returns to the elements of figuration, to the analytical study which his note of 1615 in the Roman Sketchbook had

taken to be essential; in another direction, he produces more and more drawings which seem gratuitous and experimental.

A sheet associated with *Albion's Triumph* (1632), the first masque produced after Jonson had been dispensed with, represents the proliferation of Jones's figure drawings beyond the masque. It contains a costume design for Charles I as the emperor Albanactus (p. 175).[71] The figure is composed from two similar images on Roman bas-reliefs, both engraved by Marcantonio. One is of Trajan, being crowned by Victory, from the Arch of Constantine (p. 176); the other is from a well-known sarcophagus, showing a lion-hunt (p. 176).[72] This follows Jones's normal practice; what is unusual is the more freely drawn figure on the left, adapted from one of the *ignudi* on the Sistine ceiling, as engraved by Adamo Scultori (p. 175).[73] This has nothing to do with *Albion's Triumph*, but its proximity to the other figure is symbiotic, reinforcing the point that Jones saw the masques as complex exercises in figuration, and also revealing the widening range of his figure studies.

There are similar sheets of the 1630s which bring together costume designs and apparently irrelevant figure drawings. One which opens up a further vista contains a costume design for *The Triumph of Peace* (1634), together with a number of related and unrelated heads (p. 175).[74] One of these is replicated (in reverse) on a page of the Roman Sketchbook, where it is marked with a grid of lines (p. 177). These show it to be derived from the drawing manual of Odoardo Fialetti (p. 177),[75] which contains examples of how to draw the head in foreshortening with the aid of simple linear schematisations. Another of Fialetti's heads turns up in the costume design itself.[76] These links between Jones's mature drawings and the most elementary exercises in figuration, which he could be expected to have progressed through years before, show him in a new phase of self-education.

His obsession with learning, recorded in the motto inscribed in the Roman Sketchbook, became more intense as it proved less necessary. By the 1630s he had mastered his craft as a scenographer, and the 'bodily part' of the masques had triumphed. This meant that the study of figure drawing, which had necessarily coincided with learning to design not only costumes but roles for the courtiers, could be pursued in a more independent way. In this period he turned again to the Roman Sketchbook and added many more drawings and notes to those he had made in 1614–15, during and immediately after the Italian journey. Some of the new drawings are careful copies after originals by Raphael and his pupils; some are exercises copied from drawing manuals; some result from

Marcantonio Raimondi after Francia,
David with the Head of Goliath.

A.V., *Apollo Belvedere*.

Inigo Jones, *Torchbearer: An Indian*,
for *The Memorable Masque of the Middle
Temple and Lincoln's Inn*. Devonshire
Collection, Chatsworth.

Adamo Scultori after Mantegna,
Allegory of Servitude.

Follower of Marcantonio
after Raphael, *A Warrior*.

Inigo Jones, *Albanactus*, preliminary
sketch for *Albion's Triumph*.
Devonshire Collection, Chatsworth.

Adamo Scultori after Michelangelo,
Male Nude from the Sistine Ceiling.

Inigo Jones, *Heads*, from *Sons of Peace*,
for *The Triumph of Peace*.
Devonshire Collection, Chatsworth.

Marcantonio Raimondi, *Trajan between the City of Rome and Victory.*

Marcantonio Raimondi, *Lion Hunt.*

Odoardo Fialetti, *Heads*, from *Il vero modo et ordine*.

Inigo Jones, *Heads*, from the *Roman Sketchbook*.

Inigo Jones, *Drawings of Heads*. Devonshire Collection, Chatsworth.

reversing the method of the manuals – the Albertian method of *compositione* – turning away from complete compositions, and instead making analytical excerpts from them, sometimes figures or heads, sometimes limbs or just hands and feet. Two different types of composition are analysed in this way – elaborate *storie*, such as Michelangelo's *Last Judgement*, and smaller, more intimate groupings in the etchings of Parmigianino and his follower Schiavone.[77] It is the second type which reveals the most obsessive aspect of Jones's renewed interest in figuration.

Parmigianino's own etchings are very few; but the corpus had been enlarged by the imitations, revisions and pastiches of them made by Schiavone. Mariette recorded a tradition that Jones, pursuing an interest in Parmigianino, collected as many prints by Schiavone as he possibly could.[78] In the compositions of both, it is often the posing and relation of the heads which provide an essential formal dynamic, and this is what especially caught his interest. In his Vasari, he made a note of what was said to be one of Raphael's singular talents, 'il dono della grazia delle teste', 'the gifte of the grace in heddes'.[79] There is every indication that Jones (like many others) of all the Cinquecento revisions of the *maniera* of Raphael found Parmigianino's the most compelling. The result was a large number of late drawings of heads, posed and composed in a style with strong affiliations to Parmigianino's version of Raphael (p. 178).

These appear to belong to the later 1630s and the 1640s, by which time the Civil War had put a stop to the court masques, and Jones's self-education in the 'arts of design' was probably diverted into the study of fortification.[80] We can imagine that he remained, in the words of a much later artist from another country, 'mad about drawing'. His creative mania for figuration, potently exercised over many years on the grandest scale, now had to express itself in a multiplicity of gratuitous, intimate studies, in which the same motifs were often repeated, varied and refined. His fall from monumentality is into miniaturism, paradoxically the strongest tradition of English figurative art. Whether he made any special impact there, as for example Van Dyck did on Samuel Cooper, we do not know.[81] In any event the major impact had already been made, by his conceptually and stylistically powerful representations of the most powerful figures in the state.

8

'Tis Pity She's a Whore: Representing the Incestuous Body

SUSAN J. WISEMAN

I

SORANZO.	Tell me his name!
ANNABELLA.	Alas, alas, there's all.
	Will you believe?
SORANZO.	What?
ANNABELLA.	You shall never know.
SORANZO.	How!
ANNABELLA.	Never; if you do, let me be cursed.
SORANZO.	Not know it strumpet! I'll rip up thy heart and find it there.
ANNABELLA.	Do, do.[1]

In this speech from Ford's mid-seventeenth-century play *'Tis Pity She's a Whore* there are a number of gaps between what is presented on stage and what might be called the 'meanings' of what is happening in relation to cultural contexts.[2] The story so far is that Soranzo is one of Annabella's suitors. She agrees to marry him because she is pregnant with her brother's child. Soranzo has discovered Annabella's pregnancy, but he does not know that the father is Giovanni. This exchange, therefore, draws our attention to several aspects of the play. Firstly, Soranzo's questioning dramatises the impossibility of knowing about incest from the evidence of the pregnant body; for the body does not of itself disclose the identity of the child's father, let alone the nature of the relationship between the two parents. Secondly, the conversation alerts us to the marital and legal structures governing the body, especially the female body, as the reference to a curse suggests the religious strictures which regulated sexual behaviour. Thirdly, and more generally, Annabella's body is subject to violent handling. The dialogue calls attention to the physical body, and its sexual significance is displayed to the theatre audience. Additionally, the idea of ripping up Annabella's heart to discover the name of the child's father there reminds the audience of the

earlier incestuous exchange of vows between Annabella and her lover/
brother Giovanni, while simultaneously echoing the rhetoric used in a
lovers' exchange of hearts. The audience are in possession of these facts,
but they also watch scene after scene in which the knowledge of incest is
denied, concealed or re-read through the linguistic and dramatic struc-
tures of the text.

'Tis Pity She's a Whore was written for the theatre, but the relationship
between the making of meaning in the theatre and its cultural context is
problematic. Meaning in the theatre is itself destabilised by the com-
plexity of theatrical representation and its use of a written or spoken text
in combination with other sign systems (gesture, staging, etc.), which
may support or contradict the linguistic text (obviously these con-
tradictions are sometimes inscribed within the script itself). One way of
formulating this is to separate linguistic and other signifiers. As the
theatre semiotician Veltrusky put it, 'In theatre, the linguistic sign system,
which intervenes through the dramatic text, always combines and
conflicts with acting, which belongs to an entirely different sign system.'[3]
An example of this is the way in which, in Act I, Scene i, we see Annabella
make a choice of Giovanni after a sequence of lovers have appeared and
either been discussed or themselves paid suit. We, the audience, know
that the 'truth' of any liaison between sister and brother must be an
incestuous one, but as Kathleen McLuskie says, the script's 'structure of
the lovers rejected and a lover chosen leads the audience to accept
Annabella's choice in spite of the startling danger of incest'.[4] However,
this pattern of theatrical structure which makes Giovanni into a lover
(and Giovanni's later use of language which makes their love into a
platonic union) operates throughout in tension with the audience's
knowledge of the confounding of nature and culture, self and other,
which takes place in the incestuous act. It could be argued that the
theatre, because of its specific representational status, offers a case study
in the containing and naturalising function of sexual discourse. All the
way through *'Tis Pity She's a Whore* the audience hear words and see
actions on stage which do not correspond to what they 'know' in terms of
culture. Although the experience of an audience depends on specific
historical circumstances, for both a contemporary and an early modern
audience, this play would present a contradiction or paradox between a
script (using or gesturing towards legal, religious, platonic or civil
language to misdescribe incest) and the problem of assignable cultural
meanings attached to a body on stage.

'Tis Pity She's a Whore offers a reworking of the familiar family

drama of Renaissance tragedy. It extends the complex triangles of desire and specifically the sister-brother relations found in plays including *Measure For Measure, The Duchess of Malfi* (published in 1623 with a commendatory verse by Ford), James Shirley's *The Traitor* and Ford's own *The Broken Heart*. This essay uses *'Tis Pity She's a Whore* to examine the relationship between the body and the languages (of, for example, love, law and sin) used to describe it in the English Renaissance. A central question is: what was the significance of incest and the incestuous body in the mid-seventeenth century? Moreover, what relationship can be seen between incest in a theatrical text and in other kinds of writing about sexuality, such as legal and religious discourse, or conduct manuals? Although the play is set in Parma, it is used here to raise questions about English theatre and the regulation of sexuality.[5]

During the Renaissance, a range of (masculine) discourses and institutions claimed to give the body symbolic meaning. Peter Burke's definition of 'culture' as 'a system of shared meanings, attitudes and values, and the symbolic forms (performances, artefacts) in which they are expressed or embodied' offers some scope for the discussion of dramatic and particularly theatrical representation in relation to other 'symbolic forms'.[6] Access to the past, however, is notoriously problematic, and different sign systems cannot easily be read as equivalent or arbitrarily connected. There must inevitably be important differences in the ways in which legal documents and dramatic and theatrical texts treat and utilise the symbolic representations of incest.[7]

It has been argued by both historians and cultural historians that during the seventeenth century privacy became an issue for the individual, while at the same time it also became evident that the body of the individual was claimed not only by the individual her-or-himself and by the church, but also by the state.[8] Michel Foucault and Robert Muchembled have argued that the period 1500–1700 saw a cultural change which produced a nexus of new ideas about family life and licit and illicit sexual behaviour.[9] More cautiously, Martin Ingram concludes that 'these changes add up to a significant adjustment in popular marriage practices and attitudes to pre-marital sexuality'.[10] What the historians do not address is the relationship between these societal shifts and Burke's 'performances'. Incest is often represented in early-modern cultural production (theatrical examples include *Hamlet, Women Beware Women, The Revenger's Tragedy*), and incestuous scenarios seem to have been part of the theatre's appeal to public interest. This crime is mentioned in sacred, legal and other secular official discourses, but such

discourses differ in the ways in which they consider incest, and therefore, the meanings assigned to incest differ between legal documents and dramatic or theatrical texts.

Writers including Stephen Greenblatt, Natalie Zemon Davis and Lisa Jardine have tried, in different ways, to negotiate the relationships between different kinds of texts within a field of discourse. Stephen Greenblatt writes of sexual discourse as 'a field which in the early modern period includes marriage manuals, medical, theological and legal texts, sermons, indictments and defenses of women; and literary fictions'.[11] Granted that most texts in this field attempt to keep the meanings of sexuality stable and ordered, are all these different writings on sexuality equivalent? Can the semiological systems of a theatrical text 'read' in the theatre be equated with a marriage manual?

One of the most obvious discourses about sexuality is found in conduct books by writers such as Gouge and Tilney which describe and prescribe marital arrangements and the proper ordering of sexuality within the domestic sphere.[12] The discussion of incest in Bullinger's *Christian State of Matrimony* (1541) mediates between Biblical meanings of incest and the implications of the incestuous body in Christian civil society:

he that hath not a shameless and beastly heart doth sure abhorre and detest the copulations in the said forbidden degrees. Honesty, shamefastness, & nurture of it self teacheth us not to meddle in such: therefore sayeth god evidently and playnly in the often repeated chap. Levi. xviii Defile not your selves in any of these things, for with all these are the heathen defiled, who I will cast out before you. The land also is defiled therethrowe: & I will visit their wickedness upon them, so that the land shall spew out the inhabitours thereof.[13]

Here both nature and 'nurture' are outraged by incest and associate it with both the heathen and with the rebellion of the land itself, which casts out those who commit it. For the literate these words would echo the commonplace interdictions of Leviticus and the tables of consanguinity and affinity found on church walls. It is a helpful passage in that, like *'Tis Pity She's a Whore*, it discusses copulation rather than attempted marriage, as tends to be the focus of legal documentation, which concentrates on relationships of affinity rather than consanguinity. The connections between texts like this one, prescribing the regulation of the body, with legal records and theatrical representation constitute the complex formation through which ideas of sexuality circulate in language.

In a seventeenth-century context, incest became known through the religious language of confession, as it does in Ford's play through

Giovanni's and Annabella's confessions to the friar, and Putana's secular confession to Vasques (IV. iii). Confession is needed for the church and law to assign meaning to an individual body in its social context, as the mere body in front of an audience is not self-explanatory. Even a pregnant body does not tell all its own secrets, and incest is undiscoverable from external evidence. Nevertheless, contemporaries did link sexual irregularity to external signs: in the early-modern period what was perceived as sexual laxity or deviance was associated with monstrous births. According to manuals of sexual conduct, such as the later *Aristotle's Masterpiece*, these births indicated indulgence in sexual extravagance or misbehaviour, for example intercourse at an 'inappropriate' time in a woman's menstrual cycle. Manuals such as the *Masterpiece* did not link incest explicitly to monstrous birth, but their illustrations do mythologise the dangers of forbidden liaisons, picturing, for instance, the offspring of a woman and a dog.[14]

Incest was of two types: affinity (sexual relations or intermarriage with non-blood relatives with whom there was a problem because of inheritance) and consanguinity. Lawrence Stone concludes that incest 'must have been common in those overcrowded houses where the adolescent children were still at home'.[15] He also writes that 'all known societies have incest taboos, and the peculiarity of them in England was the restriction of their number at the Reformation to the Levitical degrees'. Moreover, he suggests that the fact that the punishment for incest was 'surprisingly lenient' indicates that sodomy and bestiality were accounted crimes of greater seriousness. Incest was not declared a felony until 1650, before which – like adultery and fornication – it was investigated, tried and punished by ecclesiastical authorities. Furthermore, incest tends to appear in the records only when people were caught or accidentally married within prohibited degrees, for which latter offences pardons were granted. In 1636 Sir Ralph Ashton in Lancashire was punished for having adulterous sex with a woman and her niece. In the same year Elizabeth Sleath and her father, by whom she had had a second child, received 'severe chastisement' at the house of correction before being sent for further punishment.[16]

As Stone reminds us, information about 'sexual conventions' is hard to find. However, the law does offer certain insights into the possible fate of sexual offenders and particularly the female body. Bastardy provides a paler analogue for it in that the single woman's pregnant body partly confesses her crime; fornication and bastardy were meanings attendant upon her pregnancy, but the body of a woman would not reveal the

father to whom the parish might turn to require economic support for the child. If a woman had committed fornication, she might be declared a common whore and punished with banishment by some church authorities.[17] She might be put on good behaviour for a year, fined, whipped, put in the stocks and required to confess, wearing a white sheet in front of the church. Such punishments appear to reflect the economic, familial, physical, social and symbolic values associated with cases of women contravening the imperative to be chaste. The nature and sites of the punishment indicate the issues at stake.

In cases of bastardy where children were actually born rather than merely conceived outside wedlock, paternity was investigated by two Justices of the Peace. In 1624 a statute was passed whereby women who gave birth to an illegitimate child that would be dependant on the parish might be sentenced to one year's hard labour. Collective dishonour and financial burden seem to have been the crux of the matter for the parish, and the Justices were entitled to find ways of keeping the child off parish relief. As the body of the woman did not reveal the child's father, pregnant women could be subjected to mental and physical torture to elicit a confession of paternity. The Justices were also entitled to punish the parents by whipping, which could be done in the marketplace or in the street where the offender lived, as well as in the house of correction.[18] In cases of fornication and bastardy, illegal sexual conduct is revealed physically in the pregnancy of the woman. The symbolic *meaning* of bastardy, however, like incest, was only made evident by the woman's confession and in the demonstration of her body and her physical punishment at church and market, sites of central importance in civil and religious society. For example, in 1613 one Joan Lea was to be 'openly whipped at a cart's tail in St John Street . . . until her body be all bloody', and in 1644 Jennett Hawkes was ordered to be 'stripped naked from the middle upwards, and presently be soundly whipped through the town of Wetherby'.

Incest, however, is a much more extreme and confused crime, in which the woman must confess paternity in order that the crime be known. Her body does not reveal the implications of its condition. Without confession the meaning of incestuous sexuality remains hidden. Without confession the sin cannot be identified and confirmed by the religious, financial, civil and familial discourses which converge to declare the (female) body sinful and which look for signs of its crime in the way Soranzo does in the speech quoted at the beginning of this essay. When incest is confessed, however, it merely exposes further and greater

confusions surrounding the means of reproduction. Unlike the con-
fession of paternity in the case of bastardy when the naming of the father
clarifies a situation and enables the child to be socially placed, the naming
of the father in the case of incest multiplies familial and social connec-
tions in incompatible ways. Incest and the child of an incestuous
relationship have too many, contradictory meanings.

One theorisation of the meanings of incest is offered by Jacques
Derrida, who takes incest as the example of a sign which confuses the
oppositional status of 'nature' and 'culture'. Incest troubled Lévi-Strauss
because it fitted the categories of *both* nature and culture, and Derrida
comments, 'It could be perhaps said that the whole of philosophical
conceptualisation, which is systematic with the nature/culture oppo-
sition, is designed to leave in the domain of the unthinkable the very thing
that makes this conceptualisation possible: the origin of the prehistory of
incest.'[19] One of Derrida's aims here is to attack the truth value of
philosophical concepts, which he sees as created by the pre-conditions
which govern how any given discourse produces knowledge. We might
see this remark as offering a way to read incest in *'Tis Pity She's a Whore*,
where different discourses converge to make meanings around Annabel-
la's and Giovanni's sexual relationship which actually serve to *conceal*
the 'truth' of their incest.

For example, Giovanni's language in the early part of the play has two
results. It confuses the categories of nature and culture and erases the
confusions caused by incest through an appeal to 'beauty' as a 'natural'
producer of desire and therefore as an endorsement of that desire. Where
other signifiers such as 'heart' are expanded in the play to operate at a
complex and ambiguous level of meaning, the idea of incest constitutes
what we might call the absent centre in Giovanni's discourse, the hidden
precondition of his platonic language.

II

In *'Tis Pity She's a Whore* the female body is represented as an ethical,
financial, spiritual, amatory and psychological territory. Annabella's
body, the procreative feminine corpus, is located and relocated within
these competing ways of looking at the body. The poetic language of love
and service used by Soranzo and Giovanni serves to conceal or blur the
illicit nature of the physical love that they describe, and to misrepresent
the social and economic position of the women courted. It is the
relationship of women to sex, money and language that actually
determines the outcome of the sexual relationships presented in the play.

This is made evident in Act II when Soranzo in his study considers adapting an encomium to Venice for Annabella.

> SORANZO. Had Annabella lived when Sannazar
> Did in his brief encomium celebrate
> Venice, that queen of cities, he had left
> That verse which gained him such a sum of gold,
> And for one only look from Annabell
> Had writ of her, and her diviner cheeks.
>
> (II. ii. 12–17)

Economic exchange is here implicit in the rhetoric of praise. Part of the project of courtly love is to redefine transgressive, physical acts of love and to transform what is, say, adultery in the discourse of civil society, into platonic union in the language of patronage.[20] This language operates within an economy of patronage in which 'service' and 'duty' are rewarded. We might think of the contract of the luckless Pedringano in *The Spanish Tragedy*, or Beatrice-Joanna in *The Changeling*. In *'Tis Pity She's a Whore* this ends with literary language made literal in the ripping up of Annabella's heart.

The play indicates the duplicitous implications of the language of courtly love in the words of Soranzo and Giovanni. Soranzo appeals to Annabella in terms of courtly love (e.g. III. ii and the scene with Hippolita in II. ii). Giovanni similarly employs the comparative language of courtly love, notably in a scene of courtship (I. ii). It is here that two important metaphors are first encountered, that of the power of the gaze and the trope of the heart on which truth is written. The power of the gaze is attributed, in the terms of courtly love, to the mistress/sister (although, of course, the agent of attribution is Giovanni). Moreover, the scene suggests the legend of Prometheus, another myth of origins, crime and death:

> GIOVANNI. ... The poets feign, I read,
> That Juno for her forehead did exceed
> All other goddesses: but I durst swear
> Your forehead exceeds hers, as hers did theirs.
> ANNABELLA. Troth, this is pretty!
> GIOVANNI. Such a pair of stars
> As thine eyes would, like Promethean fire,
> If gently glanced, give life to senseless stones.
>
> II. ii. 192–8)

This culminates in Giovanni bearing his breast:

> GIOVANNI. And here's my breast, strike home!
> Rip up my bosom, there thou shalt behold
> A heart in which is writ the truth I speak.
> (II. ii. 209–11)

It is, however, Annabella's body rather than Giovanni's which comes to bear the meaning of their transgression. In this text the word 'heart', and her heart in particular, is a nexus of several different discourses. Moreover, the significance of Annabella's body is repeatedly transformed during the play by the powerful discourses which are here beginning to define it. This process locates the meaning of the female body within the dominant discourses of religion and courtly love, and her act of will in committing incest with her brother is ultimately subsumed into the civil discourse of whoredom.

If the language of courtly love serves as a structure to conceal, by reinterpreting, Giovanni's and Annabella's incest, where does the act of incest appear in the discourses of the body which permeate *'Tis Pity She's a Whore*? Perhaps it is closest to being openly articulated in Act I. This introduces the 'uncanny' disclosure of hidden desire in Annabella's recognition of her sexual attraction to her brother (her platonic 'mirror' as he later notes) when she sees his 'shape' momentarily as an object of her desire without recognising it as her brother.[21]

> ANNABELLA. But see, Putana, see; what blessed shape
> Of some celestial creature now appears?
> What man is he, that with such sad aspect
> Walks careless of himself?
> (I. ii. 131–4)

When Putana looks and tells Annabella that it is her brother, she exclaims 'ha!' Quite the reverse of Giovanni's confessional disquisition on his incestuous passion, this exclamation marks textually the recognition of desire but also the danger attendant upon it. This moment of recognition of 'something secretly familiar' is reminiscent of the repeated moments of recognition in the story of the Sand-man retold by Freud in his essay on the uncanny.[22]

Also, like Oedipus's self-blinding, it suggests the dangerous closeness of the double, more fully articulated at a linguistic level in the scene of the vows (I. ii. 253–60). The association between sight and desire is made explicit here but receives fuller elaboration later in the play when it is Putana who is blinded. For she has both 'seen' (metaphorically) Annabella's and Giovanni's act of love and has spoken of it. For Freud, blindness and damage to the eyes is a metaphor for castration. Putana, in seeing,

sanctioning *and* speaking about the sexual union of Giovanni and Annabella, appropriates the rights of the law, the father and the Church. She takes over the role of the receiver of confessions and maker of meanings in relation to the incestuous union. However, she also recognises that the meanings she offers for incest (in which female desire is of paramount importance) cannot be spoken in the public sphere. Putana's language is that of the individual acting pragmatically in civil society, but outside the law, as at II. i where she joins with Annabella in concealing the incest, saying, 'fear nothing, sweetheart; what though he be your brother? Your brother's a man, I hope, and I say still, if a young wench feel the fit upon her, let her take anybody, father or brother, all is one' (II. i. 46–9).

Thus during most of the play the languages of courtly love, platonism and pragmatism are substituted for that of incest. Simultaneously, in a series of episodes, blame and punishment are transferred from the central figures of higher social class on to the bodies of those of lower or more marginal status. These threads in the plot act almost as substitute punishments: lesser transgressions receive harsh punishment while incest remains at the centre of the play, invisible and unspoken.

An example of such a replacement can be found in the figure of Hippolita and the language associated with her. Hippolita, the 'lusty widow', has been drawn by Soranzo's seduction into adultery and attempted murder. She has previously entered into a relationship with Soranzo, and in the play we watch and hear Soranzo redefine their relations, *not* in the codes of courtly love but in the sacred (and civil, or pragmatic) vocabulary of adultery, sin and repentance. She appears in Soranzo's study when he is composing the courtly encomium we saw earlier:

> HIPPOLITA. 'Tis I:
> Do you know me now? Look, perjured man, on her
> Whom thou and thy distracted lust have wronged.
> . . .
> Thine eyes did plead in tears, thy tongue in oaths
> Such and so many, that a heart of steel
> Would have been wrought to pity, as was mine:
> (II. ii. 26–38)

In this first interview with her Soranzo exchanges the language of courtly love, used to compose the poem to Annabella, for that of Christian repentance, used to justify giving up Hippolita:

> SORANZO. The vows I made, if you remember well,
> Were wicked and unlawful: 'twere more sin
> To keep them than to break them.
> (II. ii. 86–88)

He appropriates whichever code serves his purpose, and the abandoned mistress of the language of courtly love becomes the 'whore' (a term which might signal a casual partner) and an adulteress in that of Christian repentance. The language of service and courtship reappears strangely distorted when Soranzo says, 'Ere I'll be servile to so black a sin,/I'll be a corse' (II. ii. 97). The dramatic irony implicit in this speech reminds us that Hippolita's crime and punishment contrast with the greater, central significance accorded culturally to incest. Soranzo's service to adultery is substituted by his service to incest. Once more what we see and hear is in tension with what we know.

The scene demonstrates masculine control over the discourses which produce the meanings of female sexuality. This example of femininity defined and redefined by masculine control of the languages of religion and law is repeated at IV. i. Momentarily, Hippolita appears to have taken control of the meaning of the masque for her own vengeful intentions. She and the audience discover at the same moment that she has been betrayed by the language of revenge, through the agency of Vasques, the manipulator. Her attempt to control the codes of masque and revenge for her own ends causes her to be, in Vasques's words, a 'mistress she-devil', whose 'own mischievous treachery hath killed you' (IV. i. 68–9). Although she is defeated, the language of her final curse on Soranzo is prophetic: 'Mayst thou live/To father bastards, may her womb bring forth/Monsters' (II. i. 97–9). Yet again a substitution occurs in the dramatic irony of the prophecy. The audience recognises the displacement of the central issue, incest, by the peripheral and structurable issue of bastardy, and the reference to 'monsters' reminds us of other criminal expressions of sexuality.

The replacement of incest by other language in the play as a whole is indicated most obviously by the fact that the word is rarely enunciated. Just before the play opens Giovanni has confessed incestuous desire to the Friar and made himself 'poor of secrets', though he remains rich in desire. During his post-confessional conversation with the Friar, Giovanni begins to elaborate the secular theory of beauty, fate and desire which is soon to find its elaborate ritual expression in the vows he and Annabella take by their mother's 'dust'.

The lovers themselves do not name their incest, though the Friar finally names it to Annabella in III. vi. Annabella does not utter a description of her own actions until she repents in Act V, and then she speaks of Giovanni: 'O would the scourge due to my black offence/Might pass from thee, that I alone might feel/The torments of an uncontroll'ed flame' (V. i. 21–3). The language describing Annabella's body and interpreting the incestuous desires and actions of the siblings (for actors and audience) has for most of the play been that of courtly love, Neoplatonism and the pragmatic discourse of Putana. Annabella here confesses her actions:

> ANNABELLA. My conscience now stands up against my lust
> With depositions charactered in guilt, [*Enter Friar*]
> And tells me I am lost: now I confess,
> Beauty that clothes the outside of the face
> Is cursed if it be not clothed with grace.
> (V. i. 9–13)

This moment not only offers us access to Annabella's subjectivity, in which lust and conscience are coterminous, but refers us to signifiers which also existed culturally during the Renaissance; the pun on guilt/gilt points to the interpretation of incest in society by returning us to the tables of consanguinity figured in the the prayer book and on church walls. Annabella's confession fuses for a moment the problematic language of the play which refuses to reconcile incest and the interdiction available to any church-goer. Moreover, we find in this speech not an opposition of inner and outer, but a contrast of surfaces in which grace becomes a kind of clothing. In its concentration on surface and externals the language serves to call attention to the social and cultural construction of the sequence of sin and repentance, further underlined by the entrance of the Friar as eavesdropper/audience.

In the final act of the play the word 'incest' is used in the discourse of Parmesan society. Vasques says the word, and so does the Cardinal: its articulation by these two ambiguous figures is accompanied by the ritual punishment of offenders. Giovanni at this point makes literal the discourse of courtly love using the symbolism of the exchange of hearts in describing his murder of Annabella. His reappearance bearing the bloody organ cannot be interpreted by the characters on stage. For on the one hand the appearance of the real heart makes literal on stage the discourse of courtly love, yet on the other hand it makes evident the inability of this discourse to contain, explain or give meaning to incest, which has a meaning so much more illicit than that of, say, adultery.

The enigmatic but mobile figure of Vasques plays a central role in exposing the faults of women, especially in the final stages of the play. It is only in Act V that we find that Vasques, who hears the confessions of both Hippolita and Putana, is acting for the Father – for Soranzo's father, thence for Soranzo, and therefore for the determination of meaning in relation to the father, law and religious discourse. When, at last, Vasques offers an 'explanation' (or confession) of himself, he says 'this strange task being ended, I have paid the duty to the son which I have vowed to the father' (V. vi. 111–12). In a short prose speech he 'explains' his conduct:

> VASQUES. For know, my lord, I am by birth a Spaniard, brought forth my country in my youth by Lord Soranzo's father, whom whilst he lived I served faithfully; since whose death I have been to this man, as I was to him. What I have done was duty, and I repent nothing but that the loss of my life had not ransomed his.
>
> (V. vi. 115–21)

Vasques's manipulation of language has permitted him to act as a confessor to the women, who are lured into telling him their secrets and thence, through language, brought to their downfall. It is he who has already (at this point) ordered Oedipus's punishment to be inflicted not on Annabella or Giovanni but on Putana.

The uncanny recognitions of incestuous desire in Act I are mapped more fully here when Giovanni reveals to his father the doublings brought about by incest – 'List, father, to your ears I will yield up/How much I have deserved to be called your son' (V. vi. 37–8). The Oedipal punishment for incest is transferred from the male to the female body, as well as down the social scale. Vasques names Putana as 'of counsel in this incest', and he renders up Putana, 'whose eyes, after her confession, I caused to put out' (V. vi. 127–8). In Act I Giovanni endowed the eyes of his mistress with the power to give life, linking this to Promethean fire. In Act V, the only possible reason that Putana's eyes are burnt out is because she has been witness to the incestuous passion. The importance accorded to knowledge at this point in the play suggests the power of incest to confound the boundaries of nature and culture and thus elide any clear distinctions between self and other. The maiming of Putana keeps incest hidden by removing it 'from sight'.

What follows has been disputed by critics. The Cardinal, who is both a Churchman and a powerful manipulator of the language of the city, begins his summing up:

CARDINAL. Peace! First this woman, chief in these effects;
 My sentence is, that forthwith she be ta'en
 Out of the city, for example's sake,
 There to be burnt to ashes.
DONADO. 'Tis most just.

 (v. vi. 133–7)

Soon after this Vasques is banished 'with grounds of reason', but not because of his crime. It is not entirely clear who is to be burnt. Two women are on stage, the body of Annabella and the blinded (but living) figure of Putana. It seems likely that it is Putana who is the object of the Cardinal's sentence. In delivering his judgement he takes the figures in reverse order, moving from the bottom of the social scale to the top. He turns to Annabella last. Moreover, he and Vasques have just been talking of Putana, who appears to remain on stage until the end of the play. Donado – another wronged father – is given responsibility for the burning of whichever body it is, and it seems unlikely that he would be given rights over Annabella's body in preference to her father. Thus, it seems to be Putana who is pronounced 'chief in these effects'. As Hippolita is punished by civil society for sharing Soranzo's desire, so Putana is punished by a combination of church and state for seeing and knowing but, above all, telling. The Promethean fire of Act I is translated into the purgative fire of Act V.

If Putana is to be burnt, how can the body of Annabella be read in the final scene? Her brother has taken her heart and the significance of this is explored in metaphors of consumption:

GIOVANNI. You came to feast, my lords, with dainty fare;
 I came to feast too, but I digged for food
 In a much richer mine than gold or stone
 Of any value balanced; 'tis a heart,
 A heart, my lords, in which mine is entombed:
 Look well upon 't, d'ee know 't?
VASQUES. What strange riddle's this?
GIOVANNI. 'Tis Annabella's heart, 'tis; why d'ee startle?
 I vow 'tis hers: this daggers point ploughed up
 Her fruitful womb, and left to me the fame
 Of a most glorious executioner.

 (v. vi. 23–33)

We know that Giovanni and Annabella have been lovers for 'nine moons', but we do not know when she conceived. It would be possible to play Acts IV and V with her very heavily pregnant. Annabella's body is first exposed to violence when she becomes pregnant, and the wound by

which she was murdered might run from her womb to her heart in the cut an anatomist might use to open a body. Many signifiers converge on Annabella's body. It is food, or has food buried within it. It is simultaneously a mine, an evidently vaginal image, in which Giovanni has 'digged' and found something more exotic than the minerals yielded by mining in distant places, a heart. The heart is her body, but it also signifies his heart within her breast. Her body is a rich vagina-womb-mine, but also a burial ground (ploughed up) from which Giovanni must disinter *his* buried heart. The uncanny doublings of the vows come to a mordant fruition here. The child is cut off and the womb invaded, not by a doctor extracting a child but by the brother-lover in search of her heart which signifies him, his identity. The vows, sworn by Annabella 'by our mother's dust', by Giovanni 'by my mother's dust', (I. iii. 254, 257), are fulfilled here as Giovanni possesses and consumes singly all those relations which have become so doubly double.

The opposition here is between inner and outer, and between surface and depth (unlike the metaphors in Annabella's speech of repentance above). The heart, now exposed, is endowed by Giovanni's public confession with all the private and confused meanings of incest. At one level, of course, it is a religious emblem and the emblem of the lover's heart, but like Annabella's dangerously pregnant body, the flesh itself cannot be completely interpreted without language.[23] Giovanni stands on stage with a dripping heart, but the meaning of the murder is constructed by language. Evan Vasques, that underminer of plots and reader of signs, cannot answer this sphinx's incestuous riddle. He, however, returns to the stage to inform the feasters that Giovanni has, indeed, ripped out Annabella's heart. It is possible to read Giovanni's final confession, or explanation, of her heart as once again re-inventing the meaning of his love, and of Annabella's body, for he concentrates the illicit multiplicity of relations on her heart. If we read the end of the final act this way, it comes as no surprise to find that when the Cardinal finally mentions Annabella's sin, he does not speak of all those double meanings Giovanni had elicited from her body in that half-emblem, half-meat, her heart. The Cardinal's address transforms the incest once again into something containable within the single realm of culture when in the closing words of the play he pronounces, ''tis pity she's a whore'.

This phrase reconstitutes the dominant position of family, state and the church within society. Simultaneously, however, it calls attention to the failure of the secular and sacred languages used in the play to contain or reinterpret incest.[24] The bodies of the incestuous couple have been

represented by the lovers themselves (particularly Giovanni) in the languages of courtly love and Platonism. The Cardinal's words appear to be a bid for closure, marking a point at which the irreconcilable nature of the conflicting claims of church, state, family and economics on the body – particularly the reproductive body – fail to be resolvable and fail to verify and stabilise the meaning of incest.

Incest, which is the central concern of the play, disappears once more in the Cardinal's words which reinstate the social placing implicit in the designation 'whore'. The centre, for Derrida, is 'the point at which the substitution of contents, elements or terms is no longer possible',[25] and incest signals the collapse of the structure of separateness between bodies and families. Instead of substitution there is doubling. In the Cardinal's closing line of the play (also the title) the waters of language return to cover incest and to substitute a crime which allows the meanings of femininity to remain stable. Annabella is returned from incest to the dangerous (but less dangerous) general category for the desirous female. As a 'whore' Annabella once again signifies within the problematic of endless female desire.

However, the Cardinal's closing words leave unresolved the theatre of competing demands which the play has articulated. The tension between what we hear ('whore') and the incest which we 'know' to have taken place remains. His words present another riddle which, by asserting one of the meanings of Annabella's dead body, throws into relief all the others which remain unspoken.

III

The competing discourses of the play are interwoven with its context, but are not reducible to 'sources': they are re-invested with new meanings in the 'symbolic performance' of theatre.[26] The body alone has no meaning. But the question of what happens to the body in a play such as *'Tis Pity She's a Whore* and what gives that body meaning is complex. How is a critic to interpret the body in a play? For an anatomist, meanings exist within the body, but in the theatre only the combination of script and other codes makes the meaning of the theatrical figure. Obviously, much depends on production decisions, but the relationship between text and context is important, if fraught. As Roger Chartier says;

To understand a culture . . . is above all to retrace the significations invested in the symbolic forms culture makes use of. There is only one way to do this: to go back and forth between texts and contexts; compare each specific and localized use of one symbol or another to the world of significance that lends it meaning.[27]

Put this way, the relationship of text to context is very complicated for symbolic bodies in the theatre, with all their precarious and slippery meanings. The context can only be other texts, other bodies in texts and the field of discourse within which these textual bodies exist.

Of course, it is not possible to talk with the dead, or to fully re-animate a field of discourse of which literary language is only a part.[28] Nor is it possible to work out exactly how the seventeenth-century theatre audience for 'Tis Pity She's a Whore made the leap from their own experience of sexual crimes in the community to an analysis of a symbolic performance. According to Derek Hirst, policing of 'the proper order of personal relationships' in early modern England was part of the role of neighbours, and this included regular denunciations for sexual deviance. Hirst suggests that as many as one person in seven might have been denounced by neighbours for sexual deviance.[29] This might lead us to ask how we can begin to imagine the relationship between an audience who participated in such a very active neighbourhood policing and the incestuous bodies in 'Tis Pity She's a Whore.

One answer must be to compare the play with other texts in a similar field (what, for instance, might a theatrical text share with legal texts, conduct books, etc.?). Another might be to attempt to identify the specific purposes and investments of a particular discourse, which might not be shared with other texts in the field. For example, Michael MacDonald's recent study of suicide suggests that the significance of self-murder changed with the rise of the newspaper. He suggests that eighteenth-century newspapers 'altered the reader's relationship to events: attitudes to crime, like suicide, were increasingly determined by reading, rather than by direct experience and by rumor'.[30] The news-paper, with its pretensions to forensic veracity, might fix and report 'facts' for private consumption; the theatre, with its reputation for tempting fictions, might endow the body with an ephemeral plethora of meanings. Thus, evidence from texts in a similar field help to illuminate the script of the play, and we can to some extent move between text and context to map a loose set of relationships between punishments in the ecclesiastical courts and the significance of the body in the theatre. Yet, in both the theatre and the church court the body on display does not reveal its own significance. Without explanation from script, set and costume the body of a pregnant woman cannot be fully 'read' either by the figures on the stage or by the audience. Veltrusky, quoted at the beginning of this essay, suggested that script and the actions of the body on stage were parts of independent discourses. He went as far as to say that the body on

stage and the dramatic text (language) belong to completely different sign systems; as he sees it, the dramatic text, where it exists, can control everything except the actor.[31] This makes it possible to regard the incestuous body in *'Tis Pity She's a Whore*, with the attendant gaps and misrepresentations in the script, as being constituted by the cultural understandings of the audience in relation to the interdependent contexts of analogous texts and theatre practice.

9

Self-Fashioning and the Classical Moment in Mid-Sixteenth-Century English Architecture

MAURICE HOWARD

In 1603, Henry Percy, ninth Earl of Northumberland, was contemplating new building works at his house at Syon, on the Thames near London. He had much to learn about architecture and determined to cast his net wide. In a letter to Sir Robert Cecil written about this time, he outlined a programme of visits to the houses of his fellow aristocrats, describing himself as 'ready to go, and see Copthall, for now that I am a builder I must borrow of my knowledge somewhat out of Tibballs, somewhat out of every place of mark where curiosities are used'.[1] This 'borrowing of knowledge' might seem, on the face of it, to suggest a lack of seriousness of purpose or a weakness for the whims of fashion. Indeed, earlier sixteenth-century critics had seized upon changing fashions in architecture as signs not only of aristocratic pretentiousness and profligacy but also of a neglect of the practical concerns of sound and lasting building.[2] Modern historians have similarly been inclined to read the outward ostentation of sixteenth-century architecture and the multiplicity of its sources of ornament as evidence of the lack of an educated visual sensitivity. But this denies the value and the seriousness of purpose of an idiosyncratic solution to a problem of architectural design. Henry Percy was later to amass a significant collection of foreign treatises and books on architecture, adding expertise on building to his already formidable scientific and scholarly reputation. The eclectic approach which the letter to Cecil reveals was part of a serious attempt to display a knowledge of the whole range of contemporary practice and through this construct the patron's self-identity.

One of the reasons why the exterior design of some buildings changed so dramatically in mid-sixteenth-century England was because powerful figures in society needed to respond to the political and social changes which shaped their lives. The rules determining the expression of social

position were constantly changing as political fortunes fluctuated, through contacts and rivalry with foreign courtiers, and through the rapid entry into the highest ranks of many whose origins were outside the old and established aristocracy. Like dress, which displayed a whole range of signals, from the slavish following of the latest foreign ideas to the wearing of the sovereign's colours at Court as a mark of allegiance, the design of buildings had also to be balanced between conformity with the norms of the peer group on the one hand and those marks of individuality within bounds that the peer group understood on the other. In fact, in contemporary moralistic criticism of unnecessary extravagance, dress and building were often yoked together. Twentieth-century eyes may perceive in both an equal concern for the disguise of the surface. The garish painting of early Tudor brickwork and the covering of walls with heraldic and decorative ornament can be matched by the slashed sleeves and the added bands of decorative material sewn onto the basic stuffs of Tudor garments. Like dress, the outward appearance of architecture became part of the act of self-fashioning one's public image.[3]

It is just such an image of an eclectic gathering and display of the tools of knowledge, allied to a convincing physical presence of the patrons through expensive, if carefully appropriate, forms of dress, that distinguishes the painting of the *Ambassadors* by Hans Holbein in London's National Gallery. This image offers an important example for Stephen Greenblatt in a book that has in recent years established more widely the use of the term 'self-fashioning' as a tool of literary discourse. Greenblatt sets out a series of what he calls 'governing conditions' which qualify and set the agenda for the self-fashioning process. One of these conditions 'involves submission to an absolute power or authority situated at least partially outside the self' which can thereby set the ground rules for action or be the paradigm to follow.[4] The Court is only one of the 'authorities' he cites for his subsequent discussion of literature, but in terms of the visual arts the Court was unquestionably the dominant institution, or 'authority', throughout the sixteenth century. This concept of reference to authority is especially useful for the discussion of the buildings with which the present paper engages, because the negotiation that went on around the production of works of the visual arts between a common ground (the 'safe' route of following the currently fashionable) and the individualistic (a more risky enterprise because of the potential charge of overstepping accepted rules of extravagance or breaking the rules of deference) is particularly relevant to architecture.

The moulding of the self-image can be seen in the way that the

buildings of the courtier class made continual reference to the ground
rules laid down by the sovereign, whether actively, as in the case of Henry
VIII or, just as powerfully, passively, as happened with Elizabeth I. While
Henry VIII can be said to have set the pace for the domestic architecture
of his day by his large number of new or refurbished palaces, Elizabeth
was not a significant architectural patron since no new royal palaces were
begun during her reign. Yet the Elizabethan courtier practice of building
to celebrate the monarch, to play the games of deference that were
expected by lavish entertainment of the Court, means that the great
Elizabethan country houses would not have come into being, or would
not have taken on the appearance that they did, without the mythology
that Elizabeth engendered. Thus her 'patronage' of architecture is as
important in sixteenth-century history for her avoidance of direct
involvement as her father's was for his active promotion of royal
building. In both cases, the courtier's self-fashioning was the direct result
of royal policy. When building took place, its character and terms of
reference were 'constructed' with reference to the sovereign's will and
purpose.[5] Under Henry VIII, the royal policy of spectacle and display
through tournaments, receptions and revels as means of celebrating the
power of the dynasty was perpetuated by courtier buildings which
retained something of the visual appearance of the temporary structures
put up for royal occasions. Under Elizabeth I these remained important,
but to them were added the playful display of knowledge and erudition
through the use of intricate geometric forms of plan and ornament,
through the quotation from pattern books kept in all the best courtier
libraries and through the inscription of anagrams or Latin texts on
cornices or roof-lines. The educated gentleman was expected to take an
active interest in matters of architectural theory and show some initiative
in the day-to-day planning and construction of his buildings.[6]

While the role that the sovereign played in the shaping of the
architectural self-identity of courtiers has such a clear purpose under
Henry VIII and Elizabeth I, this surely cannot have been so at that point
in mid-century when there succeeded to the throne first a minor, Edward
VI, and then his half-sister, Mary I: the reigns were too brief; the
structure of court life had little time to take shape. Yet, both historically
and architecturally, this period was one of very positive character, with
seemingly violent changes of direction. Mid-century political history,
thanks largely to the shifts of religious policy that took place and the
economic crisis caused by the debasement of the coinage, has traditio-
nally been characterised as a time of uncertainty, showing an erratic

pattern of policies and changes of personality in power. Recent historians, however, have revised this view, stressing continuities with past and future, even in the heart of political government itself – the Council and the Privy Chamber. The political direction of the period has been given a stronger, less chaotic profile.[7] Recent writing on the reign of Edward VI has pointed to the wider ideological debate that surrounded the Protestant Reformation, made explicit in the large number of books published in which the moral, messianic message of the reformed faith was applied to a variety of current issues. It has recently been recognised that, far from abandoning the potential of imagery to support this material, mid-century literature enjoyed a fertile visual culture.[8] It is interesting that architectural historians have perceived a similar pattern of policy shifts in these years but have noted the marked preference of leading courtiers under Edward VI for a style of architecture that can be read as somehow different from the rest of the century in that it appears to aim at a new visual and ideological purism.[9] This essay will examine that definition of architectural difference and decide whether it can usefully be discussed in terms of the mid-century courtiers' perception of their individual and collective political selves.

What is this architectural difference? Our knowledge of these buildings is fragmentary, due not only to alteration and demolition over the intervening centuries but also, thanks to the political fall (indeed, in most cases execution) of their instigators, because they were left unfinished or were finished at a later date with different architectural priorities. The stylistic common ground for this set of buildings rests on a much stricter adherence to the proprieties of classical architecture than seen previously in England. For example, compared with earlier buildings there was a more exact use of the classical orders of columns and pilasters and a greater precision in the cutting of the appropriate mouldings; this development can be seen in the Doric doorcase of Newark Park, the hunting lodge built for Sir Nicholas Poyntz about 1550 (p. 202), and the use of Corinthian above Ionic in the window added to Broughton Castle by Sir Richard Fiennes in the early 1550s (p. 202). As well, there was the initial appearance of the correct classical loggia articulated by columns or pilasters applied to piers; such a loggia was probably begun by Edward Seymour, Duke of Somerset, on the courtyard side of Somerset House in London, and it is also possible that the mysterious attached column in the stable court at Lacock Abbey, the suppressed nunnery converted for Sir William Sharington during the 1540s, may have been intended as the beginning of a similar construction (p. 203). Again – and in some ways

*The Doric doorcase of
Sir Nicholas Poyntz's Hunting Lodge,
c. 1550. Newark Park.*

*Window added by Sir Richard Fiennes,
early 1550s. Broughton Castle,
Oxfordshire.*

this is the most telling feature of all because it suggests the beginnings of a fundamental understanding of proportion – there was the appearance of windows in an upright format, topped by a classical pediment and placed in an equally-spaced series along the wall surface. These supplanted the earlier standard windows which were wider and positioned only with a view to their function. An example of this kind of window articulation occurs in the seminal building of these years, the Strand facade of Somerset House of 1547–52 (p. 203). Moreover, all these buildings were either built in stone or faced with stone, a marked change from the predominant, earlier Tudor fashion among courtiers for building in brick. Somerset House displayed signs of even further expense, with the incorporation of imported marble pillars into the fabric.[10]

The very fact that these common features are spread across the country

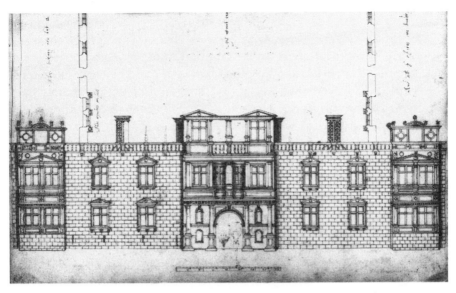

The Strand Front of Somerset House, London, from the drawing by John Thorpe
in Sir John Soane's Museum, London.

Attached column in the Stable Court,
1540s. Lacock Abbey, Wiltshire.

means that quite particular patterns of patronage are at work; earlier sixteenth-century buildings with common features generally cover far smaller geographical areas, suggesting that answers to the problems of the identity of expertise and the organisation of building workshops must be local in character. We know that mid-century courtiers sent their craftsmen long distances to fulfil their common expectations and standards of quality. A well-known example is that of the mason John Chapman, promised to John Dudley, Duke of Northumberland, in 1553 to work on Dudley Castle by Sir William Sharington, who was employing him at Lacock Abbey.[11] Architectural patrons were on the search for the right man, the 'cunning artificer'. The process of piecing together documentary and archaeological evidence can sometimes show, however, that mid-century patrons were simply at the mercy of available expertise and responsible for supposedly more 'sophisticated' architecture thanks only to the arrival of new and more highly developed skills. But the new, purer architectural classicism was not simply one phase in a sequence of fashions for new styles of building. It has a wider context in the growing general interest in classicism and the use of that interest to political and ideological ends. In addition, other complementary visual evidence suggests that mid-century English patrons began to take classical motives more seriously, in a way that suggests a wider role in the act of self-fashioning.

The evidence comes from contemporary painting. In his early years in Basel, Hans Holbein the Younger used classical architecture in the background of some of his first portraits, notably those of Jacob Meyer and his wife (dated 1516) now in the Kunstmuseum, Basel. A rare usage during his first stay in England during the 1520s occurs in the 1527 portrait of Mary Wotton, Lady Guildford (St Louis Art Museum). Like the Meyer portraits, it shows the top of a column, with a highly decorative capital. During his second stay in England from 1532 until his death in 1543, Holbein continued to use elaborate classical architectural frameworks and decoration in his work for the court, in designs for metalwork, jewellery and the famous drawing for a fireplace for Bridewell Palace. Only once, however, does he use a rich classical background for a portrait, in the lost wall painting at Whitehall of Henry VII, Henry VIII and their consorts. This, of course, is a very particular propagandist piece, and as wall painting it required a degree of constructed illusionism which only architecture could fulfil. For the rest of his work of the 1530s and 1540s, in his great line of portraits of Henry VIII's courtiers, no such background reference to classicism appears.

Rather, messages are conveyed through motto and inscription in such a way as to deny background space; the image of the sitter is as prominent as the lettering giving his or her age or personal motto.[12] By 1550, however, the use of the classical column begins to re-appear among the generation of artists who followed Holbein in England, both native and foreign. In this revived form, it is usually the base and sometimes the plinth of the column that is shown, and the applied ornament has vanished; all is now more austere, less superfluous. The column shaft or base sometimes acts as the supportive field or repository for a classical inscription. It appears notably in the several portraits of Edward VI by, or from the circle of, William Scrots and in works such as the 1549 portrait of Thomas Wentworth, first Baron Wentworth of Nettlestead (p. 206).[13] Classical architecture therefore becomes the essential frame of reference for the painted image; it becomes a significant visual symbol of status, of learning, of gravitas, just at the time when architecture also treated its potential for signification with greater attention to detail and exactness. In place of the profusion of symbols of status and pretension to learning in a work such as Holbein's *Ambassadors*, we are given a more direct message.

The appearance of classicism in architecture, and the way it has usually been considered, raises two problems of method. One is endemic to the way the artefacts, the visual 'products' of this period, have generally come to be evaluated, namely by reference to an external standard set somewhere else, usually in Renaissance Italy or France.[14] By these standards, English art is often perceived to be erratic or illogical, lacking consistent intellectual development. It is important to remember, however, that England, just like other parts of Europe, would have received from the continent not the direct and continuous experience of an evolving Renaissance style, but a series of messages, transmitted in a variety of ways, through writings, book illustration, imported luxury objects and travel by patrons. These often disconnected messages were used by patrons (as in the example of the Earl of Northumberland given above) in interesting, accumulative ways. However, it may seem with hindsight that fundamental meanings as evolved in Italy were misunderstood. The building style of mid-sixteenth-century England was not a false dawn before the arrival of Inigo Jones half a century and more later. An interpretation such as this undervalues the significance of its occurrence at this particular moment.

A far more useful and indeed likely reading is as follows. Earlier we saw how, in the early part of the century, courtier architecture was

Thomas Wentworth, Baron Nettlestead, 1549. National Portrait Gallery, London.

characterised by a stress on the overlay of ornament, often pressed into the service of a celebration of the owner's position through heraldry. Considered within the context of the whole period, the mid-century moment can be viewed as one of restraint of style between periods of excess, of the search for a vocabulary for architecture that was coherent and held in esteem because of its links with the classical past. It is an architecture of a simple and decorous message, as far as its order and control of ornament are concerned, though as we shall see the political message behind its adoption was extremely subtle. It quickly gives way to an architecture in which the vocabulary of classicism is multiplied, through texts and illustrations, and excessively re-iterated to the point where it has more in common as surface decoration, even if now more skilfully executed, with the overloaded ornamentation of the earlier part of the century, than with that of 1550.

The exterior of Wollaton Hall, for example, built during the 1580s, with its extraordinary stacking of one scheme of ornament on another, makes for a veritable source-book of Italian, Netherlandish and French ideas on ornamental order. None of its particulars is incorrect, yet blended together like this, the total impact of its mixture of source materials takes on a quality of hybrid idiosyncracy. Here is the fulfilment of Henry Percy's search for a mix of discovered 'curiosities'.[15] The significance of this architecture is made more complex because the variety of both written commentaries on classicism and the fantasising that took hold of its vocabulary of ornament in the decades after the 1550s met up with the revival of medievalism as a renewed mark of aristocratic respectability. Two examples can demonstrate this. Both Sir William Cecil and Sir Thomas Smith, key figures as secretaries to the governments of Edward VI's reign, began work on their major houses within, as far as archaeological evidence can tell us, the period of restrained style of the mid-century. The final result, however, after twenty years of building at Smith's Hill Hall and even longer at Cecil's Burghley House were buildings where the architectural order has been made complex, dependent on various sources and, in the case of Burghley, deliberately archaising, referring to earlier complexities of ornament and therefore enlarging on their imaginative scope. Novelty here is not a search for a coherent use of classical order but a resumé of the multi-layered discussion about classical ornament and its various possible meanings.[16] The purity of the classical moment was not therefore apparent even among the most learned of the survivors from its heyday; its lessons, its message, became just one of many among the sources ready to hand.

The second problem of method for this analysis concerns the motives of the builders; it is possible to rely heavily on the implied certainty of documents themselves (and among 'documents' here we would need to include buildings amongst primary evidence) rather than an examination of the interpretative spaces between them. The art historian gets caught up in constructing the web of 'intention' in too close a way; the intention itself, it is claimed, can never be fully retrieved, and seeking it only restricts the wider understanding of buildings (or other visual artefacts) within the intellectual climate of the period. At the beginning of her recent study of Renaissance drama, Catherine Belsey sets down the parameters of possibility for the discussion of literary texts from the past. She also, however, develops her analysis in the field of the visual arts by using two facades of a country house which were built at different times to demonstrate the different underlying power structures that she suggests allowed their creation. She concludes that fictional texts 'do not necessarily mirror the practices prevalent in a social body, but they are a rich repository of the meanings its members understand and contest . . . Fiction, like architecture and painting, is a signifying practice which can be understood in its period to the extent that it shares the meanings then in circulation'.[17] Here then is a possible alternative critical model to one which depends upon the (inevitably only partial and possibly flawed) reconstruction of conscious intention. The 'meanings' which particular architectural patrons understood and contested in relation to their political self-identity can be grouped under three headings: Protestant-ism, a sense of nationhood and the idea of 'Commonwealth'. The language used to explicate and explore these ideas in contemporary literature shares certain common aims: a search for economy of expression, for a direct and simple vocabulary, and justification by reference to a once-uncorrupted past. These concerns were echoed in some architectural preferences of the time and, as we shall see, its small and fragmentary, yet crucial, written legacy.

Our understanding of 'meanings then in circulation' during the mid-sixteenth century depends upon some definition of the receptive audience for those meanings. Was not the Tudor period one of faction and, therefore, made up of different audiences? Under Edward VI, we are on fairly safe ground since the political self-identity of leading courtiers was rooted in an ideological cause common to all of them; so it is not surprising that co-incidence of outlook on building cut across the factional allegiances that historians have identified as endemic to the period.[18] Rivalry between courtiers, especially at the very top, seems to

have inspired the matching and outdistancing of each other's achievements. Not only did John Dudley, Duke of Northumberland, take over some of the fallen Edward Seymour's building projects (notably the former Bridgettine abbey of Syon, converted into a great courtyard 'palace' on the Thames outside London to rival the royal establishments), he may also have intended his work at Dudley Castle, the centre of his great country estates, to rival Somerset's castle of Berry Pomeroy, in Devon. Both Dudley and Berry Pomeroy Castles are refurbishments of older structures; they both use standing buildings as lodgings for guests and retainers, while creating splendid new hall ranges fronted by a classical loggia.[19]

There was at the court of Edward VI a common investment in the cause of Protestantism, or certainly, as it is necessary to be careful with doctrinal definitions, a rolling programme of religious reform. For the visual arts, the reign of Edward VI is remembered as a time of iconoclasm. The lead given to the extreme Protestants in the destruction of images is usually dated from Cranmer's short address to the young king at his coronation in February 1547, in which an unequivocal recommendation against the use of images is tacked on to a reiteration of the established Henrician policy of the denial of papal jurisdiction. The king, said Cranmer, should see 'God truly worshipped and idolatry destroyed, the tyranny of the Bishops of Rome banished from your subjects, and images removed.'[20] Cranmer's words are perhaps paralleled by those occasional clauses tacked onto bills going through the modern British House of Commons, two or three badly-phrased sentences which seek to embody a government's knee-jerk reaction to a perceived problem but whose weakness of definition is then seized on and exploited by extremists.

Subsequently, the official line became one of attempting to distinguish between the use and abuse of images, recognising, just as the Henrician injunctions against the vandalising of churches had recognised, that permitting unbridled destruction was potentially dangerous to the state. Permissible Protestant images were, therefore, objects of 'remembraunce, whereby, men may be admonished, of the holy lifes and conversacion of theim, that the sayde Images do represent: whiche Images, if they do abuse for any other intent, they commit Ydolatrye in the same, to the great daungier of their soules.'[21] Anything more than the act of 'remembraunce' was excessive and might lead the imagination into the realms of dangerous visual, and therefore theological, speculation.

In biblical commentary, the eradication of the dross of centuries of

Romish exegesis was the foundation stone of the encouragement of the Protestant plain style of prose.[22] John Jewel's *Oratio contra Rhetoricam* of 1548 was the first polemic in a series of works which campaigned for simplicity of meaning and expression in the writing of English. Attempts were made to simplify spelling, and writers in a style identified as 'archaic', but rugged and true, became the alternative Protestant literary tradition, dethroning the courtly conventions of recent generations. The year 1550 saw Robert Crowley's edition of *Piers Plowman*, which was held up as worthy of the true English tradition (as opposed, it was implied, to the 'courtliness' of Chaucer), the editor in his marginal notes excusing the references to the Virgin Mary and to transubstantiation as later additions to the text. Plain English was wrapped in the mantle of populism, of spreading the gospel to 'the rude and unlettred people, who perchaunce through default of atteigning to the high stile, should also thereby have been defrauded of the profite and fruicte of understanding the sence'[23]

To support this programme of reform, analogies were drawn with other languages and their traditions, even, or especially, in Italy itself, since the abuse of the pure Italian language was seen as mirroring the abuse of the principles of the early Church, ever since the foundation of the bishopric of Rome. A constant and important theme of English Protestantism was to emphasise the Roman Church as corrupt, and therefore a range of Italian texts were brought forward that in different ways supported the stance of the English Reformation.[24] Dante was useful because of his attacks on the clergy and his indictment of the papal usurpation of imperial authority. The definition of an early 'truth', political and religious, which extended over the whole of Europe, or even Christendom, inevitably led back as far as the classical world and fixed England's place in the recovery of the once-uncorrupted classical legacy. A history of Europe had to be drawn which gave England a place in the founding and continuing of the traditions of classical culture. This became part and parcel of a new national history, whose formation had been in progress since the foundation of the Tudor dynasty.

This revision of English history flourished under the direct patronage of the early Tudor sovereigns. Polydore Vergil's *Historiae Anglicae*, commissioned by Henry VII, challenged the accuracy of medieval chroniclers but essentially presented the narrative of the past as an alternating pattern of upheaval and resolution, with the newly-founded Tudor régime as simply a pronounced upswing into peace and prosperity. The chronicle of Edward Hall, published *c.* 1548, propagated a far more

determinist historical development, with the Tudors as the political and ideological summation of all that was good about the past.[25] Deep in that past, but prominent above all other times as a prefigurement of the Tudor present, was England's part in the annals of the classical empire and, through that empire, the dawn of Christianity itself. The forsaking of the name of 'England' for the classical 'Britannia' in the works of John Bale and Robert Crowley underpinned the myth of the nation's special identity with the classical past. England was the birthplace of Constantine and had been brought to the true faith in an especially pure form by Joseph of Arimathea. The travels and notes of John Leland of the 1540s, which were to establish, even in their incomplete state, a crucial prototype for the beginnings of the tradition of English antiquarian writing, had been undertaken with the intention of recording and incorporating into the history of the nation the fragments of antiquity, whether in the form of documents and standing structures or the oral traditions of myth.[26]

The classical moment in architecture was thus matched by the sense of a classical past which was based upon a handful of verifiable monuments and records but placed within a classical framework, a paradigm for a time that, like Hall's interpretation of history, was essentially of contemporary fabrication. Many printed images likewise housed the narrative and allegory of the new English Protestantism in the simplest framework of classical architecture. The second edition of Foxe's *Acts and Monuments* of 1570, for example, contains a woodcut allegory of the reign of Edward VI (d. 1553) which encapsulates the realities of reformed church worship of some twenty years before (p. 212): preaching is taking place before a crowded congregation (with women prominently shown among the listeners); the communion table is visible but stripped of imagery and standing free in the body of the church. But the framework, the imagined building of the place of worship itself, is a plain, unadorned, vaulted space carried on classical pillars, entered at the right through twin entrances topped by flat lintels and viewed from the front through a massive segmental arch between corner piers. The language of classical architecture, though misunderstood in its details and used on a building quite impossible to construct, appears here on an heroic scale to match the heroic virtues of the reformed faith.[27]

Foxe's image of Edward's reign as a crowd of worshippers listening to a preacher shows the building as the physical enclosure of a community: a very positive image. In other discourses that shaped the political and religious identity of mid-sixteenth-century England, the activity of

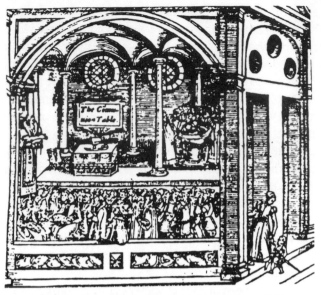

Detail of the Allegory of the Reign of Edward VI,
from the second edition of Foxe's
Acts and Monuments, 1570.

building came under attack, and in a manner that sought to undermine
the aggressive self-fashioning of the ruling class. Conveniently, we might
still place this body of literature under the heading of the idea of
commonwealth, notwithstanding the denial by some recent historians of
the myths associated with the term.[28] Its widespread use in contemporary
literature is undeniable. A comment by the literary historian, David
Norbrook, is relevant here. 'Speaking of a "commonwealth" rather than
a "kingdom",' he writes, 'was not in itself a sign of radical views but it did
imply a habit of mind that saw the state as an artifice that had been
created by a collective agency, rather than a natural hierarchy embodied
in the person of the monarch.'[29] A notion of collective agency implied a
collective good. In commonwealth writings, attacks were made not so
much on the existence of privileged wealth *per se*, but on the neglect of
the responsibilities that went with it. In the debate on the use of resources,
at a time when the ills of the economy were still argued in terms of social
problems rather than economic ones, excessive building and what it was
felt to represent became the target of censure.

But how excessive was the building, and how outspoken were the
condemnations of the individual patrons concerned? In Henry VIII's
reign, the pace of courtier building had been vigorous. This was

especially true of the last decade of the reign when many great monasteries were converted into country houses, and ecclesiastical properties in cities and towns were turned to secular use. 'Sumptuus' buildings, to use Leland's most common adjective for the new great houses, were the most visible targets of attack in a range of publications that commented upon the present social order. Mid-century writers argued that, in pursuing these building projects, the aristocracy betrayed and neglected their proper duties. Ultimately, their criticism focussed on what was perceived to be a dereliction of pastoral care within the community. The notion of the traditional role of hospitality, and its recent neglect, became a lively issue. The immediate, outward sign of selfish ambition, however, was ostentatious display. Great and expensive houses do not themselves confer status on their builders since, as Dr William Turner noted in his book on the nobility in 1555, 'as for buyldyng of costlye houses and trimmynge of them wyth costly hangynges and fayre waynscot, manye marchauntes use to do those thynges, better the(n) many ge(n)tlemen do, and yet so, for all that, are no gentleme(n)'.[30] Unnecessary buildings were criticised as vanities. Thomas Becon, in *The Jewel of Joy* of 1550, compared building to 'the web of Penelope. For that one setteth up, another, after the disbursing of many pounds, destroyeth, and buildeth up again with double expences.'[31] Or as Lawrence Humphrey writes in his book on nobility, of 1563:

I turned to all the workes my handes had finished, and the travaile I tooke, and loe al vanitie and trouble of minde, and nothing lastinge under the sonne. A golden sayeng of the wysest preacher. Which, would Nobles grave and carve on their postes, pillers, walles, houses and entryes, over theyr dores, and privie chambers: no poesye should they fynde more passing or pithy.[32]

In the hands of this body of 'commonwealth' literature, great houses and, indeed, the practice of architecture more generally, was seen as exhibiting private folly and vanity, with no potential for public edification. Somerset House was criticised with both prongs of the attack; it was costly and redolent of personal pride, and Edward Seymour's depredations of public property to make way for it were still being criticised by Stow in his survey of London written later in the century.[33]

In response to this, architecture had its own apologists and champions who brought the public dimension into focus. Two writers, William Thomas and John Shute, provided brief outlines of the view that good building could eloquently underpin not only the virtue of the state but also, by its single-mindedness and concern for order and decorum,

suggest a moral dimension to architecture's concerns. These texts also make positive links between architecture and the self-fashioned body.

William Thomas published his *The History of Italy* in 1549 and his *Principles and Rules of Italian Grammar* in 1550; the fruits of three years spent in Italy from 1545 until the end of 1548.[34] One of the purposes of the *History* was to give an account of the chief buildings and monuments of the great Italian cities. As did all English-speaking travellers of the period, Thomas lacked the vocabulary with which to describe accurately the details of classical architecture. Words for such details hardly existed in his native tongue. But now and again his equation of an unfamiliar feature with some comparable English building practice is extraordinarily sensitive to current, and in a sense prophetic of later, English adaptations of a classical motif or building type into traditional forms. He writes, for instance, of triumphal arches being 'as it were, gatehouses to pass through', and his book is, of course, exactly contemporary with the Strand façade of Somerset House, where probably for the first time in a permanent architectural form, the Roman triumphal arch was used as the basis for the design of the entrance to a major English building.[35] He implicitly stresses the value of antique remains by constantly referring to their incorporation in buildings of the present. The Palazzo Farnese, for example, which he would have seen just at the point, in 1546, of Antonio da Sangallo's death and Michelangelo's appointment as his successor, is discussed not in terms of its modernity but its indebtedness to the past for its materials:

Paul, now Bishop . . . hath rooted out of the ruins of antiquity such goodly marble pillars and other fine stone which he hath bestowed on that house that if he finish it as it is begun it will be the gallantest thing, old or new, that shall be found again in all Europe.[36]

Thomas constantly commends the use of marble and stone for public buildings; Milan, by contrast with Rome, Venice and Florence, has

nothing of that beauty and pomp that those other cities be, by reason that for the most part the Milanese building is all of brick, because hard stone and marble is not to be had by a great way off.[37]

Most importantly, the whole of Thomas's book, through its celebration of Italy, 'which seemeth to flourish in civility most of all other at this day', is a justification for fine building as the outward manifestation of the power and prosperity of the state. He takes up the argument of the apologists for extravagant spending on building in fifteenth-century Florence, namely that great private palaces, just as much as churches and

public buildings, beautified the city, impressed the traveller and were of credit to all citizens.[38] This *apologia* for the expense of building, denying any source in private ostentation and stressing public benefit, met what contemporary critics saw as the high moral intention of the builders of classical times, with which the spendthrifts of the present compared so unfavourably. As Lawrence Humphrey argued 'For in those daies rather chose they to decke the publike buildynges, then private, the commen citie then their owne houses. As Aristides, Pericles at Athens: Curius, Fabricius, at Roome'.[39] In arguing that modern buildings should enhance the honour of the city, and thus contradicting the negative arguments outlined above, Thomas implicitly justifies the erection of a palace such as Somerset House. As I have argued elsewhere, this was probably the first of the great town houses of London to wear its splendour and expense outwardly towards the street.[40]

Thomas dedicated his *History* to John Dudley, in 1549 Earl of Warwick. It is to the same patron, under his later title of Duke of Northumberland, that John Shute credits his journey to Italy in 1550 which resulted in the writing of *The First and Chiefe Groundes of Architecture*, published in 1563.[41] Where Thomas had effectively advocated classicism in architecture through the persuasive evidence of the visual impression Italian cities made on him, Shute offered chapter and verse as to how the rules of the classical architecture of the past could be transplanted to England through his exposition of the measurements of the Orders and his discussion of their various origins and appropriateness. Or rather, he begins the task, for his short treatise is clearly only the aborted beginning of a planned longer work. Shute's book has often been criticised for its derivative quality, but his admission of dependence on Vitruvius, the recently published annotations to the Vitruvian text by Guillaume Philander and the theoretical treatise of Serlio is part of his aim to follow to the letter what he believed to be unimpeachable sources. This, he contended, supported by his personal experience of Italy, will allow him to purify his countrymen's imperfect understanding of classical forms 'that I might with so muche more perfection write of them as both the reading of the thinge and seing it in dede is more than onely bare reding of it'.[42] His purpose therefore is to eradicate mistakes and establish correct procedure.

Shute uses the imagery of the human body to get his point across. In the tradition of Vitruvian commentary dating back to the work of Francesco di Giorgio in the 1470s and 1480s and made famous by the illustrations to the Cesariano edition of Vitruvius, published in 1521, Shute shows the

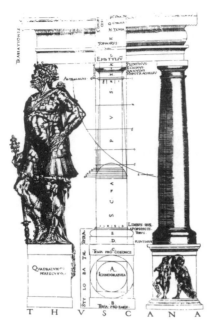
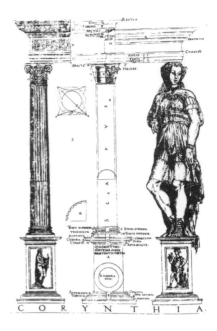
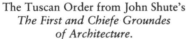

The Tuscan Order from John Shute's
*The First and Chiefe Groundes
of Architecture.*

The Corinthian Order from John Shute's
*The First and Chiefe Groundes
of Architecture.*

classical orders as suitable for specific kinds of buildings by direct correlation with the gendered interpretation of Vitruvius' text (above).[43] Each Order is shown in shaded profile and section alongside a representation of the male or female type to which it is apposite. The use of the body with its inbuilt order and proportion becomes here a metaphor for the correct architectural form used by each building, depending on its form and function. The fact that Shute simplifies the message of his original sources and gives his illustrations full-page makes his points seem all the more authoritative.

His use of the body as analogy does not end, however, with the book's illustrations; it is employed too in his use of language. Through text and illustration there develops a clear line from the ordering of the body to that of the state itself. Like Thomas, Shute perceives the notion that architecture can enhance the power and reputation of the state. To promote this idea, the body becomes a further metaphor for the limbs of the healthy nation, in which:

as the members . . . doing without impedimentes their naturall deties, ye whole body is in an helthful hermonye . . . So is it in a publicke weale when all men in their calling, do labour not onely for their owne gayne, but also for the profit and commoditie of their Countrie . . .

From this, he rather cleverly moves Queen Elizabeth, the dedicatee of his work, into a position where, through his writings, she cannot fail to accept the importance of architecture since both he, the architect, and she, the sovereign, are members of the same body:

And having the sayde trikes and devises as well of sculture & painting as also of Archtecture, yet in my keping, I thought it good at this time to set fourth some part of the same for the profit of others, especially touching Architecture . . . And because all the members of the body have cheflye and principally a duetie to the head, as governour of the whole, and without which, al the other can not live. So my duetie informeth me most soveraigne lady (the perfect and natural head next unto God of this our common weale) to shew a token of the same unto your highnes, in presenting these my poore and simple laboures . . .[44]

By patronising good building, Shute argues that the Queen would be in a distinguished line: 'Cesar, Vespasian, Adrian with many other auncient greckes and Romaines which laboured to advance their name thereby who lefte many argumentes of their vertue, hygh intentes and doinges by ye same . . .'[45] It was, as I suggested earlier, Elizabethan courtiers rather than the Queen herself who, in an active sense, took up the challenge that Shute here set down on behalf of architecture. In this way they fulfilled a commitment to building adumbrated by the courtiers of Edward VI and, through the long tradition of the English gentleman architect down to the nineteenth century, ensured that building was the proper sphere of the educated and ruling classes, an integral part of their self-fashioned image. Yet it is arguable whether at any subsequent time in English history (and many would say this is to architecture's loss) the role of building can so readily be viewed in terms of contemporary radical debate and its language as it does in mid-sixteenth-century England.

10

The Royal Body: Monuments to the Dead, For the Living

NIGEL LLEWELLYN

In all cultures, myths about the past are created and re-created by visual images. Amongst these representations, human figures play a central role, either in the form of personifications or transformed into dramatic heroes.[1] The use made of the human figure in historical representation has, traditionally, been didactic. Those tableaux of British history, for example, which depict an endless struggle between opposing factions are designed to elevate public morals. The antagonists in the Civil War are archetypical. While, on the one hand, the Cavaliers carry connotations of heroism in both their conduct and their ideology, their enemies, the Roundheads, have a long-standing reputation as iconoclasts. Traditionally, all kinds of damage to church fabric have been blamed on Parliamentarian attacks on art, a famous example being the tomb of Henry VIII which was reputedly 'melted down as idolatrous in 1645'.[2]

While there is no disputing the destruction of Henry's tomb, the most interesting question is: Why was it destroyed? A survey of the royal funeral monuments of Renaissance England will show that historians have allowed the myth of Puritan philistinism to influence their present-ation of the facts. They have characterised the iconoclasts as opposed to idolatry. The Parliamentary government was certainly opposed to the worship of images as a dangerous Papist belief, but in this case they must also have coveted the rich materials used in the unfinished tomb. Yet, it is equally clear that the tomb, as a symbol of kingship, was broken not because it was great art but because of the power it was thought to wield. Both sides in the continuing struggle recognised this symbolic potency and fought fiercely for control over the body, whether Natural, Political or Monumental (a schemata I shall explain in due course). For example, following Parliament's melting-down of the gilt-bronze figure of Henry VIII, the restored monarchy of 1660 retaliated by ordering the disinter-ment and posthumous public execution of the regicides. As we shall see, the tomb of Henry VIII presents us with a paradigm of attitudes towards

the representation of the royal monumental body in Tudor and Stuart England.

MONUMENTS AND THE DISCOURSE OF ART

Tudor and Stuart attitudes to the monumental effigies of kings and queens were quite different from our own. We tend not to regard them as particularly potent images; for us they are simply part of history or a small part of art. In contemporary Britain, visual imagery is indisputably important in advertising and political propaganda, yet the products of the Fine Arts, by and large, are regarded as politically impotent. The Prince of Wales's views may temporarily have pushed a long-standing debate about architecture into the body-politic, but sculpture and painting have been reduced to commodities. These artistic forms wield power only as tokens of wealth, not by or for themselves. The word 'sculpture' does not convey the ritual importance that the carved human figure held for past ages, and therefore as a concept it has little value to the historian interested in the effigies and other monumental figures made in post-Reformation England.[3]

In the sixteenth and seventeenth centuries there was a great deal of discussion about the function and legitimacy of carved images and the way in which they helped create and wield symbolic power. But these questions have not been addressed by art historians, who have preferred to take four traditional approaches to these funeral monuments; they have asked questions about taste, the role of the artist, decoration and periodisation.

The first approach takes style as its starting-point. Such questions have been asked as: What formal idiom is identifiable in the monumental effigies? What proportions and decorative motifs are employed in their architectural settings? Most replies to such questions have employed a rhetoric about style which implies that progress in English art can only be achieved by emulating Italian models. But such a view does not emerge from a study of these particular objects nor from a familiarity with the cultural setting for which they were made.

For important political and religious reasons there was an understandable suspicion of Italian manners and culture under the Tudors; even so, the history of English art of that period has usually been portrayed as a vain search for Italian standards. Such has been the yearning for the Italian that certain English works of art have been attributed to Italian authorship or influence; a spurious English *oeuvre* has been established for Bernini, and masons' names have been misread – 'Gildo' for Gildon,

for example.[4] The problem with this rhetoric of centre versus periphery is that it ignores most of the extant objects and distorts the history of the rest. Monuments were not designed to show off an artist's Italian training or a patron's taste: they were functional objects designed to mark permanently the site of a funeral.

A second approach gives sole responsibility to the artists in deciding all the aspects of a monument's appearance. But to my mind we should not assume that the men who called themselves 'tomb-makers' were creative artists in the modern sense. In fact, decisions about the appearance of funeral monuments were too important to be left to artisans of modest social rank, and the Monumental Body was too sensitive a cultural artefact to be left to mere mechanicals. Instead of employing the post-Romantic concept of the artist, we should use an anthropological approach which would present makers of monumental effigies as relatively passive agents in highly formalised rituals. In such an anthropological analysis, tomb-makers and patrons should be seen as actors participating in a cultural process.

Our expectations of art itself have determined the third approach. Are these funeral monuments art? Many are simply copies of other monuments, but should not true art be innovative? Many tombs are deliberately *retardataire*, but should not great art be progressive? The mixed styles of the Elizabethan and Jacobean periods surely contravene the law that high art be pure. Many have described the effigies of this period as 'wooden', but is it not the purpose of art to look real or natural or expressive? The general view is that the funeral monuments of post-Reformation England are at the very least bad art and perhaps not even art at all.

To subject the Monumental Bodies of post-Reformation England to an interrogation about their place in the traditional, conceptual schemata of art is, indeed, worthless. Their function demands a different approach. Funeral monuments were regarded as necessities of life and were complex constructions which had to fill the spaces death created in society, even when the dying made pleas for simple rituals.[5] Such a function should be taken seriously and demands that we rigorously question a fourth approach, that is, the way in which historical time is divided.

For example, the historical concept of 'the Renaissance' has proved problematic for writers on funeral monuments. It gives priority to the classical to such an extent that it fails to enlighten us about most of the objects made at that time. In addition, the Renaissance is not only a style and a period but also a normative term implying moral purity in any

culture to which it has been applied. This is why many eighteenth- and nineteenth-century authors regarded the bastardised mixtures of Italianate forms found in most Tudor and Stuart monuments as too impure to represent the Golden Age of Good Queen Bess.

THE REFORMATION, THE AFTERLIFE AND THE REPRESENTATION OF THE MONUMENTAL BODY

There is a particular difficulty caused by the Reformation of religion which the English historiographic tradition has so often set in opposition to the Renaissance. The Protestant antipathy towards Rome has frequently been blamed for England's cultural distance from the antique, yet it is, in fact, much more useful to regard Tudor and early Stuart funeral monuments as 'reformed' than antiquity 'reborn'. The active effigial images characteristic of certain English tombs after 1600 owe more to Reformist ideas about the nature of death than to the postmedieval individualism so beloved of Burckhardt. This interpretation is supported by a small group of monuments which showed two effigies, one as in life, the other – a *transi* – as after death. This mode of representation can be explained with reference to that crucial unifying tendency in human society whereby an individual dies only for her or his place to be taken by another. This process of loss and gain formed the basis of a political theory which distinguished between a Body 'Natural', which died and could be dispensed with, and a Body 'Politic', which had to be sustained.[6] Monuments played a role in the mourning ritual which both confirmed the final physical death of the Natural Body and maintained the social presence of the subject's Political Body. Robert Cecil, an adviser of princes, had a monument made just before his death in 1612 (p. 222) which shows that he was well versed in this theoretical duality.

This was only one of the many ideas that governed the making of Tudor Monumental Bodies. The reformers adapted the medieval idea of 'The Two Bodies' in a new doctrine about the pain caused by separation through death. They also preached the universal death of the Natural Body: 'There is nothing that can free any one from Death, no, not length of dates, nor wisdome, strength, riches, beautie, nor talnesse of stature'.[7] While the politicians distinguished between the decaying Natural Body and the continuous Political Body, the clerics taught their flocks to differentiate between the death of the body and that of the soul.[8] The sense of separation between the decaying body and the eternal soul had been increased by reformist attacks on the doctrine of purgatory and the

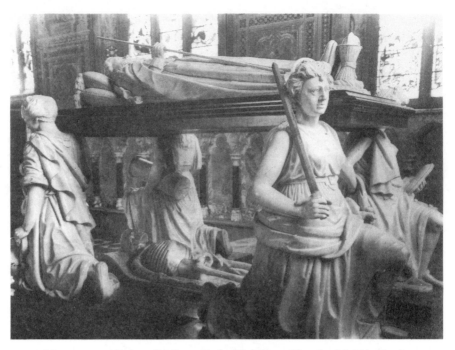

Monument to Robert Cecil, 1st Earl of Salisbury, Church of St Etheldreda,
Hatfield, Hertfordshire.

prohibition on masses read for the departed. Effectively, the Reformed
dead had been carried beyond the influence of the living. For the
Protestant elect, the victory over death had already been won, and such
spiritual aids as the doctrine of purgatory were no longer needed. Funeral
monuments could then be transformed into settings for the Monumental
Body which celebrated the lives of the virtuous dead. The new styles of
effigies emphasised continuity rather than separation and offered the
bereaved comfort against the pain of separation.

In an elusive and mysterious way the post-Reformation Monumental
Body replaced the deceased 'Natural' Body with an ideal 'Political' Body.
Symbolic values traditionally attached to the 'Natural' Body such as
pollution, decay, individuation and separation were replaced by monu-
ments which emphasised the living 'political' significance of regener-
ation, the solid, socialisation and continuity. However, this dual view of
the body, with its Natural and Political aspects, is too crude. For dying,
like other rites of human passage, is characterised by a complex tertiary
structure with a liminal point.[9] The Natural Body was once alive; it is
now dead; the liminal stage is the much longer process of dying.

Monumental Bodies were, in fact, part of the ritual developed to extend the liminal, transitionary stage and prevent death being too disruptive of the body politic.

My emphasis on the cultural function of effigies as permanent replacements of decaying and vulnerable Natural and Political Bodies demands new descriptions of their physical appearance. They have often been classed as portraits and discussed in terms such as realism, naturalism and symbolism. Such categories may be meaningful in an academy of art, but post-Reformation funeral effigies were intended for church settings and were therefore subject to quite different, contemporary arguments about the legitimacy of religious images. The reformers tended to be nervous about images in case they contravened the Commandment against idolatry and thus perpetuated Romish abuses. But after 1560, Anglicans stressed the clear distinction between a legal effigy, which replaced its subject as part of civil honouring, and a scandalous image which was an art object replicating nature and rivalling the creativity of God. As such creativity was potentially idolatrous, some reformers regarded naturalism, or a striving for verisimilitude, as an inappropriate way of depicting the Monumental Body. In these ways, changes in style – often towards that characteristic woodenness and idiosyncratic sense of proportion so disliked by the connoisseurs – were encouraged or discouraged by religious function and setting: it was not simply a question of the artist's skill. In cultural terms, the artifice required to manufacture the Monumental Body was quite different from that needed to paint portraits for display in private houses.

In addition, monuments had an important moralising function, an aspect cited by their apologists in an age when Papist iconophiles were so often associated with political rebellion. They were expected to exemplify virtue and maintain the proper divisions in that necessary order which lay at the very heart of the state. The Anglican state still required and protected monumental effigies, but their physical appearance had to be different from the abused religious images of old Catholicism. In parallel with these changes in the function of monuments came a gradual tightening of state control over funerals, a process started by Henry VIII who gave new powers to the heralds.[10] The heraldic regulations were introduced to maintain precedence and degree, and funeral monuments were expected to conform to the rule of decorum which demanded large structures for important people. The tombs acted on the people to preserve the memory of virtuous members of society, thus helping to ensure the harmony of the Commonwealth. Some showed

elaborately dressed effigies and complex heraldic displays which signalled precise details about birth and status. Such tombs helped preserve differentiation by combatting Death, so often described by the clerics as ready to sweep over all he met regardless of their class. Other monuments were shaped like hearses and thus contained within their very form a reminder of the Natural Body displayed at the last rite.

In the remainder of this essay, these themes will be explored through the history of a very special group of monuments, those to the kings and queens of post-Reformation England. I will not be treating the various monuments and projects chronologically but according to the different themes they illustrate. These royal Monumental Bodies made permanent the propagandising pomp of state funerals and, like all aspects of the death ritual, provided 'occasions and materials for a symbolic discourse on life'.[11] I shall also argue that the case of Henry VIII's monument encapsulates, through the various stages of its commissioning and its ultimate destruction, various Tudor and Stuart ideas about the represen-tation of the Monumental Body and that it illustrates the complex encoding to which that Body was subjected.

CONTINUITY, REPLACEMENT AND THE HEALTH OF THE STATE

In Renaissance England, the health of the state was signalled by the strength or weakness of the monarch, and royal funeral monuments acted as an index of the confidence of, or in, the lineage. This important but largely forgotten function explains why there is such discontinuity in the building history of English royal tombs in this period. For example, few tombs were planned and fewer still completed between the early 1500s and around 1600. The early Tudors seem to have regarded monuments as important ways of establishing political continuity, an aspect of policy revealed in the fate of the so-called 'first' design for Henry VII's tomb. A plan and estimates were submitted by the Italian sculptor Mazzoni in 1506, but they were finally rejected.[12] The traditional element in Mazzoni's scheme comprised the recumbent images, but in addition, there was to be 'the kinge's image . . . kneelinge . . .' presum-ably in the French fashion of the lost tomb of Charles VIII. The design was rejected, perhaps because its innovative figure was not perfectly tailored to the establishment of a legitimate right to the English throne, and in June 1507 Mazzoni returned to Italy, doubtless in search of patrons constrained in their expectations by different cultural circum-stances. Around 1600, James I erected a whole group of monuments to

commemorate tiny, female children, one of his motivations being the desire to consolidate power in the hands of the Stuarts.[13]

This pattern suggests that the need for monuments was manifestly greater at the establishment of the dynasty, but that once the lineage was safely established, monuments became less important, could be left unfinished or even dispensed with altogether. Thus in the mid-1500s Henry VIII's monument was left incomplete, and Mary I and Edward VI were never properly commemorated. In the following century, Prince Henry, heir to the throne and a central figure in Jacobean culture, was buried without a monument, and in the 1640s an attempt was made to signal the end of the lineage by denying Charles I any tomb.[14]

'QUEM REX JACOBUS POSUIT': COMMEMORATION AND DYNASTIC CONTINUITY[15]

Political leaders commemorate their predecessors out of piety, charity or civility; but they also act out of expediency. All monarchs must gain power and most seek to preserve it. James I erected a monument (p. 226) to his predecessor Elizabeth I (d. 24 March 1603) despite the fact that she had been partly responsible for his own mother's death. So important was it that Elizabeth's death rites did nothing to prevent the continuity of power that the new king was quickly persuaded to build lavishly.[16] The late queen was buried with her grandfather, Henry VII, a nearby site having been earmarked for her own monument.[17] To help secure the appearance of an orderly and legitimate succession, James took public responsibility for Elizabeth's Monumental Body. In the 1590s there had been a rumour that the old queen was to be commemorated in her father's tomb at Windsor.[18] Others predicted that no child of Henry VIII's would ever have a monument.[19] However, Robert Cecil, well aware of the political power of the Monumental Body, vowed: 'Rather than fail in payment for Queen Elizabeth's tomb, neither the Exchequer nor London shall have a penny left'.[20] As the crown's Master Mason, Cornelius Cure, was already busy on the tomb of James's mother – the Queen of Scots – Maximilian Colt was ordered to provide a similar design.[21] By 1606 it was ready for decoration, as we know that in that year Nicholas Hilliard (Elizabeth's portraitist) asked Cecil to meet him at Westminster to see ideas for the 'trimming'.[22]

The inscription on Elizabeth's monument is highly didactic, giving an account of her virtues and achievements and stressing not only her place in the lineage but James's place as 'heir to her kingdoms' and patron of the monument. This text is displayed on a complex superstructure carried

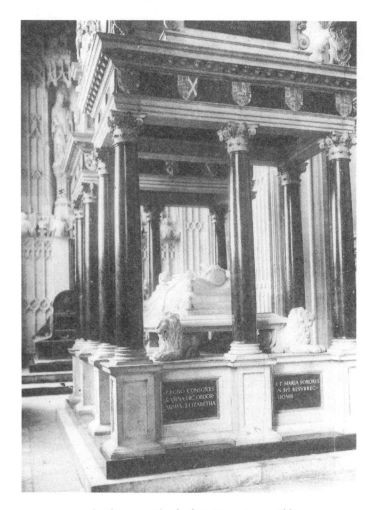

Tomb of Queen Elizabeth I, Westminster Abbey.

on ten columns which shelters the effigy lying recumbent on a panelled chest. The permanent marble figure of the queen was designed to resemble closely the temporary effigy which had been made by Maximilian Colt's brother, John, and carried at the funeral. Indeed, the whole composition of the monument must have been very close to the combination of forms on show at the obsequies themselves: bier, effigy, *baldacchino*: truly, the monument is a permanent memorial of the funeral.

It was not only European Renaissance princes who had monuments built for their predecessors, for in many societies the possession of the

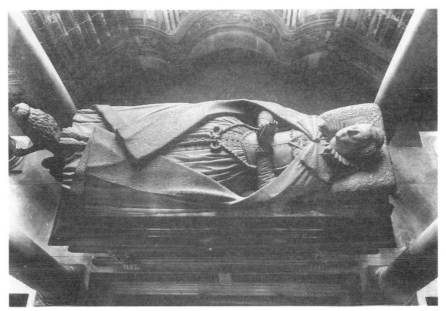

Tomb of Mary Queen of Scots, Westminster Abbey.

body of the deceased is an essential component in the assumption of authority.[23] Cultures exist where usurpers use the possession and control of the body to ease their accession.[24] This practice was also known amongst the English. Soon after the defeat of Richard III, his mortal enemy Henry Tudor paid '(out of royall disposition) . . . [for] a fair Alabastre Monument with his [Richard's] picture cut out, and made thereon [at Leicester]'.[25] Some time later this was destroyed 'by iconoclasts'; whether enemies of Richard or of Henry is unrecorded. At Richmond Palace, Henry Tudor used a set of portrait images of his ancestors to stress further the continuity of the lineage and his rights to the throne.[26] As we have seen, his granddaughter Elizabeth made no monument for herself, but in 1573, in a rare act of patronage, she replaced the battered tombs of her Yorkist ancestors with tidy, modern versions.[27]

James's monument for his mother, Mary Stuart, Queen of Scots (d. 1587) was being built at the same time as Elizabeth's (above). It seems that its purpose was to 'absolve' the taint of treason against Mary Stuart which had been the legal justification for her execution.[28] Mary's body had been buried for twenty-four years when, in a letter to the Dean of Peterborough stressing his filial duty, James ordered that she be exhumed

and set under the new tomb.[29] The king's agent, in what was regarded as an important matter of state, was Robert Cecil, who briefed Cornelius Cure and quickly ordered designs to be made.[30] Intended to balance Elizabeth's monument on the other side of the chapel, the chosen plan of Mary's tomb was splendid and orthodox: a free-standing construction with two groups of four columns connected by a large coffered arch supporting a great superstructure. Mary's recumbent effigy was set high up and showed her in state robes – a portrayal derived from a type established by Hilliard.[31] The project is usually said to have been initiated in 1607, but it must have been planned well before then. James had been obliged to keep his political distance from his mother since their separation when he was aged ten months, and Goldberg may well be right when he claims that James's decision to build a monument to her memory was motivated by a need to combat the guilt he felt at his tacit collusion in her death.

James's tomb-building helped construct a political legitimacy with a continuous history, and it found parallels in literature. In his *King James His Welcome . . . With Elizaes Tombe and Epitaph . . .* (London, 1603), I.F. [James Fenton?] gave an account of England since the fifteenth century which legitimised James's accession. Texts such as this and the inscription on Elizabeth's monument both lament a death and celebrate an accession and therefore show that liminal quality typical of the death ritual. No monument commemorates James himself, but in its unabashed borrowing from contemporary European models for royal burial, the paraphernalia employed at his funeral emphasised the legitimacy of the Stuart kingship and the continuity of dynasties.[32] At the death of James's queen, Anne of Denmark, the dynasty was secure enough to dispense with a monument, and a splendid funeral was all that was required.[33] In 1625, Charles I dutifully accorded his dead father the proper obsequies, but a monument was never built.[34]

EFFIGIES AT FUNERALS:
REPRESENTATION FOR THE RITES OF PASSAGE

James's speed in commemorating both his mother and his predecessor was, therefore, encouraged by the dynastic change: the royal death ritual usually required a good deal of time. During the period needed to arrange a grand funeral, the Natural Body would inevitably start to decay and the Political Body to become threatened by disorientation and usurpation. To prevent such threats, potent realistic representations were deployed in the death ritual to satisfy not the needs of art but the demands of

function. As the antiquary John Stow noted, Elizabeth's monumental effigy was 'The picture of her whole body, counterfeited after life',[35] and the temporary effigies carried at funerals were also realistically fashioned. Contemporaries described the effigy borne at the funeral of Henry, Prince of Wales, as such a 'lively' representation 'that it did not onely draw teares from the severest beholder, but cawsed a fearefull outcrie among the people . . .'[36] Its limbs could be moved, and it had 'several joints . . . in the arms legges and bodie to be moved to sundrie accions . . .'[37] Such funeral effigies have only survived in fragmentary form, but they all showed a lifelike realism which helped ensure the transfer of power within the body politic.

At the obsequies of a monarch, the funeral effigy gave as strong a sense of immortal dignity as was possible in order to deny the decaying but unseen presence of the Natural Body.[38] It both substituted for and replicated the deceased – no light matter in the case of a monarch.[39] But neither these effigies nor those cut in stone for permanent display were portraits in the modern sense: their makers showed no interest in personality. For Henry VII's funeral a 'pictor' was made at a cost of £6 12s 8d; it was robed and set on a wooden armature with straw and plaster packed round to form a body. The cast plaster head was taken from a death mask – an innovative Italian technique.[40] Some royal funerals went still further and employed a living stand-in for the deceased royal person, just as ambassadors and servants of the royal body were allowed as stand-ins during court rituals. In 1502, at the funeral of Prince Arthur, the first offering was made by a man-at-arms dressed in the prince's armour, carrying his shield-of-arms and mounted on his charger.[41] At a mass in memory of Henry VIII a parish coffin and hearse were used as if a Natural Body were present at a funeral.[42] Special rituals like this were necessary when grand people died, so destabilising was their loss.

The lifelike funeral effigy sustained the image of the Natural Body in the period between death and burial, but only the Monumental Body could fix the funeral ritual in the collective memory. The tomb itself came to represent Elizabeth's reign, and with time, representations of her tomb were produced in the form of prints. Copies of the epitaph were found in Suffolk churches,[43] and engravings of the tomb were distributed to parts of the country unsympathetic to the Stuarts as tokens of continuity.[44] We hear of such prints in London, Canterbury, Northants. and elsewhere (p. 230).[45] Thomas Fuller's colourful account of the death and burial of Elizabeth shows how such images were able to preserve the memory of

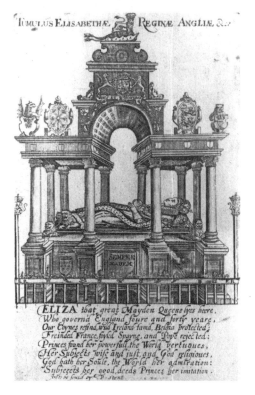

*A Contemporary Engraving of the Funeral
Monument of Elizabeth I.*

the dead: 'Her Corps were solemnli interred under a fair Tomb in *Westminster*; the lively Draught whereof, is pictured in most *London*, & many Countrey Churches, every Parish being proud of the shadow of her Tomb; and no wonder, when each Loyal Subject erected a mournfull Monument for her in his heart'.[46]

These representations functioned like the Royal Arms: they sustained the presence of the royal body.[47] Fuller's account suggests that Elizabeth's person and memory have been transformed into a monument able to present and re-present a history of the past for future generations. Similarly, control of the body of his predecessor became part of the history of James's reign and helped establish his political legitimacy.[48] Camden may have claimed that Elizabeth 'herself is her own monument, and a more magnificent and sumptuous one too than any other', but James's decision to house her Monumental Body has more than repaid his investment of nearly £1000.

THE MATERIAL FABRIC OF ROYAL MONUMENTS AND
THE MAGIC OF THE ROYAL BODY

A particular sanctity was attributed to the fabric of royal tombs and the Monumental Bodies set upon them. Such was the symbolic power attached to the royal person that, even when there was no tomb, the people needed physical or tactile contact with something. For example, an altar of touchstone and brass, constructed over the grave of Edward VI in Westminster Abbey, came to be accepted as his memorial.[49]

As permanent representations of the royal body, monuments were also open to ritualistic abuse. The power which was thought to cure the King's Evil transformed the tombs of kings into shrines, and it was that potential power attributed to Henry VIII's mausoleum at Windsor that caused the Commonwealth to destroy it. If the motivation for the destruction of Henry VIII's tomb had been simply a hatred of art or a love of money, Parliament would surely have sold off the valuable Torrigiano tombs of the early Tudors in the very heart of Westminster. As we shall see, the orthodoxy of the setting chosen by Henry VII must have made the location of these tombs appear less talismanic.

In the 1670s, royalists still regretted the break in dynastic continuity represented by the execution of Charles I and the lack of a monument to him. It was the publication of Sandford's *Genealogical History* in 1677 which highlighted the sad contrast between James's piety towards Mary Stuart and that of their own king, who had done nothing to commemorate his father. Christopher Wren saw the moment, but the grand mausoleum he designed for Windsor was never constructed.[50]

THE CHOICE OF A SITE FOR ROYAL BURIALS

The death of a Tudor monarch was countered by a ritual which stressed 'unifying values' and convinced society of its ability to sustain the loss.[51] An appropriate setting was essential if this ritual was to be effective, and Westminster provided it. The central role of the Abbey was not fully established when Henry VII started to plan his own monument, but the tomb as built accorded with his decision to construct a splendid chapel there.[52] There is, in fact, evidence that early in his reign Windsor had been chosen to house his tomb,[53] but the king realised that the tradition of royal tombs at Westminster was too valuable to ignore.[54] In an early will of about 1505, Henry demanded both burial and a monument in his new chapel because he had been crowned there, because it 'is the commen

Sepultre of the Kings of this Reame' and because it housed the body of the Confessor and other blood ancestors.[55]

At Henry VII's death on 21 April 1509 no monument had yet been prepared although there are suggestions that there was already a grille in place around the burial site.[56] In his last will made some three weeks earlier, Henry outlined a set of grandiose schemes to assemble his ancestors' remains around him: '[He] Desires to be buried at Westminster . . . where lie buried many of his progenitors, especially his granddame Katharine wife to Henry V and daughter to Charles of France, and whereto he means shortly to translate the remains of Henry VI'.[57]

The work of establishing the founder's monument on the prime site in the centre of the chapel at Westminster was thus left to the next king, Henry VIII. His plans for his own tomb were focussed on St George's Chapel, Windsor, finished by 1511, where various ancient royal remains had been received as early as the 1480s. However, as we shall see, there was to be no continuous tradition of royal burials there.[58]

The choice of Westminster Abbey as a commemorative site was influenced by a long-standing tradition which established a precedent as strong as the sense of decorum which determined the materials and, to some extent, the style of the tomb. The Abbey was a royal peculiar, the shrine of a royal saint, Edward the Confessor, and the building of Henry VII's Chapel simply reinforced its role as a dynastic mausoleum and a sign of centralised political power. This symbolism was clearly recognised by the first Stuart King of England. James wrote that the monument which was to house his long-dead mother was being constructed 'in our Churche of Westminster, the place where the Kings & Queenes of this Realme are usually interred'.[59] By the later 1610s, Westminster seems universally to have been regarded as the mausoleum of the new British monarchy;[60] indeed, its reputation as one of the tourist sights of London largely depended on its ancient function as a place of burial and commemoration for the great and the good.[61] Flocks of people visited the Abbey daily to see the tombs of the kings, struck with 'religious apprehension' and 'delight and admiration' at the 'stately entombment of such venerable ashes . . . of so many of the lords annointed'.[62]

Confident that his father's Westminster monument had signalled a clear succession and attracted by the formality of the Garter Chapel at Windsor, Henry VIII decided to build his tomb there, and there began a bizarre story which captured the essence of all these themes of cultural politics and symbolic discourse.[63]

THE TOMB OF HENRY VIII: A CASE STUDY IN COMMEMORATION
FROM ORIGINS TO DESTRUCTION

Henry VIII's tomb was started early in his reign but was still unfinished at his death. Much of its history is unclear, but the choice of materials was certainly significant. Viewing Benedetto da Rovezzano's touchstone sarcophagus (then intended for Wolsey), Henry evidently commented that it was of too rare a substance for a mere subject.[64] The material fabric of the tomb itself was enough to suggest to the king that the Cardinal had ideas above his station. Apocryphal or not, the story offers us a glimpse of the hierarchy of materials which controlled the very substance of the monumental image.

Gilt-bronze was the most prestigious material available for tomb-building, and the Tudors' very first commemorative projects recognised its value. It was specified for the effigies ordered from Torrigiano, thereby linking the Tudors with earlier monarchs commemorated at Westminster (p. 234).[65] The contract for the Lady Margaret Beaufort tomb demanded that she be depicted: 'as any image or images of any king or queen within the monastery . . . is or have been gilded'.[66] In his will, Henry VII had already connected gilded effigies with royalty: 'the same Monasterie is the commen Sepulture of the Kings of this Reame . . . And upon the same [Tombe], oon Ymage of our figure . . . of Copure and gilte'.[67]

Visitors stressed the importance of the 'golden' material used:[68] 'In this mirrour of art, and archytect, are many rare and glorious monuments of Kings and Queenes, among whom the famous founder Hen. 7. lieth under a most regall tombe, framed and artificially formed of bras, richly guilded with pure gold'.[69] Some travellers even understood gilt bronze tombs as international signs of kingship: 'But amongst al that are seene in any of these above named regions [Italy, France, Germany], made of brasse or copper, in my judgement, the Tombe of Kinge Henrie the Seventh King of Englande Surpasseth the residew'.[70] Only later in the seventeenth century do we find dissenters who begrudged the cost and 'magnificence' of the monument.[71]

Henry VIII's decision to order a gilt-bronze monument is still more striking when we consider the enormously complex technology and rare skills which such monuments demanded.[72] The London goldsmiths – few of them native English – held a virtual monopoly on gilt bronze, and Torrigiano had to recruit additional skilled labour in Florence.[73] But such was the need to employ a material which could make the right impression that the king agreed to the massive costs of securing such

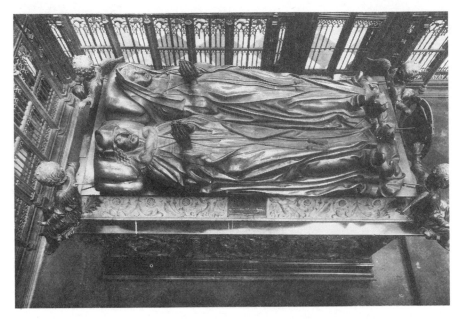

Tomb of Henry VII and Elizabeth of York, Westminster Abbey.

expertise and the expense of the casting itself. Nevertheless, by June 1519, Torrigiano had abandoned his various projects, including a tomb for Henry VIII himself, and had fled in debt.[74] Despite these practical difficulties, it is clear that the symbolic potential of gilt bronze was used to support the dynastic theory of the Two Bodies. The continuous use of the same rare statuary material was able to sustain the Political Body of the monarchy despite the natural death of an individual prince.

As for the style of Torrigiano's tombs, art historians have traditionally identified them with the start of the English Renaissance.[75] But such a judgement, which tends to stress the classical style of the subsidiary sculpture and the Italianate mood of the decoration, tends to distract us from features of design that did not originate with Torrigiano, for example, the large scale and the traditional poses of the effigies, both of which played an important role in defining the tomb's meaning.[76]

Henry VIII's first plan was to employ Torrigiano on a monument to himself and Katherine of Aragon once the tomb for his father was finished. The intention seems to have been to repeat the plan for the tomb of Henry VII but to build it a 'fourth part greater . . .'[77] Increased size was also an important factor in a further development of the project, which took the form of a proposal made by Pope Leo X, perhaps without

Henry's knowledge. On 30 November 1521, the pontiff was shown a wooden model he had commissioned from Baccio Bandinelli for a tomb design for Henry VIII, intended to reward the English king's political support.[78] Although this model is lost, there is extant a remarkable document which probably describes it. In his *History of Britaine*, John Speed includes a long account of a tomb model for Henry VIII to be erected at Windsor.[79] This is an astonishing scheme which involved more than one-hundred-and-thirty statues, forty-four panels of bronze relief and several effigies set on a complex architectural framework. It was never started, and it is hard to imagine where the funds would have been found to finish it. As with Michelangelo's work for Pope Julius II, the scheme recounted by Speed was never a practical proposition.[80] Indeed, the antiquary ends his report: 'But, *Sic transit gloria mundi*, For whosoever this Kings fame was thus intended, yet that great work neuer came to perfection'.[81]

Given the theory of the Two Bodies and the plan's Italian origins, Speed's comments on the planned effigies are especially interesting. The king was to be recumbent, alongside the Queen 'not as death, but as persons sleeping, because to shew that famous Princes leauing behinde them great fame . . .'[82] But another figure had no English precedent: it was to be an equestrian statue of Henry, life-sized, in armour, looking down on his own recumbent effigy. At such a critical moment in English religious history, such an iconographic programme would have been extremely problematic for its intended audience. Later reformers would have found the scheme alarmingly orthodox: Prophets, Evangelists, Doctors of the Church, Choirs of Angels, Scenes from the Life of Christ and, most difficult of all, God the Father with the souls of the deceased. Few of these representations would have been acceptable after the reformation of images.

The later history of this great commemorative project is exceedingly complex and full of uncertainties. Throughout the 1520s, Henry gave his tomb little thought, but finally he chose a project to be built at Windsor using the unfinished materials from Wolsey's monument to commemorate himself and Jane Seymour, his third wife and the mother of his heir. On 29 June 1529 Rovezzano reported on the progress so far made on the tomb[83] which, in his pride, Wolsey had demanded be no less well decorated or costly than the tomb for Henry VII. On 18 October, the cardinal fell from office and was forced to relinquish the Great Seal. Soon afterwards, Rovezzano was instructed to report to the King on the possibilities and costs of a conversion of Wolsey's tomb for royal use.[84] In

his reply the sculptor described a design based on a free-standing sarcophagus and listed the parts of the work already finished – platform, base, sarcophagus and four giant columns.[85]

By December 1530, this work appeared in the royal accounts as 'Henry's', and Thomas Cromwell was authorising payments to Rovezzano and his collaborator Giovanni de Maiano.[86] This experienced team of court artists pressed on until 1536 when work ceased.[87] There is little certain knowledge about the project for an elaborate monument to Henry VIII at Windsor, but by that date it had certainly advanced to a point either where it could satisfactorily be left or where no more money could be spent.[88]

Henry's will of 30 December 1546 refers to

an honourable tombe . . . for o[u]ʳ bones to rest in w[hi]ᶜʰ is well onward & almost made therefor alreadye w[i]ᵗʰ a faire grate . . . for the reputation of the dignity[89] to which he has been called, he directs that . . . [his body] . . . shall be laid in the choir . . . of Windesour, midway between the stalls and the high altar, in a tomb now almost finished in which he will also have the bones of his wife, Queen Jane. And there an altar shall be furnished for the saying of daily masses while the world shall endure. The tombs of Henry VI and Edward IV are to be embellished.[90]

The burial place was in the centre of the choir well away from the 'Pillers of the Church', 'betweene which' the tomb described by Speed was to have been set.[91]

Under Edward VI another generation of foreign artists were brought in to complete Henry VIII's tomb. A letter of 28 August 1551 mentions the house at Westminster where Edward VI's father's tomb was being made and the lodgings there for 'Modene' [Niccolo Bellin of Modena].[92] Presumably the work was to have been carried down to Windsor on completion. Later Edward VI wrote from Hampton Court, complaining that Bellin had been thrown out of his quarters and citing a survey and estimate of some damage which had been done to the chapel and to the tomb.

In the mid-1560s a report was made for Elizabeth's Treasurer, Lord Burghley, on 'speciall thinge[s] wantinge' for Henry's tomb.[93] This document suggests that around the sarcophagus a framework had been erected which still lacked certain bronze embellishments – figures, capitals, friezes, doors and other decorative items. It also lists stones unconnected with Henry's tomb but on the same site. On 15 July 1567, the Marquis of Winchester sent Burghley plans (perhaps a model) of the Windsor tomb, and another Elizabethan report[94] seems to have been

intended as a commentary on it. By now, the monument was located in the Lady Chapel, which needed repairs to its roof. Rovezzano's original model was perhaps still available for 'all things wrought and unwrought touchinge the moddell from the ground upwarde' are listed in a document which may also have been the occasion for the designs (now lost) apparently supplied in 1573 by William Cure I.[95]

At the turn of the century, the remains of the work were still regarded as worth a visit. In 1599, Thomas Platter saw in the middle of the choir Henry's burial place covered with a miserable tapestry 'as they have no tomb splendid enough to bury him' and, in front of the castle, 'an immense black stone (lapidem pydium) . . . intended for H. 8th's tombstone', probably that listed in Lansdowne MS 116. Platter continues, 'In a chapel at the back of the church I saw a very handsome tomb, which twenty-two years ago [sic] a cardinal had begun to erect in honour of King Henry viii. The pillars made of brass are all very graceful, and eight angels likewise of brass overlaid with gilt. In the centre is a stone of black marble, it is one of the very finest tombs that I have seen; if only it were finished and complete!'[96] These were sentiments with which Stow agreed,[97] although Thomas Fuller thought it worth a joke: 'Sure King Henrie lived in two of his (Wolsey's) houses, and lies now in the third, I meane his tombe at Windsor'.[98]

These sixteenth-century reports mention the great sarcophagus (adapted to commemorate Horatio Nelson after his death in 1805 for display in St Paul's Cathedral[99]); free-standing bronze figure sculpture (Cardinal Virtues?); a decorated grate of pilasters; a balustrade; and various bronze decorations including subsidiary figures (prophets). The basic scheme suggests an elaborate version of Torrigiano's tomb for Henry VII. No one mentions an effigy of a queen.

Parliamentary records give us a tantalising glimpse of what remained some sixty years later. Because of the materials used, special stress was placed on the extant metalwork. On 19 September 1645 it was resolved that a committee of M.P.s should 'consider . . . a Statue of Bras at *Windsore*; and in what Condition it is, and to report their Opinions concerning it to the House'.[100] Dramatic turns in the Civil War encouraged an expeditious examination of this matter. On 21 November, the House received intelligence from the Governor of Reading that the King intended 'a plundering voyage . . . to Windsour Castle', and they agreed to alert the Governor resolving 'That the Bras Statue . . . [belonged to] the State. And that the Committee formerly appointed do take care of the Sale thereof'.[101] To pay the wages of the

Parliamentary garrison, on 9 March 1645/46, it was 'Ordered, That the Proceed of the Sale of the Brass Statue at Windsour, not exceeding the Sum of Four Hundred Pounds' should thus be used.[102] Despite further deliberations on the value of an SS Collar, George & Garter found at Windsor as well as '5 & 20 Hundred pounds rumoured to be buried there', the officers and men of the garrison once more petitioned the House for their pay on 7 April 1646.[103] The 'Brass Statua . . . & the Images there' were ordered to be 'defaced, and the other broken Pieces of Brass, be forthwith sold to the best Advantage of the State' and any monies not over £400 to go to Colonel Whitchcote, Governor of Windsor Castle, to pay the garrison. The Lords concurred but also wanted the Commons to agree to the possibility that the Windsor statue(s) could be exported.[104] This the Commons did, ordering that the committee dealing with the sale were to deface any 'Images as may be used in any superstitious Manner . . . And that none be transported, that may be superstitiously used beyond the Seas'. The brass appears to have been sold by July when decisions were taken about the residue of the monies.[105] The four great corner candlesticks are now in St Bavon's, Ghent, which perhaps suggests that the Parliamentary commissioners found a market in the Low Countries.

What can we learn from these accounts? By April 1646, the images were defaced. Any iconoclasm that took place was the result of state policy, not philistinism as is traditionally claimed. Parliament acted out of political expediency, and the decision to combat superstition was taken to rob the images of their potency and to prevent idolatry.[106]

MONUMENTAL BODIES: THE PAST, THE FUTURE AND THE STATE

There is no space here to consider the many fascinating art-historical questions raised by the extraordinary projects to commemorate Henry VIII – for example, what was the exact nature of the single statue mentioned in so many of the sources? – but the anthropological function of the tomb certainly deserves further attention. As is illustrated by the fame of John Donne's elaborate preparations, the custom of establishing one's own monument has a special fascination for the modern mind.[107] Indeed, nowhere does the liminal quality of the death ritual surface more dramatically than in the funeral monuments erected to living people. This common practice in post-Reformation England was the result of a need for well-ordered dying as part of a new social order following the political upheavals of the fifteenth century. For monuments to living people effectively 'kill' the subject and fix their images in time. By having

an effigy cut, the subject has 'chosen' to die in a particular state, as if they had travelled somewhere and laid down with their feet to the east.

In the death ritual, monuments erected for living people form part of the extended liminal period of 'Dying'. The stage between 'Life' and 'Death' thus starts at the point when it is judged that a subject is dying – a point perhaps signalled by a decision to build a tomb. This process of 'dying' not only counters the fear of instability which death causes but initiates the subject into a social afterlife made permanent by a Monumental Body. But there are dangers as well as benefits in the permanence of the funeral monument. In some cultures 'Death' is declared and ritualised for missing persons to overcome the pain of bereavement. With their social image (the Political Body) permanently set by the ritual, any subjects who return to the community are simply ignored, as they have already been declared 'dead'.[108] By the same token, erecting a monument can be risky if the subject's circumstances change before the death of the Natural Body. For instance, when Henry VIII first considered a monument, he was a staunch supporter of the Papacy and an orthodox iconophile, but as the political struggle with the Vatican intensified and his public faith changed, he may have been relieved not already to have been set as an effigy by his continental bronze workers.

Earlier, we observed that the puzzling pattern of Royal tomb-building in Renaissance England can partly be explained by the fluctuating demands for monuments to confirm the continuity of the lineage. An additional explanation may be found in the tension between the demands of status and the potential of design and technology. Monuments marked the presence of the Natural Body, but their size was taken as an index of the symbolic power of the Political Body. This explains why Sir Henry Wotton refers to monuments as 'a piece of State'[109] and why the antiquary Weever condemns the new fashion for insignificant people and social upstarts to be commemorated in great monuments. Possibly the greatest monument of its day was the unused Bandinelli project for the tomb of Henry VIII, and this certainly obeyed the hierarchy of size in its design. Interestingly enough, anthropologists have established that the scale of royal commemorative practices is indicative of the authority of the state in the culture concerned.[110] In ordering a monument from Torrigiano, which was one-fourth larger than that already supplied for his father, Henry VIII was clearly abiding by this principle, although Bandinelli's later massive plans proved too large given the political and religious conflicts of the mid-sixteenth century. These incomplete

projects suggest that royal monuments grew in size in proportion to the ever-increasing centralised authority of the Tudor and Stuart monarchy.

This interpretation of the scale of monuments can also be applied to the massive edifices erected by James's courtiers, which have been censured for their poor taste by generations of art historians. This aristocratic obsession with monuments on a colossal scale has been identified by Stone and others as compatible with the massively inflated honours characteristic of James's court, but this feature of tomb-design also, unintentionally, subverted the state.[111] Elizabethan patrons had indeed spent larger sums on monuments than on any other sculpted or painted art, but the Jacobean nobility created such an inflation of the standard tariff regulating social rank and scale of monument that an appropriate design for the monarch became almost impossible to conceive. Rubens's painted Whitehall ceiling constructed a massive 'monarchical' image on a scale quite unrealistic in sculpture. At the death of James I, Inigo Jones's elaborate funeral architecture was an acceptable temporary solution, but the decision not to build a permanent monument for the king must have seemed a safer strategy than to build one which failed through being too small. For such a failure would have undermined the structure of precedent and shattered the image of kingship which it was precisely intended to support.

Where they exist, Monumental Bodies are always signs of life, but certain Political Bodies are simply too massive to be imagined, and in these cases the death ritual is restricted to the Natural Body.

References

Introduction

1 See, for example, the illustrations in Roy Strong, *The English Icon: Elizabethan and Jacobean Portraiture* (London, 1969).

2 The Cholmondeley Sisters, Tate Gallery, London.

3 See the illustrations in F.A. Yates, *The Theatre of the World* (London, 1969).

4 A notable example of earlier criticism on the body is C. Ricks, 'Sejanus and Dismemberment,' *Modern Language Notes*, LXXVI (1961), pp. 301–8.

5 Pliny tells the ancient story of the discovery of painting in which a young girl traces her lover's shadow on a wall (*Natural History*, XXXV. 15). For this iconographical tradition see Robert Rosenblum, 'The Origin of Painting: A Problem in the Iconography of Romantic Classicism,' *Art Bulletin*, XXXIX (1957), pp. 279–90 and *idem, Transformations in Late Eighteenth-Century Art* (Princeton, 1967), pp. 20–1. For Renaissance ideas on the microcosm see Leonard Barkan, *Nature's Work of Art: The Human Body as Image of the World* (New Haven, 1975).

6 Marcus Vitruvius Pollio, *De Architectura*, III.i. An example of how the concept was taken up in England is to be found in T.A. Joscelyne, 'Architecture and Music in *The Temple*: the Aesthetic and Intellectual Context of George Herbert's Poetry,' unpublished D. Phil. thesis, University of York, 1978.

7 The formula, or aspiration to a formula, of Le Corbusier's modular, which can be successfully used.

8 The best commentary on Alberti's *De Pictura* is M.D.K. Baxandall, *Giotto and the Orators. Humanist Observers of Painting in Italy and the Discovery of Pictorial Composition 1350–1450* (Oxford, 1971).

9 B. Berenson, *The Arch of Constantine, or, The Decline of Form* (London, 1954); B. Hinz, *Art in the Third Reich* (New York, 1979).

10 H. Wölfflin, *Der Klassische Kunst*, first published 1899 (English translation by P. and L. Murray, London, 1952).

11 M. Iversen, 'Politics and the Historiography of Art History: Wölfflin's "Classic Art",' *Oxford Art Journal*, IV (i) (1981), pp. 31–4.

12 M.D. Whinney, *Sculpture in Britain 1530–1830* (Harmondsworth, 1964), xxi, 1.

13 Lucy Gent, *Picture and Poetry 1560–1620* (Leamington Spa, 1981), esp. p. 72.

14 For example, in his preface to *Bartholomew Fair 1614*, first printed 1631.

15 Two discussions of this extensively debated topic are Catherine Belsey, *Critical Practice* (London, 1980) and Jonathan Dollimore, *Radical Tragedy: Religion, Ideology and Power in the Drama of Shakespeare and his Contemporaries* (2nd edn, Brighton, 1989).

16 Valuable signposts to this large subject are: N. Elias, *The Civilising Process* (New York, 1978); A. Ferry, *The 'Inward' Language: Sonnets of Wyatt, Sidney, Shakespeare* (Chicago, 1983). For a wider context to the topic, see M. Carrithers et al., *The*

Category of the Person (Cambridge, 1985), which includes a retranslation of M. Mauss's fundamental essay. A recent book that intermittently relates selfhood to the physical body is J. Glover, *The Philosophy and Psychology of Personal Identity* (London, 1988).

17 John Donne, 'The Ecstasy', 1.72 in *The Complete English Poems*, ed. A.J. Smith (Harmondsworth, 1971), p. 55; we see this again in his line 'that one might almost say, Her body thought' ('Of the Progress of the Soul'), 1.246, ibid., p. 294.

18 Elias, *The Civilising Process* is again relevant here.

19 For example, Keats's 'Eve of St Agnes', Stanza xxxvi, see *Complete Poems*, ed. M. Allott (London, 1970), p. 475 for one nineteenth-century reaction.

20 Two essays that valiantly challenge the view are: T.J. Reiss, 'Montaigne and the Subject of Polity' and S. Greenblatt, 'Psychoanalysis and Renaissance Culture' both in P.A. Parker and D. Quint (eds), *Literary Theory/Renaissance Texts* (Baltimore/London, 1986).

21 As its name suggests the journal *Representations* has consistently focussed on this issue since it began in 1983; the early numbers include some important essays on the English Renaissance.

22 See Parker and Quint (eds), *Literary Theory/Renaissance Texts*.

23 S. Alpers, 'Style is what you make it: the visual arts again' in *The Concept of Style* (University of Pennsylvania Press, 1979), pp. 95–117.

24 Andrew Marvell, 'An Horatian Ode', 1.31 in *The Complete Poems*, ed. E.S. Donno (Harmondsworth, 1972), p. 55.

25 The idea developed after Lucy Gent organised a symposium for the Society of Renaissance Studies at the Warburg Institute in October 1986 entitled *Sign and Discourse*.

26 See, for example, P.O. Kristeller, 'The Modern System of the Arts,' *Journal of the History of Ideas*, XII (1951), 496–527 and XIII (1952), 17–46, republished in his *Renaissance Thought II. Papers on Humanism and the Arts* (New York, 1965).

1 *Andrew Belsey and Catherine Belsey, Icons of Divinity: Portraits of Elizabeth I*

1 As she proceeded through the streets of London the day before her coronation, Elizabeth smiled when a voice in the crowd called out, 'Remember old King Henry VIII'; see J. E. Neale, *Queen Elizabeth* (London, 1938), p. 68. And in her youth Elizabeth was prone to draw attention to the likeness by standing in front of the Holbein portrait: see Leah S. Marcus, *Puzzling Shakespeare: Local Reading and its Discontents* (Berkeley and London, 1988), p. 55.

2 Louis Adrian Montrose, 'The Elizabethan Subject and the Spenserian Text', in Patricia Parker and David Quint (eds), *Literary Theory/Renaissance Texts* (Baltimore, 1986), pp. 303–40, esp. pp. 312–15.

3 Roy Strong, *Gloriana: The Portraits of Queen Elizabeth I* (London, 1987), pp. 132–3.

4 Marina Warner, *Monuments and Maidens: The Allegory of the Female Form* (London, 1987), pp. 241–66.

5 See in particular Strong, *Gloriana*; also Roy Strong, *Portraits of Queen Elizabeth I* (Oxford, 1963) and Frances A. Yates, *Astraea: The Imperial Theme in the Sixteenth Century* (London, 1975).

6 Lucy Gent, *Picture and Poetry 1560–1622* (Leamington Spa, 1981), p. 20.

7 Ibid. p. 21.

8 Strong, *Gloriana*, p. 87; John Pope-Hennessy, *The Portrait in the Renaissance* (London, 1966), p. 204.

9 Strong, *Gloriana*, pp. 85–9.

10 In 1575, the year of the 'Darnley' portrait, the Queen was represented in the royal

entertainment at Kenilworth as a questing knight: see Philippa Berry, *Of Chastity and Power: Elizabethan Literature and the Unmarried Queen* (London, 1989), pp. 95–100. Leah S. Marcus discusses the heterogeneity of Elizabeth's gender identifications in *Puzzling Shakespeare*, pp. 53–66. See also Winfried Schleiner, '*Divina Virago*: Queen Elizabeth as Amazon', *Studies in Philology*, LXXV (1978), 163–80.

11 Warner, *Monuments and Maidens*, pp. 38–60.

12 For examples see E.C. Wilson, *England's Eliza* (Cambridge, Mass., 1939). Philippa Berry points to the contradictory implications of this representation of the Queen, which was not, of course, necessarily of her own making. While on the one hand it secured the service of her 'knights', on the other it permitted them to escape in foreign exploits from the disturbing control of a monarch who was also a woman, and to show themselves capable military leaders, which Elizabeth herself could never be: see *Of Chastity and Power*, pp. 76–7.

13 Strong, *Gloriana*, pp. 85–9.

14 Case (?1540/46–1600) was in his time an influential Oxford philosopher who published a number of works on Aristotelian themes. See Charles B. Schmitt, *John Case and Aristotelianism in Renaissance England* (Montreal, 1983). The *Sphæra civitatis* was an exposition of political theory based on parts of Aristotle's *Politics*.

15 Strong, *Gloriana*, p. 133.

16 'There is no trace in [Ptolemy's] *Almagest* of what the Middle Ages and the Renaissance called the Ptolemaic System, namely the description of the Universe as consisting of planetary spheres nested one inside the other so as to fill the space between the highest sublunary sphere (that of fire) and the sphere of the fixed stars': see 'Ptolemaic Astronomy', *Dictionary of the History of Science* (London, 1981), p. 350. It is historically more accurate to call this cosmology Aristotelian.

17 Schmitt, *John Case*, p. 87.

18 Yates, *Astraea*, p. 64.

19 Ibid., quoting Dante's *De Monarchia*. See also Leonard Barkan, *Nature's Work of Art: The Human Body as Image of the World* (New Haven, 1975), ch. 2.

20 Strong, *Gloriana*, p. 133.

21 See S.J. Heninger, Jr., *The Cosmographical Glass: Renaissance Diagrams of the Universe* (San Marino, Cal., 1977).

22 On the ancient tradition, see Barkan, *Nature's Work of Art*, ch. 1; on Hildegard see ibid., ch. 3.

23 Lynn Thorndyke, *The Sphere of Sacrobosco and its Commentators* (Chicago, 1949).

24 Heninger, *Cosmographical Glass*, p. 37; Thorndyke, *Sphere*, p. 41. Case knew Sacrobosco's work (Schmitt, *John Case*, p. 159).

25 Thorndyke, *Sphere*, p. 119.

26 The variations are graphically demonstrated in Heninger, *Cosmographical Glass*, passim. See also Edward Grant, 'Cosmology', and Olaf Pedersen, 'Astronomy', in David C. Lindberg (ed.), *Science in the Middle Ages* (Chicago, 1986), pp. 265–302 and 303–37 respectively.

27 A further complication is that some astronomers placed a crystalline sphere beyond the fixed stars, which made the *primum mobile* the tenth sphere, and the sphere of Heaven, if there was one, the eleventh.

28 Finé (1532) had only eight spheres, with the function of the *primum mobile* being amalgamated with that of an unbounded Heaven beyond. Cortes, in a book which appeared in England in 1561, had eleven spheres, the outermost being described as 'The Empyreal Heaven, the Abitation of the Blesed': see Heninger, *Cosmographical Glass*, p. 39.

29 Heninger, *Cosmographical Glass*, p. 50.

30 Yates, *Astraea*, p. 65.

31 Strong, *Gloriana*, p. 39.

32 Ibid., p. 40.

33 Ibid., p. 43. See also Yates, *Astraea*, pp. 78–9.

34 Northern European painting shows glass mirrors in the fifteenth century, but they are normally convex (Pope-Hennessy, *The Portrait in the Renaissance*, p. 129).

35 *The Faerie Queene* I. iv. 10. For an account of Renaissance mirrors moralised see Ernest B. Gilman, *The Curious Perspective: Literary and Pictorial Wit in the Seventeenth Century* (New Haven, 1978), pp. 167–77.

36 Paul Delany, *British Autobiography in the Seventeenth Century* (London, 1969), pp. 12–13.

37 See Jacques Lacan, 'The Mirror Stage as Formative of the Function of the I as Revealed in Psychoanalytic Experience', *Ecrits: A Selection* (London, 1977), pp. 1–7. We do not imply that any of this could or would have been acknowledged in the sixteenth century.

38 The text of *The Winter's Tale* credits its sculptor, Julio Romano ('that rare Italian master') with powers of illusionism which fall (just?) short of God's: 'had he himself eternity and could put breath into his work, [he] would beguile nature of her custom, so perfectly he is her ape' (V. ii. 94–7). Shakespeare references are to the one-volume edition of the *Complete Works*, Peter Alexander (ed.) (London, 1951).

39 Roger Lockyer (ed.), *The Trial of Charles I* (London, 1959), p. 135.

40 For an account of the succession controversy see Marie Axton, *The Queen's Two Bodies: Drama and the Elizabethan Succession* (London, 1977).

41 David Beers Quinn, *The Elizabethans and the Irish* (Ithaca, N.Y., 1966).

42 Kenneth R. Andrews, *Trade, Plunder and Settlement: Maritime Enterprise and the Genesis of the British Empire, 1480–1630* (Cambridge, 1984), p. 2.

43 Peter Ure (ed.), *King Richard II* (London, 1961), pp. lvii–lix.

44 Philippa Berry identifies a crisis in the literary representation of the Queen during the 1590s: see Berry, *Of Chastity and Power*, pp. 134–65.

2 Ellen Chirelstein, Lady Elizabeth Pope: The Heraldic Body

I am grateful to Ellen D'Oench, Mary Price, Lesley Baier and Elizabeth Honig for having read the manuscript; and to Lila Freedman and Gloria Kury whose constant and valuable dialogue cannot be measured adequately.

1 'Pope, William of Wroxton, co. Oxon, and Elizabeth Watson daughter of Thomas Watson, esq. of Westminster – at St. Margaret's, Westminster. 13. Dec. 1615.' *London Marriage Licenses, 1551–1869*, ed. Joseph Foster (London, 1887), p. 1075; Wroxton Abbey had the largest collection of paintings by Robert Peake, including this portrait. See Tate Gallery *Report* (London, 1956), p. 16. The portrait was cleaned in 1969. A portrait of her sister-in-law, *Lady Anne Pope* (London, Tate Gallery), also from Wroxton, is inscribed with the date 1615. Lady Anne, who never married, is shown with the loosened hair of a virgin. Cherries, traditionally associated with virginity, fill the painted frame. Peake has, it seems, conflated two frames for her image: the miniature as well as the baroque framing device, seen in seventeenth-century portraits. Her hand, touching her breast, is a familiar gesture in miniature portraits.

2 Black is frequently associated with sombre and melancholy themes, but such an association does not seem to be appropriate for this painting. Its meaning here is uncertain, but the colour might suggest the amorous connotations associated with the night, or perhaps be intended to make some reference to Queen Anne and the women of the court, who were disguised as the black daughters of Niger in the *Masque of Blacknesse* in 1605. Queen Elizabeth, of course, is frequently depicted wearing a black

gown, and there is some indication that black and white together were symbolic of eternal virginity. M. Channing Linthicum, *Costume in the Drama of Shakespeare and his Contemporaries* (New York, 1972), p. 15, cites such a connection in Grange, *The Golden Aphroditis*, 1577.

3 *Ben Jonson: The Complete Masques*, ed. Stephen Orgel (New Haven, 1975), p. 179. This concept of the human body is discussed in Leonard Barkan, *Nature's Work of Art: The Human Body as Image of the World* (New Haven, 1975).

4 For example, the portrait of *Mary Throckmorton, Lady Scudamore*, c. 1614/15 by Marcus Gheeraerts, (London, Tate Gallery). The self-enclosing gesture as an aspect of the woman's role in Renaissance society is discussed by Peter Stallybrass, 'Patriarchal Territories', in *Rewriting the Renaissance: The Discourses of Sexual Difference in Early Modern Europe*, ed. Margaret W. Ferguson, Maureen Quilligan and Nancy J. Vickers (Chicago, 1986), pp. 123–42.

5 The interest northern painters displayed in the depiction of fabric is fully explored by Linda A. Stone-Ferrier, *Images of Textiles: The Weave of Seventeenth-Century Dutch Art and Society* (Ann Arbor, 1985).

6 For many years, studies of Elizabethan and Jacobean painting began with the gloomy observation that Elizabethan painters either 'misunderstood' or failed to respond to the Renaissance notion of perspectival illusion and the expressive classical body. Viewed as an archaic, isolated style only distantly related to the Italian High Renaissance, it seemed peculiar and at odds with the European mainstream. This view is expressed by both Roy Strong, *The English Icon* (London, 1969), p. 31; and David Piper, 'Tudor and Early Stuart Painting', in *The Genius of English Painting*, ed. David Piper (New York, 1975), p. 62. While frequently exposed to visiting and *émigré* northern artists, English painters continued to perform with relative independence from continental models; for a discussion of a similar pattern in contemporary literature see Thomas M. Greene, *The Light in Troy: Imitation and Discovery in Renaissance Poetry* (New Haven, 1982), ch. 13, 'Accommodations of Mobility in the Poetry of Ben Jonson', esp. pp. 269–70. For a different view of Elizabethan taste see the excellent discussion in Alice K. Friedman, *House and Household in Elizabethan England: Wollaton Hall and the Willoughby Family* (Chicago, 1989), pp. 72–6.

7 See, for example, *Lady Isabella Rich*, c. 1615 attributed to William Larkin, (Suffolk Collection, Greater London Council). There are, however, several portrait busts of men wearing only a classical mantle.

8 Roy Strong suggests that the engraving may be after a design by Inigo Jones, in his *Henry, Prince of Wales and England's Lost Renaissance* (London, 1986), pp. 130–1. In continental portraits, images of women with one bare breast have sometimes been interpreted as reflecting two aspects of marriage: modesty and sensuality. See Egon Verheyen, 'Der Sinngehalt von Giorgiones Laura', *Pantheon*, 26 (1968), pp. 220–7. There is no indication that Peake was aware of this tradition.

9 Orgel, ed., *Ben Jonson*, p. 95.

10 Cesare Vecellio, *Habiti Antici, et Moderni di tutto ii Mondo* (Venice, 1598), p. 354; J. J. Boissard, *Vitae et Icones Sultanorum Turcicorum . . .* (Frankfurt, 1596), p. 56.

11 Thus far, I have found no evidence to suggest that Lady Elizabeth participated in any masque.

12 See also the *Unknown Lady*, c. 1590–1600, attributed to Marcus Gheeraerts (London, Hampton Court). The landscape background as well as the historiated costume and long veil worn by the *Unknown Lady*, artist unknown, (Bristol, City of Bristol Art Gallery) suggests that this portrait, too, is masque-related.

13 Describing the wedding of Lady Frances Howard, formerly Countess of Essex, to Robert Carr, Earl of Somerset; quoted in *The Progresses, Processions, and Magnifi-*

cent Festivities of King James the First, ed. John Nichols, 4 vols. (London, 1828), II, p. 725.

14 Orgel, ed., *Ben Jonson*, p. 81.

15 Ibid., p. 67.

16 Ibid., p. 5; As Orgel observes elsewhere: 'A masquer's disguise is a representation of the courtier beneath. He retains his personality and hence his position in the social hierarchy. His audience affirms his equality with them by consenting to join the dance. This is the climax of the Jacobean masque, and dramatically equivalent to the Tudor unmasking, whereby the symbol opens and reveals the reality.' Stephen Orgel, *The Jonsonian Masque* (New York, 1981), p. 117.

17 For some examples of early images of America see Hugh Honour, *The New Golden Land: European Images of America* (New York, 1975); William C. Sturtevant, 'First Visual Images of Native America', and Donald Robertson, 'Mexican Indian Art and the Atlantic Filter: Sixteenth to Eighteenth Centuries' both in *First Images of America: The Impact of the New World on the Old*, ed. Fredi Chiappelli, et al., 2 vols. (Berkeley, 1976), II, pp. 417–54, 483–94; James Hazen Hyde, 'The Four Parts of the World as Represented in Old-Time Pageants and Ballets', *Apollo*, IV (1926), pp. 232–8; and V (1927), pp. 20–6.

18 *The Plays and Poems of George Chapman*, ed. T.M. Parrott, 2 vols. (London, 1914), II. For a discussion of this masque and its social context see D.J. Gordon, *The Renaissance Imagination*, ed. Stephen Orgel (Berkeley, 1975), pp. 194–202; and Stephen Orgel and Roy Strong, *Inigo Jones: The Theater of the Stuart Court*, 2 vols. (Berkeley, 1973), I, pp. 252–63, Fig. 83, 84.

19 See, for example, line 63 of *The Vision of Delight* in Orgel, ed., *Ben Jonson*, p. 247; Joel Fineman discusses the erotic overtones of the colour purple in 'Shakespeare's *Will*: The Temporality of Rape', *Representations*, 20 (1987), 37–9 and n. 14.

20 Elizabeth Pope's important status as sole heir appears in almost every reference to her; she was destined to inherit her father's property. See George Baker, *The History and Antiquities of the County of Northamptonshire* (London, 1822), p. 707; for a general discussion of women and marriage settlements, see Lawrence Stone, *The Family, Sex and Marriage in England 1500–1800* (New York, 1979); Lisa Jardine explores the representation of the wealthy heiress in *Still Harping on Daughters: Women and Drama in the Age of Shakespeare* (Sussex, 1983). In Chapter 3, 'I am Duchess of Malfi Still', she quotes Middleton's *Women Beware Women*: 'men buy their slaves, but women buy their masters.'

21 Thomas Watson was a wealthy gentleman and landowner who purchased his estate at Halsted in 1576, see Edward Hasted, *Kent*, 2 vols. (London, 1830), I, pp. 15 and 320; William Pope's family, however, was a part of the nobility; his father was created Baronet in 1611 and Earl of Downe in 1628, see John Guillim, *A Display of Heraldrie* (London, 1610), ii, p. 183. The King's visits to Sir Thomas Watson at Halsted were recorded in Nichols, ed., *The Progresses*, III, pp. 482–3, 487; and to the Pope family seat at Wroxton, in ibid., pp. 527–8, 563.

22 *Calendar of State Papers – Domestic, 1580–1625* (London, 1872), p. 382; G.E. Aylmer, *The King's Servants* (New York, 1961), pp. 208–9; Alexander Brown, *The Genesis of the United States*, 2 vols. (New York, 1890), II, p. 1043.

23 Theodore K. Rabb, *Enterprise and Empire: Merchant and Gentry Investment in the Expansion of England, 1575–1630* (Cambridge, Mass., 1967), p. 398. Rabb also lists a Robert Peake, merchant, among the subscribers, but there is no way of knowing if this is our painter. Rabb's study characterises all unknown investors as merchants. Sir Thomas Watson's name appears in 'A Declaration of the state of the Colonie and Affairs in Virginia: With the Names of the Aduenturors, and the summes aduentured, in the Action,' (1620), reprinted in *Tracts and Other Papers Relating Principally to the*

Origin, Settlement, and Progress of the Colonies in North America, ed. Peter Force (District of Columbia, 1844, reprinted Peter Smith, Gloucester, Mass., 1963), vol. III, p. 43; and as the author of 'A True Relation of such occurrences and accidents of noate as hath happened in Virginia . . . ' (1608) reprinted in *The Jamestown Voyages Under the First Charter, 1606–1609*, ed. Philip L. Barbourg (Hakluyt Society, 2d ser., no. 137, Cambridge, 1969), p. 167.

24 For a discussion of women as property, see Keith Thomas, 'The Double Standard', *Journal of the History of Ideas*, 20 (1959), 195–216.

25 Patricia Parker, *Literary Fat Ladies: Rhetoric, Gender, Property* (London, 1987), ch. 7, 'Rhetorics of Property: Exploration, Inventory, Blazon.'

26 Coral is a vine below the surface of the sea in Ovid's description of Perseus and the Gorgon's head, see *Metamorphoses*, trans. Rolfe Humphries (Bloomington, 1955), p. 105; in *The Masque of Blackness*, the light-bearers' hair was garlanded with sea-grass and stuck with branches of coral, Orgel, ed., *Ben Jonson*, p. 50. In the painting by Jacopo Zucchi, c. 1542–1590, called *The Treasures of the Sea* or *The Discovery of America* (Rome, Borghese Gallery), the nymphs play with branches of coral and drape their bodies with pearls.

27 *The Works of Michael Drayton*, ed. J.W. Hebel, et. al., 5 vols. (Oxford, 1961), II, pp. 363–4.

28 Mary Edmond, *Hilliard and Oliver: The Lives and Works of Two Great Miniaturists* (London, 1983), p. 101; Patricia Fumerton, ' "Secret" Arts: Elizabethan Miniatures and Sonnets,' *Representations*, 15 (1986), 96.

29 Gordon, *The Renaissance Imagination*, p. 18.

30 John Pope-Hennessy, 'Nicholas Hilliard and Mannerist Art Theory', *Journal of the Warburg and Courtauld Institutes*, 6 (1943), 89.

31 Nicholas Hilliard, *The Arte of Limning*, ed. R.K.R. Thornton and T.G.S. Cain (Manchester, 1981), p. 87.

32 Fumerton, ' "Secret" Arts'.

33 Piper, 'Tudor and Early Stuart Painting', p. 78.

34 Cited in John Buxton, *Elizabethan Taste* (Sussex, 1963), p. 120; see also Linda Bradley Salamon's commentary in *Nicholas Hilliard's Art of Limning: A New Edition of A Treatise Concerning the Arte of Limning, Writ by N. Hilliard*, transcription by Arthur F. Kinney, commentary by Linda Bradley Salamon (Boston, 1983), p. 97; and for a discussion of the relation between this 'private' art and the concept of the self, see Fumerton, ' "Secret" Arts'.

35 Hilliard, *The Arte of Limning*, p. 63.

36 Jim Murrell, 'The Craft of the Miniaturist,' in John Murdoch, Jim Murrell, Patrick J. Noon and Roy Strong, *The English Miniature* (New Haven, 1981), pp. 7–8.

37 Svetlana Alpers discusses this in relation to the work of Jan Bruegel: 'But besides presenting themselves as a display of human artistry, Jan Bruegel's pictures supply (or flirt with supplying) value in more ways than one: the specimens are painted so as to fool our eyes into thinking they are the real thing; they are chosen for their rarity; the materials were chosen with an eye to their cost – copper as a support frequently, lapis lazuli as pigment, gold for certain frames. It was because of these values, among others, that the paintings were priced more highly than the special specimens and objects represented in them' in her *Rembrandt's Enterprise: The Studio and the Market* (Chicago, 1988), p. 19.

38 Rosalie Colie, *Paradoxia Epidemica: The Renaissance Tradition of Paradox* (Princeton, 1966), esp. pp. 358–63.

39 Svetlana Alpers, *The Art of Describing* (Chicago, 1983), p. xxi.

40 Karel van Mander, *Dutch and Flemish Painters*, trans. Constant van de Waal (New York, 1936), p. 26. I am grateful to Celeste Brusati for directing me to this.

41 Frank Whigham, *Ambition and Privilege: The Social Tropes of Elizabethan Courtesy Theory* (Berkeley, 1984), p. 155.

42 The phrase is from Sonnet 16, see *Astrophel and Stella*, ed. Max Putzel (Garden City, 1967), p. 16; on female beauty in sixteenth-century painting see Elizabeth Cropper, 'On Beautiful Women, Parmigianino, *Petrarchismo*, and the Vernacular Style', *Art Bulletin*, 50 (1976), 374–94; the poetic tradition of praising the individual perfection of each part of the woman's body is discussed as a rhetorical strategy of fragmentation and reification in Nancy Vickers, ' "The Blazon of Sweet Beauty's best": Shakespeare's *Lucrece*', *Shakespeare and the Question of Theory*, ed. Patricia Parke and Geoffrey Hartman (New York, 1985), pp. 95–115.

43 Mary Edmond, 'Limners and Picturemakers', *Walpole Society*, 47 (1978–80), 129–34.

44 Hilliard, *The Arte of Limning*, pp. 85–7.

45 Michael Leslie, 'The Dialogue between Bodies and Souls: Pictures and Poesy in the English Renaissance', *Word and Image*, 1 (1985), 16–30.

46 Ellen Chirelstein, *The Allegory of the Tudor Succession* (exh. cat., New Haven, 1982).

47 Lucy Gent, *Picture and Poetry 1560–1620* (Leamington Spa, 1981), p. 29.

48 Leslie, 'The Dialogue between Bodies and Souls', pp. 23–7.

49 The relation between heraldry and painting has often been noted; see Roy Strong, *The English Icon*, pp. 16–17 and Piper, 'Tudor and Early Stuart Painting', p. 73. Mason Tung discusses the transformation of heraldic arms into emblems in 'From Heraldry to Emblem: a Study of Peacham's Use of Heraldic Arms in *Minerva Britanna*', *Word and Image*, 3 (1987), pp. 86–94. For a discussion of heraldry, emblem and impresa in Tudor pageantry see Alan Young, *Tudor and Jacobean Tournaments* (Dobbs Ferry, NY, 1987).

50 Gent, *Picture and Poetry 1560–1620*, p. 20.

51 See, for example, the portrait of *Lettice Knollys, Countess of Leicester*, attributed to George Gower (Longleat, The Marquess of Bath) in which the dress is embroidered with Leicester's badge, the ragged staff.

52 Keith Wrightson, *English Society 1580–1680* (London, 1982), ch. 1, 'Degrees of people'; D.M. Paliser, *The Age of Elizabeth: England Under the Late Tudors 1547–1603* (London, 1983), pp. 60–94. Perry Anderson makes an additional point that is relevant here; merchants and members of the nobility in England, unlike those in France and Spain, invested jointly in various enterprises; see his *Lineages of the Absolutist State* (London, 1979), pp. 124–6.

53 Henry Peacham, *The Compleat Gentleman* (London, 1634), pp. 153–4.

54 Hendrik Goltzius, *Manlius Torquatus*; Roy Strong makes this connection in *Henry*, ill. 43.

55 Orgel, ed., *Ben Jonson*, p. 50.

56 In John Harris, Stephen Orgel and Roy Strong, *The King's Arcadia: Inigo Jones and the Stuart Court* (exh. cat., London, 1973), p. 38; and Orgel and Strong, *Inigo Jones*, I, ch. 1, 'The Poetics of Spectacle'.

57 *Sebastian Serly, The Five Books of architecture. Translated out of Italian into Dutch and out of Dutch into English.* London. Printed for Robert Peake, 1611 (London, 1982).

58 Peake's concerns echo those of modern art historians: ' . . . that this period should gestate at its close the greatest English-born genius of the human imagination – Shakespeare, rooted so deeply in the English soil yet of such unparalleled and enduring universal relevance – seems entirely proper. But when one looks for this English counterpart in visual arts *one looks in vain* . . . ' (italics mine) Piper, 'Tudor and Early Stuart Painting,' p.62. The privileging of the standards and assumptions of Italian art

are deeply involved in these discussions of national pride. Art historians have indulged in a kind of proleptic art history.

59 Stephen Orgel, *The Illusion of Power: Political Theater in the English Renaissance* (Berkeley, 1975), pp. 10–11; the assumption behind Jones's stage is 'that a theater is a machine for controlling the visual experience of the spectator and that the experience is defined by the rules of perspective', Orgel and Strong, *Inigo Jones*, I, p. 7. This aspect of perspective is somewhat modified in John Orrell, *The Theatres of Inigo Jones and John Webb* (Cambridge, 1985), p. 147.

60 Strong, *Henry*, pp. 169–70.

61 For a discussion of the curtain painted with a perspective scene that is dropped before the beginning of the masque, see Orgel and Strong, *Inigo Jones*, ch. 1, 'The Poetics of Spectacle', esp. pp. 18–20.

62 Strong, *Henry*, p. 114; Friedman, *House and Household*, usefully explores the synthesising of different stylistic traditions, pp. 71–134.

63 Orgel, ed., *Ben Jonson*, p. 96.

64 Gloria Kury, *The Arcadian Mask* (forthcoming); Jones's description of the corporeal body seems to make the transition from body to soul less problematic than Jonson's sensuous appreciation: 'so that corporeal beauty, consisting in symmetry, colour, and certain unexpressable graces, shining in the Queen's majesty, may draw us to the contemplation of the beauty of the soul, unto which it hath analogy', from Orgel and Strong, *Inigo Jones*, II, p. 483 and I, ch. 4, 'Platonic Politics', esp. p. 5.

65 See also Isaac Oliver's *Young Lady in Masque Costume* (London, Victoria and Albert Museum). For a description of these two miniatures see Jill Finsten, *Isaac Oliver* (New York, 1981), Vol. II, pp. 82–3, 94–5.

66 See Suzanne W. Hull, *Chaste, Silent and Obedient: English Books for Women 1475–1640* (San Marino, Calif., 1982).

67 Ruth Kelso, *Doctrine for the Lady of the Renaissance* (Urbana, Ill., 1956); Ian Maclean, *The Renaissance Notion of Woman* (Cambridge, 1980), ch. 2, 'Theology, mystical and occult writings'.

68 John Freccero suggests that the laurel, emblem both of the lover's enthralment and of the poet's triumph, 'stands for a poetry whose real subject matter is its own act and whose creation is its own author', see 'The Fig Tree and the Laurel: Petrarch's Poetics', *Diacritics*, 5 (1975), 34–40.

69 I have paraphrased Stephen Greenblatt who discusses this in *Renaissance Self-Fashioning: From More to Shakespeare* (Chicago, 1980) pp. 230–1; the importance of this rhetorical strategy to the English Renaissance is explored by Joel Altman, *The Tudor Play of Mind: Rhetorical Inquiry and the Development of Elizabethan Drama* (Berkeley, 1978), pp. 31–106.

3 Elizabeth Honig, In Memory: Lady Dacre and Pairing by Hans Eworth

1 L. Stephen, ed., *Dictionary of National Biography* (London, 1889), XVIII, p. 432; Thomas Barrett-Lennard, *An Account of the Families of Lennard and Barrett* (n.p., 1908), pp. 196 ff.

2 I find a date of 1558 or very near to it most likely: for reasons which will become clear, it seems that the commissioning of this portrait must have been linked to the vindication of Thomas Fiennes. Roy Strong dated the work *c.* 1555 on the evidence of costume both in *The English Icon* (London/New York, 1966), p. 101, and in *Hans Eworth* (exh. cat., Leicester/London, 1965), p. 10. A lost pair of portraits by Eworth dated 1557 showed Mary Neville's granddaughter-by-marriage, Anne Wooton, and her husband, Bassingbourne Gaudy; G. Vertue, *Notebooks*, vol. II in *The Walpole*

Society, xx (1931–32), p. 87; perhaps Eworth's successful completion of this commission led to his receiving the other.

In the discussion which follows it should be kept in mind that Eworth was a native of the Low Countries and received his artistic training there, as did many of the other painters active in sixteenth-century England. Thus, although the demands of English patrons and their culture produced a distinct tradition, there was a strong link to continental developments in portraiture.

3 The portrait of Mary Neville measures 73.7 × 57.8 cm. It is impossible to judge the real size of the portrait of Thomas Fiennes, although the width of its frame relative to the surface of the image indicates that it is quite small. Vertue recorded that this portrait was after a 'large picture' then owned by the Dacre family (*Notebooks* vol. v in *The Walpole Society*, xxvi (1937–38), p. 19), but that could have been the late sixteenth-century copy still in the family (cf. Strong, *Hans Eworth*, p. 10). My first analysis of the visual complexities of Mary Neville's portrait was much helped by the guidance of Jules Prown.

4 The portrait of Thomas Fiennes is accepted as being by Holbein by Paul Ganz, *The Paintings of Holbein* (London, 1956), p. 251, cat. no. 108, and, tentatively, by John Rowlands, *Holbein* (Oxford, 1985), p. 226, cat. no. L17. While this cannot be firmly established, since the painting no longer exists, it does not seem unlikely. The painting fits well with Holbein's *œuvre* from *c.* 1540; a portrait by him from 1538 is inscribed on the frame in a very similar way (Ganz, *The Paintings of Holbein*, no. 100), and Fiennes would have been in a position to commission his portrait from the best painter available.

5 *Hamlet* IV, v.

6 While prayer books had long been luxury items for noble ladies, a concern with women's *reading* religious texts was new to the Renaissance. Erasmus and Vives, whose thoughts on women were especially important to the English upper classes, had both argued that women should read the Bible. See Suzanne W. Hull, *Chaste, Silent and Obedient: English Books for Women 1475–1640* (San Marino, Calif., 1982), pp. 91–105; Ian Maclean, *The Renaissance Notion of Woman* (Cambridge, 1980), p. 20; Pearl Hogrefe, *Tudor Women: Commoners and Queens* (Ames, Iowa, 1975), ch. 8, 'Women with a Sound Classical Education'.

7 I do not know of any other sixteenth-century English portrait which shows a woman writing. A closed or half-open devotional book becomes a fairly common prop in female portraiture only several decades later; see for instance the portrait of Anne Wyatt, Mrs Twisden (Col. C. Wynne Finch), and several portraits by Marcus Gheerærts the Younger from the early seventeenth century.

8 Hans-Georg Gadamer, *Truth and Method*, trans. G. Barden and J. Cumming (New York, 1975), p. 128, in the section on 'The Ontological Foundation of the Occasional and the Decorative'; see also appendix II, pp. 453 ff.

9 On marriage portraiture see David R. Smith, *Masks of Wedlock* (Ann Arbor, 1982) and E. de Jongh, *Portretten van Echt en Trouw* (exh. cat., Haarlem, 1986). Both of these deal with Dutch portraiture; no comparable work on English portraits exists, but many of their observations are valuable for its study.

10 For an overview of this debate see the introduction to Ralph A. Houlbrooke, *The English Family 1450–1700* (London/New York, 1984).

11 The strongest argument for a steady 'development' of companionate marriage was made by Lawrence Stone, *The Family, Sex and Marriage in England 1500–1800* (London, 1977). For a critique of his teleology see the review by Alan Macfarlane in *History and Theory*, xviii/1 (1979), 103–26. Stone's schema implies that the new ideas flowed from the wealthier classes downwards; for an opposing view see Macfarlane's *Marriage and Love in England 1300–1840* (Oxford, 1986): he also criticises Stone on

these grounds (review, pp. 109–10). See also John R. Gillis, *For Better, For Worse. British Marriages 1600 to the Present* (Oxford/New York, 1985), p. 14; Linda T. Fitz, ' "What Says the Married Woman?",' *Mosaic,* XIII (1980), 1–22.

12 Stone, *The Family, Sex and Marriage,* p. 102.

13 Macfarlane, *Marriage and Love,* ch. 9, 'Romantic Love,' and p. 46.

14 Berthold Hinz, 'Studien zur Geschichte des Ehepaarbildnisses,' *Marburger Jahrbuch,* XIX (1974), 150–1.

15 This despite K.M. Davies's argument that the advice offered in these books frequently echoes that offered in earlier ones: 'Continuity and Change in Literary Advice on Marriage' in *Marriage and Society,* ed. R.B. Outhwaite (London, 1981), pp. 58–80. Note that her goal is to define a more 'popular' discourse of marriage: the Tudor sources she uses were intended for priests as counselling guides. The books I discuss below were intended for the elite circles in which most of Eworth's patrons moved.

16 On Tilney's book see Linda Woodbridge, *Women and the English Renaissance* (Brighton, 1984), pp. 59–60.

17 (London, 1568).

18 On other proponents of affective marriage see Macfarlane, *Marriage and Love,* pp. 134 ff. and Davies, 'Continuity and Change'; on less 'affective' writers see Maclean, *The Renaissance Notion of Woman,* p. 59.

19 Fitz, ' "What Says the Married Woman?",' p. 9.

20 See below, p. 67.

21 On obedience as a prime virtue, see Hull, *Chaste, Silent and Obedient, passim.*; Hogrefe, *Tudor Women,* pp. 3–9. Stone, *The Family, Sex and Marriage,* argues that the dominance of husbands over wives actually increased during this period; he also points out the apparent contradiction between this and the rhetoric of the affective marriage.

22 It is sometimes claimed that this rhetoric occurred in reaction to an abundance of 'disobedient' women in the surrounding society (Fitz, ' "What Says the Married Woman?",' p. 23; Hogrefe, *Tudor Women,* p. 8); while this seems too simplistic, tension certainly existed at some level.

23 For example see H. Bullinger, *The Christian State of Matrimony. Wherein husbandes and wyves may learne to keepe house together wyth love,* trans. M. Coverdale (n.p., 1541; reprint Amsterdam/Norwood, N.J., 1974), p. lvi verso (with all scriptural bases) and *passim.*

24 Tilney, *Brief & pleasant discourse,* p. B vi verso.

25 See Barbara J. Todd, 'The remarrying widow: a stereotype reconsidered' in *Women in English Society 1500–1800,* ed. Mary Prior (London/New York, 1985), pp. 54–92. She finds that not until after 1570 did upper-class men begin making wills penalising their wives for remarrying, a trend then followed by those of other ranks (p. 73). However, her study only concerns the small town of Abingdon in Berkshire where local gentlemen were surely following a trend begun in still higher circles. On wealthy widows in general see Hogrefe, *Tudor Women,* p. 23; on the economic situation of widowhood see Vivien Brodsky, 'Widows in Late Elizabethan London: Remarriage, Economic Opportunity and Family Orientations' in *The World We Have Gained,* ed. L. Bonfield et al. (Oxford, 1986), pp. 122–54.

26 On the dichotomy of woman as sensual and emotional vs. man as rational and judgmental see Maclean, *The Renaissance Notion of Woman,* p. 42 and *passim*; on the lecherous widow stereotype see Woodbridge, *Women and the English Renaissance,* pp. 177–8.

27 Juan Luis Vives, *A very fruteful and pleasant booke called the Instruction of a christen woman,* trans. R. Hyrde (London, 1557), pp. Nn ii verso ff. (1st edn, 1529). On this

book see G. Kaufmann, 'Juan Luis Vives on the Education of Women,' *Signs*, 3/4 (1978), 891–6.

28 Ibid., p. Ll iv verso. On the wife as custodian, see Maclean, *The Renaissance Notion of Woman*, pp. 58–9; Hogrefe, *Tudor Women*, pp. 59 ff.; for contemporary praise of women for performing this duty well, see Woodbridge, *Women and the English Renaissance*, p. 37.

29 Barrett-Lennard, *An Account*, p. 207; information derived from the *History of Families of Barrett and Lennard* by Thomas, Lord Dacre, c. 1770. I am grateful to Julia Walworth for helping me to obtain this information.

30 On the identification of the sitters in this painting see Susan Foister, 'Nobility Reclaimed,' *The Antique Collector*, IV (1986), 58–60. My thanks to Anne Thackeray for directing me to this article.

31 Until recently the painting was in fact thought to be a marriage portrait, representing Frances Brandon and her scandalously young husband and former master of the horse, Adrian Stokes. See Strong, *Hans Eworth*, pp. 4–5 (no. 8). The only other mother/son portrait of which I know which uses this format is, significantly, a portrait of Mary Queen of Scots and James VI (col. Duke of Atholl, Blair Castle, dated 1585); although far less subtle than Eworth, this anonymous artist too places the royal mother on the left and slightly behind her son. It is interesting to note that Gregory Fiennes was already married when Eworth painted this portrait, another fact which his mother erases in claiming her place in the family image (Barrett-Lennard, *An Account*, p. 208). It is further recorded that Gregory's wife, Anne Sackville, complained that he was kept in undue subjection by his mother (*DNB*, vol. XVIII, p. 428).

32 This placement probably derives from the rules of heraldry (Smith, *Masks of Wedlock*, p. 47) and thence from the genesis of marriage portraiture in donor portraits on triptych wings (Hinz, 'Ehepaarbildnisses,' pp. 143–5). The heraldic formula is based on the man being shown to the woman's right, in the more important position. On left-right in marriage portraits see also de Jongh, *Portretten*, p. 36 and *passim*.

33 Within Eworth's *œuvre* the only exception to this, apart from Mary Neville, is his portrait of Mary Fitzalan (Strong, *Hans Eworth*, no. 26): she was a notoriously learned young lady who translated Latin and Greek and hence had particularly masculine abilities.

34 In her recent book *Death, Burial and the Individual in Early Modern England* (London/Sydney, 1984), Clare Gittings discusses this dilemma: see ch. 2, 'Funerals and Faith'. She does consider the issue of preserving the memory of the dead but concentrates on social aspects of funeral ceremonies.

35 Philippe Ariès, *The Hour of our Death*, trans. H. Weaver (New York, 1981), pp. 229–30); John Buxton, *Elizabethan Taste* (London/New York, 1963), p. 136.

36 Vives, *Instruction of a christen woman*, p. Ll iv recto.

37 Ibid.

38 A good example of this is the portrait by George Gower said to be of Lady Walsingham (1572, Col. Viscount de L'Isle) in which the woman holds open the miniature of a young man: see also the portrait of Lady Catherine Grey (before 1568, Petworth, cat. no. 251); the portrait of Elizabeth, wife of Sir Walter Raleigh, as Cleopatra (Col. Basil Oxenden); and a portrait of Frances Howard, Duchess of Richmond and Lennox (1633, Arundel Castle): the last-named is also shown reading a book.

39 Maclean, *The Renaissance Notion of Woman*, pp. 42, 64. The theory was that female humours were moist and cold; these produce a retentive memory because impressions register easily and remain fixed upon moist, cold things. Memory was in fact often defined as 'passive intellect' and hence obviously the domain of the passive sex.

40 This possible connection was first brought to my attention by the members of Margaret Ferguson's seminar on 'Women Writers of the Renaissance,' to whom I

presented an early version of this paper. For women's biographies of their husbands, see those listed in Patricia Crawford, 'Provisional Checklist of Women's Published Writings 1600–1700', in M. Prior, ed., *Women in English Society*, pp. 232–64; see also Elaine Hobby, *Virtue of Necessity, English Women's Writing 1649–88* (London, 1988), ch. 3, 'Autobiographies and Biographies of Husbands'.

41 On thought as vision in the Renaissance, see Forrest G. Robinson, *The Shape of Things Known* (Cambridge, Mass., 1972). For a strong account of memory as a visual process see, for instance, the work of Nicolas Sanders, discussed below.

42 The portrait of Joan Wakeman is fractionally longer than that of her husband: possibly the latter was cut down at some point, as the two did not remain in the same collection.

43 On the Wakemans see *DNB*, vol. LIX, ed. S. Lee (London, 1899), pp. 1–3. Richard Wakeman's uncle, the Bishop of Gloucester, had made the family fortune by going along wholeheartedly with Henry VIII and Cromwell at the time of the Reformation. It has sometimes been argued, based on the fact that Eworth was patronised by Mary Tudor but not by Elizabeth, that he must have been a Catholic; the Wakeman family background argues against this, as does the fact that he painted the portraits of the Earl and Countess of Moray (Strong, *Hans Eworth*, no. 34 and 35) in 1561, shortly after their marriage had been performed by John Knox.

44 On the phenomenon of inscriptions, see Michel Butor, *Les Mots dans la peinture* (Geneva, 1969).

45 On this see Ariès, *The Hour of our Death*.

46 An early example of this is a *Family Portrait* by Frans Floris from 1561 (Lier, Museum Wuyts Van Campen Caroly). Perhaps the most famous and complex dynastic family portrait is the genresque *Family Making Music* by Jan Miense Molenaer (Haarlem, Frans Halsmuseum), discussed in De Jongh, *Portretten*, cat. no. 69 and by Berthold Hinz, 'Das Familienbildnis des J.M. Molenaer in Haarlem; Aspekte zür Ambivalenz der Porträtfunktion,' *Städel Jahrbuch*, ns. 4 (1973), 207–16. For a very different British example see the portrait of the family of Lady Anne Clifford (Westmorland, Appleby Castle, c. 1646).

47 On the craft quality of Holbein's work, note for example the grounds on which Van Mander praises him in his *Life* – the quantity of the master's production, his ability in all media, including what we now consider 'minor arts', see Karel van Mander, *Lives of the Dutch and Flemish Painters* (1604), trans. C. van de Waal (New York, 1936), p. 89. The emphasis on craftsmanship is clear in the 'practical' sections of Hilliard's *Treatise on the Art of Limning*, ed. R.K.R. Thornton and T.G.S. Cain (Ashington, 1981), but is also strong in the theoretical sections, despite a surface gloss of continental ideas. For an interesting example, note his transformation of Pliny (p. 62): he changes the story of how the Romans forbade slaves to paint, used by continental theorists to show art's inherent nobility, into a guild-like concern for product quality. My reading of these northern Renaissance art theoretical texts owes much to the teaching of my adviser, Celeste Brusati.

48 Hilliard, *Treatise on the Art of Limning*, p. 76.

49 The concept is articulated at least as early as Pliny; for Renaissance theorists see M. Jenkins, *The State Portrait* (New York, 1947), p. 4; David Rosand, 'The Portrait, the Courtier, and Death' in *Castiglione. The Ideal and the Real in Renaissance Culture*, ed. R.W. Henning and D. Rosand (New Haven, 1983), pp. 91–129; for tomb sculpture see Lawrence Stone, *Sculpture in Britain: The Middle Ages* (Harmondsworth, 1955), *passim*.

50 Proclamation of 19 September 1560, cited in Margaret Aston, *England's Iconoclasts: Laws Against Images* (Oxford, 1988), p. 315.

51 See for example the Catholic pro-image tract of Nicolas Sanders in which he easily switches back and forth between physical and mental images in his defence of the

former: 'Let us omitte for a time artificial Images, and speake only of those which are foormed in every mans own soule or minde.' *A Treatise Of the Images of Christ* (Louvain, 1567), p. 92 verso.

52 See John Philips, *The Reformation of Images*, (Berkeley/Los Angeles, 1973), pp. 43–4, 54–7, 103; for a recent discussion of theories for and against iconoclasm on the continent, see David Freedberg, 'Art and Iconoclasm, 1525–1580: The case of the Northern Netherlands' in *Kunst voor de beeldenstorm*, 52 (exh. cat., Amsterdam, 1986), pp. 69–72.

53 Roy Strong, *Gloriana. The Portraits of Queen Elizabeth I*, (London, 1987), pp. 40–1.

54 On such opinions in contemporary anti-image tracts see Philips, *The Reformation of Images*, p. 86; see also van Mander, *Lives of the Dutch and Flemish Painters, passim*.

55 Portrait of Edward Grimston of Bradfield, dated 1598; Strong, *The English Icon*, no. 199.

56 In the only other work attributed to Eworth in which a shadow is cast, a window and the lack of an inscription make its illusionistic function clear. *Unknown Lady*, c. 1550–5, in Ibid., no. 51.

57 Sanders, *A Treatise*, p. 54 verso.

58 Maclean, *The Renaissance Notion of Woman*, pp. 8, 11; this was much debated in the 'controversy' on the nature of woman, for which in England see Woodbridge, *Women and the English Renaissance* and Francis Utley, *The Crooked Rib* (New York, 1970).

59 For the conflation of painting and [the portrayal of] beautiful women in Italian Renaissance art and theory see Elizabeth Cropper, 'The Beauty of Woman: Problems in the Rhetoric of Renaissance Portraiture' in *Rewriting the Renaissance. The Discourses of Sexual Difference in Early Modern Europe*, ed. M.W. Ferguson, M. Quilligan and N.J. Vickers (Chicago/London, 1986), pp. 175–90. The general concept of woman as image has been the subject of much feminist art history/theory in recent years; for an introduction to the issue with particular relevance to Renaissance art see John Berger, *Ways of Seeing* (London, 1972), ch. 3.

60 Lucy Gent, *Picture and Poetry 1560–1620* (Leamington Spa, 1981), p. 7.

61 Maclean, *The Renaissance Notion of Woman*, p. 15; Phillip Stubbes, *Anatomie of Abuses* (London, 1583), *passim*.

62 Philips, *The Reformation of Images*, p. xi; Stubbes, *Anatomie of Abuses*, pp. E viii recto ff.

63 Stubbes, *Anatomie of Abuses*, p. E viii recto.

64 Ibid., G verso – G ii recto.

65 Hilliard, *Treatise on the Art of Limning*, p. 76.

66 See Cornelis a Lapide, *In omnes divi Pauli epistolas commentaria* (1638) cited in Maclean, *The Renaissance Notion of Woman*, p. 11.

67 Tilney, *Brief & pleasant discourse*, p. E iiii verso.

68 On this painting see De Jongh, *Portretten*, cat. no. 11, pp. 98–101; Smith, *Masks of Wedlock*, p. 62; Hinz, 'Ehepaarbildnisses', p. 174. The iconography of *vanitas*/death and marriage surfaces periodically in English and continental portraiture. See for example Hinz, 'Ehepaarbildnisses', fig. 30 (L. Furtnegal, *Portrait of the Artist Hans Burgkmair and his wife Anna*, 1527); fig. 70 (memorial portrait, Eworth circle).

69 Hinz, 'Ehepaarbildnisses,' especially 'Familienbildnis,' pp. 207–8.

70 Van Mander, *Lives of the Dutch and Flemish Painters*, pp. 91 ff.

71 Gadamer, *Truth and Method*, p. 122 in the section on 'The Ontological Value of a Picture'.

72 Ibid., pp. 123–4.

73 Van Mander, *Lives of the Dutch and Flemish Painters*, p. 95. The idea is familiar in Van Mander's writings, but it is by no means his standard way of ending a Life; hence we may consider that it was chosen as particularly appropriate to Holbein.

74 I assume that the device of the fastener was in the original portrait since Holbein uses a
similar ploy to transgress the boundary of the picture's surface in the portrait of *Mary
Wyatt, Lady Lee*, painted around the same time – Ganz dates it c. 1540 (*The Paintings
of Holbein*, p. 235, cat. no. 112). For suggestions on the function of the frame see Louis
Marin, 'The Frame of the Painting or the Semiotic Functions of Boundaries in the
Representative Process,' in S. Chatman et al., eds, *A Semiotic Landscape* (The Hague/
Paris/New York, 1979), pp. 777–82.

4 *Tamsyn Williams, 'Magnetic Figures': Polemical Prints of the English Revolution*

Unless otherwise stated, references are to material in the British Library; and the tracts
were published in London.

1 [George Wither], *The Great Assises Holden in Parnassus By Apollo And His
Assessours: At which Sessions are Arraigned Mercurius Britanicus* (1645), E269(11),
p. 21.
2 *The Diarium, Or Journall: Divided into 12. Jornados In Burlesque Rhime, Or
Drolling Verse, with divers other pieces of the same Author* (1656), E1669(2), To the
Reader.
3 Francis Barker, *The Tremulous Private Body* (London and New York, 1985).
4 Samuel Richardson, *Some brief Considerations On Doctor Featley his Book,
intituled, The Dipper Dipt, Wherein In some measure is discovered his many great
and false accusations of divers persons, Anabaptists, with an Answer to them, and
some brief Reasons of their Practice* (1645), E270(22), p. 18; Thomas Stirry, *A Rot
Amongst The Bishops, Or, A Terrible Tempest in the Sea of Canterbury, Set forth in
lively Emblems to please the judicious Reader* (1641), E1102(4), To the reader.
5 John Vicars, *Coleman-street Conclave Visited* (1648), E433(6).
6 Mark Parinter, *Newes From Avernus* (1642), E148(9), To the reader.
7 Edward Dering, *A Discourse of Proper Sacrifice, In Way of Answer to A.B.C. Jesuite,
another Anonymus of Rome: Whereunto the reason of the now Publication, and
many observable passages relating to these times are prefixed by way of Preface*
(1644), E51(13), Preface.
8 *The Court Mercurie* (22 June – 2 July, 1644), E53(8).
9 Brian Manning, *The English People and the English Revolution* (2nd edn, London,
1978), p. 98.
10 *A Terrible Plot Against London And Westminster Discovered* (1642), E131(9).
11 J.D. Peter, *Complaint and Satire In Early English Literature* (Oxford, 1956), p. 100.
12 T.W. Craik, *The Tudor Interlude* (3rd edn, Leicester, 1967), ch. 3.
13 Peter, *Complaint and Satire*, p. 113.
14 *The Countrey Lasse*, Roxburghe Ballads I, pp. 52–3.
15 *God Speed the Plow, And Bless the Corn-Mow*, Roxburghe Ballads II, p. 188.
16 *An Old Song of the Old Courtier of the Kings, With a New Song of a new Courtier of
the Kings*, Roxburghe Ballads III, pp. 72–3.
17 Stephen Bateman, *A christall glasse of christian reformation, wherein the godly maye
beholde the coloured abuses used in this our present tyme* (1569), C37d2.
18 *Cornu-Copia, Or, Roome for a Ram-head* (1642), E151(6).
19 *The Kingdomes Monster Uncloaked from Heaven: The Popish Conspirators,
Malignant Plotters, and cruell Irish, in one Body to destroy Kingdome, Religion and
Lawes; But under colour to defend them, especially the Irish, who having destroyed
the Protestants There, flye hither to defend the Protestant Religion Here*, 669f8(62).
20 Cf. *Mercurius Civicus* (4 – 10 March 1646), E327(16).
21 See P. Vincent, *The Lamentations Of Germany* (1638), 1077c19.

22 *The Picture of an English Antick, with a List of his ridiculous Habits, and apish Gestures* (1646), 669f10(72).
23 *Englands Wolfe With Eagles Clawes: Or The cruell impieties of Bloud-thirsty Royalists, and blasphemous Anti-Parliamentarians, under the Command of that inhumane Prince Rupert, Digby, and the rest* (1646), 669f10(82).
24 Keith Thomas, *Man and the Natural World, Changing Attitudes in England 1500–1800* (new edn, London, 1984), pp. 47–8.
25 *A Short, Compendious And True Description Of the Round-Heads, and the Long-Heads, Shag-polls, briefly declared, with the true discovery both of the time and place of both their Originall beginnings, deduced and drawn out of the purest and refinedst Antiquities or Records of Time* (London, 1642), E150(12).
26 *A Remonstrance of Londons Occurrences In a Brief, Real, And Ingenious Demonstration of all particulars, and the bundle of Newes that flying Report doth annunciate in all matters* (1642), E153(5).
27 E.g. *The Bloody Prince, Or A Declaration Of The Most cruell Practices of Prince Rupert, and the rest of the Cavaliers, in fighting against God, and the true Members of His Church* (1643), E99(14); *Ruperts Sumpter, And Private Cabinet rifled* (1644), E2(24).
28 *An exact description of Prince Ruperts Malignant She-Monkey a great Delinquent: Having approved her selfe a better servant, then his white Dog called Boy* (1643), E90(25); *The Humerous Tricks And Conceits Of Prince Roberts Malignant She-Monkey, discovered to the world before her marriage* (1643), E93(9).
29 See Thomas Middleton and Thomas Dekker, *The Roaring Girle, Or Moll Cutpurse* (publ. 1611); *Hic Mulier: Or, The Man-Woman: Being Medicine to cure the Coltish Disease of the Staggers in the Masculine-Feminine, of our Times* (1620); *Haec-Vir: Or The Womanish-Man: Being An Answere to a late Booke intituled Hic-Mulier* (1620).
30 *Cornu-Copia, Or, Roome for a Ram-head* (1642), E151(6); [John Taylor], *The Devil Turn'd Round-Head: Or, Pluto become a Brownist* (1641), E136(29).
31 Henry Peacham, *Minerva Britanna Or A Garden Of Heroical Devises, furnished, and adorned with Emblemes and Impresa's of sundry natures, Newly devised, moralized, and published* (1612), C38f28.
32 Thomas Hobbes, *Philosophical Rudiments Concerning Government and Society* (1651), E1262.
33 *Three Speeches, Being such Speeches as the like were never spoken in the City* (1642), E240(31).
34 *Olever Crumwells Cabinet Councell Discoverd* (1649), Satires no. 769.
35 *Montelion 1661*, E1876(2).
36 See William Haller, *The Elect Nation: The Meaning and Relevance of Foxe's Book of Martyrs* (New York, 1963); Robert Clifton, 'The Popular Fear of Catholics during the English Revolution' in C.S.R. Russell, ed., *The Origins of the English Civil War* (London and Basingstoke, 1973).
37 *Perfect Occurrences* (3–10 January 1645), E258(11).
38 William Cartwright, 'The Ordinary', *Comedies, Tragi-Comedies, With other Poems, By Mr. William Cartwright, late Student of Christ-Church in Oxford, and Proctor of the University* (1651), E1224(1), Act I, Scene III.
39 Thomas Fuller, *Good Thoughts In Bad Times, Consisting of Personall Meditations* (1645), E1142(1), pp. 239–40.
40 E.g. *A Terrible Plot Against London And Westminster Discovered* (1642), E131(9).
41 John Marston, *The Dutch Courtesan* (perf. 1604, publ. 1605); Ben Jonson, *The Alchemist* (perf. 1610, publ. 1612); Ben Jonson, *Bartholomew Fair* (Perf. 1614, publ. 1631).

42 *The Ranters Ranting; With The apprehending, examinations, and confession of Iohn Collins, I. Shakespear, Tho. Wiberton, and five more which are to answer the next Sessions* (1650), E618(8).

43 Henry Parker, *A Discourse Concerning Puritans* (1641), E204(3).

44 John Bastwick, *The Confession Of the faithfull Witnesse of Christ, Mr. John Bastwick Doctor of Physick* (1641), E175(3).

45 John Taylor, *A Cluster of Coxcombes, Or, Cinquepace of five sorts of Knaves and Fooles: Namely, The Donatists, Publicans, Disciplinarians, Anabaptists, and Brownists: their Originals, Opinions, Confutations, and (in a word) their Heads jolted together* (1642), E154(49).

46 *Lords Loud Call To England: Being a True Relation of some Late, Various, and Wonderful Judgements, or Handy-works of God, by Earthquake, Lightening, Whirlewind, great multitiudes of Toads and Flyes; and also the striking of divers persons with Sudden Death, in several places; for what Causes let the man of wisdome judge, upon his serious perusal of the Book itself* (1660), E1038(8), pp. 1–2.

47 669f11(6).

48 III.ii.9.

49 John Taylor, *A Swarme Of Sectaries, And Schismatiques: Wherein is discovered the strange preaching (or prating) of such as are by their trades Coblers, Tinkers, Pedlers, Weavers, Sow-gelders, and Chymney-Sweepers* (1641), E158(1).

50 T.C., *A Glasse for the Times By Which According to the Scriptures, you may clearly behold the true Ministers of Christ, how farre differing from false Teachers* (1648), E455(10).

51 *The Adamites Sermon: Containing their manner of Preaching, Expounding, and Prophesying: As it was delivered in Marie-bone Park, by Obadiah Couchman, a grave Weaver, dwelling in Southwark, who with his companie were taken and discovered by the Constable and other Officers of that place; by the meanes of a womans husband who dogged them thither* (1641), Worcester Library BB 1.1.13(26).

52 *A Declaration, Of a strange and Wonderfull Monster: Born in Kirkham Parish in Lancashire (the Childe of Mrs. Haughton, a Popish Gentlewoman) the face of it upon the breast, and without a head (after the mother had wished rather to bear a Childe without a head then a Roundhead) and had curst thye Parliament* (1646), E325(20).

53 *The Ranters Monster; Being a true Relation of one Mary Adams, living at Tillingham in Essex, who named her self the Virgin Mary, blasphemously affirming, That she was conceived with child by the Holy Ghost; that from her should spring forth the Savior of the world; and that all those that did not believe in him were damn'd: With the manner how she was deliver'd of the ugliest ill-Shapen Monster that ever eyes beheld, and afterwards rotted away in prison: To the great admiration of all those that shall read the ensuing subject; the like never before heard of* (1652), E658(6).

54 J.B. Steane (ed.), *Thomas Nashe: The Unfortunate Traveller And Other Works* (2nd edn, London, 1978), pp. 277–86.

55 E.g. John Marston, *The Dutch Courtesan* (publ. 1605); Thomas Middleton, *A Mad World, My Masters* (publ. 1608).

56 *The Brownists Conventicle: Or an assemble of Brownists, Separatists, and Non-Conformists, as they met together at a private house to heare a Sermon of a brother of theirs neere Algate, being a learned Felt-maker* (1641), E164(13).

57 *A Discovery of Six Women-Preachers, in Middlesex, Kent, Cambridge, and Salisbury* (1641), Worcester Library BB. 1. 13(9).

58 *The Sisters of the Scabards Holiday: Or, A Dialogue between two reverent and very vertuous Matrons, Mrs. Bloomesbury, and Mrs. Long-Acre her neare Neighbour* (1641), E168(8).

59 E.P., *Heresiography: Or, A description of the Heretickes and Sectaries of these latter times* (1645), E282(5), p. 85; *A Relation of several Heresies; I Jesuites* (1646), E358(2), pp. 7–8.

60 Samoth Yarb, *A new Sect of Religion Descryed, called Adamites: deriving their Religion from our Father Adam* (1641), Worcester Library BB 1.13(14).

61 Robert Heath, *Clarastella; Together with Poems occasional, Elegies, Epigrams, Satyrs* (1650), E1364(1), p. 16.

62 *A Nest of Serpents Discovered* (1641), E168(12); see also note 51.

63 E.g. Daniel Featley, *The Dippers Dipt* (1645), Satires no. 419.

64 (1649), E587(13–14).

65 Christopher Hill, *The World Turned Upside Down* (5th edn, London, 1980), p. 208; A.L. Morton, *The World of the Ranters, Religious Radicalism in the English Revolution* (2nd edn, London, 1979), p. 103.

66 L. Clarkson, *The Lost Sheep Found: Or, The Prodigal returned to his Fathers house, after many a sad and weary Journey through many Religious Countreys, Where now, notwithstanding all his former Transgressions, and breach of his Fathers Commands, he is received in an eternal favor, and all the righteous and wicked Sons that he hath left behinde, reserved for eternal misery; As all along every Church or Dispensation may read in his Travels, their portion after this life* (1660), 1352c38.

67 *The Ranters Declaration, With Their new Oath and Protestation; their strange Votes, and a new way to get money; their Proclamation and Summons; their new way of Ranting, never before heard of; their dancing of the Hay naked, at the white Lyon in Peticoat-land; their mad Dream, and Dr. Pockridge his Speech, with their Trial, Examination, and Answers: the coming in of 3000, their Prayer and Recantation, to be in all Cities, and Market-towns read and published; the mad-Ranters further Resolution; their Christmas Carol, and blaspheming Song; their two pretended-abominable Keyes to enter Heaven, and the worshiping of his little-majesty, the late Bishop of Canterbury: A new and further Discovery of their black Art, with the Names of those that are possest by the Devil, having strange and hideous cries heard within them, to the great admiration of all those that shall read and peruse this ensuing subject* (1650), E620(2).

68 J.D. Peter, *Complaint And Satire In Early English Literature* (Oxford, 1956), p. 104.

69 *A true Relation Of The Life, Conversation, Examination, Confession, and iust deserved Sentence of James Naylor the grand Quaker of England* (1657), E1645(4).

70 *Iames Nailor Quaker, set 2 howers on the Pillory at Westminster, whiped by the Hang:man to the old Exchainge London: Som dayes after, Stood too howers more on the Pillory at the Exchainge, and there had his Tongue bore throug with a hot Iron, & Stigmatized in the Forehead with the Letter; B; Decem:ʳ 17; anno Dom: 1656;*, British Museum Case 4, Vol. VII (23).

71 *The Quakers Quaking* (1657), E1641(3).

72 Barry Reay, *The Quakers and the English Revolution* (London, 1985), pp. 62–100.

73 Louis de Montalte, *The Provinciales: Or The Mysteries Of Jesuitisme, discovered in certain Letters, Written upon occasion of the present differences at Sorbonne, between the Jansenists and the Molinists, from January 1626 to March 1627* (1657), E1623(1).

74 *Terrible and bloudy Newes From the disloyall Army in the North Declaring their perifidious and tyrannical proceedings to the whole Kingdom of England: As also the raising of new Forces in the Kingdome of Scotland, to assist Monro against Lieutenant Generall Crumwell* (1648), E462(28).

75 (3–10 February 1645), E269(6).

76 *Mercurius Aulicus* (12–19 January 1645), E269(5).

77 *The Sounding Of The Two Last Trumpets, the sixth and seventh: Or Meditations by*

way of Paraphrase upon the 9th, 10th, and 11th, Chapters of the Revelation, as containing a Prophecie of these last Times (1641), E174(1); *The Baiting of the Popes Bull* (1627), 697e21.

78 *The Scotish Dove* (4–11 March 1645), E327(31).

79 *An Answer To The Articles Preferd Against Edward Finch, Vicar of Christ-Church, by some of the Parishioners of the same* (1641), E175(11), To the reader.

80 C.W. Mercer, *Angliae Speculum: Or Englands Looking-Glasse* (1646), E327(13); *A Pill to purge Melancholy: Or, Merry Newes From Newgate; Wherein is set forth, the pleasant jests, witty Conceits, and excellent Couzenages, of Captain John Hind, and his Associates* (1652), E652(2), To the reader.

81 *Eikonoklastes* (1649), E578(5), Preface.

82 *Eikon Alethine* (1649), E569(16), To the seduced people of England.

83 John Vicars, *Coleman-street Conclave Visited* (1648), E433(6), To the reader.

84 *Aqua-Musae; Or, Cacafogo, Cacadaemon, Captain George Wither Wrung in the Withers* (1644), E269(22).

85 *Bethshemesh Clouded, Or Some Animadversions On The Rabbinical Talmud Of Rabbi John Rogers Of Thomas-Apostles London; Called His Tabernacle for the Sunne, Irenicum Evangelicum, or Idea of Church-Discipline* (1653), E722(3), p. 30.

86 *Eikon Alethine* (1649), E569(16), To the seduced people of England.

87 *The Oxford Character Of the London Diurnall Examined and Answered* (1645), E274(32).

88 William Prynne, *A fresh Discovery Of some Prodigious New Wandring-Blasing-Stars, & Firebrands, Stiling themselves New-Lights* (1646), E267(3), pp. 11–12.

89 *A Declaration From The Children of Light (who are by the world scornfully called Quakers) against several false reports scandals and lyes, in several news Books and Pamphlets put forth by Hen. Walker, R. Wood, and George Horton, whose lyes, and slanders shall not pass for truth, but shall be judged, and cast out by Michael and his Angels into the world, which is their habitation amongst the Children of darkness* (1655), E838(11).

90 (7–14 November 1649), E579(11).

91 *Eikonoklastes* (1649), E578(5), Preface.

92 *The Sussex Picture, Or, An Answer To The Sea-Gull* (1644), E3(21).

93 *An Answer To A Foolish Pamphlet Entituled A swarme of Sectaries & Schismaticks* (1641), E160(15).

94 [Richard Overton], *Mercuries Message Defended, Against the vain, foolish, simple and absurd cavils of Thomas Herbert a ridiculous Ballad-maker* (1641), E160(13).

95 *The Scotish Dove* (4–11 March 1645), E327(21).

96 *Religions Enemies* (1641), Worcester College, BB.1.13(65); William Lilly, *An English Ephemeris Or Generall and monethly Predictions upon severall Eclipses, and Celestiall Configurations, for the Yeare of our Lord 1650* (1650), E1301(3); William Lilly, *Merlini Anglici Ephemeris: Or, General and Monethly Predictions upon several eminent Conjunctions of the Planets, for the Year 1650* (1650), E1301(2); *Heads of all Fashions* (1642), E145(17).

97 C.H. Firth and R.S. Rait, eds., *Acts And Ordinances Of The Interregnum, 1642–1660* (London, 1911), Vol. I, p. 184, Vol. II, p. 245; F.S. Siebert, *Freedom Of The Press In England 1476–1776* (Urbana, Ill., 1952), p. 189.

98 *Diurnall Occurrences In Parliament* (6–13 June 1642), E202(6); *Mercurius Aulicus* (12–19 January 1645), E269(5); *Mercurius Britanicus* (3–10 February 1645), E269(6); *Commons' Journal*, 10 and 13 June 1642.

99 *Commons' Journal*, 20 April 1646.

100 *The Kingdomes Weekly Intelligencer; Sent Abroad To prevent misinformation* (25 November–3 December 1645), E310(9).

101 *A Discourse of Proper Sacrifice In Way Of Answer to A.B.C. Jesuite, another Anonymus of Rome; Whereunto the reason of the now Publication, and many observable passages relating to these times are prefixed by way of preface* (1644), E51(13), p. 16.
102 John Cordy Jefferson (ed.), *Middlesex County Records* (1888), Vol. III, pp. 205–7, 286, 287.
103 M. Corbett and M. Norton, *Engraving In England In The Sixteenth And Seventeenth Centuries, Part III, The Reign Of Charles I* (Cambridge, 1964), pl. 193.
104 See note 98.
105 *The Confession Of the faithfull Witnesse of Christ, Mr. John Bastwick Doctor of Physick* (1641), E175(3).
106 William L. Sachse (ed.), 'The Diurnal of Thomas Rugg 1659–1661', *Camden 3rd Series*, Vol. XCI (London, 1961), p. 73.
107 R.L.S. [R. L'Estrange], *L'Estrange His Apology: With A Short View, of some Late and Remarkable Transactions, Leading to the happy Settlement of these Nations under the Government of our Lawfull and Gracious Soveraign Charls the II. whom God Preserve* (1660), E187(1), Preface.

5 Jonathan Sawday, The Fate of Marsyas: Dissecting the Renaissance Body

I should like to acknowledge the advice of my colleague, Mr John Peacock, of Southampton University, in the preparation of this essay. I am also indebted to colleagues in the London Renaissance Seminar, the Liverpool University Renaissance Studies group and the Essex University Early Modern Research group, with whom I have had most profitable discussions. The Committee for Advanced Studies at Southampton University assisted me with the costs of preparing this essay for publication.

1 A.G. Debus, *Man and Nature in the Renaissance* (Cambridge, 1978), p. 59.
2 For recent work on the cultural history of the body (as opposed to the historical understanding of the body as a site of scientific discovery) see in particular: Francis Barker, *The Tremulous Private Body* (London, 1984); Devon L. Hodges, *Renaissance Fictions of Anatomy* (Amherst, 1985); Glenn Harcourt, 'Andreas Vesalius and the Anatomy of Antique Sculpture,' *Representations*, 17 (1987), 28–61; Luke Wilson, 'William Harvey's *Prelectiones*: The Performance of the Body in the Renaissance Theatre of Anatomy,' *Representations*, 17 (1987), 62–95; Jonathan Sawday, *Bodies by Art Fashioned: The Renaissance Culture of Dissection* (London, forthcoming).
3 Citations of Golding's Ovid are from W.H.D. Rouse, ed., *Shakespeare's Ovid Being Arthur Golding's Translation of the Metamorphoses* (London, 1961).
4 For a discussion of the significance of the Marsyas myth see: Edgar Wind, *Pagan Mysteries in the Renaissance* (London, 1958), pp. 171–78; Leonard Barkan, *The Gods Made Flesh: Metamorphosis and the Pursuit of Paganism* (New Haven/London, 1986), pp. 79–80.
5 See Harold E. Wethey, *The Paintings of Titian* (London, 1969–75), vol. III (*The Mythological and Historical Paintings*), pp. 91–3, 153–4.
6 Harcourt, 'Andreas Vesalius,' p. 55.
7 Wind, *Pagan Mysteries of the Renaissance*, pp. 172–3.
8 The account of this famous series of lectures can be found in Ruben Eriksson, ed., *Andreas Vesalius' First Public Anatomy at Bologna 1540. An Eyewitness Report by Baldasar Heseler Together with His Notes on Mathaeus Curtius' Lectures on 'Anathomia Mundi'* (Uppsala/Stockholm, 1959). All citations are to this edition. This quote is from pp. 85–7.
9 The history of anatomical practice and discovery in the Renaissance is a complex one. Helpful accounts may be found in: A. Rupert Hall, *The Revolution in Science 1500–*

1750 (London, 1954; rev. edn, 1983), pp. 39–53 and Debus, *Man and Nature*, pp. 54–73. More specialised discussions include: J.H. Randall, 'The Development of Scientific Method in the School of Padua,' *Journal of the History of Ideas*, 1 (1940), 117–206; C.E. Kellett, 'Sylvius and the Reform of Anatomy,' *Medical History*, 5 (1961), 101–16; W.P.D. Wightman, ' "Quid sit methodus?" "Method" in Sixteenth Century Medical Teaching and "Discovery",' *Journal of the History of Medicine*, 19 (1964), 360–76; K.F. Russell, 'Anatomy and the Barber Surgeons,' *Medical Journal of Australia*, 1 (1973), 1109–15. A useful summary of Renaissance anatomical study, with particular reference to Vesalius, can be found in the introduction to the reproduction of the Vesalian plates in J.B.deC.M. Saunders and Charles D. O'Malley, eds, *The Illustrations from the Works of Andreas Vesalius of Brussells* (New York, 1950; rpt. 1973). An indispensable guide to the history of medicine in England in the seventeenth-century is Charles Webster, *The Great Instauration: Science, Medicine, and Reform 1626–1660* (London, 1975). See also: Robert G. Frank, Jr., 'The Physician as Virtuoso in Seventeenth-century England' in Robert G. Frank, Jr., and Barbara Shapiro, eds, *English Scientific Virtuosi in the Sixteenth and Seventeenth Centuries* (Papers read at a Clark Library Seminar, 1977; Los Angeles, 1979) and Charles W. Bodemar and Lester S. King, *Medical Investigation in Seventeenth-century England* (Papers read at a Clark Library Seminar, 1967; Los Angeles, 1968).

10 See, for example, the account of grave robbery on the part of Vesalius and his students in Saunders and O'Malley, eds, *Illustrations*, p. 170.

11 Eriksson, ed., *An Eyewitness Report*, p. 177.

12 Ibid., p. 209.

13 Michel Foucault, *Discipline and Punish: The Birth of the Prison*, trans. Alan Sheridan (Harmondsworth, 1979), p. 55.

14 The paradox can be thought of in the following way. The operation of inscriptive power on the body seems to have destroyed individual identity in one form, only to return it in another. This preservation becomes even more effective if the body becomes the subject of a pictorial or descriptive anatomy. Thus Rembrandt's famous *Anatomy Lesson of Dr Nicholaas Tulp*, a painting which sets out to memorialise the anatomist and his assistants, might equally be termed 'the anatomy of Adrian Adrianszoon, street thief, executed January 1632'. In similar measure, the names of Bonconvento and Buderio have been preserved only because they were anatomised. The care which the artists took, in anatomical depiction, to preserve the faces of the victims is also worth noticing. For a discussion of Rembrandt's painting in the context of 'penal anatomy' see William S. Heckscher, *Rembrandt's Anatomy of Dr Nicolaas Tulp: An Iconological Study* (New York, 1958), pp. 97–106. For a stimulating discussion of this problem see Barker, *The Tremulous Private Body*, p. 23.

15 See Ruth Richardson, *Death, Dissection, and the Destitute* (London, 1988).

16 Wethey, *The Paintings of Titian*, III, p. 153.

17 As Richardson, *Death, Dissection, and the Destitute*, pp. 3–29, has shown, the dead human body was and is the focus of a complex pattern of beliefs and popular theology. The 'commodification' of the corpse by the anatomist or the grave-robber seemed to violate a widely held set of cultural values.

18 Beyond Leonardo's recommendation (cited below) that the artist should study anatomy, art theorists of the period were convinced that practical dissection was of the utmost importance to a proper delineation of the body. See, for example, Sebastiano Serlio, *L'Architettura* (1537, trans. 1611), Bk. II fol. 6ᵛ and the preface to the English translation of Lomazzo's *Trattato dell' arte della pittura, scultura e architettura* (1584, trans. 1598) sig. *j. Taken to its logical end, these recommendations might lead to the position adopted by Ivins and Panofsky – that Renaissance anatomy is not so much part of the history of science as it is part of the history of art. See William Ivins, Jr.,

'What about the *Fabrica* of Vesalius?' in Archibold Malloch, ed., *Three Vesalian Essays to Accompany the 'Icones Anatomicae' of 1934* (New York, 1952) and Erwin Panofsky, 'Artist, Scientist, Genius: Notes on the Renaissance-Dammerung' in Wallace K. Ferguson, ed., *The Renaissance: Six Essays* (New York, 1962). Harcourt, 'Andreas Vesalius,' p. 33, offers an incisive account of the artist-scientist problem. A further element in the discussion is introduced when the almost universal Renaissance fascination with proportion is recalled in the context of the delineation of 'Vitruvian man' – an image which, in Wittkower's words, 'seemed to reveal a deep and fundamental truth about man and the world': Rudolph Wittkower, *Architectural Priniciples in the Age of Humanism* (4th edn, London, 1973), p. 14.

19 Irma A. Richter, ed., *Selections from the Notebooks of Leonardo da Vinci* (London, 1952; rpt. 1980), pp. 150–1. On Leonardo as an anatomist, see in particular: J.H. Randall, 'The Place of Leonardo da Vinci in the Emergence of Modern Science,' *Journal of the History of Ideas*, 14 (1955), 191–202; K.D. Keele, 'Leonardo da Vinci's Influence on Renaissance Anatomy,' *Medical History* 8 (1964), 342–53; Martin Kemp, *Leonardo da Vinci: The Marvellous Works of Nature and of Man* (London, 1981).

20 That anatomists in the early-modern period desired to have their discipline understood as an autonomous subject of study is suggested by the seemingly endless protestations of the 'dignity' and 'worth' of the subject. On the social status of surgeons and physicians, see Roy Porter, *Disease, Medicine, and Society in England 1550–1860* (Studies in Economic and Social History; London, 1987), pp. 18–22; F.F. Cartwright, *The Social History of Medicine* (London, 1977). Richardson, *Death, Dissection and the Destitute*, p. 117, has suggested something of the urgent desire, on the part of British nineteenth-century anatomists, to distance themselves from the punitive aspects of their science. The situation in the early-modern period appears analogous.

21 The link between anatomical drawings in the period and the work of artists such as Titian is a complex one. Harcourt, 'Andreas Vesalius,' pp. 31–5 provides a useful overview of the question.

22 Comments cited by Robert Herrlinger, *A History of Medical Illustration from Antiquity to AD 1600* (Nijkerk, 1970), p. 87. Herrlinger goes on to observe that the woodcuts in Book 2 of the *De Dissectione*, attributed to Jollat, indicate a failure to handle perspective that is suggestive of an artist who had 'skipped over the Renaissance' entirely and stood with one foot in the gothic world, the other in the mannerist: Ibid., p. 99.

23 An anatomy lesson. From Johannes de Ketham, *Fasciculus Medicinae* (3rd edn; Venice, 1495). Reproduced from Ludwig Choulant, *History and Bibliography of Anatomic Illustration*, ed. and trans. Mortimer Frank (New York, 1945; rpt. 1962), p. 118. The illustration shown is from the third (1495) edition of de Ketham's work. Wilson, 'William Harvey's *Prelectiones*,' p. 65 reproduces a slightly earlier version of the same illustration.

24 Wilson, 'William Harvey's *Prelectiones*,' p. 64.

25 Title-page of Berengarius (Jacopo Berengario da Carpi), *Isagoge Breves* (Venice, 1535), British Library copy. The illustration was still thought suitable as a title-page as late as 1664 when an English translation of Berengarius was published at London under the title *ΜΙΚΡΟΚΟΣΜΟΓΡΑΦΙΑ or A Description of the Body of Man*. For a discussion of the illustrations in Berengarius' work see Choulant, *Anatomic Illustration*, pp. 136–42 and Herrlinger, *A History of Medical Illustration*, pp. 74–80.

26 Title-page of Andreas Vesalius, *De humani corporis fabrica* (Basel, 1543). Reproduced from Saunders and O'Malley, eds., *Illustrations*, p. 43.

27 See Hermani Monteiro, 'Some Vesalian Studies' in E. Ashworth Underwood, ed., *Science, Medicine, and History: Essays on the Evolution of Scientific Thought and*

Medical Practice in Honour of Charles Singer, 2 vols. (London, 1953), I, pp. 371–3; C. E. Kellett, 'Two Anatomies,' *Medical History*, 8 (1964), 342–53; Saunders and O'Malley, eds, *Illustrations*, pp. 42–5, 248–52; Wilson, 'William Harvey's *Prelectiones*,' pp. 70–4; Karp, pp. 159–61; Jonathan Sawday, 'Bodies by Art Fashioned: Anatomy, Anatomists, and English Poetry 1570–1680' (Ph.D. dissertation, University of London, 1988), pp. 184–7.

28 See John M. Steadman, 'Beyond Hercules: Bacon and the Scientist as Hero,' *Studies in the Literary Imagination*, 4 (1971), 3–47.

29 Heseler, for example, in the passage quoted above, is careful to highlight the dominant role Vesalius took in the ritual of the anatomy demonstration. The anatomy theatre at Padua which was built in 1594 provides further evidence for a deliberate attempt, in the illustration, at presenting Vesalius as receiving the endorsement of his audience by being placed amongst them. In reality, there would have been simply no room for such a great crowd to cluster around the anatomist and the corpse in the dissection pit. For a description of the theatre see Geoffrey Keynes, *The Life of William Harvey* (Oxford, 1966; rpt. 1978), pp. 25–6 (plates V, VI).

30 When the title-page of the *Fabrica* was re-engraved for the second edition of 1555, numerous alterations were made which, it has been observed (Saunders and O'Malley, eds, *Illustrations*, p. 44), 'destroyed the symbolic significance of the figures'. The alterations to the skeleton are amongst the most marked. Equipped with a scythe in the 1555 version, the skeleton is transformed into an undoubted *memento mori*. At the same time the casual fashion with which the figure was treated in 1543 disappears, underlining its now single iconographical function: it must now be heeded rather than ignored.

31 The gaze of the corpse which is directed towards the anatomist is, if anything, even more pronounced in the drawing which, it has been assumed, was produced as a preliminary stage in the design of the title-page. The drawing, often attributed to Titian but probably the work of Jean Kalkar, is in the Hunterian Collection at Glasgow University. It is reproduced in Saunders and O'Malley, eds, *Illustrations*, p. 250.

32 Muscular figures, from Vesalius (Bk. II, 6th and 7th plates), reproduced in Saunders and O'Malley, eds, *Illustrations*, pp. 103, 105.

33 Ibid., p. 92.

34 Hodges, *Renaissance Fictions of Anatomy*, p. 5.

35 Harcourt, 'Andreas Vesalius,' p. 48.

36 Karp, p. 160; Saunders and O'Malley, eds, *Illustrations*, p. 29.

37 Self-demonstrating figures, from Juan de Valverde de Hamusco, *Anatomia del corpo humano* (2nd edn, Rome, 1560), III, p. 94 (British Library copy) and Andreas Spigelius, *De humani corporis fabrica* (Venice, 1627), p. 57 (BL copy).

38 The anatomised anatomist, from Valverde de Hamusco, *Anatomia*, III, p. 108 (British Library copy).

39 Herrlinger, *A History of Medical Illustration*, p. 124, states that the work rivalled that of Vesalius in popularity, since it was considered to be handier than the *Fabrica*, easier to print and cheaper.

40 Harcourt, 'Andreas Vesalius,' pp. 30, 35; Ackerman, pp. 67–8.

41 Dissected figure in a landscape. Charles Estienne and Estiènne de la Rivière, *De dissectione partium corporis* (Paris, 1545), 23[4]6 (sig. Q5ᵛ) (British Library copy).

42 Rouse, ed., *Shakespeare's Ovid*, p. 128.

43 See Keynes, *The Life of William Harvey*, pp. 72–5; C.D. O'Malley, 'Helkiah Crooke M.D., F.R.C.P. (1570–1648),' *Bulletin of the History of Medicine*, 42 (1968), 1–18.

44 Helkiah Crooke, *Microcosmographia* (London, 1615), p. 12. Crooke's claim was indeed echoed by other English anatomists and divines. See for example: Thomas Rogers, *The Anatomie of the Minde* (London, 1576), sig. A3; Peter Lowe, *A Discourse*

of the Whole Arte of Chirurgerie (2nd edn; London, 1612), p. 122; John Woolton, *A Treatise of the Immortalitie of the Soule* (London, 1576), sig. 2ᵛ; John Weemes, *Works* (London, 1636), p. 22.

45 So John Donne, in a famous passage from the *Sermons*, first evokes the scattered bodies of humanity 'shivered . . . scattered in the ayre' before evoking God as performing a divine conjuring trick – rendering the fragments into one whole. See John Donne, *Sermons*, ed. George R. Potter and Evelyn M. Simpson, 10 vols. (Berkeley/Los Angeles, 1953–62), VIII, p. 98.

46 Self-dissecting figure, from Berengarius, *Isagoge Breves* (Bologna, 1523), fol. 6ᵛ (British Library copy).

47 Wind, *Pagan Mysteries of the Renaissance*, p. 173.

48 Figure on p. 133: Interior of the Leiden anatomy theatre (1644); first published by Andries Clouk (1610). Leiden University Library, Port. 315 – III. 20. Figure on p. 132: Interior of Leiden anatomy theatre (*c.* 1640); first published by Jacob Marcus (1609). Leiden University Library, Port. 315 – III. 19. For further information on the Leiden theatre see: Th.H. Lunsingh Scheurleer, 'Un Amphithéâtre d'anatomie moralisée' in Th.H. Lunsingh Scheurleer and G.H.M. Posthumous Meyjes, eds, *Leiden University in the Seventeenth Century: An Exchange of Learning* (Leiden, 1975); Jonathan Sawday, 'The Leiden Anatomy Theatre as a Source for the Cabinet of Death in *Gondibert*,' *Notes & Queries*, 30 (1983), 437–9; R.W.I. Smith, *English Speaking Students of Medicine at the University of Leyden* (Edinburgh/London, 1932). I am grateful to Dr D. de Vries, curator of the map collection, Leiden University Library, for allowing these illustrations to be reproduced here.

6 Anna Bryson, *The Rhetoric of Status: Gesture, Demeanour and the Image of the Gentleman in Sixteenth- and Seventeenth-Century England*

1 [Sir] Thomas Smith, *De Republica Anglorum* (London, 1583), ed. L. Aston (Cambridge, 1906), p. 30.

2 See, for example, M. Girouard, *Life in the English Country House. A Social and Architectural History* (New Haven/London, 1978); J. Simon, *Education and Society in Tudor England* (Cambridge, 1966); F. Heal, 'The Idea of Hospitality in Early Modern England,' *Past and Present*, CII (1984), 63–93.

3 This literature is described and listed in J.E. Mason, *Gentlefolk in the Making: English Courtesy Literature 1531–1774* (Philadelphia, 1935) and R. Kelso, *The Doctrine of the English Gentleman in the Sixteenth Century* (Illinois, 1929 and 1964). (For Peacham see note 37 below).

4 Baldassare Castiglione, *Il Cortegiano* (Venice, 1528). The book appeared in English as *The Courtyer. Done into Englyshe by T[homas] H[oby]* (London, 1561), and there were further editions of this translation in 1577, 1583 and 1603. For a brief analysis of Castiglione's ideal see S. Anglo, 'The Courtier: the Renaissance and Changing Ideals,' in A.G. Dickens, ed., *The Courts of Europe* (London, 1977).

5 James Cleland, *Hero-Paideia: or the Institution of a Young Nobleman* (Oxford, 1607), Bks V ns II; Robert Brathwayt, *The English Gentleman* (London, 1630), p. 83. See also, for example, Obadiah Walker, *Of Education, Especially of Young Gentlemen* (Oxford, 1673), Pt. II, ch. 1.

6 Desiderius Erasmus, *De Civilitate Morum Puerilium* (Antwerp, 1526). The first English translation appeared as Erasmus, *De Civilitate Morun* [sic] *Puerilium, A Lythell Booke of Good Manners for Chyldren: into the Englysshe tonge by R. Whytyngton* (London, 1532). Editions of 1540 and 1554 survive. Quotation will be from the edition of 1540.

7 Giovanni Della Casa, *Il Galateo, Ovvero de' Costumi* in *Opere* (Venice, 1558). First

translated into English as *Della Casa, Galateo of Maister Iohn Della Casa, Archebishop of Beneventa. Or Rather, A Treatise of the Maners and behaviours, it behoveth a man to use and eschewe, in his familiar conversation*, trans. Robert Peterson (London, 1576).

8 See, for example, the entertaining J. Wildeblood, *The Polite World. A Guide to the Deportment of the English in Former Times* (rev. edn, London, 1973).

9 Norbert Elias, *The Civilising Process. The History of Manners*, trans. E. Jephcott (Oxford, 1979).

10 Michel Foucault, *The History of Sexuality*, vol. 1: *An Introduction*, trans. R. Hurley (New York, 1978).

11 For medieval courtesy books see the collections and analysis in E. Rickert, *The Babees Book: Medieval Manners for the Young* (London, 1908); F.J. Furnivall, ed., *The Babees Book, etc.* (Early English Text Society, Original Series, XXXII, 1868); F.J. Furnivall, ed., *Meals and Manners in Olden Time*, (E.E.T.S., Original Ser., 1868 and 1894).

12 Elias, *The Civilising Process*, ch. 2.

13 See Furnivall, ed., *Meals and Manners*.

14 All these texts are reprinted in Furnivall, ed., *Meals and Manners*.

15 F[rancis] S[eager], *The Schoole of Vertue, and booke of good Nourture for chyldren and youth to learn theyr dutie by* (London, c. 1550); Richard Weste, *The Booke of Demeanor and the Allowance and Disallowance of certaine Misdemeanours in Companie*, originally included in his *The Schoole of Vertue* (London, 1619) (both reprinted in Furnivall, ed., *Meals and Manners*); William Fiston, *The Schoole of Good Manners, or a new Schoole of Vertue . . .* (London, 1629). Thomas Paynell, *The Civility of Childehode* (London, 1560) is yet another courtesy book based on Erasmus's *De Civilitate*.

16 Elias, *The Civilising Process*, ch. 2.

17 Frederik Dedekind, *The Schoole of Slovenrie: or Cato turn'd Wrong Side Outward*, trans. 'R.F.' (London, 1604). A similar text is *Annono., Cacoethes Leaden Legacy, Or His Schoole of Ill Manners* (London, 1624).

18 M.M. Bakhtin, *Rabelais and his World*, trans. H. Iswolsky (Cambridge, Mass., 1968).

19 Lucas Gracian Dantisco, *Galateo Espagnol, or the Spanish Gallant*, trans. W. S[tyle], (London, 1640), p. 10.

20 Della Casa, *Galateo*, pp. 6–9, 113–14.

21 Nicholas Faret, *L'Honnet Homme ou l'Art de Plaire à la Cour* (Paris, 1630), translated as *The Honest Man* by E[dward] G[rimstone] (London, 1632). Other similar texts include Eustache du Refuge, *A Treatise of the Court*, trans. John Reynold (London, 1622).

22 Elias, *The Civilising Process*, ch. 2.

23 Della Casa, *Galateo*, p. 5.

24 Ibid.

25 Antoine de Courtin, *The Rules of Civility, or Certain Ways of Deportment observed in France, amongst all Persons of Quality, upon Several Occasions*, anon. trans. (London, 1671), e.g. ch. 8. See also similar detail on deference in *Youth's Behaviour; or Decencie in Conversation amongst Men*, trans. Francis Hawkins (4th edn, London, 1646), ch. 2.

26 Erving Goffman, 'The Nature of Deference and Demeanour', *American Anthropologist*, LVIII (1956), p. 476.

27 Geoffrey Chaucer, *The Canterbury Tales*, Prologue, ll. 99–100, in W.W. Skeat, ed., *The Works of Geoffrey Chaucer* (Oxford, 1923), p. 420. Chaucer characterises the 'squire' in the following terms:

Curteis . . . lowely, and serysable,

And carf biforn his fader at the table

28 Erasmus, *De Civilitate*, sig. A2ᵛ–B2ᵛ.

29 Ibid., sig. A3ʳ.

30 Weste, *Booke of Demeanor* in Furnivall, ed., *Meals and Manners*, p. 210.

31 Fiston, *Schoole of Good Manners*, sig. (B5)ʳ.

32 Della Casa, *Galateo*, pp. 2, 4.

33 Anon., *The Art of Complaisance; or the Means to Oblige in Conversation* (London, 1673), p. 1.

34 Cleland, *Hero-Paideia*, bk. 5, ch. 3, p. 170.

35 Josiah Dare, *Counsellor Manners his Last Legacy to his Son* (London, 1673), pp. 53–4.

36 For interesting interpretations of the changing ideals in such texts see, for example, J.H. Hexter, 'The Education of the Aristocracy in the Renaissance' in his *Reappraisals in History* (Aberdeen, 1961) and M.E. James, 'English Politics and the Concept of Honour,' *Past and Present*, Supplement No. 3 (1978).

37 See, for example, the views of Henry Peacham in *The Compleat Gentleman* (London, 1622), p. 5, who asserts that 'to be drunke, sweare, wench, follow the fashion and to do just nothing are the attributes and markes nowadayes of a great part of our gentry'.

38 See Hexter, 'The Education of the Aristocracy' and M.H. Curtis, *Oxford and Cambridge in Transition* (Oxford, 1959).

39 Erasmus, *De Civilitate*, sig. A2ʳ–ᵛ.

40 For the development of London as a centre of gentlemanly social life see F.J. Fisher, 'The Development of London as a Centre of Conspicious Consumption in the Sixteenth and Seventeenth Centuries,' *Transactions of the Royal Historical Society*, 4th series, xxx (1948), 37–50.

41 Peacham, *The Compleat Gentleman*, ch. 1, pp. 2–3. See also Sir Thomas Elyot, *The Boke Named the Governour* (London, 1531), bk. 1, ch. 9 for similar recommendations of eloquence to the gentleman.

42 For the nature and importance of academic rhetoric see W.G. Crane, *Wit and Rhetoric in the Renaissance. The Formal Basis of Elizabethan Prose* (New York, 1937), pp. 1–5.

43 Thomas Wilson, *The Arte of Rhetorique, for the use of all soche as are studious of Eloquence* (London, 1553), sig. P1ʳ; John Bulwer, *Chirologie* (London, 1644), epist., sig. (A5)ᵛ.

44 For Castiglione's debt to Cicero see J.R. Woodhouse, *Baldessar Castiglione, A Reassessment of 'The Courtier'* (Edinburgh, 1978).

45 Wilson, *Arte of Rhetorique*, sig. P4ᵛ. Cf. Erasmus, *De Civilitate*, sig. A8ʳ–ᵛ.

46 Quoted in B.L. Joseph, *Elizabethan Acting* (Oxford, 1951), p. 92.

47 *Aristotles Politiques or Discourses of Government*, trans. *John Dickenson from the French of Loys Le Roy* (London, 1598), sig. B2ᵛ–B3ʳ. See also, A.B. Ferguson, *Clio Unbound: Perceptions of the Social and Cultural Past in Renaissance England* (North Carolina, 1979), esp. chs. x and xi.

48 Discussions of this linguistic and conceptual development are to be found in A.B. Ferguson, *Clio Unbound*; Elias, *The Civilising Process*, Part 1; P. Beneton, *Histoire des Mots: Culture et Civilisation* (Paris, 1979).

49 K.O. Kupperman, *Settling with the Indians, the meeting of English and Indian Cultures in America, 1500–1640* (London, 1980).

50 See H. Shennan, *Civility and Savagery* (London, 1972).

51 Erasmus, *De Civilitate*, sig. C2ᵛ and C3ʳ.

52 Weste, *Booke of Demeanor* in Furnivall, ed., *Meals and Manners*, pp. 210–11.

53 Della Casa, *Galateo*, p. 12.

54 Courtin, *Rules of Civility*, ch. 3, p. 16.

55 Stefano Guazzo, *The Civile Conversation*, trans. George Pettie and Bartholomew Young (London, 1586), bk. 2, pp. 81–2.

56 For *The Tempest* and the concept of civility see W.G. Zeeveld, *The Temper of Shakespeare's Thought* (New Haven, 1974), ch. 10.

57 Erasmus, *De Civilitate*, sig. A4ᵛ; Della Casa, *Galateo*, p. 83; Thomas Dekker, *The Gul's Horn-Booke* (London, 1609) reprinted in C. Hindley, ed., *Old Book Collectors Miscellany* (London, 1872), II, p. 22.

58 William Vaughan, *The Golden-Grove, moralized in three parts* (London, 1600) Bk. 2, pt. 5, ch. 29. See also the surly and violent picture given by John Evelyn, in his *Character of England* of 1659, reprinted in T. Park, ed., *Harleian Miscellany* (London, 1808–13). Implicit in Vaughan's taunt is the idea that the élite body follows a canon of proportion such as Vitruvius' mentioned in the Introduction to this collection of essays.

59 Dekker, *The Gul's Horn-Booke*, in Hindley, ed., *Old Book Collectors Miscellany*, II, ch. 3, p. 25.

60 See Samuel Pepys, *The Diary of Samuel Pepys*, ed. R. Latham and W. Matthews (London, 1970–83), IX, pp. 335–6 for a report of one such incident.

61 Courtin, *Rules of Civility*, ch. 3, pp. 19–20.

62 Robert Brathwayt, *The English Gentleman* (London, 1630), p. 83.

63 James I was quoted by Cleland in *Hero-Paideia*, bk. 5, ch. 18, p. 210. On p. 64 Cleland also warns against 'foolish shamefastness' in blushing, hanging down the head, etc.

64 Castiglione, *The Courtyer*, trans. Hoby, sig. E2ʳ.

65 See for example Nicholas Breton's anti-court dialogue, *The Court and the Country* (London, 1618). For the European anti-Court tradition see P.M. Smith, *The Anti-Courtier Trend in Sixteenth-Century France* (Geneva, 1966) and for England see P.W. Thompson, 'Two Cultures? Court and Country under Charles I', in C. Russell, ed., *The Origins of the English Civil War* (London, 1973).

66 William Russell, fifth Earl of Bedford, 'Advice to his Sons' in *Practical Wisdom: or the Manual of Life. The Counsel of Eminent Men to their Children* (London, 1824), p. 238.

7 John Peacock, Inigo Jones as a Figurative Artist

The following abbreviations are used in the notes to this chapter: Barbaro, Vitruvius refers to *I Dieci Libri Dell' Architettura Di M. Vitruvio, Tradotti & commentati da Mons. Daniel Barbaro* (Venice, 1567); Herford and Simpson refers to C. H. Herford and Percy and Evelyn Simpson, *Ben Jonson*, 11 vols (Oxford, 1925–52); Vasari, Milanesi refers to *Le opere di Giorgio Vasari*, ed. Gaetano Milanesi, 9 vols (Florence, 1878–85).

1 Historical Manuscripts Commission, *Rutland*, IV (1905), p. 446: 'Item, 28 *Junii* [1603], to Henygo Jones, a picture maker, *xli.*'

2 John Peacock, 'Ben Jonson's Masques and Italian Culture' in *English and Italian Theatre of the Renaissance*, (Warwick Studies in the Humanities), ed. J.R. Mulryne and M. Shewring (London, 1990).

3 Herford and Simpson, VII, p. 209, lines 1–19.

4 Benedetto Varchi, *Lezzione . . . della maggioranza delle arti* (Florence, 1556): 'i poeti imitano il di dentro principalmente . . . et i pittori imitano principalmente il di fuori'; 'pare che sia tanta differenza fra la poesia e la pittura, quanta è fra l'anima e'l corpo'; G.B. Armenini, *De' veri precetti della pittura* (Ravenna, 1586): 'si chiama la pittura poetica che tace, e la poetica pittura che parla, e questa l'anima dover essere, quella il corpo'; quoted in Paola Barocchi, *Scritti d' arte del Cinquecento*, 3 vols. (Milan/Naples, 1971–7), I, pp. 264, 265, 373.

5 Herford and Simpson, VII, p. 172, lines 90–2.

6 Ibid., p. 190, lines 272–6.

7 Lodovico Dolce, *Dialogo della pittura intitolato l' Aretino*, in *Trattati d' arte del Cinquecento*, ed. Paola Barocchi, 3 vols. (Bari, 1960), I, pp. 171 ff.

8 Ibid., I, p. 172.

9 G.P. Lomazzo, *Trattato Dell' Arte Della Pittura, Scoltura, Ed Architettura* (Milan, 1585), p. 487: 'la poesia è come ombra della pittura, e l' ombra non può stare senza il suo corpo, che non è altro ch' essa pittura, si come gentilmente lo descrisse Leonardo . . .' Leonardo's own argument can be read in Irma A. Richter, *Paragone. A Comparison of the Arts by Leonardo da Vinci* (London/New York/Toronto, 1949), pp. 54–9.

10 For the increasing importance of *disegno* as a concept see A. Blunt, *Artistic Theory in Italy 1450–1600* (Oxford, 1962), pp. 140 ff; E. Panofsky, *Idea. A Concept in Art Theory* (New York, 1968), pp. 85 ff; Luigi Grassi, *Il disegno italiano dal Trecento al Seicento* (Rome, 1956), pp. 7 ff.

11 Herford and Simpson, VIII, pp. 402–6, 'An Expostulation with Inigo Jones', line 96; D.J. Gordon, 'Poet and Architect: The Intellectual Setting of the Quarrel between Ben Jonson and Inigo Jones' in *The Renaissance Imagination* (Berkeley/Los Angeles/London, 1975), pp. 77–101.

12 Giorgio Vasari, *Delle Vite De' Piu Eccellenti Pittori Scultori Et Architettori . . . Primo Volume della Terza Parte* (Florence, 1568), now in the library of Worcester College, Oxford.

13 Ibid., p. 84.

14 Ibid., sig. *****2 verso; Vasari, Milanesi, IV, pp. 7ff:
 'Il disegno fu lo Imitare il piu bello della natura in tutte le figure, cosi scolpite, come dipinte, la qual parte viene dallo haver la mano, & l' ingegno, che rapporti tutto quello, che vede l' occhio in sul piano . . .
 La maniera venne poi la piu bella, dall' havere messo in uso il frequente ritrarre le cose piu belle; & da quel piu bello o mani, o teste, o corpi, o gambe aggiugnerle insieme; & fare una figura di tutte quelle bellezze . . . '

15 Ibid., I, p. 168: 'disegno, padre delle tre arti nostre architettura, scultura e pittura . . .'

16 Varchi, in Barocchi, *Scritti*, I, p. 497: 'il disegno è madre di ognuna di queste arte . . .'

17 Ibid., p. 535: 'Dico dunque, procedendo filosoficamente, che io stimo, anzi tengo per certo, che sostanzialmente la scultura e la pittura siano una arte sola, e conseguente-mente tanto nobile l' una quanto l' altra . . .'; 'Ora ognuno confessa che non solamente il fine è il medesimo, cioè una artifiziosa imitazione della natura, ma ancora il principio, cioè disegno . . .'

18 Vasari, Milanesi, I, p. 173: 'Per che chi studia le pitture e sculture buone fatte con simil modo, vedendo et intendendo il vivo, è necessario che abbia fatto buona maniera nell' arte.'

19 Pliny, *Historia Naturalis*, XXXV.64; see *The Elder Pliny's Chapters on the History of Art*, trans. K. Jex-Blake, ed. E. Sellers (Chicago, 1968), p. 109.

20 *L' Opere Morali Di Xenophonte Tradotte Per M. Lodovico Domenichi* (Venice, 1567), fol. 95 recto; Jones's copy is in Worcester College, Oxford.

21 Sebastiano Serlio, *Tutte L' Opere D' Architettura·Et Prospetiva*, (Venice, 1619; facsimile, Ridgewood, N.J., 1964), II, fol. 18 verso. Serlio makes special mention of Girolamo Genga, who progressed from being painter, perspectivist and scene-designer to becoming court architect (to the Duke of Urbino) – exactly the pattern of Jones's career.

22 Herford and Simpson, VIII, p. 404, line 56.

23 Vitruvius, *De Architectura*, ed. and trans., Frank Granger, 2 vols. (London/Cam-bridge, Mass., 1931–4), III.i.1–3. For a recent discussion of this way of thinking in

sixteenth-century Italian art see David Summers, *Michelangelo and the Language of Art* (Princeton, 1981), pp. 285 ff.

24 Vitruvius, *De Architectura*, III.i. 5–9.

25 Ibid., IV.i. 6–8.

26 Ibid., I.i. 5–6.

27 These various drawings are reproduced in Rudolf Wittkower, *Architectural Principles in the Age of Humanism* (3rd edn, London, 1962), plates 1–4. See also Nigel Llewellyn, 'Two Notes on Diego Sagredo,' *Journal of the Warburg and Courtauld Institutes*, 40 (1977), 292–300.

28 Pietro Cataneo, *L'Architettura* (Venice, 1567), p. 37; Jones's copy is in Worcester College, Oxford.

29 G.A. Rusconi, *Della Architettura* (Venice, 1590), pp. 2–4; Jones's copy is in Worcester College, Oxford.

30 See e.g. *Tethys' Festival*, lines 172–232, in Stephen Orgel and Roy Strong, *Inigo Jones: The Theater of the Stuart Court*, 2 vols. (Berkeley, 1973), I, p. 194.

31 Barbaro, Vitruvius, pp. 111–12. Jones's copy is at Chatsworth. On Barbaro see Bruce Boucher, 'The Last Will of Daniele Barbaro', *JWCI*, 42 (1979), 277–82.

32 Barbaro, Vitruvius, p. 110: 'La natura maestra ci insegna come havemo a reggerci nel compartimento delle fabriche: imperoche non da altro ella vuole, che impariamo le ragioni delle simmetrie, che nelle fabriche de i tempii usar dovemo, che dal sacro tempio fatto ad imagine, & simiglianza di Dio, che è l' huomo, nelle cui compositione tutte le altre meraviglie di natura sono comprese.'

33 G.P. Lomazzo, *A Tracte Containing The Artes of curious Paintinge Carvinge Buildinge*, trans. Richard Haydocke (Oxford, 1598; facsimile, Amsterdam/New York, 1969), Book I, p. 85.

34 Ibid., pp. 108–10.

35 Lomazzo, *Trattato*, p. 94: 'degni di ascendere alla superna gloria, vivendo co'l mezzo delle buone opere, & del timore d' Iddio, co'l nome delquale faccio fine a queste proportioni.'

36 Lomazzo, *A Tracte*, p. 107.

37 L. B. Alberti, *Ten Books on Architecture*, trans. James Leoni (London, 1755; facsimile, London, 1955), IX.v, p. 195. Leoni translates from the Italian version which Jones himself used, *L' Architettura di Leone Battista Alberti*, trans. Cosimo Bartoli (Monreale, 1565), p. 256: 'Siamo avertiti da buon' maestri antichi, & lo habbian' detto altrove, che lo edifitio è quasi come uno animale, si che nel finirlo, & determinarlo bisogna immitare la natura.'

38 See Hans-Karl Lücke, *Alberti Index*, vol. I (Munich, 1975), p. 69, 'Animal'; Aristotle, *Poetics*, VII.4–5, in S.H. Butcher, *Aristotle's Theory of Poetry and Fine Art* (New York, 1951), p. 31.

39 Alberti, *Ten Books on Architecture*, IX.viii, p. 203; cf. *L'Architettura*, p. 267: 'è bisogno haver finito cosi ignuda tutta la tua muraglia avanti che tu la vesti di ornamenti, & l' ultima cosa sarà lo addornala.'

40 Barbaro, Vitruvius, p. 30.

41 Vasari, Milanesi, I, 146–8.

42 Andrea Palladio, *I Quattro Libri Dell' Architettura* (Venice, 1570), II, p. 3; Plutarch, *Life of Coriolanus*: see Shakespeare, *Coriolanus*, ed. P. Brockbank (London, 1976), p. 320.

43 Palladio, *I Quattro Libri*, II, p. 3. Jones annotated this passage: 'Comparason to a mans boddi/ the most butiful partes of mans boddy most exposed to sight so in building'; Bruce Allsopp, *Inigo Jones on Palladio*, 2 vols. (Newcastle-on-Tyne, 1970), I, p. 43.

44 Facsimile prepared for the Duke of Devonshire (London, 1832); the book is

unpaginated. The phrase about clothing has been inserted, suggestively, as an afterthought.

45 Bartoli's version of *L' Architettura* was published with *Della pittura*, trans. Lodovico Domenichi (Monreale, 1565); Jones's copy is at Worcester College, Oxford.

46 L.B. Alberti, *On Painting and On Sculpture*, ed. Cecil Grayson (London, 1972), p. 71. See Michael Baxandall, *Giotto and the Orators. Humanist observers of painting in Italy and the discovery of pictorial composition 1350–1450* (Oxford, 1971), pp. 121–39.

47 Vasari, Milanesi, I, pp. 168 ff.

48 I give the title of the second section of Fialetti's manual; the principal title is *Il vero modo et ordine. Per Dissegnar Tutte Le Parti Et Membra Del Corpo Humano* (Venice, 1608).

49 David Rosand, 'The Crisis of the Venetian Renaissance Tradition,' *L' Arte*, XI–XII (1970), 5–53; Vincenza Maugeri, 'I manuali propedeutici al disegno, a Bologna e Venezia, agli inizi del Seicento,' *Musei ferraresi 1982, Bollettino annuale 12* (Florence, 1984), pp. 147–56.

50 Vasari, *Delle Vite* (Worcester College), p. 327.

51 *Tempe Restored*, lines 47–50, in Orgel and Strong, *Inigo Jones*, II, p. 480.

52 Daniele Barbaro, *La Pratica Della Perspettiva* (Venice, 1569; facsimile, Bologna, 1980), p. 129: 'questa mostra, che in tale pittura si rappresenta'.

53 Barbaro, Vitruvius, pp. 319 ff; Vitruvius, as note 23, VII.5. See David Rosand, 'Theatre and Structure in the Art of Paolo Veronese' in *Painting in Cinquecento Venice* (New Haven/London, 1982), pp. 178 ff.

54 Barbaro, *La Pratica Della Perspettiva*, p. 3.

55 This is the Preface to Part Three; for the qualities of the *istoria* see Vasari, Milanesi, I, p. 174.

56 Ibid., IV, pp. 9–12.

57 Roy Strong in Orgel and Strong, *Inigo Jones*, I, pp. 34–5, suggests Jones had instruction from Isaac Oliver.

58 Vasari, Milanesi, V, p. 442: 'il giovamento che hanno gli oltramontani avuto dal vedere, mediante le stampe, le maniere d' Italia . . .'

59 Ibid., pp. 405–6.

60 Orgel and Strong, *Inigo Jones*, I, pp. 196–7, no. 53.

61 Bartsch XIV. 295. 390.

62 Orgel and Strong, *Inigo Jones*, I, pp. 185, 187, no. 50.

63 Bartsch VIV. 13. 12.

64 Vasari, Milanesi, IV, p. 11.

65 Orgel and Strong, *Inigo Jones*, I, pp. 247, 250, no. 81.

66 Bartsch XIV. 186. 23 and XIV. 248. 329. For a fuller discussion of this design see John Peacock, 'Inigo Jones and the Florentine Court Theatre,' *John Donne Journal*, V (1986), 207 ff.

67 Orgel and Strong, *Inigo Jones*, I, pp. 262–30. no. 84.

68 Engraving by Adamo Scultori, Bartsch XV. 427. 103; see Stefania Massari, *Incisori mantovani del '500* (Rome, 1980), p. 51.

69 Vasari, Milanesi, III, pp. 390, 396.

70 Bartsch XIV. 343. 461.

71 Orgel and Strong, *Inigo Jones*, II, pp. 452, 469, no. 204.

72 Bartsch XIV. 275. 361 and 317. 422; see also Phyllis Pray Bober and Ruth Rubenstein, *Renaissance Artists and Antique Sculpture* (London, 1986), pp. 191–2 (No. 158), 232–3 (No. 199).

73 Bartsch XV. 426. 28; see Massari, *Incisori mantovani del '500*, pp. 53 ff., No. 62 (illustrations for Nos. 62 and 63 here wrongly transposed).

74 Orgel and Strong, *Inigo Jones*, II, pp. 536, 565, No. 274.
75 Fialetti, *Il vero modo et ordine*, pl. 3, Bartsch XVII. 296. 202.
76 Ibid., pl. 7 (part 2), Bartsch XVII. 299. 218.
77 For a fuller discussion see John Harris and Gordon Higgott, *Inigo Jones. Complete Architectural Drawings* (New York, 1989), ch. XI, 'Figurative Drawings'.
78 *Abécédario de P.J. Mariette*, ed. Ph. de Chennevières and A. de Montaiglon (Paris, 1854–8), Vol. III, pp. 314–16.
79 Vasari, *Delle Vite* (Worcester College), sig. *****3 verso.
80 I am grateful to Gordon Higgott for his advice on this point.
81 Daphne Foskett, *Samuel Cooper 1609–1672* (London, 1974), pp. 70–1.

8 *Susan J. Wiseman, 'Tis Pity She's a Whore; Representing the Incestuous Body*

1 John Ford, *'Tis Pity She's a Whore*, IV. iii. 49–53. The edition used here is John Ford, *'Tis Pity She's a Whore*, ed. Derek Roper (Manchester, 1975). Subsequent references in text.
2 The dates of first performance are between 1615 and 1633, when the play was first printed.
3 Jiri Veltrusky, 'Dramatic Text as a Component of Theatre,' in *Semiotics of Art: Prague School Contributions*, ed. Ladislav Matejka and Irwin R. Titunik (Cambridge, Mass/London, 1976), pp. 94–117, esp. p. 114.
4 Kathleen McLuskie, *Renaissance Dramatists* (Hemel Hempstead, 1989), pp. 129–30. Freud also discusses the choice of a lover but concentrates on the choice of a bride by a male lover. The opening act of *'Tis Pity* emphasises the mutuality of the choice, though in Act V Giovanni's language restructures the process as controlled by him. See Sigmund Freud, 'The theme of the three caskets' in his *Complete Works*, ed. James Strachey (London, 1958), XII, pp. 289–301.
5 *'Tis Pity She's a Whore* is discussed as a 'city tragedy' in Verna Foster, "'Tis Pity She's a Whore and City Tragedy,' in *John Ford: Critical Re-Visions*, ed. Michael Neill (Cambridge, 1988).
6 Peter Burke, *Popular Culture in Early Modern Europe* (London, 1978), p. xi.
7 For a critique of arbitrary connections between texts within a field of discourse see Walter Cohen, 'Political Criticism of Shakespeare,' in *Shakespeare Reproduced: the Text in Ideology and History*, ed. Jean E. Howard and Marion F. O'Connor (London, 1987), pp. 37–8.
8 See for example Francis Barker, *The Tremulous Private Body* (London, 1984), pp. 3–4.
9 Michel Foucault, 'The Repressive Hypothesis,' *The History of Sexuality*, trans. Robert Hurley (Harmondsworth, 1981), I, pp. 17–21. First published as *La volonté de savoir* (Paris, 1976). Robert Muchembled, *Culture populaire et cultures des élites dans la France moderne* (Paris, 1978).
10 Martin Ingram, 'The Reformation of Popular Culture? Sex and Marriage in Early Modern England,' in *Popular Culture in Seventeenth Century England*, ed. Barry Reay (London/Sydney, 1985), p. 157.
11 Stephen Greenblatt, 'Fiction or Friction,' *Shakespearean Negotiations* (Oxford 1988), p.75. See also the essays in Natalie Zemon Davis, *Society and Culture in Early Modern France* (Cambridge, 1987); her *Fiction in the Archives* (Cambridge, 1987); Lisa Jardine, *Still Harping on Daughters* (Brighton, 1983).
12 William Gouge, *Of Domesticall Duties* (London, 1622); Edmund Tilney, *A Brief and Pleasaunt Discourse of Duties in Mariage* (London, 1568).
13 Heinrich Bullinger, *The Christian State of Matrimony*, trans. Miles Coverdale (London, 1541), ch. viii, 'Of matrimonye,' p. xviii. Bullinger also refers critically to the stringent Roman Catholic laws on incest within the degrees of affinity in ch. xix.
14 *Aristotle's Masterpiece* (London, 1690), p. 177.

15 Lawrence Stone, *The Family, Sex and Marriage* (Harmondsworth, 1979), p. 309. See also Peter Laslett, *Family Life and Illicit Love in Earlier Generations* (Cambridge, 1977).

16 Lenore Glanz, 'The legal position of English women under the early Stuart kings and the interregnum, 1603–1660,' unpublished Ph.D. dissertation, Loyola University of Chicago, 1973, p. 195; *C.S.P.D. Chas. I,* IX, pp. 190, 500–1. Other recorded punishments include fines: see Glanz, 'The legal position of English women,' p. 196; *C.S.P.D. Charles I,* v, pp. 41, 62, 90, 91, 102, 108.

17 Glanz, 'The legal position of English women,' p. 202.

18 Ibid., pp. 202–9.

19 Jacques Derrida, 'Structure, Sign and Play' in his *Writing & Difference,* trans. Alan Bass (London/Henley, 1978), p. 284.

20 See Joan Kelly, 'Did women have a Renaissance?' in her *Women, History and Theory* (Chicago/London, 1984), pp. 30–6. Reprinted from *Becoming Visible: Women in European History,* ed. Renate Bridenthal and Claudia Koonz (Boston, 1977).

21 Plato, *Phaedrus,* 255d, 'he appears to have caught the infection of blindness from another; the lover is his mirror in whom he is beholding himself, but he is not aware of this.' *The Dialogues of Plato,* trans. B. Jowett (Oxford, 1953), III.

22 Sigmund Freud, *The Standard Edition of the Complete Psychological Works of Sigmund Freud,* ed. J. Strachey et al., vol. xvii: 1917–1919 (London, 1955), 'The Uncanny,' pp. 217–52, esp. p. 245.

23 See for example Christopher Harvey, *The School of the Heart* (1647) in *The Complete Works,* ed. Alexander Grosart (London, 1874). See also Michael Neill, ' "What Strange Riddle's This?" Deciphering *'Tis Pity She's a Whore,*' in Neill, ed., *John Ford: Critical Re-Visions,* pp. 153, 155–6. The range and violence of critical opinion quoted by Neill points to the opacity of the final scene of *'Tis Pity She's a Whore.*

24 Jacqueline Rose, 'Sexuality in the reading of Shakespeare: *Hamlet* and *Measure For Measure,*' in *Alternative Shakespeares,* ed. John Drakakis (London, 1985), p. 118.

25 Derrida, 'Structure, Sign and Play,' p. 279.

26 See Derek Roper's introduction to Ford, *'Tis Pity She's a Whore,* pp. xxvi–xxxvii for summary of discussion of sources.

27 Roger Chartier, *Cultural History,* trans. Lydia G. Cochrane (Cambridge, 1988), p. 96.

28 Greenblatt, *Shakespearean Negotiations,* pp. 1–3. Greenblatt begins, 'I began with the desire to speak with the dead,' and goes on to explore the difficulties around this idea.

29 Derek Hirst, *Authority and Conflict* (London, 1987), p. 49.

30 Michael MacDonald, 'The Secularisation of Suicide in England 1660–1800,' *Past and Present,* CXI (May 1986), 50–100, esp. p. 51; see also D.T. Andrew's comment and MacDonald's reply in ibid., CXIX (May, 1988), 158–70.

31 Veltrusky, 'Dramatic Text as a Component of Theatre,' p. 115: 'the general function of drama in the shaping of the semiotics of theatre can be brought out only by means of confronting the two sign systems that are invariably present, that is, language and acting.' See also, Patrice Pavis, 'Notes Toward a Semiotic Analysis,' trans. Marguerite Oerlemans Bunn, *The Drama Review,* LXXXIV (1979), 93–104, esp. p. 104: 'Very often it is the *out of sync,* the absence of harmony between parallel scenic systems, that . . . produces meaning.'

9 Maurice Howard, Self-Fashioning and the Classical Moment in Mid-Sixteenth-Century English Architecture

1 *Historical Manuscripts Commission, Marquess of Salisbury,* xv (London, 1930), pp. 382–3. The letter is undated but endorsed '1603'.

2 Lawrence Humphrey, *The Nobles or of Nobilitye. The Original nature, dutyes, right and Christian Institucion thereof. Three Bookes . . .* (London, 1563), v. III. v.

3 Numerous early Tudor palaces are known to have been painted, either to accentuate the colour of the brick or to disguise it in yellow and black. See Peter Curnow, 'The East Window of the Chapel at Hampton Court Palace,' *Architectural History*, XXVII (1984), pp. 1–14 and H. Colvin, et al., eds, *The History of the King's Works*, Vol. IV: *1485–1660*, part ii (London, 1982), pp. 68–74, on Dartford Priory. On dress at this period and the issue of decorating the structure of costume, see Aileen Ribeiro, *Dress and Morality* (London, 1986), pp. 59–66.

4 Stephen Greenblatt, *Renaissance Self-Fashioning* (Chicago/London, 1980), p. 2.

5 Most useful on Elizabeth I and her country house visits is Jean Wilson, *Entertainments for Elizabeth I* (Woodbridge, Suffolk/Totowa, N.J., 1980). See also Greenblatt, *Renaissance Self-Fashioning*, pp. 165–9 on the queen and role-playing.

6 David Starkey, 'Ightham Mote; Politics and Architecture in Early Tudor England,' *Archaeologia*, CVII (1982), pp. 153–64, presents what he sees as the transfer of part of a particular temporary royal structure into a courtier house. Malcolm Airs, 'The English Country House in the Sixteenth Century,' *Oxford Art Journal*, II (April 1979), pp. 15–18, argues for the considerable knowledge of the aristocracy in the later sixteenth century in architectural matters; M. Girouard, *Robert Smythson and the Elizabethan Country House* (New Haven/London, 1983), pp. 4–6, is less convinced.

7 In general, see Jennifer Loach and Robert Tittler, eds, *The Mid-Tudor Polity c. 1540–1560* (Basingstoke, 1980) and particularly Dale Hoak's article on Northumberland and the Council, pp. 29–51. A counter-argument in many respects, stressing the continued importance of the Privy Chamber, is presented by John Murphy, 'The Illusion of Decline: the Privy Chamber 1547–1558' in David Starkey, ed., *The English Court from the Wars of the Roses to the Civil War* (London/New York, 1987), pp. 119–46.

8 See John N. King, *English Reformation Literature. The Tudor Origins of the Protestant Tradition* (Princeton, 1982), *passim*, and Patrick Collinson, *The Birthpangs of Protestant England: Religious and Cultural Change in the Sixteenth and Seventeenth Centuries* (London, 1988), ch. 4.

9 On mid-century patrons, see John Summerson, *Architecture in Britain 1530–1830* (5th edn, Harmondsworth, 1969), ch. 2; E. Mercer, *English Art 1553–1625* (Oxford, 1962), ch. 1, 2; Adam White, 'Tudor Classicism,' *Architectural Review*, CLXXI (1982), pp. 52–6.

10 See M. Howard, *The Early Tudor Country House. Architecture and Politics 1490–1550* (London, 1987), ch. 9, for a full list and comments on the appearance of the new classical idiom. See R. Haslam, *Country Life*, CLXXVIII (1985), pp. 943–7 on Newark; H. Gordon Slade, *Archaeological Journal*, CXXXV (1978), pp. 138–94 on Broughton; Colvin et al., eds, *The History of the King's Works*, IV, pp. 252–71 for the most recent published work on Somerset House. The issue of the classical loggia at Lacock is discussed by M. Howard, 'Adaptation and Re-adaptation: The Fate of Some Early Country House Conversions' in *Dissolution and Resurrection* (Papers of the 1985 Oxford Conference, forthcoming).

11 C.H. Talbot, 'On a Letter of Sir William Sharington to Sir John Thynne, June 15th, 1553,' *Wiltshire Archaeological Magazine*, XXVI (1891–2), pp. 50–1 and W. Douglas Simpson, 'Dudley Castle: the Renaissance Buildings,' *Archaeological Journal*, CI (1944), pp. 119–25.

12 For a useful discussion of Holbein's portraits and ways of reading sitters and their imagery, see Mark Roskill and Craig Harbison, 'On the nature of Holbein's portraits,' *Word and Image*, III, no. 1 (1987), pp. 1–26.

13 On the Wentworth portrait, see Roy Strong, *The English Icon: Elizabethan and Jacobean Portraiture* (London, 1969), pp. 67, 69–74.

14 Anthony Blunt's extremely useful 'L'influence française sur l'architecture et la

sculpture décorative en Angleterre pendant la première moitié du XVIe siècle,' *Révue de l'art*, IV (1969), pp. 17–29 represents the search for sources and references at its most scholarly, yet it is ultimately inconclusive concerning direct influences.

15 On Wollaton, see Girouard, *Robert Smythson*, ch. II.

16 Mercer, *English Art 1553–1625* discusses the nature of this excess. On Hill Hall, see P.J. Drury, 'A Fayre House Buylt by Sir Thomas Smith: The Development of Hill Hall, Essex 1557–81,' *Journal of the British Archaeological Association*, CXXXVI (1983), pp. 98–123. On Burghley, see Girouard, *Robert Smythson, passim*.

17 Catherine Belsey, *The Subject of Tragedy. Identity and Difference in Renaissance Drama* (London, 1985), pp. 4–5.

18 On faction, see Murphy, 'The illusion of decline.'

19 On Berry Pomeroy, I am indebted to the work of H. Gordon Slade, as yet unpublished.

20 See Jasper Ridley, *Thomas Cranmer* (Oxford, 1962), pp. 262–3. On iconoclasm, see J. Phillips, *The Reformation of Images: Destruction of Art in England 1535–1660* (Berkeley, Calif., 1973); see also Margaret Aston, *England's Iconoclasts*, vol. 1: *Laws Against Images* (Oxford, 1988).

21 King, *English Reformation Literature*, p. 146.

22 For discussion of the Protestant plain style, I am particularly indebted to King, *English Reformation Literature* and David Norbrook, *Poetry and Politics in the English Renaissance* (London/Boston, 1984), esp. ch. 2.

23 King, *English Reformation Literature*, p. 141.

24 Norbrook, *Poetry and Politics*, pp. 44–6.

25 On the many works on the construction of English history at this time, see particularly M. McKisack, *Medieval History in the Tudor Age* (Oxford, 1971); T.D. Kendrick, *British Antiquity* (London, 1950); and F.J. Levy, *Tudor Historical Thought* (San Marino, Calif., 1967).

26 See Norbrook, *Poetry and Politics*, ch. 2 and, on Leland, Kendrick, *British Antiquity*, ch. IV and the introduction to Leland's *Itinerary* by L. Toulmin-Smith, vol. 1 (London, 1906). Collinson, *The Birthpangs of Protestant England*, pp. 14–17, stresses the essential internationalism of English Protestant thought at this period, thus qualifying the self-identification of England as the 'elect' nation, as promulgated in the influential work of W. Haller, *Foxe's Book of Martyrs and the Elect Nation* (London, 1963).

27 The image is discussed in the context of representations of women in Protestant literature in John N. King, 'The Godly Woman in Elizabethan Iconography,' *Renaissance Quarterly*, XXXVIII (1985), pp. 47.

28 For the traditional belief in the 'commonwealth' party, see historians from A.F. Pollard, *England under the Protector Somerset* (London, 1900) to W.K. Jordan, *Edward VI. The Young King* and *Edward VI. The Threshold of Power* (London, 1968 and 1970). Whitney R.D. Jones, *The Tudor Commonwealth 1529–1559* (London, 1970), which has become the standard book on the subject, emphasises the essentially conservative quality of their ideas but reiterates the sense of an identifiable group. Since then, however, other historians have sought to deny the myth of a group altogether: see M.L. Bush, *The Government Policy of Protector Somerset* (Montreal, 1975) and G.R. Elton, 'Reform and the "Commonwealth-Men" of Edward VI's Reign' in P. Clark, Alan G.R. Smith, N. Tyacke, eds, *The English Commonwealth 1547–1640* (Leicester, 1979), pp. 23–38.

29 Norbrook, *Poetry and Politics*, p. 49.

30 William Turner, *A new booke of spirituall physik for dyverse diseases of the nobilitie and gentlemen of Englande* (London, 1555), fol. 9v.

31 In J.Ayre, ed., *The Catechism of Thomas Becon* (Cambridge, 1844), p. 430.

32 Humphrey, *The Nobles or of Nobilitye*, sig. T.VIIv–T.VIIIr.

33 See British Library, Harleian MS 2194, fol. 20ᵛ (renumbered) and John Stow, *The Survey of London*, ed. H.B. Wheatley (rev. edn, London, 1956), pp. 387, 395.

34 On Thomas, see E.R. Adair, 'William Thomas' in R.W. Seton-Watson, ed., *Tudor Studies* (London, 1924), pp. 133–60 and Edward Chaney, 'Quo Vadis? Travel as Education and the Impact of Italy in the Sixteenth Century' in *International Currents in Educational Ideas and Practices. Proceedings of the 1987 Annual Conference of the History of Education Society of Great Britain* (London, 1988), pp. 1–28.

35 As well as Colvin, et al., eds, *The History of the King's Works*, IV, see N. Pevsner, 'Old Somerset House,' *Architectural Review*, CXVI (1954), pp. 163–7 for a discussion of some of the possible design sources of the entry.

36 William Thomas, *The History of Italy*, ed. George B. Parks (Ithaca, 1963), p. 63.

37 Ibid., p. 114.

38 See R. Goldthwaite, *The Building of Renaissance Florence* (Baltimore/London, 1980), ch. 2.

39 Humphrey, *The Nobles or of Nobilitye*, sig. V.Iᵛ.

40 On Somerset House as an urban palace, see Howard, *The Early Tudor Country House*, ch. 9.

41 On Shute, traditions of architectural writing in England and the reputation of the architectural profession, see M. Howard, 'The Ideal House and the Healthy Life: the Origins of Architectural Theory in England' in A. Chastel and J. Guillaume, eds, *Les Traités d'Architecture de la Renaissance* (Tours, 1988), pp. 425–33.

42 John Shute, *The First and Chief Groundes of Architecture* (London, 1563), sig. A.III.iv.

43 On the Orders and gender in the Renaissance, see George Hersey, *The Lost Meaning of Classical Architecture. Speculations on Ornament from Vitruvius to Venturi* (Cambridge, Mass/London, 1988), ch. 5 and 6.

44 Shute, *The First and Chief Groundes of Architecture*, sig. A.III.i.

45 Ibid., sig. A.III.ii.

10 *Nigel Llewellyn, The Royal Body: Monuments to the Dead, For the Living.*

I would like to thank several people for reading earlier drafts of this essay: Sydney Anglo, Lucy Gent, Maurice Howard and Clare Pumfrey.

1 For thoughts on this see Philip Norman, 'Britain's Age of Parody,' *Guardian* ('Weekend', 10–11 December 1988), 1–3, 22.

2 K.A. Esdaile, *English Church Monuments, 1510 to 1840* (London, 1946), p. 59. Margaret Aston, *England's Iconoclasts*, Vol. 1: *Laws Against Images* (Oxford, 1988) came to hand too late to be considered for this essay.

3 For such misgivings see my *Signs of Life: Funeral Monuments in Post-Reformation England* (forthcoming).

4 Some authors use metaphors of food and fashion: 'it was as though the Englishman in Henry VIII's time, had put on an Italian garment and carried macaroni about him, although he still fed on beef,' J.A. Gotch, *The Architecture of the Renaissance in England* (London, 1894), I, p. xxi.

5 See R. Huntingdon and P. Metcalf, *Celebrations of Death. The Anthropology of Mortuary Ritual* (Cambridge, Mass., 1979), pp. 122–3; S.C. Humphreys and H. King, eds, *Mortality and Immortality: the Anthropology and Archaeology of Death* (London, 1981), p. 3.

6 E.H. Kantorowicz, *The King's Two Bodies: A Study in Medieval Political Theology* (Princeton, 1957), *passim*.

7 George Strode, *The Anatomie of Mortalitie* (London, 1618), p. 54.

8 William Perkins, *A salve for a sicke man* (Cambridge, 1595), p. 7.
9 See the account of Van Gennep and Hertz given in Huntingdon and Metcalf, *Celebrations of Death*, pp. 9–13.
10 P.S. Fritz, 'From "Public" to "Private": The Royal Funerals in England, 1500–1830' in J. Whaley, ed., *Mirrors of Mortality. Studies in the Social History of Death* (London, 1981), p. 76.
11 Humphreys and King, eds, *Mortality and Immortality*, p. 9.
12 British Library, Harleian MS 297, fols. 28–30; see B.H. Meyer, 'The first tomb of Henry VII of England,' *Art Bulletin*, LVIII (1976), 358–67. The Mazzoni contract is usually dated 1506–7 as it mentions Thomas Drawswerd as Sheriff of York: see R.W. Carden, 'The Italian Artist in England during the Sixteenth Century,' *Proceedings of the Society of Antiquaries*, 2nd ser., XXIV (1911–12), 171–204. In fact, British Library Add. MS 29694 fol. 14 lists Drawswerd as Sheriff for 1505. A grille to surround the burial place was, perhaps, all that came of this scheme.
13 For a minute inspection of the chronology of the various early-sixteenth-century projects, see Carol Galvin and Phillip Lindley, 'Pietro Torrigiano's portrait bust of King Henry VII,' *Burlington Magazine*, CXXX (December 1988), 892–902. For the funerals and monuments of Princesses Mary Stuart (buried 16 December 1607) and Sophia Stuart (born 22 June 1606 and died the next day), see M. Edmond 'Limners and Picturemakers – New light on the lives of miniaturists and large-scale portrait-painters working in London in the sixteenth and seventeenth centuries', *Walpole Society*, XLVII (1978–80), 165. See J.L. Chester, ed., *The . . . Registers of the . . . Abbey of . . . Westminster* (Harleian Society Publications X, London, 1876), pp. 108–9, for the date of 16 December 1607 (the wrong date) for the death of Mary; see *Calendar of State Papers Domestic* (hereafter CSPD) *1603–1610* (London, 1853), p. 372 for the date of 29 September 1607 (warrant to pay for funeral of Princess Mary); for tomb costs for Princess Mary see Historical Manuscripts Commission (hereafter HMC), LXXII (Laing Mss i), p.109 and HMC, *Papers at Hatfield House*, XX (London, 1968), p. 108. For a romantic, modern account see J.D. Tanner, 'Tombs of the Royal Babies in Westminster Abbey' *Journal of the British Archaeological Association*, XVI (1953), 38, who repeats Thomas Fuller's comment about the conceit of the cradle moving visitors, especially women, more than do the grander tombs round about; see also Thomas Fuller, *History of the Worthies of England* (London, 1662), II, p. 129.
14 Oxford, Bodleian Library, Gough Maps XLV, no. 63 is a drawing marked 'Plattes for ye Tombes of K.Ed. Q.Mar' possibly by William Cure I and possibly coterminus with lost plans by Cure of 1573 for a monument to Henry VIII, see H.M. Colvin, *Architectural Drawings in the Bodleian Library* (Oxford, 1952), p. 4 and plate 1. Mary I was buried 14 December 1558 in the north aisle of Henry VII's Chapel in Westminster Abbey: see CSPD, *1547–1580* (London, 1856), p. 117: there was never a tomb. The queen is mentioned in the inscription (West end, lower) on the monument to her sister Elizabeth I erected 50 years later, *pace* Thomas Fuller, *The Church-History of Britain . . .* (London, 1655).
15 '. . . that King James put here' from William Camden, *Reges . . . et alii . . . in Westmonasterii seputi . . .* (London, 3rd edn, 1606), p. 24.
16 For the costs of her funeral see British Library, Harleian MS 69, fol. 60ʳ and Add. MS 35324; see also J. Nichols, *The Progresses . . . of King James . . .*, 4 vols. (London, 1828), I, pp. 188–90.
17 Located as early as the 1603 edition of William Camden's guide, *Reges . . . et alii . . . in Westmonasterii sepulti . . .*, sig. D3ʳ.
18 Thomas Platter, *Travels in England, 1599*, ed. C. Williams (London, 1937), p. 209.
19 J. Wall, *The Tombs of the Kings of England* (London, 1891), p. 413. Indeed, no substantial monument was ever constructed for Edward VI (d. 6 July 1553) for whose

funeral expenses see CSPD, *1547–1580* (London, 1856), p. 54, entry for 8 August 1553.

20 Wall, *The Tombs of the Kings of England*, p. 413; see also warrants for monies in CSPD, *James I (1603–10)*, p. 201 (4 March 1605).

21 M.D. Whinney, *Sculpture in Britain, 1530–1830*, rev. edn. by J. Physick (London, 1988), p. 433, n. 47. The contract came to £765; see N. Pevsner, *The Buildings of England: The Cities of London and Westminster*, (3rd edn, Harmondsworth, 1973) and HMC Hatfield. The original estimate was £600; see Wall, *The Tombs of the Kings of England*, p. 413.

22 HMC, Salisbury MSS ix/xviii, p. 409; in fact the contract went to John de Critz, see BL Add. MS 36970, fol. 17v, published by E.P. Shirley, *Notes & Queries*, 3rd ser., v (1864), p. 434. For the claims that Mauncey was also involved, see *Proceedings of the Huguenot Society*, VII (1901–4), 75. In that same year the body was moved to the new site, see *Archaeologia*, LX (ii), 567.

23 See Kantorowicz, *The King's Two Bodies* and R.E. Giesey, *The Royal Funeral Ceremony in Renaissance France* (Travaux d'Humanisme et de la Renaissance, XXXVII, Geneva, 1960), *passim*.

24 Elaborate funerals were celebrated in ancient Thailand for precisely these reasons, see Huntingdon and Metcalf, *Celebrations of Death*, p. 129.

25 William Burton, *The Description of Leicester Shire. Containing matters of antiquitye* . . . (London, 1622), p. 163. The piece was by James Kelway and cost the modest sum of £10 5s.

26 G. Kipling, *The Triumph of Honour* . . . (Leiden, 1977), pp. 59, 61.

27 The tombs are at Fotheringay, Northants.; see E. Mercer, *English Art 1523–1625* (Oxford, 1962), p. 220.

28 Jonathan Goldberg, *James I and the Politics of Literature* (Baltimore/London, 1983), p. 14.

29 Letter dated 20 September, 1613: Bodleian Library, Ashmol. MS 836, fol. 277. The tomb is well illustrated in John Dart, *Westmonasterium* (London, 1723) and reprinted in J. Physick, *Five Monuments from Eastwell* (V&A Brochure No. 3, London, 1973), plate 19.

30 HMC, Hatfield Papers XV (London, 1930), p. 347.

31 Roy Strong, *Tudor and Jacobean Portraits* (London, 1969), I, p. 222; the financial accounts, dates and other descriptions occur in Pevsner, *London and Westminster*, p. 442, plate 51; Whinney, *Sculpture in Britain 1530–1830*, pp. 17, 20, plate 12; Pell Records: James I ed. F. Devon (London, 1836), pp. 168, 190; Mercer, *English Art 1523–1625*, p. 231; K.A. Esdaile in *Archaeologia Cantiana*, XLIV (1932), 232; Thomas Dingley in *History from Marble*, ed. J.G. Nichols in *Camden Society* (London, 1867), II, p. ccccclxxv. Cornelius was followed by his nephew William Cure II; John Mauncey had the painting and gilding contract. The iron grate was by Thomas Bickford (see Crown Works Accounts 1613–14 in PRO and in an undated version in British Library, Harleian MS 1653, fol. 79r).

32 Charted by John Peacock in his 'Inigo Jones's Catafalque for James I,' *Architectural History*, XXV (1982), 1–5.

33 See A.M. Hind, *Engraving in England* . . . (Cambridge, 1952–5), II, plate 31 for an engraving of her funeral hearse. For various accounts see Edmond, op. cit., n. 13, p. 166; Chester, ed., *The . . . Registers*, p. 115.

34 For the taking of a death mask for James's funeral effigy, see Edmond, op. cit., n. 13, p. 166. For the funeral expenses see CSPD, *1625, 1626* (London, 1858), p. 564 (4 April 1626) and pp. 4, 14, 15, 19, 20, 22, 26, 56, 447; CSPD, *1625–1649 Addenda* (London, 1897), p. 12. For the catafalque design by Inigo Jones (now at Worcester College, Oxford) made by Hubert Le Sueur at a cost of £20, see John Peacock, 'Inigo

Jones's Catafalque for James I' and PRO Declared Accounts A. 1. 2425/57 October
1626 – September 1627. An engraving of Jones's design was published with the
Bishop of Lincoln's funeral sermon and in Francis Sandford, *A Genealogical History
of the Kinges and Queens of England* . . . (London, 1707). Colt did some elaborate
decorations for the hearse; see Edmond.

35 John Stow, *The Annales of England* . . . (London 1631).
36 See Roy Strong, *Henry, Prince of Wales and England's Lost Renaissance* (London,
 1986) pp. 7, 229 for more manuscript references to funeral witnesses, etc. See Hind,
 Engraving in England, II, plate 200 for the engraving of the funeral hearse from
 Henry Holland, *Heruuologia Anglica* . . . (London, 1620), p. 51. Henry died on 6
 November 1612 and was buried on 8 December following.
37 W.St.J. Hope, 'On the Funeral Effigies of the Kings and Queens of England,'
 Archaeologia, LX, no. ii (1907), 555.
38 Giesey, *The Royal Funeral Ceremony*, p. 19
39 Ibid., p. 145.
40 The head is very close to the moulded terracotta portrait in the Victoria and Albert
 Museum; see R.P. Howgrave-Graham, 'Royal Portraits in Effigy: Some New
 Discoveries in Westminster Abbey,' *Journal of the Royal Society of the Arts*, CI
 (1952–3), 469–70. Galvin and Lindley, 'Pietro Torrigiano's Portrait Bust,' have
 recently argued that both effigy and bust are by Torrigiano; for the claim that the
 monumental effigies at Westminster must be based on a pre-existing painted portrait
 perhaps by Maynard, see Kipling, *The Triumph of Honour*, pp. 65–6.
41 Giesey, *The Royal Funeral Ceremony*, p. 91, who cites other, foreign cases.
42 J.C. Cox, *Churchwarden's Accounts from the fourteenth century to the close of the
 sixteenth* (London, 1913), p. 174.
43 Robert Reyce, *The Breviary of Suffolke, 1618*, ed. Lord Francis Hervey (London,
 1902), pp. 203–4.
44 Antiquaries usually comment on the tomb's splendour, for example, Valentin
 Arithmaeus, *Mausolea, regum, reginarum . . . Londini Anglorum in iccidentali urbis
 angulo structo* . . . (Frankfurt, 1618); Camden, *Reges . . . et alii . . . in Westmonas-
 terii sepulti* . . . (1606 edn), etc; De Passe's engraving for Holland's *Heruuologia* . . .
 (see Hind, *Engraving in England*, II, plate 7); and the title-page of 1625–6 for Samuel
 Purchas's *Haktylus Posthumous, or Purchas his Pilgrimes* which shows the tomb
 along with other images (see Hind, *Engraving in England*, II, plate 243).
45 K.A. Esdaile, 'Sculpture and Sculptors in Yorkshire,' *Yorkshire Archaeological
 Society*, XXXVI (1944–47), 82–3.
46 Thomas Fuller, *The Church-History of Britain: from . . . Christ untill the year 1648*
 (London, 1655), X, p. 4.
47 In an unpublished talk David Cressy has stressed how the continual celebration of
 Elizabeth's accession day, 17 November, well into the seventeenth century sustained
 popular support for a Protestant heroine.
48 For an account of the tomb which stresses this feature see Holland, *Heruuologia*, p.
 41.
49 Wall, *The Tombs of the Kings of England*, p. 189. Esdaile describes a modest chest in
 alabaster (perhaps by Torrigiano) with a picture of the Risen Christ on the top in 'The
 part played by Huguenot sculptors,' *Proceedings of the Huguenot Society*, XVIII
 (1949), 255. It is illustrated in Sandford. John Strype thought these were 'religious
 stones'; see *Annals of the Reformation* . . ., 7 vols. (Oxford, 1824), I, p. 400. The
 altar was demolished on 16 April 1561. Ryves, *Mercurius Rusticus* (London, 1685)
 and Arithmaeus, *Mausolea, regum, reginarum*, sig. B.vi.ʳ, support the evidence in
 Sandford that Edward's altar survived the Reformation.
50 R.A. Beddard, 'Wren's mausoleum for Charles I and the cult of the Royal Martyr,'

Design and Practice in British Architecture. Studies in architectural history presented to Howard Colvin, Architectural History, XXVII (1984), 36–49.

51 Huntingdon and Metcalf, *Celebrations of Death*, pp. 121–2.

52 Maurice Howard, ' "The holy companie of heven": Henry VII's Chapel,' *History Today*, XXXVI, no. ii (February 1986), 36–41.

53 As early as 1501, see R.W. Carden, 'The Italian Artists in England during the Sixteenth Century,' *Proceedings of the Society of Antiquaries* (2nd series), XXIV (1911–12), 178.

54 For the papal bulls for Windsor obtained during 1494–99 see *Victoria County History Berkshire* (London, 1907), II p. 109 and R. O. Rymera, *Foedera, Conventiones, Litteras, etc.* (edn, London, 1704–35), XII, pp. 505, 591, 644, 672.

55 Wall, *The Tombs of the Kings of England*, pp. 362–3; British Library, Harleian MS 1498 (made 16 July, an. reg. 19) contains various indentures between the king, the prior and the abbot of Westminster relating to the terms of his will regarding burial and commemoration.

56 For these projects generally I benefitted from a talk – I think unpublished – given by Phillip Lindley at the annual Conference of the Association of Art Historians, London 1987.

57 *Letters & Papers, Foreign & Domestic, Henry VIII*, I (1) 1920, item I. 1–3. Will of Henry VII in PRO, Exch. T.R., Wills (Hen vii). By 1552 'the palles of herses . . . of King Henry the vii' were listed amongst the goods making up the wealth of St George's Chapel, Windsor; see British Library, Add. MS 5498, fol. 42v.

58 In the 1590s, it was reported that Elizabeth wished to be buried at Windsor, see Platter, *Travels in England, 1599*, p. 209.

59 Oxford, Bodleian Library, Ashm. MS 836, fol. 277; quoted in Goldberg, *James I*, p. 14.

60 Arithmaeus, *Mausolea, regum, reginarum*, sig. A5r.

61 John Weever, *Ancient Funerall Monuments* (London, 1631), pp. 450–1.

62 Ibid , p. 41 and Thomas Fuller, *History of the Worthies of England* quoted in K.A. Esdaile, *English Church Monuments*, p. 138.

63 Charles I (1600–1649) was also attracted to the formality of the Garter Chapel. His personal revival of the St George's Day procession of the Garter Knights signalled a return to the formality of the Elizabethan court ritual, a distancing of the royal person from the courtiers and a policy of divorcing the servants of the body from overtly political circles; see D. Starkey, ed., *The English Court from the Wars of the Roses to the Civil War* (London, 1987). There is some evidence that a monument for Charles was started in the east end of St George's Chapel, but the Civil War prevented the completion of the project; Wall, possibly in confusion with the monument to Henry VIII, claims that the work was demolished by 'the rebels' on 6 April 1646 when the figures, etc. were all sold off; see his *The Tombs of the Kings of England*, pp. 437–8.

64 K.A. Esdaile, 'The Part Played by Refugee Sculptors, 1600 to 1750,' *Proceedings of the Huguenot Society*, XVIII (1949), 254. A tale is told by Fuller: 'That King *Henry* one day finding the Cardinall with his workmen making His Monument, should say unto him, *Tumble your self in this Tombe whilst you are alive, for when dead, you shall never lie therein*', *The Church History of Britain*, v, pp. 244–5, 252.

65 Wall, *The Tombs of the Kings of England*, pp. 362–3; British Library, Harleian MS 1498 (the will made 16 July, an. reg. 19) which mentions work to be done by Nicholas Ewan – a coppersmith and gilder who was to have £410 – and a founder who was to receive £63. See Esdaile, *English Church Monuments*, p. 57.

66 R.F. Scott, 'On the Contracts . . .', *Archaeologia*, LXVI (1915), 365–76, esp. p. 366; contract dated 23 November 1511.

67 Wall, *The Tombs of the Kings of England*, pp. 262–3.

68 See, for example, the Duke of Wurtemberg (1592) published in Tübingen in 1602 and quoted in W.B. Rye, *England as seen by Foreigners in the days of Elizabeth and James the First* (London, 1865), p. 9. See also Thomas Platter, *Travels in England, 1599*, p. 178.

69 John Norden, *Speculum Britanniae. The first parte. A description of Middlesex* (London, 1593), p. 43 with a manuscript version of the same in British Library, Harleian MS 570, fols. 35^{r-v}. Camden's phrase was *'ex solide aere'* in *Reges . . . et alii . . . in Westmonasterii seputi . . .* (1600 edn), p. 19, an entry largely copied by Arithmaeus, *Mausolea, regum, reginarum*, sig. B.ii.r.

70 From Turler's notes made in 1575 printed in Rye, *England as seen by Foreigners*, pp. 83–4. Edward Chamberlayne also calls it 'massie Brass, most curiously wrought . . .' in his *Angliae Notitia; or, the Present State of England* (12th edn, London, 1687), Part II, p. 305.

71 For example, Francis Osborn who thought there might be 'Ugly buggs' in Henry VII's tomb by the mid-seventeenth century, see his *Advice to a son, Or directions for your better conduct* (6th edn, Oxford, 1658), pp. 33–4.

72 His contract with the Italian Pietro Torrigiano was signed 26 October 1512 for £1000; see Carden, 'Italian Artists,' p. 178. The actual costs were substantially more; work was finished in 1519; see Horace Walpole, *Anecdotes of Painting in England*, ed. Dallaway (London, 1849), I, p. 102, quoting John Stow, *Annals* and many later sources. See also A.P. Darr, 'The Sculptures of Torrigiano: The Westminster Abbey Tombs,' *Connoisseur*, CC (1979), 177–84 and his thesis, *Pietro Torrigiano and his sculpture for the Henry VII Chapel, Westminster Abbey*, Ph.D. dissertation, New York University, 1980.

73 R.H.H. Cust, ed., *The Life of Benvenuto Cellini*, 2 vols. (London, 1927), I, pp. 38–40.

74 Carden, 'Italian Artists.'

75 For the 'start of the Renaissance' tradition see Walpole, *Anecdotes of Painting*, I, p. 102 (quoting Stow, *Annals*); through John Flaxman, *Lectures on Sculpture* (London, 1829), pp. 24–5, and *Gentleman's Magazine*, LXXXVIII, no. i (1818), p. 301; right up to Whinney, *Sculpture in Britain 1530–1830*, p. 4, plates 1, 2a.

76 Alfred Higgins, 'On the Work of Florentine Artists in England . . . Tombs of . . King Henry VIII,' *Archaeological Journal*, LI (1894), 129–220, 367–70.

77 See Wall, *The Tombs of the Kings of England*, pp. 373, 378–82, for the contract drawn up on 5 January 1518/19 and *Archaeologia*, LXVI (1915), p. 366.

78 M. Mitchell, 'Works of Art from Rome for Henry 8th . . .', *Journal of the Warburg and Courtauld Institutes*, XXXIV (1971), 178–203.

79 (London, 1623), pp. 796–7. Extract reprinted in Mitchell, 'Works of Art from Rome for Henry 8th,' 201–3.

80 See ibid., *passim* for a discussion of the place of the design in the history of European art.

81 Ibid., p. 203.

82 Ibid., p. 202.

83 *Letters and Papers* in PRO, IV (ii), s113.

84 Carden, 'Italian Artists,' p. 195.

85 Higgins, 'Florentine Artists in England,' Appendix iv.

86 Carden, 'Italian Artists,' p. 197.

87 Ibid.; C.R. Beard, 'Torrigiano or da Maiano?,' *The Connoisseur*, LXXXIV (1929), 77.

88 Carden, 'Italian Artists,' p. 189.

89 'Roome and dignities' in British Library, Cotton MS Titus B1, fol. 233r.

90 Wall's version of the will is found in *The Tombs of the Kings of England*, pp. 320, 377. See also British Library, Cotton MS Titus B1, fol. 233v (an Elizabethan copy of the original); this will is abstracted in *Letters & Papers Foreign & Domestic of the Reign of Henry VIII*, XXI (2) (1910), 320–2 – which cites the reference R.O. Rymer, *Foedera*, XV, p. 110. None of the many copies of this much-studied will offer any additional information on the current state of the monument, e.g. British Library, Stowe MS 576, fol. 10 is a contemporary copy with the king's signature (in 22 pages); BL Harl. MS 293, fol. 107 is a later copy of 16 pages with a memo by Stowe that the original was in the hands of Mr Bradshawe and that this was made from it: fol. 108r makes no mention of the current state of the tomb; BL Add. MS 15387, fol. 269 is a contemporary Italian translation in 58 pages in a modern copy. A passage at fols. 273^{r-v} makes no comment on its current state; BL Titus MS B.1., fol. 232 is a copy in an Elizabethan hand in 25 pages with discussion of the succession after the death of Elizabeth I; BL Add. MS 4712, fol. 69 is a later copy: no comment at fol. 71r about the current state of the tomb but a later annotation notes 'H.6 and K.Ed.4 tombes to be repayred and made more princely.' At the very end (fol. 77v) is a Latin note on a drawn in seal dated '14 Feb anno regni nostri primo' and signed R Southwell and below this an extra note implying that this marginalia was made when the manuscript was copied on 1 May 1604; two other copies in PRO.
91 Mitchell, 'Works of Art from Rome for Henry 8th,' pp. 202–3.
92 Carden, 'Italian Artists,' p. 189 and M. Biddle, 'Nicholas Bellin of Modena: an Italian artificer at the courts of Francis I and Henry VIII,' *Journal of the British Archaeological Association*, XXIX (1966); a second letter is dated 5 October 1551.
93 British Library, Lansd. MS 116, fols. 49r–50v.
94 CSPD, *1547–80*, ed. H. Lemon (London, 1856) and British Library, Lansd. MS 94, fols. 27 ff.
95 Whinney, *Sculpture in Britain 1530–1830*, p. 431, n. 29 and Colvin et al., eds, *The History of the King's Works*, III, p. 321.
96 Platter, *Travels in England, 1599*, p. 209.
97 *Annals* (London, 1631).
98 Thomas Fuller, *The Holy State* (Cambridge, 1642), p. 254.
99 Alison Yarrington, 'Nelson the citizen hero: state and public patronage of monumental sculpture 1805–18,' *Art History*, VI (1983), 315–19.
100 *Journals of the House of Commons*, IV, 25 December 1644 – 4 December 1646 (London, n.d.), p. 279.
101 Ibid., p. 350, entry for 21 November 1645.
102 Ibid., p. 468.
103 Ibid., p. 502.
104 Ibid., p. 505 (10 April 1646).
105 Ibid., p. 631 (31 July 1646).
106 Higgins, 'Florentine Artists in England,' Appendix VIII; Esdaile says the tomb was melted down as idolatrous by Parliament (*English Church Monuments*, p. 59); Walpole reports that the sale realised £600 (*Anecdotes of Painting*, I, p. 109).
107 See for example, Helen Gardner, 'Dean Donne's Monument in St Paul's,' in R. Wellek and A. Ribeiro, eds, *Evidence in Literary Scholarship . . .* (Oxford, 1979), pp. 29–44 and the primary account in Isaak Walton, *Lives of Dr John Donne and Others* (edn of 1826).
108 See Huntingdon and Metcalf, *Celebrations of Death, passim*.
109 Henry Wotton, *The Elements of Architecture* (London, 1624), ed. F. Hard (Charlottesville, Va., 1968).
110 The pyramids in ancient Egypt were never intended to contain royal 'Bodies Natural';

they were so large that they functioned perfectly well without, see Huntingdon and Metcalf, *Celebrations of Death*, p. 150.

111 Lawrence Stone, *The Crisis of the Aristocracy 1558–1641* (2nd edn, Oxford, 1967), pp. 264–5.

Select Bibliography

The bibliography that follows offers a selection of recent publications together with a range of standard works; early printed books, manuscripts and antiquarian works have not been included. Some of these books are cited in the notes to the individual essays in this collection; others have been added. Many contain their own bibliographies which should be consulted.

Andrews, Kenneth R., *Trade, Plunder and Settlement: Maritime Enterprises and the Genesis of the British Empire 1480–1630*, Cambridge: Cambridge University Press, 1984.

Aston, Margaret, *England's Iconoclasts*, volume 1: *Laws Against Images*, Oxford: Oxford University Press, 1988.

Axton, Marie, *The Queen's Two Bodies: Drama and the Elizabethan Succession*, London: Royal Historical Society, 1977.

Barkan, Leonard, *Nature's Work of Art: The Human Body as Image of the World*, New Haven: Yale University Press, 1975.

——, *The Gods Made Flesh: Metamorphosis and the Pursuit of Paganism*, New Haven & London: Yale University Press, 1986.

Barker, Francis, *The Tremulous Private Body: Essays on Subjection*, London: Methuen, 1984.

Belsey, Catherine, *The Subject of Tragedy: Identity and Difference in Renaissance Drama*, London: Methuen, 1985.

Berry, Phillipa, *Of Chastity and Power: Elizabethan Literature and the Unmarried Queen*, London: Routledge, 1989.

Blunt, Anthony, *Artistic Theory in Italy 1450–1600*, Oxford: Oxford University Press, 1962.

Bober, Phyllis Pray, and Rubenstein, Ruth, *Renaissance Artists and Antique Sculpture: A Handbook of Sources*, London: Harvey Miller, 1980.

Bonfield, Lloyd, et al., *The World We Have Gained: Histories of Population and Social Structure*, Oxford: Blackwell, 1986.

Carrithers, M., et al., *The Category of the Person: Anthropology, Philosophy, History*, Cambridge: Cambridge University Press, 1985.

Chatman, S., ed., *A Semiotic Landscape*, The Hague, Paris & New York: Mouton, 1979.

Collinson, Patrick, *The Birthpangs of Protestant England: Religious and Cultural Change in the Sixteenth and Seventeenth Centuries*, Basingstoke: Macmillan, 1988.

Colvin, Howard, et al., eds., *The History of the King's Works*, Volume IV: *1485–1660*, London: HMSO, 1982.

Corbett, M., and Norton, M., *Engraving in England in the Sixteenth and Seventeenth Centuries*, Part III: *The Reign of Charles I*, Cambridge: Cambridge University Press, 1964.

Debus, Allen George, *Man and Nature in the Renaissance*, Cambridge: Cambridge University Press, 1978.

Elias, Norbert, *The Civilising Process. The History of Manners*, Oxford: Blackwell, 1989.

Fehrer, Michael, 'Fragments for a History of the Human Body' *Perizone*, issues 3–5, New York: Zone Books, 1989.

Ferguson, M.W., Quilligan, M., and Vickers, N.J., *Rewriting the Renaissance. The Discourses of Sexual Difference in Early Modern Europe*, Chicago: University of Chicago Press, 1986.

Foucault, Michel, *Discipline and Punish: The Birth of the Prison*, trans. Alan Sheridan, Harmondsworth: Penguin, 1979.

——, *The History of Sexuality*, Volume One: *An Introduction*, Harmondsworth: Penguin, 1981.

Frank, Robert G., Jnr., and Schapiro, Barbara, *English Scientific Virtuosi in the Sixteenth and Seventeenth Centuries*, Los Angeles: University of California Press, 1979.

Gent, Lucy, *Picture and Poetry 1560–1622. Relations between Literature and the Visual Arts in the English Renaissance*, Leamington Spa: James Hall, 1981.

Gillis, John R., *For Better, For Worse: British Marriages, 1600 to the Present*, Oxford: Oxford University Press, 1985.

Girouard, Mark, *Life in the English Country House: A Social and Architectural History*, New Haven & London: Yale University Press, 1978.

——, *Robert Smythson and the Elizabethan Country House*, New Haven & London: Yale University Press, 1983.

Glover, John, *I: The Philosophy and Psychology of Personal Identity*, London: Allen Lane, 1988.

Goldberg, Jonathan, *James I and the Politics of Literature*, Baltimore & London: Johns Hopkins University Press, 1983.

Greenblatt, Stephen, *Renaissance Self-Fashioning: From More to Shakespeare*, Chicago & London: University of Chicago Press, 1980.

——, *Shakespearean Negotiations: The Circulation of Social Energy in Renaissance England*, Oxford: Clarendon Press, 1988.

Harris, John, and Higgott, Gordon, *The Architectural Drawings of Inigo Jones*, London: Zwemmer, 1989.

Heninger, S.J., Jnr., *The Cosmographical Glass: Renaissance Diagrams of the Universe*, San Marino, Calif.: Huntingdon Library, 1977.

Henning, R.W., and Rosand, David, eds., *Castiglione: The Ideal and the Real in Renaissance Culture*, New Haven: Yale University Press, 1983.

Hersey, George, *The Lost Meaning of Classical Architecture: Speculations on Ornament from Vitruvius to Venturi*, Cambridge, Mass., & London: MIT Press, 1988.

Hill, Christopher, *The World Turned Upside Down: Radical Ideas during the English Revolution* (5th edn), Harmondsworth: Penguin, 1980.

Hilliard, Nicholas, *Treatise on the Art of Limning*, eds., R.K.R. Thornton and T.G.S. Cain, Ashington, Northumberland: Carcanet, 1981.

Hirst, Derek, *Authority and Conflict: England 1603–1658*, London: Edward Arnold, 1986.

Hobby, Elaine, *Virtue of Necessity: English Women's Writing 1549–1688*, London: Virago, 1988.

Hodges, Devon L., *Renaissance Fictions of Anatomy*, Amherst, Mass.: University of Massachusetts Press, 1985.

Howard, Maurice, *The Early Tudor Country House. Architecture and Politics 1490–1550*, London: George Philip, 1987.

Hull, Suzanne W., *Chaste, Silent and Obedient: English Books for Women 1475–1640*, San Marino, Calif.: Huntingdon Library, 1982.

Humphreys, Sally C., and King, H., eds., *Mortality and Immortality: the Anthropology and Archaeology of Death*, London: Academic Press, 1981.

Huntingdon, Richard, and Metcalf, P., *Celebrations of Death: The Anthropology of Mortuary Ritual*, Cambridge: Cambridge University Press, 1979.

James, Mervyn, *Society, Politics and Culture: Studies in Early Modern England*, Cambridge: Cambridge University Press, 1986.

Jardine, Lisa, *Still Harping on Daughters: Women and Drama in the Age of Shakespeare*, Brighton: Harvester Press, 1983.

Joscelyne, Trevor, 'Architecture and Music in *The Temple*: The Aesthetic and Intellectual Context of George Herbert's Poetry' (unpublished D. Phil. thesis, University of York, 1978).

Kantorowicz, E.H., *The King's Two Bodies: A Study in Medieval Political Theology*, Princeton: Princeton University Press, 1957.

Kipling, G., *The Triumph of Honour: Burgundian Origins of the Elizabethan Renaissance*, The Hague: Leiden University Press, 1977.

Kupperman, Karen O., *Settling with the Indians: The Meetings of English and Indian Cultures in America, 1580–1640*, London: Dent, 1980.

Laslett, Peter, *Family Life and Illicit Love in Earlier Generations*, Cambridge: Cambridge University Press, 1977.

Macfarlane, Alan, *Marriage and Love in England: Modes of Reproduction 1300–1840*, Oxford: Blackwell, 1986.

Maclean, Ian, *The Renaissance Notion of Woman*, Cambridge: Cambridge University Press, 1980.

McLuskie, Kathleen, *Renaissance Dramatists*, Hemel Hempstead: Harvester Wheatsheaf, 1989.

Marcus, Leah, *Puzzling Shakespeare: Local Reading and its Discontents*, Berkeley, Calif., & London: University of California Press, 1988.

Matejka, Ladislav, and Titunik, Irwin R., eds., *Semiotics of Art: Prague School Contributions*, Cambridge, Mass., & London: MIT Press, 1976.

Mercer, Eric, *English Art 1553–1625* (Oxford History of English Art), Oxford: Clarendon Press, 1962.

Norbrook, David, *Poetry and Politics in the English Renaissance*, London: Routledge & Kegan Paul, 1984.

Orgel, Stephen, and Strong, Roy, *Inigo Jones: The Theatre of the Stuart Court*, 2 volumes, Berkeley, Calif., & London: University of California Press, 1973.

Parker, Patricia, *Literary Fat Ladies: Rhetoric, Gender, Property*, London: Methuen, 1987.

—— and Quint, David, eds., *Literary Theory/Renaissance Texts*, Baltimore: Johns Hopkins University Press, 1986.

Phillips, John, *The Reformation of Images: Destruction of Art in England 1535–1660*, Berkeley: University of California Press, 1973.

Porter, Roy, *Disease, Medicine and Society in England, 1550–1860*, Basingstoke: Macmillan, 1987.

Prior, Mary, ed., *Women in English Society 1500–1800*, London: Methuen, 1985.

Reay, Barry, *The Quakers and the English Revolution*, London: Temple Smith, 1985.

Ribeiro, Aileen, *Dress and Morality*, London: Batsford, 1986.

Richardson, Ruth, *Death, Dissection and the Destitute*, London: Routledge & Kegan Paul, 1988.

Scarry, Elaine, *The Body in Pain*, Oxford: Oxford University Press, 1985.

——, ed., *Literature and the Body*, Baltimore & London: Johns Hopkins University Press, 1988.

Schmitt, Charles B., *John Case and Aristotelianism in Renaissance England*, Kingston, Ont.: McGill–Queen's University Press, 1983.

Smith, David R., *Masks of Wedlock*, Ann Arbor, Mich.: UMI Research, 1982; Epping: Bowker, 1982.

Stallybrass, Peter, and White, Allen, *The Politics and Poetics of Transgression*, London: Methuen, 1986.

Starkey, David, ed., *The English Court: from the Wars of the Roses to the Civil War*, London & New York: Longman, 1987.

Stone, Lawrence, *The Family, Sex and Marriage*, Harmondsworth: Penguin, 1979.

Strong, Roy, *The English Icon: Elizabethan and Jacobean Portraiture*, London: Routledge & Kegan Paul, 1969.

——, *Tudor and Jacobean Portraits* (National Portrait Gallery, London), 2 volumes, London: HMSO, 1969.

——, *Henry, Prince of Wales and England's Lost Renaissance*, London: Thames and Hudson, 1986.

——, *Gloriana: The Portraits of Queen Elizabeth I*, London: Thames and Hudson, 1987.

Summerson, John, *Architecture in Britain 1530–1830* (5th edn), Harmondsworth: Penguin, 1969.

Thomas, Keith, *Man and the Natural World: Changing Attitudes in England 1500–1800*, Harmondsworth: Penguin, 1984.

Warner, Marina, *Monuments and Maidens: The Allegory of the Female Form*, London: Weidenfeld & Nicholson, 1987.

Webster, Charles, *The Great Instauration: Science, Medicine, and Reform 1626–1660*, London: Duckworth, 1975.

Whaley, Joachim, ed., *Mirrors of Mortality: Studies in the Social History of Death*, London: Europa, 1981.

Whinney, Margaret D., *Sculpture in Britain, 1530–1830* (rev. edn by John Physick), London: Penguin, 1988.

Woodbridge, Linda, *Women and the English Renaissance*, Brighton: Harvester Press, 1984.

Yates, Francis A., *Astraea: The Imperial Theme in the Sixteenth Century*, London: Routledge & Kegan Paul, 1975.

Index